THE

GOVERNMENT STORE

IS

OPEN FOR BUSINESS

A review of the Commissariat
In Colonial NSW 1788-1835

By

Gordon W. Beckett
(Version 4)

For book orders, email orders@traffordpublishing.com.sg

Most Trafford Singapore titles are also available at major online book retailers.

Printed in Singapore.

ISBN: 978-1-4669-2749-0 (sc)
ISBN: 978-1-4669-2750-6 (hc)
ISBN: 978-1-4669-2751-3 (e)

Trafford rev. 07/23/2012

 www.traffordpublishing.com.sg
Singapore
toll-free: 800 101 2656 (Singapore)
Fax: 800 101 2656 (Singapore)

OPEN FOR BUSINESS

A review of the commissariat in colonial nsw
1788-1835

CHAPTERS

INDEX TO TABLES

Where tables are sourced from outside and independent sources, they are so noted. All other tables are sourced from Beckett, G. W. *Handbook of Colonial Statistics* – Colonial Press 2005.

INTRODUCTION

TO THE COMMISSARIAT

'It is unfortunate that no history of the commissariat system in Australia has been written' (N.G. Butlin)[1]

Imagine 1100 men and women heading to a new land[2], a new country, and think what planning for stores, provisions, materials would need to be made. Such a venture, it might be assumed, would require that at least something was known about the destination. However, in this case, only a brief reconnaissance had been made and written up in a journal[3]. An embroidery of the facts and an embellishment of the truth, at least in the Cook journal about the destination, meant no one really knew fact from fiction. This was not to be a day's outing, but rather a lifetime and longer must be planned for – clothing, hospital equipment and medical supplies, building materials, a leader's headquarters and above all foodstuffs.

How best to organise, acquire, store and recover all these items? An official, a government worker, a storeman! Andrew Miller! Therefore, in these uncertain circumstances, Miller became potentially the most important man in the new settlement- a storeman, a Commissary. There is often misunderstanding and misuse of the two key words here, commissary and commissariat[4].

The argument put forward in this study is that the commissariat was not only the storehouse of the colony but the engine-room and powerhouse of the early colonial economy. How this was achieved forms the main body of this thesis.

Why this challenge was undertaken is a matter further discussed later in this chapter, but it is worthy of stating at this juncture, that as one of the three most important economic drivers in

[1] Butlin, N.G. *Forming the Colonial Economy: Australia 1810-1850 (Cambridge University Press, 1994)*, 148
[2] This is a reference to the First Fleet under Captain Arthur Phillip
[3] Frost in Botany Bay Mirages demonstrates that there had been consideration given to sending a scouting ship to set up camp in the best location, but time and cost decided against this move. The journals relied upon, were those of Cook and Banks. Cook's journal was 'doctored' by Beaglehole, the publisher.
[4] The Macquarie Dictionary (3rd Edition) defines the *commissariat* as 'a department (of the army) charged with supplying provisions', AND as 'the organised method, by which food, equipment, transport etc is delivered to the armies, whilst the definition of commissary is 'an officer of the commissariat'. The U.S. uses the term commissary as being a store that supplies food and equipment, especially in an army, mining or lumber camp. To avoid confusion, this text will refer to the commissariat as the store and the commissary as the storekeeper.

the history of the colony of NSW, the commissariat seems to be the least understood, especially as to its overall operations, purpose, activities, role, outcomes, and successes. In fact, the role of the commissariat has been generally misunderstood as far as (1) the detail of commissariat operations has been neglected by most historians, and (2) the commissariat left behind no substantial archive of records. However perfunctory the research to-date has been concerning the commissariat, there is no question that the commissariat holds a most important place in colonial economic history. Parsons tries to develop an understanding of the early commissaries[5], rather than the overall role and operation of the commissariat, whilst the two Butlin's in addition to Abbott & Nairn provide generous overviews of commissariat activities. There is, by necessity of the lack of records, a challenge in trying to reconstruct the many aspects of the colonial commissariat.

Literature Review

When Professor N.G. Butlin wrote 'it is unfortunate that no history of the commissariat system in Australia has been written',[6] it raised a real concern, in my mind, as to why a history of the colonial commissariat need be written. However, once initial research was undertaken, it became apparent that the commissariat was the central feature of the colonial economy and the main economic driver of the early economy, at least between 1788 and 1830, and so little was known about its structure and operations.

One writer who appears to have given a little more detailed attention to the commissariat is T.G. (George) Parsons of Macquarie University. Although his main research work is included in a volume on *Australian Financiers*, the editors of the volume (Schedvin and Appleyard) suggest 'for most of the 19th century our financiers combined finance with a range of other activities. The commissaries combined the provisioning of the colony with the issue of currency and elementary deposit banking'. Alan Frost in *Botany Bay Mirages* sees NSW as the creation of English commercial and imperial ambition, but points out that 'London displayed an absolute lack of interest in questions of economics and finance'.

[5] Parsons, T.G. '*Colonial Commissaries*' Australian Financiers – Chapter One (Editors) R.T. Appleyard and C.B. Schedvin
[6] Butlin, N.G. '*Forming a Colonial Economy*' Page 148

Parsons, assist his understanding of the role of the commissariat by describing the base role of the commissariat in succinct terms:

> *'The Commissaries fed and clothed the convicts, the military and the civil officers. They victualled all those settlers, mainly emancipists, who were supported by the government for at least the first two years of their freedom and also provided them with tools and clothing. The commissariat was the principal market for colonial produce, buying grain and other products from the settlers, who relied on the commissaries for a secure, stable income. Commissary bills and store receipts were the currency of NSW; the commissariat dominated colonial finance, acted as a bank, controlled and administered the flow of foreign exchange in the shape of treasury bills issued to pay for the cost of the colony, provided loans and credit and encouraged the establishment of enterprises that could meet its demands. The personnel of the department were intimately involved with the emergence of colonial Australia.[7] '*

A more 'accepted view' of the commissariat can be found in general historical works like *Oxford Companion to Australian History*, in addition to the main economic history texts including Butlin, S.J. *Foundations of the Australian Monetary System;* Butlin, N.G. *Forming a Colonial Economy* and Abbott & Nairn (Eds) *Economic Growth of Australia.*

When considering a subject such as 'The Commissariat of the Colony', accessing any existing literature would come by way of researching the fundamental chapter structure

British colonial policy

British expenditure and government policy on transportation

British Commissariat appropriations for the colony

Raising of local revenues and the associated expenditures

Economic policies of the governors

Colonial economic drivers

The contributors to literature in this field are essentially specialists in each of the topics. For instance, each of the top ten economic historians had their own area of specialty and wrote their studies accordingly.

[7] Parsons, T.G. *'Colonial Commissaries'* Australian Financiers – Chapter One (Editors) R.T. Appleyard and C.B. Schedvin. Page 12-13

Timothy Coghlan had statistical interests, labour utilisation and pricing policies as his core focus.

E. O. Shann used as a theme the mainstay of the colonial economy being the pastoral and agricultural interests and foreign investment

Butlin, S.J. made a major contribution by following the rise of the financial institutions

Butlin N.B. took as a starting point the Aboriginal economy in 1788 and followed colonial economic development in its many aspects until he could find a starting point for his GDP statistics from 1861

Geoffrey Blainey concentrated more on the general history side and developed the theme of disadvantages and advantages of the remoteness of the colony.

Those second tier economic historians who closely followed one or more of the above specialists include Hartwell and Abbott & Nairn – Economic Development in VDL and on the mainland; Steven – a concentration on trading within the colony; Hainsworth on Sydney traders, merchants, and Linge on the rise of manufacturing.

General historians who oftentimes flavoured their text with economic idioms include Clark, Barnard, Shaw, Madgwick, O'Brien and Fitzpatrick.

Therefore, a study of public finance will include selective examination of the limited literature of specialists in their fields, since no one economic historian has covered the subject of public finance nor examined the records relating to colonial finance. Thus full and unlimited access must be made to the official records – the HRA, the HRNSW, the SRO-NSW files and in particular the AJCP

If the literature is allocated to the six main concepts within the thesis, it can be seen just how limited it is:

Economic policies of early governors	- HRA
Role of Public Finance	- Butlin, S.J., Beckett in *William Lithgow*
Foreign Investment	- Abbott & Nairn, Hartwell
Economic Drivers	- Coghlan, Beckett in *Economics of the Commissariat*
Role of Manufacturing	- HRA, HRNSW, Linge
Analysing the Financial statements	- HRA, Sydney Gazette and the Beckett analysis.

It can be seen that the available literature covers only a few of the topics within this subject and that much of the research is from original documents and is an interpretation of original sources. A great deal of important general background is gained from Clark, Blainey, Shann and Butlin but most of the specifics of public finance come from reading and interpreting original documents.

Noel Butlin's *Forming a Colonial Economy* is a culmination of many years of detailed research and writing. S.J. Butlin's *Foundations* rivals his brother academic approach to the colonial economy but was written almost 40 years earlier. In the interim period, N.G. Butlin satisfied himself with contributing to a whole series of Australian Economic History *Working Papers,* underwritten and sponsored by Australian National University. A careful review of these working papers enables a student of the colonial economy to build up a network of appropriate information on various elements of the colonial economy. For instance, Butlin contributed 15 articles to the ANU working papers' series between 1954 and 1993 (this last article, like his final two books were published posthumously after an editing and completion by his son).

These 15 articles ranged from topics such as private capital formation and Australian Domestic product (these two working papers led to his book – *Investment in Australian - Economic Development 1861-1900*); the articles *Modelling Aboriginal depopulation, Macassans & Aboriginal Small-pox* and *Aboriginal populations in South-east Australia* led to his book *Our Original Aggression;* the articles *White human Capital* and *Colonial Statistics before 1850* led to a joint contribution with Ginswick and Statham entitled *Colonial Statistics before 1850* in Australians: A History. Butlin assembled '*General Returns of Convicts in NSW – 1837*, as the fourth of his six books. All of his articles led to his final two works published posthumously 'Economics of the Dreamtime' and 'Forming a Colonial Economy'. Butlin's keen interest in the colonial economy made substantial use of the Abbott and Nairn edited work *Economic Growth of Australia* 1788-1821, which was a compilation of studies by 12 eminent economic historians in Australia, including Abbott, Fletcher, Hainsworth, Hartwell, Nairn, Shaw, Margaret Steven and Walsh. The text covers the foundation of the colony, constraints on progress, the nature and rate of growth, and constituent elements of the

colonial economy. It gives only passing reference to the growth of manufacturing and neglects the establishment and growth of the public service under Governor Darling. Notation is made however of the McMartin work *Public Servants and Patronage*. No reference is made to the Linge text 'Industrial Awakening' a powerful 900 page work claiming to be a geography of Australian manufacturing rather than an economic history of the topic.

The secondary source literature available is not as important or as relevant as the primary sources. The primary sources, which include the files of original returns of the colony and which are located in the SRO/NSW and the SLNSW are the main access to data and interpretive information. The main goal of the thesis is not to perpetuate the current myths and false perceptions about the commissariat and public finance, but to add to the literature by defining the economic impact of a government business operation, a local taxation, the savings to Britain when they substituted Treasury appropriations with that local revenue, rather than allowing the local taxation to be the discretionary outlays so badly required by the governors, in order to add those little luxuries to the social fabric in the early colony. Analysing the causes of the economic cycles in the colony enjoins an analysis of governor policies, an understanding of economic events in Britain and the relationship between the two economies. Selecting and analysing key economic events and economic drivers involves an understanding of colonial period historical events and interpreting those, which affected economic growth or development. The current literature perpetuates the concept that Britain was the source of all financial gain in the colony. Only closer analysis shows the major contribution made by a few selective government policies, in addition to the workings of the commissariat, the transitional policies from command to free market economy accompanied by a transfer of enterprise from government to the private sector, leading to the rise of a manufacturing sector comparable to the significant but overstated agricultural sector.

The abject concentration of past economic historians on the primary industry sector, at the expense of the secondary industry sector is largely based on a selective misconstruction of Coghlan and Shann's preoccupation with wool and the pastoral industry, much like Shaw's misdirection in trying to be an economic historian rather than a quality general historian, and focusing on the failures of the squattocracy.

The literature relating to the fiscal arrangements within the colony is quite 'thin'. The NLA, and the SLNSW have copies of the Sydney Gazette which published the financial statement produced by Rev'd Samuel Marsden and Darcy Wentworth on behalf of the Orphan Fund and the Gaol/Police Fund. The SRO of NSW holds the originals of these statements. The Blue Books (from 1822) are now available in hard copy at the NLA in addition to the microfiche copies, which were hard to read and copy. The volumes of HRA and HRNSW contain much correspondence relating to instructions from the Secretary of State in London and of the Governor's despatches to London. Much can be interpreted from these records, with one disappointment being the number of 'attachments to despatches 'not being available' in the HRA. Therefore, access is now more readily available to the financial records of the colony and this fact may encourage more historians to analyse these records.

There is a sorry situation in terms of current economic historians. They are few in number, as most universities (ANU, UNSW, UT, Flinders and Monash) have closed their Departments of Economic History, so there will be a period when the literature is not revised or updated and just does not exist. To my knowledge, UNE is the only institution still offering on campus courses. Few writers have undertaken or completed economic analyses of the fiscal changes in the colonial economy. Fewer still have tried to explain or understand the public finance issues or mechanism. Those few commentators of colonial economic development or economic growth include:

Coghlan, T.A. '*Labour & Industry in Australia* (1918)

Coghlan is the father of all economic historians in this country and justly deserves this standing and position. However, the Coghlan arrogance as represented by ANU's Dr Fry in introducing the Macmillan edition of his four-volume treatise on Labour & Industry in Australia is easily justified by any economic historian in the 21st century. Although Coghlan was the author during his lifetime of a great many official reports and studies, his great work, published in 1918, is without a single reference, mainly because as Coghlan writes in his preface – 'For the statistics, I am my own authority'. Fry treats this as arrogance on Coghlan's part but in fact mistakes a lack of notation of numerous census reports, studies and treatises as a shortfall rather than observing the difficulty of recording and citing much of the material, he had access to as a civil service but which could hardly be cited in an unofficial history of the

colony. In fact, Coghlan's observations and opinions are much more persuasive without the use of citations. Coghlan opines on matters of great moment on events between 1788 and 1900 and brings a balance to the importance of non-economic events as well as the rise of a manufacturing sector in the colony. Beckett extends this Coghlan analysis by also adopting 'exploration' as a significant economic driver and refers to Coghlan trade prices disclosed for the preparation of the economic modelling used to calculate GDP before 1861. Coghlan is an essential reference for any economic study of importance and sometime a Coghlanesque restatement of his opinions and findings must be prepared in order to offer wider access to his brilliant insight through Labour & Industry in Australia in much the same way John Ritchie gave public exposure to the Bigge Reports in *Punishment & Profit.*

Shann, E. O. *'Economic History of Australia'* (1930)

The limitations and general sternness of the Shann text has been mentioned above. As with other similar texts, it filled a gap between Coghlan in 1917 and Butlin S.J. in 1953. Shann was ably supported by Schedvin and Shaw in the 1940s and Fletcher and Fitzpatrick in the 1950s. It is appropriate that like certain politicians who became 'a man for his times' (eg Churchill), economic writers bring forth a study suitable for the moment, and no-one can take away the contribution made by Shann, Schedvin, Fletcher or Fitzpatrick. However, they were relevant for those niche times but for today are fill-ins of economic history knowledge, that need revising and updating, for readers today do not enjoy the fastidious, unfaltering and constructive language used particularly by Shann without the folksy style of Clark, Barnard and R.M. Younger

Fitzpatrick, Brian contributed two main texts to the economic history literature. The first, from 1939, was *British Imperialism and Australia 1783-1833.* In **1941,** he converted this text into a 'student edition' and renamed it *The British Empire in Australia.* The second main text was a slim volume covering the period 1788-1945 in about 250 pages. Fitzpatrick makes no reference to the government store in his second text however, in his first work *British Imperialism and Australia 1783***-1833 (published 1939)** he goes into limited aspects of the commissariat ; such as questions of rations, pricing of various commodities, the officers monopoly of the commissariat and the 'notes' issued by the store. In his re-writing of his first

text, worded for students and published in 1941) he adds marginally to his earlier references by adding a short commentary on commissariat expenditures.

In all, for a supposed treatise of British Imperialism in Australia, Fitzpatrick makes too little of the commissariat. It was the store, as operated initially under the control of the governor (set down in his instructions from Britain) and then the military masters, who oversaw store policy, including the issuance of store receipts to facilitate barter, operations of the business enterprises within the store system, and the use of the store as a quasi-bank. Fitzpatrick overlooks these important aspects of British colonial policy. As H. V. Evatt notes in his introduction 'the truth is otherwise than the Government of Britain took pains to 'lay the foundations of a great self-governing Dominion'. The truth is also that the commissariat was an important instrumentality of British rule and cost control in its colonies and deserves further recognition by those claiming to write 'an economic history of Australasia'

Butlin, S.J. *'Foundations of Australian Monetary Policy'* (1953)

This study is the penultimate study of public finance ever published in this country. Its limitations are that it was first published in 1953, and overrides, by its concentration on the overview of public currency, any detailed examination of the colonial treasury, the commissariat, or the government business enterprises. This preoccupation with expansion of the currency overlooks the numerous economic drivers that kept economic development at a fever pitch, and fails to measure the economic impact of the Macquarie economic policies, the rise of manufacturing, whilst persuading his reader that the pastoral expansion of the 1830-1840s was essentially linked to the growth of banking. Pastoral expansion, in fact, gave rise to a new structure of the financial institutions, especially pastoral houses as one-stop brokerage, finance and marketing operations, but S.J. Butlin does not consider this link. In spite of any shortcomings, the study is the epitome of colonial economic history but could have been fleshed out a bit more cautiously and thoroughly

Butlin, N.G *'Economics and the Dreamtime'* & *'Forming a Colonial Economy'* (1992)

It is unfortunate that these two books were published posthumously after an editing by Noel Butlin's son. Butlin's prolific output was usually developed, initially through publication

as ANU Working Papers on selected topics, and then assembled into a working text. Butlin's economic history interests were wide ranging and indeed his interest in the Aboriginal economy led to a major research study into Aboriginal population numbers in 1788. The assembly of these statistics by use of a model and back projections are still quoted in academic circles, as being more reliable than the Rhys-Jones estimates of a decade earlier. Butlin is the most knowledgeable and productive of the recent economic historians and is a figure to be revered and respected in the area of colonial economy topics. Like many writers, certain of his specific conclusions raise concerns but overall his understanding of the colonial economy is to be admired.

Abbott & Nairn (Eds) *'Economic Growth of Australia* 1788-1821 (1969)

Abbott and Nairn surrounded themselves with a few 'names' in economic history in an attempt to emulate Hartwell's significant accomplishment of 'The Economic Development of Tasmania'. Those names, who are established authors in their own right include Brian Fletcher, R.N. Hartwell, D.R. Hainsworth (*The Sydney Traders), M.J.E. Steven (Merchant Campbell)* and A.G.L. Shaw. The problem with a text such as this is the shortage of continuity between the various writers, and the taking of certain writers away from their comfort zones of expertise. For example Steven cleverly articulates the life, times and economic contribution of Robert Campbell in her *Merchant Campbell,* but fails to display the same skills in bringing to life her chapter in this present book on 'exports' or the changing pattern of commerce. Shaw tries to describe the shortage of labour in the colony, as a late arriving phenomenon, but in fact, the excess of demand over supply of labour can be easily traced back to 1798, rather than the 1820s to which Shaw is attributing the shortage. Hainsworth makes a serious contribution about trade within the colony, but he can't swing the imbalances within the text away from the agricultural scene. Of the section relating to 'Constituents of the NSW economy' almost half is given over to agricultural whilst only a junior lecturer at the Military Academy is left to underpin the role of manufacturing and secondary industry in the colony (G.PO. Walsh). This book fills the gap in economic history literature for the late 1960s but fails to fill the need for serious, specialised economic history of the colonial period.

Jackson, R.V. *'Australian Economic development in the 19th century'* (1977)

Jackson's work is a late attempt by ANU to delay the approaching closure of economic history as an academic exercise. By the late 1970s, many universities were contemplating the passing of economic history as a specialty and anticipating the return of traditional economic and commercial studies. Jackson recites in just over 150 pages, a range of events nominated as having made a difference within the colonial economy, but fails to link them together as integrated economic drivers which together created a significant GDP. Jackson nominates population, exports, transport, urbanisation, money, and banking as key events, but fails to note any linkage between them, and suggests they are 'stand-alone' selections. This is not a very convincing text but has as its main strength its stated intentions to 'give an account (albeit to first year students who have a minimum acquaintance with economics) of Australia's economic experience from the beginnings of white settlement to about 1900'.

White, Colin '*Mastering Risk – Environment Markets & Politics in Australian Economic History* (1992)

R.V. Jackson credits Colin White with reviewing the various drafts of the Jackson texts. His own text does a much better job of linkage between key economic events commencing with the Aboriginal economy, describing the form of colonial capitalism used, the free trade versus protection endeavours pre-1900, and concludes with an analysis of 'historical roots of current economic dilemmas'. This is not a broad based text in colonial economic history but rather the ramblings of preferred ideology as compared with a detailed or determined study of colonial economic history. White mentions in passing the ignominy of having no value applied to convict output but fails to notate that this caused major problems for successive governors in achieving adequate funding for colonial needs. Being a pet peeve of this writer, it is disappointing that no economic historian (other than White) actually observes the actuality of not applying value to convict output, and no-one observes the effect this had on not only Treasury funds appropriation to the colony, but the meanness of successive Secretary's of State in Britain in comparing expenditures between governors, based solely on absolutes rather than per head of population. Beckett, as a career accountant takes a special interest in valuing output and production, and in observing the aboriginal economy of 1788, finds a comparable situation in trying to measure Aboriginal economic/manufacturing output when all materials were natural and would have no assigned value, and Aboriginal manufacturing labour was a sideline to hunting and gathering.

This selection covers just about all references to economic growth and public finance, which have all been examined in conjunction with the preparation of this study.

Other Literature

The last set of literature records to be reviewed include, AJCP, Journal Articles and Pamphlets However, two bibliographic articles have provided further references in journals relating to specific topics within these broad subjects. The Economic History Review produced a bibliography of Australian Economic Historiography by C.B. Schedvin, whilst Jules Ginswick another noted economic historian produced 'Select *Bibliography of pamphlets on Australian Economic & Social History 1830-1895'* (Published by Law Book Company in 1961). The Economic History Review also published an article by A/Professor Boot on the Colonial Economy. Boot, an ANU lecturer, specialised in the colonial economy, but wrote only sparingly (probably) by publishing his lecture notes with only limited editing. Such notes do not a successful text make, and Dr Boot can make no claims to being a 'noted' colonial period economic historian.

As Schedvin, points out in his *Essays in Bibliography and Criticism (HER Vol XXXII, No4)* this essay presents an overview of the writing of Australian economic history since the decisive reorientation in the early 1960s towards uncovering the mechanism of economic growth and development. Schedvin, a long-time student of Australian economics (The *War Economy* co-authored with S.J. Butlin, and *Australia and the Great Depression – [published1970]),* claims in his Essay in bibliography that since the early 1960s, Australian economic history has grown in status and importance, the result of which has been a transformation in our knowledge about many aspects of early Australian material life. The main achievements, he suggests has been in quantification, in uncovering the relationship between resource endowment and economic development, and in the application of simple mechanical models. The purpose of his essay was to note the more significant contributions in economic history in Australia. The Schedvin contribution to literature in this field is of great value and his findings and references have been explored for this Beckett writing.

In his text on '***Select Bibliography of Pamphlets on Australian Economic History***', Jules Ginswick, a noted economist and collaborator with N.G. Butlin, writes 'in the SLNSW (Mitchell Library) there are something like 4000 pamphlets which are bound and catalogued[8], in addition to which there are many thousands unbound and uncatalogued. These pamphlets offer a rich source for students of Australian economic history. This bibliography was conceived as an aid to honours students in the School of Economic History at University of Sydney, and does not pretend to be a full list.'

A successful researcher explores all avenues of opportunity and sometimes reaches valuable veins of recorded knowledge. Although now completely out-of-print and retained only in the NLA, the ANU and Flinders University and UNSW (Faculty of Economics and Commerce) all sponsored what was then called '*Working Papers*'. The ANU series was the most prolific although the Flinders compilations showed great potential, and it was N.G. Butlin, during his lengthy stay at ANU that contributed to the ANU Working Papers in Economic History. The Flinders series petered out after only a few 'working papers' were prepared but those were of a good quality and the series showed great potential. UNSW (FEC) produced an annual 'Conference in Economic History' from which was produced a series of conference papers. This student has only ever met (to the best of his knowledge) one working economic historian, Dr David Meredith (A/P in the FEC at UNSW) and it was a great pleasure to spend some hours talking with Dr Meredith in the grounds of ANU.

Beckett then heard Geoffrey Blainey speak on the 5 leading Australian economic historians, and had the opportunity afterwards to speak with Blainey. He sees a re-emergence of interest in Australian economic history but feels the loss of momentum and the stalling of university programs in this field will slow down any new interest. What was of particular interest was his selection of the five top economic historians. He mentioned that Manning Clark had moved from economic history back to general history whilst Shann had moved from general history to economic history. His selections included Coghlan, Shann, Fitzpatrick, Butlin and Fletcher. The young writers of today were not mentioned which does not bode well for an active future in Australian economic history

[8] Since this essay was contributed and printed in 1961, probably another few thousand have been added

As I have noted elsewhere, Butlin used these working papers as a precursor to the assembly of a number of these working papers into his published books. This researcher followed somewhat the same lines, by spending a year in the bowels of the NLA in Canberra (Beckett was a member of the management committee in the National Library during that time) and assembling over 100 ring-binders of documents classified into 43 'topics' relating to colonial economic history. From an enhanced and comprehensive personal research library, Beckett prepared 17 *Australian Colonial History Monographs* on topics such as

> British Investment in the Colony 1788-1855
> The Operations of the Commissary
> The Development of the Public Accounts
> The 'Funds' as part of the Colonial Treasury
> The colonial economy of NSW
> British Influence in the Economy 1788-1850 and the Depression of 1842

From these Beckett produced three larger works

> *'William Lithgow – the First Colonial Auditor-General'* – His Life and Times
>
> *'An Economic Study of Australia's Oldest Land Grant Company- Van Diemen's Land Company'*, and the current project
>
> *'The Government Store is Open for Business'* – The economic role of the commissariat of NSW

This preoccupation with colonial economic history has become a mature age pastime but one that is challenging and ongoing. A self-contained resource centre is not quickly or easily come by and provides the ongoing commitment to further research in this chosen subject.

AJCP, HRA and HRNSW

AJCP

The AJCP is the local reference guide that substitutes the need for an historian to spend months in the Public Records Office in London. Over one million documents were selected and copied onto various means of storage such as, microfilm, microfiche, and hard copy over a period of nearly 50 years, as a joint project between the NLA, the SLNSW and the PRO. Although many of the records are duplicated in the HRA, and HRNSW, there are still many,

many records of an original nature and the source of much unique and rich information from which interpretation is possible.

Original research from each of these primary sources, which is intended to contribute to the limited current literature and which is submitted in conjunction with this study includes:

1. An economic model defining & revealing GDP between 1810 and 1830
2. Measuring the growth of manufacturing in the colony between 1788 and 1830
3. A detailed analysis of the Revenues & Expenditures in the Orphan and Gaol/Police Funds

The literature is obviously far from being current, and is mostly set in the period of peak interest in economic history- being the 1950-1980s. A review today should be couched in a debate about the current view of 'reasons for the colony', a renewed consideration of why 'there was no treasury in the colony', and a first assessment of the real growth and impact of manufacturing in the economy pre-1825. This latter part of the study would then enable a section relating to GDP pre-1861, the point at which Butlin commences his work on GDP and economic growth in Australia. Since the N.B. Butlin works listed above were published posthumously, it is interesting to conjecture how much better his own contribution to this literature may have been if he personally had edited, introduced and presented his most recent writings. It is disappointing that the sole monument to the Butlin contribution to colonial economic studies (The *Noel Butlin Archives*) within the ANU, does not have any Butlin books nor his private papers, but is rather a collection of industrial company records (eg the papers of the AAC, and the CSR Company and numerous others are held there). However worthy these collections are for future historians, the Butlin papers themselves would be a major contribution to Butlin's thinking, research and writings on the many important history debates still raging. For instance the current history wars between Connor (UT) and Windshuttle would be better based if Butlin's research notes on his aboriginal population estimates in 1788 were available. Manning Clark's estimate of 400,000 is at odds with Butlin's estimates of over one million, whilst Windshuttle and Connor's estimates range between 500,000 and 750,000.

A final observation about the literature of economic development in Australia and the public finance is that with the output being in so few hands, there is the chance of that output being

skewed and without appropriate independence. It could result in the close marrying syndrome where inbreeding occurs and the outcomes are often negated through lack of objectivity. Fresh/new blood cannot but help determine a renewed interest in the subject.

Thesis Structure

The convict crews for construction work, land clearing and timber felling, wherever located, had to be victualled and fitted out with clothing and tools by the commissariat. This need, together with the spread of settlement, led to a diversification of planned commissary locations – first Sydney town, and then Parramatta, Liverpool, Windsor, and the newly created Government Farms at Castle Hill, Pennant Hills, Toongabbie, Rose Hill, Emu Plains and Rooty Hill.

Because of this growth, the location of the central stores in Sydney town also changed and grew. The first store was built on the west bank of the Tank Stream in 1788. A second and more permanent store was built behind the military barracks, where Wynyard Station now stands. The third store was conveniently located adjacent to the Queen's Wharf, later renamed the Hospital Wharf. A fourth store was then built on Bridge Street east of George Street, near Macquarie Place. This fourth location housed and distributed fresh foods, whilst the other three stored materials, general supplies and non-perishable goods. Grain stores had been built adjacent to the two 'public' windmills – one on York Street, and a second was built by John Palmer near his land grant on Woolloomooloo Bay. The convict work centres were built behind the main George Street Store, and used as a facility to load and unload boats; in the adjacent Dockyard, with the Timber Yard further south down George Street, then the Lumber Yard was located on the corner of George and Bridge Streets, and the main Stone Quarry was opposite the Lumber Yard on west side of George Street. The female convicts commenced operations in the colony at the Female Factory on the extension to the Parramatta River, northwest of the township. These locations are more clearly identified on a map found in the Appendix to this study.

The main outlying areas in which a commissariat store was located included Windsor (serving the Hawkesbury towns), Liverpool (serving the Camden area), and Parramatta. In the VDL sub-location, outlying stores were found in Hobart and Port Dalrymple (Launceston).

Brick making took place in three locations: The southern part of the Hyde Park – below the Convict barracks at Brickfield Hill and at Rose Hill on the south bank of the Parramatta River. In all, there were over 20 commissariat locations in and around Sydney town and the outlying settlements. All were serviced and supported from the Commissary-General's Offices in George Street. Stone Quarries were located in High Street (opposite the Lumber Yard), Bennelong Point, and York Street, (below the Observatory).

Government Farms were located at Emu Plains, Castle Hill, the Cow Pastures, Rooty Hill and Toongabbie, and provided grains, vegetables, fruits, milk, butter and fresh meat. Timber harvesting was centred in the Pennant Hills area; north of Sydney Town but in close proximity to the Lane Cove River down which logs could be floated to the Harbour before removal to the Timber Yard.[9]

The main role of the study has already been identified – that is to create and maintain a government store in the colony, secure the inventory and issue items as needed, and maintain those items in a usable condition. The underlying role does not recognise concepts such as the colony was full of thieves and therefore store inventory was more than likely to be stolen, nor that many items such as tools and axes were not suitable to the purpose at hand, and that there were many breakages, to the extent that tools being rendered useless occurred daily, with little means of repairing or replacing those items. 'A shot in the dark' would be a label for the commissariat challenge arising from the ignominy of planning for this penal settlement. Phillip had planned for many contingencies but misuse and theft of tools was apparently not one of those contingencies. Alan Frost in *Botany Bay Mirages* asks why a pilot program was not arranged, or a dry run made, or one vessel sent out earlier than the others to select a campsite and establish a pre-settlement? Could this be an absence of mind or an absence of sound planning, which could come back to haunt the settlement leaders later?

In either case, the first days of the commissariat and its Commissary (Andrew Miller) were hectic, and confused. The ships could not be completely unloaded and sent back home, meanwhile a campsite was needed to be established, and stores such as bedding, cooking

[9] A full identification of the over 20 commissary operations is shown in the Appendix to this study.

implements, foodstuffs, and selected tools were needed as a priority. There was no physical store, only a tent with casual security, and certainly no mechanism for recording who had what and where everything was. Thus, the commissariat got off to a bad start. As if Miller's commissary role was not demanding enough, he was also the scribe for Governor Phillip, who was anxious to record his thoughts and observations of the new camp-site.

From small beginnings, mighty timbers grow. A small beginning for the colonial commissariat perhaps, but a very important one, and a solid base to grow from. Later chapters will describe the commissariat in action – as an employer, as an entrepreneur, as a manufacturer, and as the main economic driver in the colony.

The chapter organisation has been based on the structural arrangement of the commissariat, to better understand the various aspects of the government store operations.

The convict crews for construction work, land clearing and timber felling, wherever located, had to be victualled and fitted out with clothing and tools by the commissariat. This need, together with the spread of settlement, led to a diversification of planned commissary locations – first Sydney town, and then Parramatta, Liverpool, Windsor, and the newly created Government Farms at Castle Hill, Pennant Hills, Toongabbie, Rose Hill, Emu Plains and Rooty Hill.

Because of this growth, the location of the central stores in Sydney town also changed and grew. The first store was built on the west bank of the Tank Stream in 1788. A second and more permanent store was built behind the military barracks, where Wynyard Station now stands. The third store was conveniently located adjacent to the Queen's Wharf, later renamed the Hospital Wharf. A fourth store was then built on Bridge Street east of George Street, near Macquarie Place. This fourth location housed and distributed fresh foods, whilst the other three stored materials, general supplies and non-perishable goods. Grain stores had been built adjacent to the two 'public' windmills – one on York Street, and a second was built by John Palmer near his land grant on Woolloomooloo Bay. The convict work centres were built behind the main George Street Store, and used as a facility to load and unload boats; in the adjacent Dockyard, with the Timber Yard further south down George Street, then the Lumber Yard was located on the corner of George and Bridge Streets, and the main Stone Quarry was opposite the Lumber Yard on west side of George Street. The female convicts commenced

operations in the colony at the Female Factory on the extension to the Parramatta River, northwest of the township. These locations are more clearly identified on a map found in the Appendix to this study.

The main outlying areas in which a commissariat store was located included Windsor (serving the Hawkesbury towns), Liverpool (serving the Camden area), and Parramatta. In the VDL sub-location, outlying stores were found in Hobart and Port Dalrymple (Launceston).

Brick making took place in three locations: The southern part of the Hyde Park – below the Convict barracks at Brickfield Hill and at Rose Hill on the south bank of the Parramatta River. In all, there were over 20 commissariat locations in and around Sydney town and the outlying settlements. All were serviced and supported from the Commissary-General's Offices in George Street. Stone Quarries were located in High Street (opposite the Lumber Yard), Bennelong Point, and York Street, (below the Observatory).

Government Farms were located at Emu Plains, Castle Hill, the Cow Pastures, Rooty Hill and Toongabbie, and provided grains, vegetables, fruits, milk, butter and fresh meat. Timber harvesting was centred in the Pennant Hills area; north of Sydney Town but in close proximity to the Lane Cove River down which logs could be floated to the Harbour before removal to the Timber Yard.[10]

The main role of the study has already been identified – that is to create and maintain a government store in the colony, secure the inventory and issue items as needed, and maintain those items in a usable condition. The underlying role does not recognise concepts such as the colony was full of thieves and therefore store inventory was more than likely to be stolen, nor that many items such as tools and axes were not suitable to the purpose at hand, and that there were many breakages, to the extent that tools being rendered useless occurred daily, with little means of repairing or replacing those items. 'A shot in the dark' would be a label for the commissariat challenge arising from the ignominy of planning for this penal settlement. Phillip had planned for many contingencies but misuse and theft of tools was apparently not

[10] A full identification of the over 20 commissary operations is shown in the Appendix to this study.

one of those contingencies. Alan Frost in *Botany Bay Mirages* asks why a pilot program was not arranged, or a dry run made, or one vessel sent out earlier than the others to select a campsite and establish a pre-settlement? Could this be an absence of mind or an absence of sound planning, which could come back to haunt the settlement leaders later?

In either case, the first days of the commissariat and its Commissary (Andrew Miller) were hectic, and confused. The ships could not be completely unloaded and sent back home, meanwhile a campsite was to be established, and stores such as bedding, cooking implements, foodstuffs, and selected tools were needed as a priority. There was no physical store, only a tent with casual security, and certainly no mechanism for recording who had what and where everything was. Thus, the commissariat got off to a bad start. As if Miller's commissary role was not demanding enough, he was also the scribe for Governor Phillip, who was anxious to record his thoughts and observations of the new campsite.

From small beginnings, mighty timbers grow. A small beginning for the colonial commissariat perhaps, but a very important one, and a solid base to grow from. Later chapters will describe the commissariat in action – as an employer, as an entrepreneur, as a manufacturer, and as the main economic driver in the colony.

The chapter organisation has been based on the structural arrangement of the commissariat, to better understand the various aspects of the government store operations

Chapter 1 relates the reasons for the establishment of a commissariat in the colony and the pre-planning that commenced in Britain through the end of the Phillip Administration.

Chapter 2 is concerned with the store operations– the range of services offered, the adoption of the barter system for payment, the issue of *store receipts* and the adoption of the Bigge Reports and recommendations. Chapter 2 outlines the planning by the commissariat for dealing with a market-driven economy as a central plank to its operations, and its ability to purchase supplies, without individual official approval for each purchase from any source was paramount. Diversity of sources were to be encouraged and dealt with including, visiting ships, private treaty with seamen and military officers, setting realistic prices for grain for local farmers to produce sufficient quantities and survive, as well as direct purchase from suppliers in Britain, who would guaranty quality and timely arrival The commissariat

organisation structure and its relationship to the governor as its local sponsor and protector would also have to be developed along commercial lines. The commissariat was to be a government instrumentality in commercial service to its core constituents – the settlers, emancipists, traders, military personnel and convicts. How would it achieve and maintain this important position?

Chapter 3 relates the personnel arrangements in the store, including the supervision of the store by colonial governors, military officers and then a Board in London. In Chapter 3, policy changes by governors will be tracked, and the specialty areas within the commissariat such as the accounts branch and the operational management will be considered. The commissariat like any government instrumentality was closely aligned to the governor of the day whose policies could change from time to time and indeed policies did change between governors. Policy directives would be received from the Lords of the Treasury, or the Military Commissioners of the Commissariat in London, and they would be implemented as directed or modified by the local needs. One of the advantages of being in a geographical backwater was that the closest person looking over your shoulder was 18 months away. The overall fiscal and business policies of the commissariat will be examined and reviewed and a performance evaluation determined.

Chapter 4 describes the highlights of the colonial economy, its need and the commissariat efforts to satisfy the needs of the colonial economy, and become its main driver of growth and development. It is also appropriate, in Chapter 4, to identify more exactly the importance of the commissariat within the colonial economy. For instance, what impact did the commissariat expenditures have on the local economy? What areas of the colonial economy were dependent on commissariat expenditures? What direct and indirect benefits did the commissariat operations and expenditures bring to the local economy? Did the commissariat grow with the demand for its services or was it always lagging behind demand and dragging the economy back with it? Was it truly an economic driver, or a follower that went with the flow? Chapter 4 will also try to analyse these issues and bring to life a commissariat in action, before turning to other aspects of the commissariat at work and its economic importance.

If the history of the commissariat is to be told in economic terms, then the point must be made that successive governors from Phillip forward moulded the store into a reflection of their own needs and requirements and each had special operations assigned to the commissariat. Macquarie took such self-serving roles one-step further and crossed the line by having the commissariat carry out tasks that were not authorised by the Colonial office, and this is an important part of the story. Another understated impost on the government store during its first 30 years of operation was the external enforced pace of colonial expansion; instead of market forces requiring additional labour and human resources, extra labour and resources were imposed on the colony and there was the obligatory process of putting these people to work, feeding and housing them and creating a public works program, artificially enhanced rather than at a date and rate suited to the colony. This mechanism forced Macquarie to augment the role of the commissariat well past the official boundaries, and it took the Bigge enquiry to make known publicly this overachievement. The commissariat, as the organiser of convict rations and output largely influenced the full utilisation of the large numbers of transported prisoners. It was also the Macquarie 'assignment' system, which forced landowners to create clearing and development programs to utilise the convict labour 'assigned' rather than only develop land that could profitably and successfully be placed into production.

Chapter 5 outlines the commissariat output, its production facilities and the various business enterprises. Chapter 5 explains how the commissariat became the prime producer of materials and supplies used within the colony. Out of plain necessity, and probably by default rather than intentional policy the demand for timber products, bricks, tiles, stones, rude furnishings and carts needed to be and could be supplied locally. Did a commissariat officer commence a day by saying to himself, the commissariat needs to make timber products, rather than buy them from Britain? Did he then plan for a timber-cutting site, a selection of tools, a method of getting the logs back to a central point for sawing and sizing, and then design lengths and dimensions to suit a variety of building designs? That level of deliberate planning was unlikely but that was the outcome, which grew out of necessity. There was a need for local building materials, based on the time required to order and receive supplies from Britain, and the urgency of securing accommodation for military and civil personnel, a fire- and theft-proof storehouse, and the building of essential infrastructure, such as wharves, bridges, and

housing for both settlers and convicts. Local materials had been identified, such as good clay deposits for brick and tile manufacturing, grain was being produced suitable for liquor production, and all that was needed was some skilled labour and basic equipment. Thus, the government business enterprises were assigned as a responsibility of the commissariat, and in conjunction with the Superintendent of Convicts, commissariat personnel planned for equipment, materials, a means of transport, and provisioning of remote convict camps.

Chapter 6 consolidates the various activities in the store complex by relating how such events are accounted for and reported

Chapter 7 relates the conversion of many commissariat activities from the public to the private sector and describes how the manufacturing sector grew rapidly and became a catalyst for importing skilled labour from Britain. Chapter 7 further explains that these commissariat business enterprises covered a great deal of activity. From the making of bricks and tiles, basic forged tools, slops (clothing), shoes, furniture, timber building frames for walls and rooves, timber felling camps, vegetable production, meat production and abattoirs, boat building, provisioning visiting ships and stevedoring. In addition, convicts were organised into gangs to clear land, form cart tracks, establish a ferry service across the harbour from north to south, and between Sydney town and Parramatta town, via the main river flowing between the two towns.

The commissariat was not only about producing goods. It also took business services under its wing, and created a means of exchange by way of barter (store receipts), negotiated payroll bills, consolidated bills for remittance overseas creating a foreign exchange facility, and became a catalyst a local free market for agricultural products from settlers and emancipists. The colonial commissariat, as the most important economic establishment was usually well resourced with labour, but as Commissioner Bigge identified, theft and misappropriation of goods and foodstuffs, raised concerns about using convicts in the stores. Obviously with convicts providing most of the transport between stores and often between suppliers and the store, not a great deal could be done to eliminate losses from this source. However, theft was not the only skulduggery taking place in the commissariat. Conflicts of interest, fraud, miss-appropriation and malfeasance all added to the basic woes created by simple theft.

Although the instructions to the Commissary-general stated that an authorising officer (for much of the time the governor filled this role) had to sign every requisition and every store voucher, there was a lot of room for deliberate error. The weekly and monthly inventory counts rarely agreed with the theoretical balances; misreporting and delivery errors (both for receipts and issues) accounted for most of the difference, whilst theft was a close second.

As the story of the colonial commissariat unfolds it will become apparent that the role of the commissariat was moulded in the need of the times. Under Phillip it was a civilian operated subsidiary facility of nominal importance. Under Macquarie, its role grew until it became the most powerful establishment and facility in the colony. It took responsibility for the victualling, the housing, the work organisation and support of over 16,000 convicts, along with proper planning for convict output so that the Macquarie public building program could be fully and ably supported, as well as for the food production and numerous other operations of government under the energised Macquarie Administration.

The story of the commissariat is worth telling, as it reflects much of the economic growth of the colony, and the expenditure by the commissariat was probably the largest 'investment' made by the British Treasury in the colony. Certain events defined and moulded the role of the commissary - the growth of and need for basic manufactures, exploration, growth of population, decentralised populated areas and the need to develop a main export industry fuelled the operations of the commissariat.

Chapter 8 is the statistical summary of all commissariat activity and introduces a wide range of statistics with annotations. Statistical summaries have been sourced from AJCP sources, and a variety of official and academic sources ands as well are the result of original research.

A Simple Chronology

1787	First Fleet assembled including a selection by the commissary of stores, provisions, equipment and tools
1788	First temporary tent-store under first commissary Andrew Miller Phillip establishes a 12 acre farm at Farm Cove First bricks produced First clothing factory opens at Rose Hill
1788-1812	Commissariat administered by Governor

1789	Second Government farm established at Rose Hill
1790	Ship building yard opens on western side of Sydney Cove
1791	Phillip sends two ships on first sealing expedition; whaling off east coast had been successful. Phillip's goal was to develop these industries for export.
1792	John Palmer appointed second Commissary
1795	First windmill erected on Observatory Hill for grinding grain into flour
1797	The colony had 2,500 sheep
1799	First government factory opens
1800	Governor King sends sample fleeces to Sir Joseph Banks in England 'House of Industry' (later the Female Factory)opens in Parramatta to make cloth
1802	Governor King prepares first instructions for operating commissariat
1805	Campbell sails to Britain with full load of sealskins and oil for direct trade
1810	Population had reached: Sydney 6,158; Hawkesbury 2,389; Parramatta 1,807; Newcastle 100. This included 15,513 men (including 1,000 soldiers), 2,220 women and 2,721 children. Approx. 30% of the adult population were convicts.
1813	Military assumes administration of commissariat Crossing of Blue Mountains opens new land for sheep and cattle
1823	The three Bigge Reports were published by the House of Commons
1824	Governors Brisbane and Darling commenced implementing the Bigge Report The first land grant company (the AAC) was formed in London
1826	The second land grant company (VDL Co.) was formed

That Butlin had to encourage the writing of a history of the commissariat is not so much a reflection on economic historians of the past, but an indictment of the paucity of the available records which reflected a misunderstanding of the allurement of and the romance of the commissaries and their commissariat operations.

One of the longest serving commissaries – and one of the most self-serving – was John Palmer. Having been rescued unharmed from the wreck of the *Sirius* off Norfolk Island in 1791, Phillip put him to work as the second Commissary-General, after Andrew Miller retired from an extremely stressful posting. Starting with literally nothing when he arrived in Sydney, within 5 years, Palmer had become one of the three wealthiest men in the colony, and he didn't get to that position without deliberate endeavours to rort and influence the system. Palmer manipulated the system, as was the standard practice in those early days, and exchanged favours with those who would indulge him his accumulating ways. The commissary was the most influential person in the colony, and his favours could make you successful or leave you to rot. That his sister married the most successful trader in the

colony[11], further secured Palmer's position in the commissariat, and his wealth and influence in the colony, for the next twenty years. It was not unusual for commissaries to have an outside commercial interest that tied into the commissariat. Palmer, for instance, owned a windmill and contracted to grind grain for the commissariat, and he owned a bakery, but no records have been found of the commissariat selling grain to his bakery. Palmer's land grants were used for growing grain for sale to the commissariat and it would not be too cynical to think that Palmer received the best price for his grain and any 'wasted' or damaged grain going though the mill would end up in the bakery. These 'conflicts of interest' are discussed further in Chapter 4, together with general corruption in the commissariat.

Summary of Chapter 1

The growth of the commissariat reflected significant changes in location of settlers, developing resources, and exploration and population growth. Following such growth came new industries and manufacturing activities. The goal was always to make the settlement self-sufficient and self-supporting. The commissariat became closely involved in both livestock growth and manufacturing growth.

The commissariat was the supply store for the whole settlement between the administrations of Phillip and Macquarie, and then under Macquarie it became the manufacturing centre of the colony, but at all times it was fuelling the colonial economy and became its powerhouse. From food and tools to building components and financial services, the commissariat underpinned consumption within the settlement, it developed exports, rationed distribution and created a communication system between Sydney and the outlying settlements that encouraged growth of new areas and widened the limits of settlement by opening up new pastoral lands. Even if the commissariat did not carry out the exploration, it equipped and victualled the explorers, and following new discoveries, created a road network essential to carry new settlers into the far corners of the colony, and outlying supply bases, and through its purchasing policies for grain, meat and wool, created an opportunity for many farmers and pastoralists to survive in their early years.

[11] Sophia Palmer married Robert Campbell in 1801

This then is the story of the economic role of the commissariat together with an analysis of its operations in the colony of New South Wales.

CHAPTER 1

ESTABLISHING THE COMMISSARIAT IN COLONIAL NSW - 1788

Reviewing the Official Records on the Commissariat

The HRNSW contains numerous references to original records reporting the instructions on how to operate, or anecdotal reports on how the commissariat operated. In 1786, Phillip wrote[29]:

> 'It is planned that a quantity of provisions equal to two years consumption should be provided, which will be issued from time to time, according to the discretion of the Superintendent, guided by the proportion of food which the country and the labour of the new settlers may produce.'

He added that 'Clothing per convict was estimated to cost £2.19.6 including jackets, hats, shirts, trousers, shoes' but 'the type of clothing was not always suitable for the climate, and should be ready made rather than relying on the convicts to sew their own.' He noted that 'The *Sirius* brought seed wheat and barley and four months supply of flour for the settlement, together with a year's provisions for the ships company,' and:

> 'Supplies of grain or flour from England will be necessary to maintain the colony until there is sufficient local crops in store rather than 'in the ground', because of grub, fire, drought and other accidents'.

On 9 January 1793, he noted that 'I have directed the commissary to make a purchase and have thus augmented the quantity of provisions in the colony to 7 months at the established ration.'

On 6 January 1793, Phillip recorded his opinion that the projected expense for the settlement for 1794 for the 5,500 population was £25,913. With 3,000 convicts included in the population, this translated to of £13.14.0 per head per annum, (approximately 9d. per day) and pointed out 'this sum cannot increase, but must gradually diminish'. Phillip was allowing only 1,900 persons 'on the store' or less than 40% of the population. His numbers were obviously incorrect but the cost he calculated conveniently came within the official allowance of 14d. per head per day.

On 9 November 1794, the Colonial Office reported that 'the stock of stores of provisions and ready-made clothing should now be sufficient for the settlement for one year. With the quantity of clothing shipped in mid- 1794, there would be a sufficient supply for 2,500 men and 700 women, according to the last official report of numbers.' Mr. Henry Dundas (British MP) insisted that the convicts should be made 'to wear the allotted clothing for a full year.' On 15 February 1794, the Colonial Office directed that 'Each ship was to carry supplies for the trip and for maintenance upon arrival, for convicts, soldiers and sailors. 'King, as Phillip's Deputy and Governor of Norfolk Island, recorded on the 20 July 1794, that the island had produced 'a second crop in sufficient quantity for storage for the next year. - being 11500 bushels plus 4000 reserved for seed, stock, and the producing families.' 'Stores were ordered from the Cape of Good Hope for the Sydney settlement and the hospital on 22 June 1788 to be selected by John Hunter, as captain of the *Sirius*

On 10 June 1797, Governor Hunter submitted a plan that

> '...were Government to establish a public store for the retail sale of a variety of articles - such as clothing, or materials for clothing, hardware, tools, sugar, soap, tea, tobacco and every article that labouring people require - supported by a reputable shopkeeper who should produce regular accounts and charge a small premium to cover these other costs, then the people would get what they wanted with ease, and at far less expense than in any other way.'

On 10 January 1798, Governor Hunter repeated his request for a public store:

> 'If my suggestion is adopted, a branch of the store should be placed on Norfolk Island. Such a store should lessen the expense of maintaining the convicts and into the store; I would also suggest the retailing of liquor and spirits, for the purpose of putting a stop to the importation of that article.'

Again on the 25 May 1798, Hunter recommended using:

> '...the public store as a means of controlling the high price of grain. Such a store would operate as an encouragement to industry. Without some form of price control on grain the settlers cannot live let alone provide for a family. The speculators and the monopolists all contrive to keep the settlers in a continual state of beggary and retard the progressive improvements of the colony.'

The success of Simeon Lord's colonial merchandising in 1801 proves that Hunter was on the right track with his 'public' store.

[29] HRNSW Vol 1 Part 2

The Colonial Secretary wrote to Hunter on 3 December 1798 about the meat supply:

> '...*when the livestock belonging to the crown, added to that of individuals, is in so flourishing a state as to supply the needs at 6d a pound or less, it is evident the Government will gain by supplying the settlement with fresh meat instead of sending salted provisions from England.*'

This request was later modified to limit the store purchases for meat to those from farmer settlers.

On 2 February 1800, William Broughton, a churchman and Magistrate, was also appointed as the storekeeper at Parramatta to replace a man Hunter had sacked for fraud.

Governor King recorded his success in conserving the stores by writing that

> '...*since I took office, I have reduced the number of fully rationed people relying on the public stores by 450. This has saved annually the amount of £10,488, using the rate of £23 per head. I have also reduced the price of wheat to 8d per bushel, pork to 6p per lb, and maize to 4s instead of 5s per bushel.*'

When Hunter was recalled to England, the commissariat was left with many debts owed by settlers and he was concerned that they would be denied and he be held responsible. He wrote to the new Governor, Phillip King, and recorded:

> '*I trust it is clear that there has been no lavish waste and no improvident use of the public stores during my authority. These debts are just, even though many of the individuals may doubt their being indebted to the Government for so much. 'It appears there were doubtful debts of over £5,000 due to the store.*'

In response, King made demands on the settlers and accepted grain at a higher price than usual in settlement of the debts. When news of the demands became known, it produced an unusual response from John Macarthur, who suddenly recalled that much of what he had taken from the stores, and charged against the public account, over the previous 12 months was in fact his personal responsibility and he settled with the stores on this basis.

On 7 November 1800, King re-appointed John Palmer to his former position as Commissary. Other appointments included Broughton to Norfolk Island, Deputy Chapman from Norfolk to Sydney and William Sutter as Storekeeper at Parramatta. In order to conserve grain, King reduced the ration to 13.5 lb of wheat per week.

At the time of his appointment, Palmer had been handed a set of instructions, including:

> *'All troops and convicts in the territory were to be properly supplied and the commissary was to keep a grain stock of 12 months supply*
>
> *He was to transmit annually a list of expected consumption, and all purchases were to be made under the authority of the Governor and prices paid to be no greater than market prices*
>
> *All bills of exchange must be accompanied with an affidavit of purchase countersigned by the Governor.*
>
> *You will also make receipts for all payments in the presence of at least one witness - preferably a magistrate - and make three sets of all vouchers, one for the treasury, one with the accounts and one for the store use.*
>
> *Keep a separate account of all items transmitted from England.*
>
> *Make a survey of any stores lost or damaged - which goods are to be sold or destroyed at the Governors discretion.*
>
> *Make up annually an account of all receipts and expenditures, accompanied by one set of vouchers.*
>
> *You are responsible for the preservation of all stores and provisions and the employees who work for you, and to the public. '*
>
> (Signed)
>
> Portland (Duke of Portland)

This set of notes on how the commissariat should operate was prepared by the Duke of Portland and handed to Governor-in-Chief Phillip Gidley King on 28 September 1800. They are attached for historical purposes.

A list of some of the main provisions and supplies that arrived with the First Fleet indicated the role and difficulties facing the storekeeper. In addition to foodstuffs, supposedly sufficient for the first six months, some of the provisions and supplies which were shipped with the First Fleet in 1787, were:

Table 1.1: Supplies sent with the First Fleet

700 steel spades	5448 squares of glass	50 pickaxes	30 box rulers
30 grindstones	700 axe handles	140 angers	50 hayforks
700 iron shovels	200 canvas beds	700 wooden bowls	30 pincers
330 iron pots	747,000 nail of various sizes	700 gimlets	42 splitting wedges
700 garden hoes	63 coal buckets	700 wooden platters	100 plain measures
6 hand-carts	100 pairs of hinges	504 saw files	8000 fishhooks
700 West India hoes	80 carpenter's axes	10 forges	12 brick moulds
4 timber carriages	10 sets cooper's tools	300 chisels	48 dozen fishing lines
700 grubbing hoes	20 shipwright's adzes	700 clasp knives	6 harpoons
14 chains	40 corn-mills	60 butcher's knives	10000 bricks
700 felling axes	175 claw hammers	500 tin-plates	12 lances
14 fishing nets	12 ploughs	100 pairs –scissors	
700 hatchets	175 handsaws	60 padlocks	

The complete list[12] of articles sent with the First Fleet was much longer and represented a storeman's nightmare if records of issues and returns were to be maintained. For instance, the unloading of stores and provisions for immediate use commenced on 7 February but; since the settlement held over 1,000 people, there was obviously not sufficient bedding, blankets, cooking utensils, or eating utensils for everyone[13]. The allowance of clothing for a male convict for a year was equally inadequate; although raw cloth, needles and cotton had arrived with the Fleet and female convicts could be encouraged to hand sew clothing if necessary. The records show that the total costs of all male and female convict clothing was only £4,144.

In *'Botany Bay Mirages'*, Alan Frost has raised the question of whether the inadequate quantity of tools and supplies was deliberate, or merely poor planning. A case can be made for improper planning rather than deliberate mismanagement. Phillip was left in sole charge of the voyage and received very little guidance, support or interest from the Secretary of State's office, the Naval Board or the commissariat division of the British Treasury.[14] It is unlikely that, after a fairly ordinary career as a naval officer, Phillip would suddenly have reverted to poor leadership. Indeed, he had commented to the Naval Board that the vessels allotted to the Fleet were not adequate in size or number. He also questioned the short amount of time allowed for the planning process, but received no worthwhile response. Clearly, this was not regarded as a voyage of high importance compared with British naval activities in other parts of the world. So, the fact that Phillip used a great deal of judgment and commonsense, speaks volumes for his quiet confidence and determination that he was the most suitable choice as the head of this mission.

For the first storekeeper, local circumstances were such that the supplies brought from England needed to be carefully protected against theft and loss. The tools, in particular, were to be issued daily and returned each evening; however according to Marjorie Barnard, within 14 days of arriving in the colony, over one-third of the tools loaned out for chopping trees and clearing land had been lost, stolen or deliberately concealed from the storekeeper.[15] The chief cause was the unwillingness of convicts to work; removing the tools meant they were unable

[12] HRNSW Vol 1, Part 2 p.16

[13] The list of 'stores' and 'provisions' is found in both the HRNSW and in John Cobley *'Sydney Cove'* Vol 1

[14] Alan Frost raises this possibility in *'Botany Bay Mirages'* Chapter 8 'No Cheaper Mode…' as does Barnard in *'Phillip of Australia'*.

[15] Barnard *'A History of Australia'* Chapter 3 'Taking Shape' *p60.*

to chop firewood or cut timber framing for the new camp. As a way of keeping the tools in repair, Miller had set up forges on the banks of Sydney Cove and used iron and steel pieces brought out as ballast to forge new tools and replace lost items. Watkin Tench in his *'Narrative of the Expedition to Botany Bay'* provides some useful insights into the conditions faced by Phillip and Miller. In November 1788 he noted: 'Temporary, wooden stores, covered with thatch or shingles into which the cargoes of all the ships have been lodged, are completed, and a hospital erected'.[16] However, the stores were not to remain as such for long as the end of one such building was converted into a temporary church for Sunday services. These frail structures were neither fire-proof nor rat-proof and the summer of 1789 saw the end to these temporary structures when Phillip designed a new, sturdier and more permanent store in a location closer to the settlement's military camp. Later in 1789, Tench recorded that 'the storehouse was finished at Rose Hill (by then renamed Parramatta). It was 100 feet by 24 feet and was built of local brick, deep red in colour, but not as durable as the Sydney product'.[17]

Displaying rare frustration, Phillip wrote to Assistant Secretary of State, Phillip Stephens, in August 1790 'Leather is needed for soles for men's shoes and materials for mending them. Shoes here last but a very short time, and the want of these materials and thread to mend the clothing will render it impossible to make them serve more than half the time for which they were intended'. The following month Phillip wrote to Nepean, the Under-Secretary of State for the Colonies, and made two observations: 'I cannot help repeating that most of the tools sent out were as bad as ever' and, 'the wooden ware sent out were too small; they are called bowls and platters, but are not larger than pint basins. There was not one that would hold a quart'.[18]

Tench also described the development of the new town of Rose Hill and the buildings adjacent to the store: 'the new stone barracks is within 150 yards of the wharf, where all boats from Sydney unload. In addition there is an excellent barn, a granary, an enclosed yard to rear

[16] Flannery quotes Tench in *'1788 Watkin Tench'* p81
[17] Flannery *ibid* p127
[18] Governor Phillip to Under- Secretary Nepean HRNSW Vol 1, Part 2 p481. In terms of the departmental hierarchy, the Colonial Office had a Secretary, an Under-Secretary and then a number of Assistant-Secretaries

livestock, a commodious blacksmith's shop and a most wretched hospital, totally destitute of every convenience'.[19]

In 1790 Phillip told Nepean that the colony badly needed 'honest and intelligent settlers, and free men to act as superintendents of convicts'. Phillip also requested a new, more appropriate style of clothing for the convicts, even suggesting a form of mark to protect them from being sold. He badly needed a windmill, and requested axes, saws, combs, iron pots and 'two or three hundred iron frying pans which will be a saving of the spades'.[20] Unlike Macquarie some twenty years later, Phillip was of two minds about free enterprise in the colony. He did approve an open market, but then reverted to government importing 'specialty' items into the colony. According to Barnard, "in April 1792, Phillip established a regular market in Parramatta". It was for fish, grain, livestock, clothing and anything else that might legitimately be bought or sold. It was open to convicts. In October 1790, Phillip reported to Secretary Dundas in London: "The commissary was obliged to purchase various articles brought out by the sailing officers of the *Pitt*, where the private property sold in this settlement amounted to upwards of £4,000, which may serve in some measure to point out what might be bought by a ship loaded wholly on account of government".[21]

During 1792, Phillip was faced with a minor mutiny. The military under the leadership of Major Grose advised Phillip that they (the military) had chartered *The Britannia* to sail to the Cape for supplies. In spite of strong protests from Phillip, the ship sailed on 24 October and thus was born the 'pernicious system of private trading by the military'.[22] Phillip wrote movingly to the Right Hon. Henry Dundas, the Secretary of State in London, of this continuous struggle to get necessities: 'The period at which the colony will supply its inhabitants with animal foods is nearly as distant at present as it was when I first landed'. He added:

> *'I beg leave to observe that all those wants which have been pointed out in my different letters still exist: for iron pots, we have been nearly as distressed as for provisions: cross cut saws, axes and the various tools for husbandry are also much wanted; many of the articles are now made here, but the demand is greater than*

[19] Flannery *ibid* p 145
[20] Governor Phillip to the Rt. Hon Henry Dundas HRNSW Vol 1 Part 2 p595
[21] Governor Phillip to the Rt. Hon Henry Dundas HRNSW Vol 1 Part 2 p.613
[22] Barnard, *Phillip of Australia*, p. 126

can be supplied because of the shortage of materials; many bales of clothing have been received, but arrive rotten and so injured from the damp that they have scarcely borne washing a second time'.[23]

Table 1.2: Value of Bills drawn by the NSW Commissary on the British Treasury[24]

Year	Amount (£)
1806	13,873
1807	31,110
1808	23,163
1809	49,514
1810	72,600

These increases could be directly attributed to the additional population being victualled in the colony, the higher level of rations, purchases by the commissary of foodstuffs and provisions from visiting foreign vessels, and higher prices of produce in England due to the prevailing economic conditions. Secretary Liverpool was also aware of the growing local revenue being raised in the colony from import duties, which he had little control. Macquarie, on the other hand, saw this locally raised revenue as 'cream' and discretionary revenue for his personal use – not to be handed over to the Treasury in London. Liverpool made mention of the growing expenditure on public works and wanted this item to be trimmed; the civil list was growing at the same rate but his goal was to make the 'Police' and 'Orphan' funds pay for these extra persons. He directed that there be 'no increase in the civil staff' unless covered by local funding. He approved the purchase of a brig for the colonial service provided it was paid for from local funds. Macquarie could see his dream dwindling away rapidly unless he could maintain his control over the commissariat, so that he could manipulate expenditures to suit his own needs whilst keeping the majority of local revenues under his control.

Some of Liverpool's premonitions of uncontrolled expenditure may well have been caused by Macquarie, especially as the commissariat pursued a 'support' role. In 1810 Macquarie wrote to Liverpool's predecessor, Viscount Castlereagh, offering his opinion of the condition of the local commissary:

> *'I found the Public Stores almost destitute of dry provisions, which situation had occasioned very serious alarm for some time before my arrival. This very exhausted state of His Majesty's Stores had been very much occasioned by the last dreadful and*

[23] Governor Phillip to the Rt. Hon Henry Dundas HRNSW Vol 1 Part 2 p.643
[24] These figures are assembled from Governor Macquarie despatches found in HRA 1: vols 9 & 10

calamitous inundation of the Hawkesbury River, which had swept away the entire crops in that fertile district – an event not infrequent, and which has repeatedly involved the inhabitants in the deepest misery and distress'.[25]

In response to this finding, Macquarie acted swiftly, adding 300 acres of grain to the government farms, importing wheat from Bengal and reducing all rations. Castlereagh had expressed doubts about the preference for government over private farms but Macquarie protested that the government herds and farming should be maintained further livestock be imported for breeding purposes. He maintained control over the colonial economy by giving notice of a bank and a local currency and an appropriation of funds for the restocking of the commissariat. He also supported the operations of the Lumber and Dock Yards.

Over the next 10 years, Macquarie commenced what Commissioner Bigge later declared to be 'excessive spending; however, it produced significant results for the economy. He was generally responsive to the needs of the traders, merchants and entrepreneurs who he considered were the drivers of the economy. As shown by his instruction of 8 July 1815, he was intent on simplifying the process of business in the colony and of making the store receipts, issued by the commissariat, a form of medium of exchange for the local settlers.[26]

Summary of Instructions for Operating the Commissariat in Colonial NSW

Phillip Gidley King arrived as Governor in 1800 and noted that, up to the time of his appointment, there had been no explicit set of instructions issued for the guidance of the Commissary, except for verbal commands from each successive governor or administrator. In October 1800 he appointed Thomas Laycock as acting Commissary to fill the vacancy between the departure of James Williamson and the return in November of John Palmer from England. King saw the need for a set of instructions for the guidance of the 'officer on whom alone the public economy of the colony rests'[27] In the same despatch King advised that on behalf of the colony, he had purchased the wine cellar from retiring Governor Hunter and directed the commissary to pay for it and 'receive it'. The cost was £151.11.6.

[25] HRA 1:X: 221

[26] HRA 1:8:p623

[27] HRA 1:2:675 King to Secretaries of the Treasury (Governor's Despatch # 2, September 1800)

King was as good as his word and produced a set of instructions as well as transmitting annual statements of the commissariat's revenues and expenses to the Treasury - the first and last governor to do so. After King, the commissariat handled its own transmittals until 1813, when they were made to Army headquarters (quartermaster's regiment) in England for consolidation and transfer to the Treasury. According to the NSW – SRO, King's commissariat records still exist in the PRO in London, but they do not appear to be part of the AJCP records.

The Instructions of Governor King

The HRA[28] offers a complete set of the instructions of Governor King, of which the following is a summary: -

The Commissary was 'to control the receipt and issue of all stores and provisions into and from His Majesty's stores.

No articles were to be received or issued without a written order from the Governor.

Detailed store receipts were required of all 'grain or animal food' purchased or otherwise received into the store.

Accounts of expenditure were to be furnished quarterly and more often if required.

The Commissary was to plan to match ration requirement with food availability. The Governor was to be advised of any shortfall and where it would be covered from and how much it would cost.

The Commissary was 'directed to reform the irregularity that has existed in the mode hitherto followed in making payment for such articles as have been purchased from settlers for public use'. Previously promissory notes had been made out for goods received; but these notes were frequently counterfeited and hence offered little security. King proposed a system of store receipts, which were to show the quantity and nature of goods received as well as their monetary value. At convenient intervals, the Governor would draw a Bill on the British treasury, at which time a call would be made for the return of all store receipts issued to settlers.

King obviously wanted to create regularised recording & reporting for the commissary and required the commissary to present to the governor once a year the following account books for audit.

'Victualling Book' - containing names of persons who received provisions during the year.

[28] HRA 1:2:632-6 sets out a complete copy of the instructions

'Clothing and Slop Expense Book' - to record issues of clothing, blankets etc.

'Book to record Receipts of Stores', provisions and clothing, from all sources; also the expense thereof, and an inventory of stores on hand at the end of each year.

'Store Purchasing Book' specifying purchases of food from settlers, noting date, quantity, application and cost, a cross-reference was to be made with store receipts issued.

'Purchasing Book', to set out the quantities and cost of stores purchased from masters of visiting vessels or 'other strangers' - again to be supported by vouchers. Method of payment is to be specified - in kind, in grain, meat or money.

'Book of Particular Expense' showing provisions and clothing issued during the year to non-convicts e.g. civil and military officers. A similar book was to be kept for issues to free settlers.

An open list of all births, deaths and absentees during the year - these details were to be supplied by the clergy in the colony.

Whenever a ship was due to sail to England a 'State of the Settlement Report' was to be prepared for despatch with the vessel. This statement was to include a current population record, the number on stores, inventory in the store and a weekly return of expenditures.

A 'Weekly Victualling and Store-issue Book' was to be kept by each remote storekeeper, and a quarterly summary sent to the Sydney store.

In many ways, the requirements imposed by Governor King were not unlike the range of statistical returns provided in 1822 by the first *Blue Book*. All of the above books and returns were to be delivered to the governor on 31 October each year, prior to their transmission to England, and a 'correct copy was to be kept in the commissariat office' as directed by the British Treasury instructions.

The British Treasury Instructions

The British Treasury must have also seen the need for a formal set of instructions to be issued to the Commissary as, in November 1800, Commissary Palmer returned with a set of instructions for his guidance.[29] These Treasury regulations are more general than those of

[29] HRA 1:3:5 King's despatch # 3 of 10 March 1801 records Palmer delivered to him a letter from Secretary Long inclosing instructions from Treasury Commissioners for the commissary's guidance. King questioned the third article, which authorised the commissary to directly draw bills, for purchases on the public account, on the Treasury instead of going through the governor.

Governor King but they were not inconsistent. The main difference was a policy change which now authorised the Commissary to draw bills without the approval of the governor, contradicting the earlier written policy that 'all bills drawn for public purposes in the settlement should be drawn by the governor and by no other person'. King's despatch to the Duke of Portland of March 1802 included a State of His Majesty's Settlements in NSW Report[30], which confirmed, essentially down to the last detail, that King's instructions were being adhered to exactly and also showed that the commissariat was becoming of considerable importance in the colony as a market and exchange. King's order of August 1802 authorised the Commissary to sell surplus perishable stores to free settlers at a profit. The commission charged varied at first but was later fixed at 50%. Remuneration to Commissary Palmer was by a small percentage on sales, although from this he had to pay for extra bookkeeping clerks from his own pocket.

A period of instability occurred during the military administration, between the time of the Bligh rebellion and the arrival of Lachlan Macquarie. During this time, Williamson, Wiltshire, Fitz and finally Broughton replaced Palmer as successive Commissaries.

Governor Macquarie's Instructions to the Commissary

Macquarie wasted no time in commencing his investigation of the commissariat for on 31 January 1810, less than one month after his arrival in the colony, he issued a general order[31], a summary of which is as follows:

Remote storekeepers were to submit vouchers (Form #1) for requisitions on the general store in Sydney each month.

Form #2 was a return of all foodstuffs received by storekeepers weekly.

Form #3 was a copy of Store receipts for all stores received.

All requisitions for stores had to be counter-signed by the Governor's secretary.

Invoices for all store purchases were to be sent to the Governor's secretary

Statements of receipts and expenditures were be made each June and December and forwarded to the Governor's secretary.

[30] HRA 1:3:418 details the civil establishment in the colony and the lengthy report of the administration of the commissariat department

[31] Found in SRO NC11/5

Storekeepers were to furnish to the governor weekly summaries of receipts and issues of stores.

The Commissary was to keep lists of all persons victualled from the public stores.

The 'Statement of the Settlement' was to be sent with each ship sailing for England.

In February 1811, Macquarie directed that only the commissariat was to import into 'bonded store' all wines and spirits ordered for the colony, with a fee receivable of one-half gallon for every one hundred gallons measured. From 1827 the Bonded Store became part of the Customs Department. He also oversaw the removal of civil servant families from store support - only the civil servant himself could draw rations. By an order dated December 1814, the sale of articles from government stores to any private individual was disallowed, thus introducing freedom of trade - this meant the colonial government would issue permits for imported articles to be distributed amongst the settlers and created a new class of merchants.

Following the Bligh rebellion, Treasury officials in London considered the commissariat to be in need of reorganisation. Up to this time, it had been a separate colonial department under the control of the governor, paid for through the Budget appropriation process. The reform proposal was to transfer responsibility for the colony's commissariat to the Commissary-General in England, who headed sub-branch of the Treasury department. A Deputy Commissary -General was to head the colonial operation and would be subject to instructions issued from the British Commissariat. Another revision was that all deputy commissaries would now be recruited in England and the colonial governor would only have a supervising role[32]. The activities of David Allen have been discussed in Chapter 2 and do not require repeating. However, there was a source of disagreement between the D.C.G and the governor, other than over commissariat personnel and their overt dishonesty. The governor was to be concerned with changes in the methods of payment to free settlers for stores received into the

[32] HRA 1:8:126 + note 19 (p657) Bathurst to Macquarie February 1814: Note 19 records 'Prior to June 1813, the commissariat department was a distinct colonial entity under the immediate control and direction of the governor. A separate establishment was created for it and salaries were voted annually by Parliament. On 11th June 1813 David Allen arrived holding the appointment of D.C.G. He assumed control of the commissariat and a new *regime* was established. The department became a branch of the commissary-general in England, a sub-department of the treasury and officers held their appointments as part of the general English commissariat staff. The D.C.G. was head of the department generally, qualified by the local supervision of the governor of the colony. He communicated directly with his superiors in England and not through the governor as formerly. It is evident that the functions of the governor were curtailed considerably by this change

commissariat. The store had been using 'store receipts' as payment and, as Butlin points out in *Foundations*[33]:

> *'...because of the lack of money in the colony, the store receipts became in effect the circulating currency. However, this led to difficulties in making up accounts, since it was often quite impossible to obtain the receipts back from the settlers in order to make up quarterly or annual returns. The fact was that many settlers found that the demand in the colony for those store receipts was sufficient to make the return of them unnecessary'.*

Macquarie's attempt to solve the problem came via a government order[34], which stipulated 'all store receipts are to be brought to the D.C.G at the end of every two months. Failure to hand them in would cancel the value of the receipt'.

It was David Allen's excursion into issuing promissory notes to replace the store receipts that eventually brought about his dismissal. Macquarie's reports[35] on the matter show that, at this time, the commissariat had branches in Sydney, Parramatta, Windsor, Liverpool, Bathurst, Hobart, Port Dalrymple and Newcastle. Allen's replacement was Drennan who arrived in January 1819 but, immediately upon his arrival, he attempted to mislead Macquarie by alleging he had also been authorised to issue promissory notes in lieu of store receipts. A subsequent Commission of Inquiry into Drennan's activities did much good for there are no further accounts of corruption during the Macquarie Administration. Drennan could not explain a debt or account for missing funds of 'upwards of £6,000'[36] Brisbane had also directed D.C.G Wemyss to transmit a detailed and ;'certified' statement about Drennan to London, explaining the public accounts deficiency.

The next attempt to reorganise the stores was made by Governor Darling in August 1827, with the support of', and upon written instructions from, the Treasury. The Treasury requested:

> *'...it being desirable, with a view to a more systematic arrangement of the Accounts of the Public Expenditure of the Colony, that the expenses of articles issued from the General Store, be ascertained and classified under the following three headings:*
> *1. Colonial 2. Military 3. Maintenance of Convicts.*

[33] S.J. Butlin's Foundations of the Australian Monetary System 1788-1851'

[34] SRO records NC11/5

[35] HRA 1:10:116 'Macquarie to the Lord Commissioners of the Treasury (Pages 100 -135)

[36] HRA 1:10:629 Brisbane to Earl Bathurst 6th April 1822

It will be necessary that the D.C.G be furnished with separate requisitions and vouchers for each of these heads respectively.

Under Heading 1, are to be classed all articles, issued for purposes not military or not connected with the maintenance, clothing, housing or management of convicts

Under Heading 2, all Army, Military, hospital barrack, and quartermaster's stores and all articles for the construction or repair of buildings for the housing of the troops.

Under Heading 3, all articles issued for the purpose of clothing, management or housing of convicts. This will also comprise all stores and supplies for the other penal settlements and for the use in government vessels and for agricultural establishments'.

The practical arrangement for this proposal required that[37]

'...once every six months a Board comprising the Colonial Treasurer, the D.C.G, the Commissary of Accounts and the Colonial Auditor was to be convened for the purpose of transferring adjustments between the colonial treasury account and the Military Chest account and in that way reimburse the store for obligations made on behalf of the colonial administration.'

In 1827[38], 'he British Government accepted that the whole expense of police, gaols, convicts and the colonial marine was to be carried by the 'Home Treasury', although the arrangement was short-lived. Ten years later, the colonial legislature claimed Britain owed its treasury over £700,000 in reimbursements for costs expended under these categories. This 1827 plan soon caused problems for the commissariat because, at this time, the use of coinage was becoming genera. The depleted military chest could not continue to draw bills for reimbursement, so the commissariat regularly 'borrowed' funds from the colonial treasury in order to save the military chest.[39] In June 1827 D.C.G Laidley was appointed to run the commissariat but, when Darling recommended that he keep an extra set of books for the information of his superiors in London, Laidley complained about being short-staffed. An enquiry showed that 'the number of clerks employed in the commissary nearly equalled the number in all civil departments put together. A number of government orders following the

[37] HRA 1:13:698 Minute #51 Darling to Goderich

[38] HRA 1:14:332 Darling to Huskisson August 1828

[39] HRA 1:16:658 Bourke to Goderich confirming loan of funds to D.C.G Laidley (June 1832)

enquiry were aimed at improving the efficiency in the keeping of accounts in the commissariat'.[40]

It appears that Darling listened to his small, select Board of General Purposes, which was in effect an advisory board to the governor. Darling issued an order (Government Order #1 of 1827) providing for the formation of a Board of Survey to examine the stores in each government department and recommend how best to integrate them with the commissariat store. Reports of the survey were prepared and submitted to William Lithgow, Auditor of Colonial Accounts. The eventual results of the survey were seen in 1836 when the British Government made further changes to the operations of the commissariat by establishing within it a branch of the British Ordnance Department. This new department was given physical custody of 'the military works and buildings' and the ordnance and other stores, as well as the buildings occupied by the convicts, and the stores and clothing required in the convict establishments.[41] The result was a commissariat very much reduced in size after January 1836. With this change the physical stores had moved entirely to the Ordnance Storekeeper's department, leaving the commissariat virtually an administrative-financial branch of the British Treasury. It was still required to transport stores and this led to the growth of a transport branch of the commissariat. Under the same minute the total responsibility for gaols, police and colonial marines transferred from the Imperial to the colonial government.

The downsizing was all part of a plan in the early 1840s to stop transporting convicts to the colony. . Until 1855 the NSW commissariat continued to pay for all convict establishments, including hospital and other medical expenses for convicts, although in 1850 all barracks and military buildings were handed over to the colonial government. Britain's military responsibility to the colony continued until 1870, when all imperial forces and the remaining commissariat functions (mainly payroll) were withdrawn from the Australian colonies.[42]

[40] HRA 1.15.745 Darling to Under-Secretary Hay – September 1830; (the number of clerks employed by the D.C.G. was 40)

[41] HRA 1:17:706 Treasury Minute dated 10 March 1835 attached to letter from Hon J. Stewart (H. M. Treasury) to Under Secretary Hay

[42] Australian Encyclopaedia: 'Military'

Macquarie's Reform of the Commissariat

In April 1817, Macquarie confirmed with the Earl of Bathurst that he intended to reform the operations of the commissary in the colony, in line with recommendations received from London. He advised Bathurst of new appointments to senior posts to replace officers engaged in insider trading and 'maladministration' and then went on to describe the 'old' and the 'new' systems.

> 'When the settlement was founded, the commissariat department was a distinct colonial entity in the charge of a 'commissary of stores and provisions' that was directly under the control of the governor. The first commissary was Andrew Miller, who resigned in 1790 due to ill health. After the wreck of the Sirius at Norfolk Island in March 1790, the purser, John Palmer, was appointed to succeed Miller as commissary. As the colony developed, the commissary expanded, and the staffs were increased by the appointment of assistant and deputy commissaries and storekeepers. Those officials received a colonial salary, rations and allowances. In the year 1812, it was decided to alter the system and the commissariat in the colony became a branch of the army commissariat, a sub-department of the English Treasury. The change was made immediately after the arrival of deputy commissary-general David Allen in the convict ship Fortune in June 1813'.

Macquarie's latest change was based on his perception that the operations were presently unnecessarily large and expensive. He also observed that the commissary was now subjected to internal abuse, waste and fraud. He proposed to restore government farms and make the commissariat much more self-supportive by manufacturing more of its own produce. The commissariat was also to source as much as possible from its remaining procurement from local suppliers, thus leaving private suppliers to carry large inventories and offer purchase terms. Thus, the commissariat would not have to prepay British-based suppliers with FOB bills.

The first livestock to be removed from the government herds were transferred free of charge to eligible settlers who were encouraged to use these animals for breeding purposes. There were other procedural changes; in 1813 responsibility for the military reverted back to the commissary rather than the civil authorities.[43] This change was part of an overall revamping of the military system and a restructuring in anticipation of economic rehabilitation which would occur after the Napoleonic Wars. The change involved separation of ordnance support services, the military commissariat and a convict commissariat into three separate operations

[43] Bathurst to Macquarie HRA 1:8: 619

and independent stores...

As if sensitive to his wavering place in history, Macquarie assembled all his official reports for the previous ten years and wrote what he called a 'synopsis' of his administration for the Earl of Bathurst. With reference to the commissary, he commented:

> 'The system I have invariably pursued in respect of the treatment and management of the convicts is to temper justice with humanity. The value of savings to the colony and the commissary by killing wild herds of cattle for meat will be over £7,000 (using 5d per lb for the valuation). The reduction in the price of fresh meat has caused great economy to the commissary. Beef supplies are growing, and the government herds prevent monopolies of individual suppliers to the commissary. A new government farm was established at Emu Plains because of the need for fresh produce from this extremely fertile tract of land. The use of convict labour in this way means that they are usefully employed and they more than repay to the government the amount of their maintenance and all of the other expenses of the Establishment. There are over 300 convicts employed there, these being those convicts who were not required for the settlers, or for the public roads and bridges or other government purposes. The principal part of the present expense of the colony is incurred in feeding, clothing and lodging the male and female convicts. Other slightly lesser expense is incurred in the support of the civil, military and marine establishments, and in victualling, for a certain period, free settlers, their families and convict labourers. The commissary carries out the planning and support for each of these groups.'

Although Macquarie attempted to reduce the price of wheat delivered into store to 8 shillings per bushel, the settlers convinced him that 'the grower of grain would be a loser at that price' and he restored the price to ten shillings per bushel[44]. His earlier opinions had been influenced by Commissioner Bigge and, as a result Macquarie, changed from being a supporter of government farms to supporting the purchase of grains from the settlers.[45] However by 1820, after Bigge's departure, he again reported that 'there is no further economy in the measure of cultivating lands on account of the crown'.[46] This concern was later reiterated and confirmed by Major Ovens in his report on convict work practices for Governor Brisbane.[47] In addition to Macquarie's observations that government farms were uneconomic, Ovens concurred with his theory that the cost of convict labour used in clearing open pastoral land was not recovered

[44] (HRA 1: X: 683 Emphasis added
[45] Commissioner Bigge was a former Chief Justice of the British West Indies and was appointed by Bathurst to complete an assessment of the government operations in NSW for the House of Commons
[46] M.H. Ellis *Lachlan Macquarie* P.124
[47] M.H. Ellis *Lachlan Macquarie* P. 132

by any increase in the sale price of the land. Ovens had calculated that eight convicts in a team or gang took one week to clear and burn one acre of land.[48]

The Macquarie 'Synopsis' also included an impressive list of the public buildings and works erected, and other useful improvements made in NSW at the expense of the crown from 1 January 1810 to 30 November 1821. He listed 67 items in Sydney, 20 in Parramatta, 15 at Windsor, twelve at Liverpool, and 52 in the outlying settlements of Richmond, Pitt Town, Penrith, Emu Plains, Spring Wood, Bathurst, Campbell Town, Pennant Hills, and Castle Hill.[49] He also drew attention to the impressive progress made in road construction, claiming 267 miles of roads around Sydney and Parramatta had been made under his direction.

In a memorial presented to Macquarie on his departure from the colony, the magistrates, clergy, merchants, landholders, free settlers and public officers wrote, 'Your Excellency's exertions for the welfare and improvement of these settlements, strongly exemplified by the rapidly increasing and growing consequence of the colony, have fully evinced the judgement of your appointment and command our gratitude and affection'.[50] They were well chosen and relevant words of appreciation from a selection of grateful settlers all of whom had benefited from Macquarie's administration, as had the entire settlement.

The governor of the day demanded statistics, statistics and more statistics. In addition to the 50-80 pages in the annual 'Blue Books', the Commissary prepared reports on inventory levels, the value and source of all purchases and rations by each group, where sent, and how many were being served.[51] From these sources it is possible to track how the commissary funds were distributed between each of the banks in the colony; we know the cost of supplies as well as

[48] M.H. Ellis *Lachlan Macquarie* P135
[49] The Sydney and Parramatta buildings by Macquarie are listed in the last Chapter. The writer has computed the construction costs of each building by estimating the material content and the estimated length of construction time. Some estimates have been based on the Greenway notes found in the appendix to M.H. Ellis's biography of Francis Greenway, especially those relating to construction rates by various trades.
[50] HRA 1:11:102
[51] The 'Blue Books' Reporting System commenced in 1822 and was a compilation of internal reports of revenues and expenditures and colonial statistics. The British Treasury in London prepared its format and three copies were prepared at significant clerical time and expense. One copy was sent to the Secretary of State's office in London, one was retained by the Governor in the Office of the Colonial Secretary and the third was directed to the House of Commons. Previous to the Blue Books, the three colonial funds were the Gaol (and then renamed Police) Fund, the Orphan Fund and the Colonial Fund. After 1822 other funds emerged for revenue discretionary purposes and they were fully reported in the Blue Books; such ancillary funds included the Commissary Fund, the Land Fund, and the Immigration Fund.

the quantity of grain and meat and the value of clothing and cloth supplied. We also know the contractors for all provisions and their payments, the quantity of tools provided, military and hospital rations, bills drawn each year and details of loans flowing between the commissary, military chest, colonial treasury and the London Treasury.

Between 1832 and 1842, the Military Chest was the preferred funding source for military and commissary revenue and expense. The Treasury renewed with vigour its instructions on handling funds and recording advances, loans, transfers and all expenditures. Although the working instructions provide an insight into the approved methods of operating the commissariat stores and accounts, to understand the process fully it is necessary to examine the inventory control procedures, purchasing and 'receiving into store' procedures, detailed accounting reports, ration levels established from time to time, and funding mechanisms. These topics are explored in detail in the following chapters.

CHAPTER 2

STORE OPERATIONS AND PROCEDURES

Introduction to Chapter 2

The challenge in examining the role and achievements of the commissariat is to first identify those roles and achievements. The next seven chapters will flesh out the various procedures followed by the government store, from its role in financial services and as the very first colonial bank to its use as a catalyst in creating a manufacturing industry for the colony. In between times, the commissariat helped drive the economy, supervised convict work practices, and recognised convict output and production outcomes from its numerous business enterprises.

The role of the store changed over time and with changes in economic policies of successive governors. Many aspects of the store require identification and analysis – for example, the commissaries themselves, the personnel structure of the organisation, the outlying locations which were serviced from the central store. The purchasing arrangement from local farmers needs examination. The development of business enterprises, and outsourcing e.g. grinding grain, making bread, supplying meat, growing vegetables and fruit, requires further attention and explanation.

The driving force behind the continued growth of the store was the growing stream of convicts arriving from Britain, and their needs for housing, clothing and food, as well as productive work. The lack of initial operating procedures hindered the store in its administrative reporting, but unleashed the diversity of operations, since the commissary and the governor both considered the practical uses of the store had no boundaries. Governor King's instructions in 1802 restricted certain store activities and by limiting operations, slowed the spiralling growth. However, the demands on the store were obviously more persuasive than arbitrary limits imposed by a governor, and so the store renewed its growing roles and activities and resumed its place as the growth factor and driver in the colonial economy.

The Need for a Government Store

From its commencement in 1788, the aim of the Colony of New South Wales was self-sufficiency even though it had been set up to solve the problem of Britain's overcrowded prisons. By 1823, the British Government had decided that it would limit its direct expenditure to the transportation of the convicts and their supplies while in transit; the Colonial Administrators would be responsible for the convicts' security, food, clothing and accommodation in the Colony. Furthermore, proceeds from the sale of Crown land were to be the exclusive reserve of the British authorities rather than the colonists. The Governors were therefore forced to look for ways in which the Colony could help to support itself through working the convicts to create food, minerals (e.g. coal production), roads, housing and public buildings. Other convicts were assigned to landowners on a fully-maintained basis, thus saving the British Treasury a great deal of money.

This policy of maintenance of convicts by the colonial Government created the need for an accounting by the Colony to the British Parliament. This led to the appointment in 1824 of a Financial Controller/Colonial Accountant to prepare monthly and annual despatches to the British Colonial Secretary. From 01802 to 01822 the official financial statements had been 'audited' summaries of the Orphan and Police Funds. From 1822, the official reports were incorporated into the 'Blue Books'. Following self-government in 1856, the procedures changed as the Colony became fully responsible for its own economic planning and fiscal management.

A Brief Overview of the Government Store

The first storekeeper arrived with Governor Phillip and the First Fleet. Andrew Miller had been appointed whilst the Fleet was preparing to sail, initially to take responsibility for the loading and storing of requisitioned stores. Upon arrival in Sydney Cove, Miller's first task was to erect a stores tent, secure it as far as possible, and commence unloading from the ships the stores that would be required during the first few weeks. These stores and provisions included such items as tents, pots and cooking utensils, blankets, hospital equipment and supplies and tools for clearing the land and erecting tents. Little was known about local conditions and Phillip's plan to have a wooden storehouse built within a few weeks could not be accomplished. He had tried to anticipate a wide range of obstacles and challenges, but did

not allow for the difficult landscape or the unfamiliar characteristics of the local timber, which forestry challenges of sawing, moving, sizing and drying proved the most difficult of all. In their various reports, Cook, Banks and Matra had all praised the local timbers after only a cursory evaluation but, with no expertise amongst his crew or the convict population, Phillip's task of clearing timber and using it for construction was almost impossible.[52]

Andrew Miller – Commissary # 1

Upon their arrival, Phillip relied on Miller to operate the most basic of stores and without burdening him with limiting rations as he anticipated that the second Fleet store ships would be carrying provisions for the next full year. Miller's biggest task was the security of the provisions; the remaining items were then to be unloaded so that the ships could return to naval service. Phillip later prepared a rationing program for Miller so that the provisions would last six months, the time Phillip thought the Second Fleet was behind his own.

Obviously the simplistic and basic nature of the tent store added to Miller's burdens. The stress of establishing the commissary for the new settlement and acting as private secretary to the governor eventually broke Miller's health and he wanted to return home. However, he was not to see his home again; he died during the sea voyage back to England.

For the first storekeeper, local circumstances were such that the supplies brought from England needed to be carefully protected against theft and loss. The tools, in particular, were to be issued daily and returned each evening; however according to Marjorie Barnard, within 14 days of arriving in the colony, over one-third of the tools loaned out for chopping trees and clearing land had been lost, stolen or deliberately concealed from the storekeeper.[53] The chief cause was the unwillingness of convicts to work; removing the tools meant they were unable to chop firewood or cut timber framing for the new camp. As a way of keeping the tools in repair, Miller had set up forges on the banks of Sydney Cove and used iron and steel pieces brought out as ballast to forge new tools and replace lost items. Watkin Tench in his *'Narrative of the Expedition to Botany Bay'* provides some useful insights into the conditions

[52] Cook & Banks had written positively (and subsequently amended by Beaglehole) about the lush landscape to be found at Botany Bay, and James Matra (another Cook crewman) extended this interest in local timber to its use as a trade item between the colony & Britain, when Matra submitted his recommendation of the use of the new land as a penal settlement. Refer also Beckett: 'Reasons for the Colony' in *British Colonial Investment in the Colony 1788-1856.*

[53] Barnard *'A History of Australia' Chapter 3* 'Taking Shape' *p60.*

faced by Phillip and Miller. In November 1788 he noted: 'Temporary, wooden stores, covered with thatch or shingles into which the cargoes of all the ships have been lodged, are completed, and a hospital erected'.[54] However, the stores were not to remain as such for long as the end of one such building was converted into a temporary church for Sunday services. These frail structures were neither fire-proof nor rat-proof and the summer of 1789 saw the end to these temporary structures when Phillip designed a new, sturdier and more permanent store in a location closer to the settlement's military camp. Later in 1789, Tench recorded that 'the storehouse was finished at Rose Hill (by then renamed Parramatta). It was 100 feet by 24 feet and was built of local brick, deep red in colour, but not as durable as the Sydney product'.[55]

John Palmer – Commissary # 2

Miller's successor, John Palmer, had sailed as purser aboard Phillip's flagship, *Sirius*. He had joined the Navy at the age of nine and participated in a series of voyages to many parts of the world, including North America where he married into a wealthy colonial family. After the founding of the colony, and with the expectation that he would soon return to England, Palmer sailed with the *Sirius* to the Cape Colony and Batavia on a mission to purchase food for the struggling, and hungry, colony of NSW. Whilst shipping provisions from Sydney to Norfolk Island, the ship struck an uncharted submerged rock just southeast of the Island and sunk. Palmer was saved, but the *Sirius* and its cargo was lost and Phillip found a new posting for Palmer in Sydney, replacing Miller as chief store-keeper. It was a further seven years before Palmer sailed for England, but he soon returned to the colony with his wife and sister, Sophia. The Palmer family became financially secure with a magnificent walled estate, carved from the rocky terrain of Woolloomooloo Bay, just east of Farm Cove. Sophia was to shortly marry Robert Campbell thus forming a most strategic alliance between the colony's first successful trading house (Campbell & Co, the chief supplier of stores to the colony) and the chief procurer of provisions for the colonial store (John Palmer).[56]

In '*Botany Bay Mirages*', Alan Frost has raised the question of whether the inadequate quantity of tools and supplies was deliberate, or merely poor planning. A case can be made

[54] Flannery quotes Tench in '*1788 Watkin Tench*' p81
[55] Flannery *ibid* p127
[56] Refer: Margaret Steven '*Merchant Campbell 1769-1846*' and Beckett '*John Palmer – Commissary*'

for improper planning rather than deliberate mismanagement. Phillip was left in sole charge of the voyage and received very little guidance, support or interest from the Secretary of State's office, the Naval Board or the commissariat division of the British Treasury.[57] It is unlikely that, after a fairly ordinary career as a naval officer, Phillip would suddenly have reverted to poor leadership. Indeed, he had commented to the Naval Board that the vessels allotted to the Fleet were not adequate in size or number. He also questioned the short amount of time allowed for the planning process, but received no worthwhile response. Clearly, this was not regarded as a voyage of high importance compared with British naval activities in other parts of the world. So, the fact that Phillip used a great deal of judgment and commonsense, speaks volumes for his quiet confidence and determination that he was the most suitable choice as the head of this mission.

Tench also described the development of the new town of Rose Hill and the buildings adjacent to the store: 'the new stone barracks is within 150 yards of the wharf, where all boats from Sydney unload. In addition there is an excellent barn, a granary, an enclosed yard to rear livestock, a commodious blacksmith's shop and a most wretched hospital, totally destitute of every convenience'.[58]

Displaying rare frustration, Phillip wrote to Assistant Secretary of State, Phillip Stephens, in August 1790 'Leather is needed for soles for men's shoes and materials for mending them. Shoes here last but a very short time, and the want of these materials and thread to mend the clothing will render it impossible to make them serve more than half the time for which they were intended'. The following month Phillip wrote to Nepean, the Under-Secretary of State for the Colonies, and made two observations: 'I cannot help repeating that most of the tools sent out were as bad as ever' and, 'the wooden ware sent out were too small; they are called bowls and platters, but are not larger than pint basins. There was not one that would hold a quart'.[59]

Phillip Establishes the Commissariat

[57] Alan Frost raises this possibility in '*Botany Bay Mirages*' Chapter 8 'No Cheaper Mode...' as does Barnard in '*Phillip of Australia*'.
[58] Flannery *ibid* p 145
[59] Governor Phillip to Under- Secretary Nepean HRNSW Vol 1, Part 2 p481. In terms of the departmental hierarchy, the Colonial Office had a Secretary, an Under-Secretary and then a number of Asst Secretaries

In 1790 Phillip told Nepean that the colony badly needed 'honest and intelligent settlers, and free men to act as superintendents of convicts'. Phillip also requested a new, more appropriate style of clothing for the convicts, even suggesting a form of mark to protect them from being sold. He badly needed a windmill, and requested axes, saws, combs, iron pots and 'two or three hundred iron frying pans which will be a saving of the spades'.[60] Unlike Macquarie some twenty years later, Phillip was of two minds about free enterprise in the colony. He did approve an open market, but then reverted to government importing 'specialty' items into the colony. According to Barnard, 'in April 1792, Phillip established a regular market in Parramatta'. It was for fish, grain, livestock, clothing and anything else that might legitimately be bought or sold. It was open to convicts. In October 1790, Phillip reported to Secretary Dundas in London: 'The commissary was obliged to purchase various articles brought out by the sailing officers of the *Pitt*, where the private property sold in this settlement amounted to upwards of £4,000, which may serve in some measure to point out what might be bought by a ship loaded wholly on account of government'.[61]

During 1792, Phillip was faced with a minor mutiny. The military under the leadership of Major Grose advised Phillip that they (the military) had chartered *The Britannia* to sail to the Cape for supplies. In spite of strong protests from Phillip, the ship sailed on 24 October and thus was born the 'pernicious system of private trading by the military'.[62] Phillip wrote movingly to the Right Hon. Henry Dundas, the Secretary of State in London, of this continuous struggle to get necessities: 'The period at which the colony will supply its inhabitants with animal foods is nearly as distant at present as it was when I first landed'. He added:

> 'I beg leave to observe that all those wants which have been pointed out in my different letters still exist: for iron pots, we have been nearly as distressed as for provisions: cross cut saws, axes and the various tools for husbandry are also much wanted; many of the articles are now made here, but the demand is greater than can be supplied because of the shortage of materials; many bales of clothing have been received, but arrive rotten and so injured from the damp that they have scarcely borne washing a second time'.[63]

Butlin described the functions of the Commissariat in the following terms.

[60] Governor Phillip to the Rt. Hon Henry Dundas HRNSW Vol 1 Part 2 p595
[61] Governor Phillip to the Rt. Hon Henry Dundas HRNSW Vol 1 Part 2 p.613
[62] Barnard, *Phillip of Australia*, p. 126
[63] Governor Phillip to the Rt. Hon Henry Dundas HRNSW Vol 1 Part 2 p.643

'The (British) Treasury described the commissary as one that 'keeps in the stores and issues provisions, fuel and light for the use of the service abroad'. Such a formal description fails to capture many of the crucial features of the Australian Commissariats and their subsidiaries. In addition the commissary in NSW became a source of foreign exchange and of local instruments of exchange. They were, at once, banks and credit agencies, and a springboard for banking enterprises. They were also the instruments for encouraging and reallocating productive activity for regulating staple prices and subsidies to such an extent that they have been perceived as 'staple markets'. The commissary also became the means for making supplementary allowances to officials, for compensating persons for performing public services for which no British appropriation existed or for totally funding some other public services. Through rations distribution, they effectively paid workers engaged in convict gangs on public infrastructure. '[64]

The Young Plan recommended that Phillip arrange a 'quantity of provisions equal to two years' consumption, which must be issued from time to time, according to the discretion of the superintendent, in the expenditure of which, he must be guided by the proportion of food which the country and the labour of the new settlers may produce'[39]. Young's Plan also included the purchase of cattle and grain from the Cape of Good Hope. Phillip:

'will be enabled to obtain cattle and hogs, as well as seed grain, all of which must be procured for the new settlers, with a view to their future subsistence, and as expenses will be incurred, it be necessary that your Lordships should authorise the naval commander to draw upon you for the amount; and that, in addition thereto, a quantity of merchandise should be put on board the ship of war sufficient to obtain supplies by means of barter with the inhabitants of the islands contiguous to the new intended settlement'.[40]

Phillip's plan included 'garden seeds' and fresh plants, tools and implements, clothing, instruments and medicines, as well as general stores and provisions. Further to the detailed planning, Phillip received the first set of instructions signed by Lord Howe that included the admonition that the marines, administrators and prisoners were 'to be victualled, and to have such tools, implements, and utensils as they may have occasion for whilst employed in the new settlement'[41.] [He] received instructions from many sources. For instance, the Lords of the Admiralty set down instructions for the rations to be provided for the marines, during their passage to Botany Bay and then for their maintenance in the colony. When the estimates of

[64] Butlin, N.G.' *What a way to run an Empire, Fiscally'* p52
[39] By Admiral Young, who was advising Phillip on assembling the Fleet HRNSW Vol I Pt 2 Page 15
[40] HRNSW Vol 1Part 2 P16-17
[41] The Lords of the Admiralty to Lord Sydney 21st November 1786 HRNSW Vol 1 Part 2 p29

the civil establishment were provided in 1787, the Commissary and the surgeon were at the bottom of the scale; both were to receive only £182.10.0 per annum[42].

Phillip would not need the commissariat until the Fleet arrived at Botany Bay. The Navy Board had contracted for the victualling of all parties in the Fleet between Portsmouth and Botany Bay. The rations approved for the first stage (the voyage) were to be two-thirds of the allowance given to men serving in the West Indies. Upon arrival at Botany Bay, the Commissary's task and indeed challenge would begin. The first task would be to unpack the hard stores – the equipment required for housing and feeding the new arrivals. Tents were to be made available, for fast erection by the military, for the prisoners as well as the governor and his civil companions.[43] Detailed plans, only in outline, had been made prior to arrival but these all changed when Phillip decided not to set up camp in Botany Bay but to move to the next harbour – Port Jackson, where fresh water and more fertile-looking land were available. Phillip's own instructions to his senior commanders were that male prisoners were to be accommodated on one side of the tank stream, with females on the other. Military officers would be separate from the men in the ranks and the governor would have his own small but exclusive area. Only when the camp was in place would provisions be unloaded from the ships, anchored nearby in Sydney Cove. Another important commissariat function was to erect the hospital tent, and furnish the equipment and medical supplies to make it operational. There were 81 persons who arrived in a sick condition and needed medical, if not hospital, treatment.

Andrew Miller was the first Commissary in the settlement and on 9 July he prepared a list for Phillip of 'Articles most wanted in the Settlement'. This became the first official 'requisition' and included such items as: axes, chalk-lines, cross-cut saws, pit saws, iron in bars, steel in bars, gunpowder, musket balls, paper, canvas, nails, spikes and hooks. Soon after, Miller became ill and wished to return home but he died during the return journey.

Phillip realised the essential need for a qualified and experienced Commissary and appointed John Palmer as Miller's successor. Palmer, the former purser of the *Sirius* which had sunk off Norfolk Island, soon commenced a running correspondence with both the Governor and the Naval Board in London (as agents for British suppliers and contractors) which reveals much

[42] Quoted by McMartin, *ibid*

about early commissariat operations. The first formal set of written instructions was included within a message from the Duke of Portland to the Governor of NSW and was issued 12 years after the First Fleet.[47] The point of interest in this very first set of operating instructions is that its release coincided with the return to the colony of John Palmer, the experienced and self-indulgent second Commissary who, unlike his successors, was handling the work of what he claimed to be the equivalent of 12 pursers on seasoned ships, without assistance other than a few convicts whose use was limited to lifting and carrying. Later instructions recognised the need to share the workload and establish some specialist clerical and supervisory positions, but this first set loaded the Governor with the task of personally and solely signing 'all bills drawn in the Settlement for public purposes'.[48] 'My duty', he responded to the Secretary of the Treasury, 'requires acquiescence therein, until their Lordships in the Treasury direct otherwise'. King thereupon stated his preference that he issue the orders for the Commissary to draw the bills, which would be carried out under strict control, and 'using every necessary precaution' to ensure the validity of the transactions. The first instructions dealt with the method of drawing Treasury bills:

> *'When it is necessary or Advisable to make purchases of provisions or stores, which purchases are to be made, if possible, when the governor is on the Spot, and at no other time, you are to do it under the authority of the governor or commander for the time being, either signified to you in writing previous to the purchase, or approved by his signature to the accounts of such expenses, and on the best terms that can be procured and you are to obtain a certificate of two respectable merchants, or Magistrates, to the bill of Particulars, that the price paid was the market price according to the quality and condition of the articles...*[49]

This opening extract was about one-third of the whole instruction, which was written in a single lengthy sentence and would have required considerable attention to understand its overall import. Phillip complied closely with his written instructions, even as to costs. He wrote to Secretary Nepean from Rio Janeiro (Phillip's spelling), that 'the victualling of all those who are under the inspection of the Commissary, including fixing and every other expense, amounts to no more than 3 ¾d a head per day'[44]. After the camp was in operation, the next step was to plan a location for a store. The first store was a basic tent, but it was followed soon after by a 'rude' timber-framed affair with tree-branches for thatching and

[47] HRA Vol ii P694 – 8th November 1800
[49] Instructions to Governor Phillip HRNSW Vol 1 Part 2 p19
[44] HRNSW Vol 1 Pt 2 P473

twine securing the cross poles to the vertical frame. The walls were bark, mud and more branches acting as a protection to the weather. The building, such as it was, was not fireproof, nor did it afford any protection against mice or other vermin. Phillip set a schedule of permanent buildings, which commenced with the erection of his own prefabricated house, then convict barracks, followed by the stores, military barracks and finally an official office for his own use[45]. He was aware that a church and courthouse would be called for fairly soon, but hoped that better quality timber, building tools and supplies would be brought by the Second Fleet before these buildings were ready for construction. On 9 July 1788, Phillip wrote to Lord Sydney advising that 'two stores had been finished and the ships are now landing the remainder of the stores and provisions'.[46]

That the commissariat operations reflected the changing needs within the colony is evidenced by its regular reorganisation. Until Macquarie's arrival, there had been stability in the organisation structure and only two commissaries had been appointed: the basic operations of victualling convicts and selected settlers had remained constant, as had the provision of tools and equipment to convict work parties. Under Macquarie, the expansion of services provided by the commissariat had grown disproportionately and into relatively unchartered areas. He recognised the need for banking and financial services in the colony but, when his proposal for a chartered bank was rejected, he imposed that role on the commissariat. Likewise, the growing intake of convicts into the colony led to vast organisational strictures on government, and these imposts were assigned to the commissariat.

The demand on the commissariat was always significant and varied according to the number of convicts arriving in the colony, which in turn depended on the military and economic circumstances prevailing in Britain and Europe. On 1 February 1793, only five years after the First Fleet arrived in Botany Bay, Britain was at war with France, the Napoleonic Wars that dragged on until 1815. There were several important consequences: the attention of the British Government was distracted [18] away from the affairs of an insignificant and distant colony (Botany Bay); transportation of convicts more difficult and less necessary; the flow of free immigrants to the colony was reduced even further; and it enabled a small group of elite

[45] HRNSW Vol 1 Pt 2
[46] HRNSW Vol 1 Part 2

military officers stationed in the colony to create a monopoly position. In spite of the *Navigation Acts*, the war in Europe provided an excuse to develop trade between the British colony and the American colonies, although it was one-sided in favour of the American shippers. Heavy economic commitments to the war in Europe and a downturn in the British economy from 1810-1815 led to constant pressure from the British Government to reduce expenditure in the colony. The Colonial Office in London thought this could be partly accomplished by moving people 'off the store' and reducing expenditures on public works. Both of these alternatives affected commissariat operations. Apart from foodstuffs, the commissariat mainly bought timber for building, leather for boots and shoes, wool (hair) for blankets and supplies such as barley for brewing beer. The commissariat received supplies from four general sources: imports, government farms and workshops, civil and military officers and private individuals. In some matters, the commissary strongly supported private enterprise - for instance the area under grain on government farms never rose above 10% of the total farmed land in the settlement and by 1808 this was insignificant[19]. Similarly, government cattle numbers, notwithstanding the lost herd later found in the Cow Pastures at Camden, represented a decreasing proportion of total cattle numbers in the colony, falling from 70% in 1800 to 12% in 1814, whilst government sheep numbers fell from 10% to 2% of those in the colony in the same period.

The Bigge Reports of 1823

The third Bigge Report provides an important insight into Commissariat activities. Commissioner John Thomas Bigge, a former Chief Justice of the West Indies colony of Jamaica, was appointed by Lord Bathurst to visit the Colony and assess progress and to evaluate the growing expenditures of Governor Macquarie. The instruction to Commissioner Bigge read in part: 'you will inquire into the courts of justice, the judicial establishments and the police regulations of the colony[5]. You will also turn your attention to the question of education and religious instruction. The agricultural and commercial interests of the colony will further require your attentive consideration. With respect to them you will report to me their actual state and the means by which they can be promoted.' Bathurst added:

> *'I would more particularly refer to the authority, which the governor has hitherto exercised, of fixing the prices of staple commodities in the market, and of selecting*

[5] The first two paragraphs of Earl Bathurst's letter of 6th January 1819 to J.T. Bigge have been summarised for purposes of expediency.

the individuals, which shall be permitted to supply meat to the government stores. With respect to these regulations, you will investigate how far their repeal is likely to lead to any general inconvenience, or to any public loss. I am aware that when the colony was first established the necessity of husbanding the scanty means of supply and of regulating its issue, might justify an interference on behalf of the government; but now that the quantity of land in cultivation is so much increased, and the number of cultivators enlarged, I confess I have great reason to doubt the expediency of these regulations; at the same time I feel unwilling to recommend so material an alteration without some examination on the spot as to its probable effects.'

A second letter of the same date and also from Earl Bathurst directed J.T. Bigge to consider the suitability of Sydney town as the main recipient of convicts and the opportunity of:

'...forming on other parts of the coasts, or in the interior of the country, distinct establishments exclusively for the reception and proper employment of the convicts, who may hereafter be sent out. From such a measure, it is obvious that many advantages must result. It would effectively separate the convict from the free population, and the labour of forming a new settlement would afford constant means of employment, including that of a severe description. By forming more than one of such separate establishments, the means of classifying the offenders, according to the degree of crime, could be facilitated. But on the other hand, you will have to consider, what would in the first instance, be the expense of the measures, and what may be the probable annual charge which may result from their adoption.'

Earl Bathurst, in a separate note[6] to Viscount Sidmouth dated April 1817, set out his concerns of the mixing of convicts with free settlers and the problems resulting from ever increasing numbers of convicts being transported[7]. He wrote:

'Another evil resulting from the increased number (of convicts transported), is the great difficulty of subjecting any of the convicts to constant superintendence, either during the hours of work or relaxation; and the necessity of leaving a large proportion of them to the care of providing their own lodgings during the night, from the inadequacy of public buildings allotted to their reception, forms one of the most formidable objections to the current system. I intend to place the settlement on a footing that shall render it possible to enforce strict discipline, regular labour and constant superintendence, or the system of unlimited transportation to New South Wales must be abandoned. I propose the appointment of commissioners with full powers to investigate all the complaints which have been made, both with respect to the treatment of the convicts and the general administration of the government.'

[6] The full instructions from Bathurst to Bigge and the correspondence from Bathurst to Sidmouth are printed with the third report by Bigge to Westminster, as presented to the House of Commons in February 1823
[7] Ritchie, John *Punishment and Profit*

In his instructions to Commissioner Bigge, Bathurst had recognised the impact of over-regulation and enforced pricing of goods sold to the government stores. However, the commissariat (or Government store) relied on imports for its grain and meat supplies and, until 1800, to a lesser extent on the private sector. From 1804, grain was in reasonable supply, except in periods of drought, floods and disease, and was grown mainly by the small settlers. Cattle and sheep raising tended to be in the hands of the military and civil officers and other settlers with larger holdings. The government set basic prices for commodity purchases by the Stores, but these were often exceeded because of the general shortage of labour[7]. The governor set fixed prices for the commissariat for grain but the settlers found they had to sell at lower rates to influential middlemen, who then obtained the fixed price. This group had influence over what supplies the stores would buy and from whom. According to Linge[9, a] similar clique 'was able to buy up ships' cargoes and resell them at ten times the price and more'. After 1800 Governor King tried to break the monopoly position of these groups (mainly officers) but his efforts brought only temporary relief to small settlers, many of whom were in debt.

The difficulty of changing the role and activities of small farmers was that the vast majority was ex-convicts with little literacy and certainly neither the knowledge nor capital to improve their farming techniques or buy stock and equipment. In Van Diemen's Land, Lt-Governor Sorrell lent small operators a bull or ram from the government herds and flocks for breeding purposes in an endeavour to improve the herd and provide some small assistance so these operators could acquire breeding livestock. Such arrangements was not extended to or followed in the colony of NSW although Samuel Marsden, a leading practitioner of flock improvement in the colony, did loan some special rams to neighbours and parishioners around Parramatta. The record shows Governor Darling loaned 'cows' to small farmers although this was a strange way of increasing the private herds rather than the public herds.

Commissioner Bigge[10] reported:

[8] Fletcher, B.H 'The Development of Small-scale farming in NSW under Governor Hunter' ,JPAHS 50, pp 1-8
[9] G. J .R. Linge ' Industrial Awakening'
[10] Bigge, J.T. Report # 3 Agriculture & Trade in NSW (1823)- p.132

'Clerks in the Commissariat department generally consist of persons who have been convicts, and also of persons who are still in that position, but who have received tickets of leave. They receive pay, differing in amounts from 1s 6d to 5s per day, and 'lodging' money; they likewise receive the full ration, and a weekly allowance of spirits. A system must be installed that reduces the perpetual temptation to plunder from the necessary exposure of public property. It is for this reason recommended that public rations of bread should be baked by contract (at a potential savings of 1/6th of the flour used); Private contracts (let under the tender process) to supply the hospitals with bread, meat and vegetables have proven to be of advantage to those establishments; both changes result in considerable savings to government.'

The report confirms that in 1820, those victualled in NSW numbered 5,135 to whom 7,027 rations were issued daily (some convicts were on 1½ regular ration because they were considered to be in heavy manual labour). In total, the numbers victualled, including military and civil officers, rose from 8,716 in August 1820 to 9,326 in December 1820. 'I see', stated Bigge, 'no reason for not applying the former rule by which the rations of those officers whose salaries exceeded £90 per annum were taken away. I recommend that they be taken off the stores and a compensating amount be paid to them from the Colonial Police Fund' [9]

Controlling Commissariat Operating Costs

The British Government constantly reminded colonial governors of the growing cost of running the colony and the need to take people 'off the stores'. During 1800-1803 more than 2000 convicts were transported, adding to the number dependent on the store: there was also a significant increase in the number of small farms allotted, mainly to the growing number of convicts whose sentences had expired. At that time, a small 30-acre land grant, achieved at least three benefits for the new owners: they generally improved his social status (and therefore their mindset towards crime and property ownership); they were taken off the stores and told to be self-sufficient; and they became eligible to sell produce to the store thus becoming an important cog in the colony's food chain. [11]

In his 'Working Paper', Butlin offers some interesting numbers with respect to the growth in farming activity, for the period 1800-1810.

'Excluding the holdings of civil and military officers, the number of farms grew from 400 in 1800 to 600 in 1804 and 700 in 1807. Thus, even though grain

[9] Bigge, J.T. Report # 3 Agriculture & Trade in NSW (1823)- p.149
[11]. Butlin, N.G 'What a way to run an Empire, fiscally' (Working Papers in Economic History (ANU)

production had reached a reasonably satisfactory level by 1804 and 40 new farms were coming into production each year, the number of mouths to feed was increasing by only a few hundred annually at this time. However, meat remained scarce. Cattle were preferred to sheep because they were less prone to attack by wild dogs, thrived better in the wet and humid climate and were more suitable for salting down; whereas in 1801 the ratio was 6 to 1 in favour of sheep, by 1809 the ration was reduced to only 3 to 1'. [11.]

The 'Epitome of the Official History of NSW' suggests livestock numbers in 1800 were 1,044 cattle and 6,124 sheep; in 1810 the number had increased to 12,442 cattle and 25,888 sheep; by 1821 cattle numbers had grown to 102,939 and sheep to 290,158 [12].

This series of events before 1810 set the foundation for the future direction of the pastoral industry in the colony. Although there were troubling but isolated incidences of military officer domination of trade and profiteering, the colonial economy was growing and settling into a pattern of life suitable for self-sufficiency and growing independence and local governance. From 1811 to 1815, the pattern changed and turned into a commercial depression in the colony, brought about by a number of internal and external factors. 'Sealing vessels were having to sail further to find grounds not already picked bare by Colonial, British and American gangs, and in 1810, news reached Sydney that the British Government had imposed a duty of £20 per ton on oil caught in the Colonial waters'. [14] Further, in England the price for sealskins fell from 30/- to between 3/- and 8/-. Between 1810 and 1812 the British economy suffered a downturn and the financial troubles, brought on by a long drawn-out war in Europe, were soon transmitted to NSW. Indian and English merchant houses called up debts and refused to underwrite further speculations and the British Government pressed the colonial administration to further reduce running costs[15]. Locally, the commissariat's venture into money operations helped intensify the shortage of money in the settlement and, to add to these distractions, in 1813 local duties were imposed on sandalwood, sperm oil, skins and timber, whether intended for home consumption or export. The English Government weighed in with another cost cutting exercise by reducing the military numbers in the colony from 1600 in 1813 to 900 in 1815. Steven concludes that by 1815, 'Sydney's commerce had almost totally

[12] 'An Epitome of the Official History of NSW' compiled from the Official and Parliamentary Records of the Colony in 1883, under the direction of the Government Printer, Thomas Richards.

[14] Linge 'Industrial Awakening' *op cit*

[15] To these circumstances, Briggs and Jordan, writing the 'Economic History of England' adds the Malthus observations on a rising population (8% between 1808 and 1812) and the effects of the industrial revolution.

collapsed'[16.] She also suggests that one side benefit of the commercial downturn was that, because individuals and partnerships could no longer see easy openings in trade, commerce, land and livestock, they may have turned their attention to industrial activity, establishing a profitable base for further local production of manufactured items and import-replacement industries. [17]

Operations of the Commissariat

The commissariat started as a government sponsored and funded store. Its success in purchasing and distributing rations to the settlers, civil list people and convicts was followed by an expansion of its role. In conjunction with the Superintendent of the Convicts, who reported directly to the governors, the commissariat expanded its operations to include organising the allocated output convict. Under Macquarie, this role did not include building construction but it did include the provision of all building materials, mostly locally-produced, but some were 'imported' from Britain.

The Commissariat Tender Process

Commissioner Bigge had recommended more extensive and expansive use of tendering as a means of trimming commissariat costs.

This reasoning empowered the *Sydney Herald*, which used its willingness to reprint Government advertisements directly from the *Gazette*, as a way of promoting a wider readership. From its first issue on 18 April 1831, the *Sydney Herald* had followed a deliberate editorial policy of opposing the Church and School Land policies of Governor Darling, and of seeking government advertising for its weekly journal. Starting a new newspaper in the colony was not unusual but most failed. An important observation is that many readers followed the editor rather than the newspaper itself. The three best known and best supported editors were Howe (*Gazette*), Edward Smith Hall *(Monitor)*, and William Charles Wentworth (*Australian*) and each newspaper had its regular readers and editorial sympathisers. The *Sydney Gazette* survived as the government organ and printer of all government notices. Howe's *Weekly Express*, the *Australian* and then the *Monitor* commenced when the *Gazette* began publishing daily, but the *Gleaner*, the *Blossom*, and the *Australian Quarterly Journal* all

[16] M. Steven '*Merchant Campbell 1769-1846*' p.136.
17 M. Steven *ibid* p142.

opened and closed down fairly quickly, having failed to secure a wide readership or sufficient advertising. Hall began the *Monitor* in 1826 but, after spending extended periods in prison following his conviction on charges of 'criminal libel' and sedition against Governor Darling, he sold the paper in 1838.

It took time to develop advertising revenue and, to survive, and a newspaper had to be both slightly controversial and willing to print government notices. The deliberate policy of the *Sydney Herald* was to pursue subscriptions, which in turn required broad advertising and reports of wide-ranging interest. After the first issue of 1832, the newspaper was printing 'shipping intelligence', police incidents', 'domestic intelligence', meteorological information and all market and commodity prices, especially the Wholesale Farm Produce Prices. The natural extension of this approach was to print calls for tenders and further extend its subscription base, so the newspaper printed a repeat of the Commissariat call for tenders in its last issue for November 1831 and, in its first issue for 1832, printed the names and terms of the successful tenderers. Was an independent editorial policy an impediment to government advertising? The short answer is 'yes', but, not unlike today, public opinion carried a lot of weight. By reprinting free of charge the government's public notices, a newspaper built up a readership and subscription base and it would be a foolish governor or public official who, when faced with the threat of withdrawing the government notices if not paid for, decided to drop the advertising.

What is of interest in this process is the nature of the tenders and prices submitted to the commissariat. The Deputy Commissary General, James Laidley, agreed to the repeat of a number of commissariat advertisements in the *Sydney Herald* of 2 January 1832, including the call for tenders for the construction of three watch-houses in Sydney. The tender process allowed two weeks for the submission of prices 'strictly according to plans, specifications and conditions, available for inspection at the main commissariat office'. It also required 'security for performance (completion) in the amount of £250 for each building', and only two payments were allowed, the first being 75% of the payment when work was 'about 50% complete' with the balance due when work was fully completed'. Thus tenderers needed a good cash flow and substantial reserves if they wished to tender for any public works.

A second advertisement offered the sale of commissariat-owned sheep and cattle. A public auction was to be held some 18 days hence (on 20 January 1832) at Bathurst, then at Emu Plains. A selection of breeding livestock (cows, heifers, bulls, calves, wethers, ewes, lambs and rams) and bullocks was offered. Selected farm equipment, surplus to government farm needs was also to be auctioned at the Emu Plains government farm – including 'a thrashing machine, a winnowing machine, sundry ploughs, timber carriages, farm tools and general implements'. Since the farm had closed some years previously this was a 'clearing' sale, which would attract a lot of interest and a large number of buyers. Ex-government equipment and livestock was in great demand in a settlement where few items of farm equipment were imported from Britain other than by the commissariat.

A third advertisement announced the successful tenders for provisioning the commissariat for the year 1832. The accepted tenderers were responsible for delivering a full range of fresh foodstuffs to HM Troops and Mounted Police in Sydney, Parramatta, Windsor, Campbell Town, Bong Bong, Lumley, Goulburn Plains, Yalbrett, Illawarra, Springwood, Hawkesbury, Mount Victoria, Maitland, Darlington, Hunter Valley, Port Stephens, Port Macquarie and Bathurst and Newcastle. These were just some of the many diverse locations used by the military and police which the commissariat was bound to service with rations and provisions. A clever means of handling the situation was for direct deliveries of fresh provisions to be made by local suppliers at what appeared to be very attractive prices. Foodstuffs were also to be supplied to convict establishments at Sydney, Parramatta, Windsor, Liverpool, Emu Plains, Bong Bong, Newcastle, Maitland, Port Macquarie, and Bathurst, and to lock-up houses at Campbell Town, Bong Bong, Maitland and Darlington. Provisions were also to be supplied to road parties in 12 districts, surveying parties in 10 locations and the 6 regional hospitals. Other tenders had been awarded for supplying fuel and light, forage, sundries, grinding and dressing grain and land and water transport. Land transport covered carriage between the larger towns of Sydney, Parramatta, Windsor, Newcastle and Maitland, Emu Plains, and Bathurst. The tender for water transport had been awarded between Sydney, Hawkesbury, Port Macquarie and Newcastle and included the conveyance of coals.

This tender program is an interesting aspect of commissariat operations because it shows that the government, in spite of having access to a great deal of convict labour, did not think it

could provide these services at any lesser cost than a private contractor. Contract prices appeared to be more than competitive with wholesale prices of the same commodities quoted in the same edition of the *Sydney Herald,* so the suppliers provided these provisions at a more favourable price recognising the long-term nature of the contracts as compared with the vagaries of the short-term wholesale market. As Commissioner Bigge had predicted, the tender process appeared to save the commissariat money by encouraging competitive pricing, as well as saving a great deal of in-store clerical and goods handling work.

Sourcing the Macquarie Building Materials

Building materials were sourced from government work sites including:

Lumber Yard
Dockyard
Stone Yard
Female Factory
Timber Harvesting Operation
Land-clearing Gangs
Road-making Gangs
Government Farms
Government milling (of government grain)
Construction Workers
Brick and Tile-making Workers – Sydney and Rose Hill

The growing number of convicts arriving in the colony, made their provisioning an increasing challenge – firstly to ensure that each person was clothed fed and housed. In turn, this placed pressure on the building program, the farming program, the work program and distribution planning. Farming obviously included grain, meat, vegetables but also the animals used to provide raw materials for clothing garments, blankets, mattresses etc. Initially, the government's aim was to 'manufacture' these items in house, but Macquarie's sense of forward planning provided an opportunity for local farmers, merchants, entrepreneurs and cottage industry manufacturers to become commercial suppliers to the commissary in competition with government-owned facilities.

The 'subsidiary' government commissary operations began with meeting the challenge to put the convicts to work and feed, house and clothe them. Simultaneously, the Lumber Yard (initially called the Convict Factory) opened in Sydney Town on the corner of George (High) and Bridge Streets, the Female Factory opened in Parramatta, and the government farms were

established at Emu Plains, Castle Hill and Parramatta. These farms were essentially used for grain, vegetables and animal (livestock) management.

The Role of the Commissariat (in the operations of the Colonial Government)

The accounting process, as well as other operational needs of the commissariat, was directly influenced and moulded by the official role of the colonial commissariat. This role varied from governor to governor but remained within official guidelines, at least until the arrival of Macquarie. The Macquarie Administration was to first to add unauthorised activities to the commissariat processes.

Planning for a commissariat for the new colony was well under-way by 1786. It was to be operated and managed along the lines of a naval purser's office and was to be responsible for all purchasing, storage, payment and distribution of goods. Its purpose was to provision the convicts, civil employees, the military personnel, and their families. However when the new colony decided not to adopt a currency, the Commissary's role was made especially challenging as currency is the traditional means of exchange. Initially, there would be no buildings and only convict labour was available to work the stores in Sydney, Parramatta and the Hawkesbury area - 'always unreliable and untrustworthy', said John Palmer the third Commissary.

The first supply ships arrived in Port Jackson with the First Fleet on the 26 January 1788. The unloading of bare essentials, such as tents and a few tools and minimal food, was completed that day, but the balance of the supplies would be left aboard the *Sirius* and the *Golden Grove* until a storehouse was available. The land had to be cleared of trees and timber cut before work could start on the first makeshift buildings. Carpenters were in short supply and priority was given to the erecting of barracks for the soldiers and military personnel followed by a facility for the Governor and only then a storehouse.

The first Commissary, Andrew Miller, had been hand picked by Governor Arthur Phillip, based on based on his knowledge of Miller as a seaman, rather than on his experience as a commissariat chief. Phillip provided detailed instructions of how he wanted the operation to

be performed and he, in turn, had been given his instructions by the Lords of the Admiralty and the Colonial Secretary. The most important were the overall goals of:

Keeping the cost per head per day for supplies as low as possible

Keeping the number of fully victualled persons as low as possible

Establishing the Colony to be self-supporting as quickly as possible

Putting the convicts out to work to earn their keep (although this was a new and untried policy)

Assigning convicts to non-government masters on a full support basis (again an untried and untested policy, but one strongly supported by Phillip)

Phillip had transported the first 1,000 convicts and military without loss of life or property and the first breeding animals arrived in the colony in good condition. By 28 January 1788, two days after their arrival in Port Jackson (later Sydney Harbour), he was assigning duties for the unloading of animals, convicts and material supplies ready to commence his colonial operations and the convicts were set to clearing the ground for vegetable plantings and building sites.

Phillip decided that, instead of relying on stores transported on an irregular basis from Britain, he would commence a planting program to provide fresh vegetables, grain and fresh meat. Supplemented by fish and game, the result would be a happy, healthy colony in which to live and work. He did not plan, nor was he prepared for the harsh climate, the periodic droughts and flooding rains or the unhappy natives. His goal of victualling the whole colony for less than 14d per day was going to be difficult, but it would be possible if some level of self-support could be accomplished. He had brought quantities of seed for planting, but his fears were that northern hemisphere soils and climate would be very different from conditions in 'New Holland' and his crops would fail or yields would be minimal. However, his first corn crop returned his planting 20 times over (HRNSW), and he was pleased and hopeful of future returns being plentiful. In fact, he wrote to the Lord Commissioners stating that 'this Colony will become the greatest investment ever made by the British'.

Phillip planned for other possible ways to reduce costs; such as reducing imports, commencing an export trade and establishing remote settlements which would allow for settlers on farming

ground, encourage the establish of jobs and trades and build the necessities. Phillip went about his work, putting these plans into practice and he assumed, incorrectly, that the convicts and the military shared his enthusiasm and commitment to hard work. However, his experiment with tobacco planting, and grains, other than corn and wheat, and even sugar was encouragingly successful.

His first remote settlement was to be established at the head of the harbour, near fresh water and with boat access at high tide. Rose Hill, soon to become Parramatta, was to be established with convict and military quarters, a church and some emancipist settlers. To this end, he released convicts of good conduct who were willing to marry and provided them with grants of good land, usually 30 acres, and an admonition to become self-sufficient and sell their surplus to the commissariat store. He did allow these emancipists to retain access to the government store for a period of two years. In the future, he would exchange settlers' grain for government -owned cows, to enable the commencement of a breeding program and further expand the likelihood of a successful colony.

His building and construction priorities changed. He saw the urgent need for a hospital building as he had a surgeon in his midst and some of his convicts had already been speared, and even killed, by the natives. So the barracks were completed, then the hospital and finally the storehouse were ready by early April 1789. Phillip wrote in his journal that:

> '...the timber has one very bad quality, which puts us to great inconvenience; I mean the large gum tree, which warps and splits in such a manner, when used green, to which necessity obliges us, that a storehouse boarded up in this wood is rendered useless.' (HRNSW)

David Collins, a military lieutenant and Private Secretary to Phillip, wrote on April, 1788:

> 'As the winter of this hemisphere is approaching, it becomes absolutely necessary to expedite the buildings intended for the detachment, so, every carpenter that could be procured amongst the convicts was sent to assist, since as many as could be released from the transports were employed working on the hospital and storehouses.'

On the following day, 6 April 1878, Collins recorded:

> 'Worship was moved indoors as divine service was performed in the new storehouse. One hundred feet by twenty-five feet were the dimensions of the building, constructed with great strength and covered in with thatching. But we were always mindful of fire since no other materials could be found and we became mindful of accidental fire.'

Obviously, building of the hospital, the storehouse and some female convict huts had been completed and the military barracks were well under way. Phillip's plan was now in full swing. This first temporary storehouse was built somewhere around the Sydney Cove (at the top end of High Street, now George Street) where a landing wharf had been constructed and the camp was becoming functional. Subsequently, permanent storehouses were built nearer the hospital, using roof tiles instead of thatching with a convict-constructed 'road' connecting the landing area, storehouse and hospital.

During 1788, Andrew Miller, the first Commissary, became sick and frail under these onerous duties and asked to be returned to England. He died en route and was replaced as Commissary by his former assistant, Zechariah Clark, who had originally come from England as agent to Mr Richards, the shipping contractor. On 12 April 1788, Collins reported that the 'issuing of provisions, was in future, under Mr Clark, to be once a week.'

Lieutenant John Hunter, soon to be Lieutenant Governor of Norfolk Island, recorded in his diary for 5 September 1788, that:

> *'...because of some failed crops, rotting food, and a plague of rats in the storehouse, that the colony would need more stores and provisions than any Pacific island could supply, and he would dispatch the* Sirius *to the Cape of Good Hope, in order to purchase such quantity of provisions as she might be capable of taking on board; and that she should be made as light as possible for that purpose. In consequence, eight guns and their carriages were removed together with 24 rounds of shot for each gun, 20 barrels of powder, a spare anchor and various other articles. These were all put on shore at Sydney Cove. I was also directed to leave the long boat behind for use by the Colony. The master of the* Golden Grove *store-ship was also ordered to get ready for sea to take supplies, convicts and some military personnel to Norfolk Island.'*

Phillip was obviously panicking about the shortage of supplies and the empty storehouse. Stocking the proposed settlements at Rose Hill and Norfolk Island, and the despatch of a ship to the Cape, had almost emptied the first settlement at Sydney Cove of people as well as provisions.

A number of storehouses had been established. The first was a temporary one at Sydney Cove; now there permanent building near the hospital on the first Sydney town street - High Street (now George Street) near the lumber yard store, the military detachment store and the

naval store. Clarke was nominally in charge of all stores but he was also assigned other duties with the Governor and, with the hope of cutting rations even further by only opening the regular store once each week, he was obviously in charge of only empty buildings.

In October, 1788, Watkin Tench observed in his diary that:

> *'We have now been here over half a year and are becoming acclimatised, even if we lack the shelters thought necessary. Since our disembarkation in January, the effort every one has made was to put the public stores into a state of shelter and security and to erect habitations for the hospital, convicts and us. We are eager to escape from tents, where only a fold of canvas was between us and the hot beams of the summer sun and the chilling blasts of the winter wind from the south. Under wretched covers of thatch lay our provisions and stores, exposed to destruction from every flash of lightning and every spark of fire. A few of the female convicts had got into huts but almost all of the officers and all the men, were still in tents.'*

In February 1789, James Smith, the only free immigrant who had procured a passage from England on the *Lady Penrhyn,* was placed in charge of the new storehouse at Rose Hill and was also sworn in as a peace officer or special constable. He claimed to be a 'practical farmer' and Phillip gave him a number of convicts to assist him in exercising his duties; this was the first trial of the assigned convict system.

On 18 March 1789, Collins recorded the first major theft of stores and provisions from the secured commissariat. Seven members of the military convicted of theft, undertaken over a period of some weeks and robbing the store of liquor and large quantities of provisions. Phillip made an example of these men, but to little avail as later that same year another six soldiers were convicted and hung for doing exactly the same thing.

CHAPTER 3

PERSONNEL ORGANISATION AND SUPERVISION OF THE COMMISSARIAT OPERATIONS

Introduction to Chapter 3

Store operations and procedures were carried out in many locations, recorded in many ways and supervised by numerous personnel. This is the core effort of the commissariat.

Imagine the purchasing efforts of numerous clerks in the store who received requisitions to arrange for delivery of specific items required by government in any number of the business enterprises undertaken by the store. Imagine the paperwork of requisitions, purchase orders, payment by Treasury Bills, receiving goods into store, and their despatch and transportation to the government clerk who placed the initial order. Imagine the purchasing of local grain and foodstuffs in exchange for a 'store receipt'. Then recall the many hands that might have handled that store receipt in its process of being exchanged for valuable-like consideration, before finally being consolidated with many others for exchange into tradeable currency. Think of the enormous challenge in planning convict manufacturing – the planning would have started with the desired outcomes (such as a public building of significance), been converted into a bill of materials - such as bricks, tiles, timber framing, stone, furnishings, nails, hinges, windows, doors and so much more, and then related to each section of the lumber yard, the timber yard, the stone yard, the brick and tile yard, and even the government farms. This was a production planning exercise, the like of which we would rarely see even today. A massive undertaking, it was largely overlooked by historians, but quiet reflection must show the level of activity and the importance of this role. Maintaining over 2,000 workers in a 'factory' setting like the Lumber Yard would be challenging, but try organising 2,000 convicts, and their supervisors, whilst keeping raw materials, such as timber, clay, coal, lime, steel available for their ongoing use must have been a triumph of patience, goodwill and foresight. Well paid workers would hardly be the most positive in a setting such as this, but imagine 'workers' who resisted all approaches by authority, maintained a 'rage' against everyone else in the colony whilst watching for every opportunity to thieve, destroy, undermine and thwart positive efforts to arrange work.

The story of the commissariat has reached a point where it has been explained why it was established and its general and basic operating processes, but now its activities require explanation, as do its business enterprises which employed these large numbers of convicts and benefited the settlement in so many ways.

King Moulds the Colonial Commissariat

In his introduction to Fitzpatrick[31], Dr. Evatt observed that 'a close analysis of all the legal contests between 1788 and 1820 has not yet been made, but in my opinion the result will be to corroborate the essential truth of the Fitzpatrick thesis that there was no worthwhile economic history to write, in any detailed, business history, sense'. Dr. Evatt observed that, compared to the Shann & Fitzpatrick style of economic history, other historians seemed to be writing political and administrative history. Evatt however, added a further dimension to the interpretation of the early governors' despatches[32], and rightly predicted the most reliable records of the pre-1820 period were those court papers such as affidavits, documents used in evidence and the evidence of the witnesses. Dr. Evatt opined that these cases would prove a major historical source.

This economic history of the commissariat cannot be responsibly based only on the HRA records. Other than for the terms of the instructions to each governor and to the commissary himself, the main sources to be relied upon should be the series of three Bigge Reports and the in-house accounting records of the Commissariat.

The commissariat's formative period occurred during the administration of Governor King and, coincidentally, that was when the most significant fiscal misdemeanours took place. Hainsworth reminds his readers, 'between 1800 and 1806, the commissioned Military officers

[31] Fitzpatrick, Brian 'British Imperialism and Australia – An Economic History of Australia'

[32] Evatt claims that the 'magnificent collection of dispatches that are contained within the HRA contain an inbuilt weakness: the despatches, at best, contained what the governors believed to be true and more importantly what they believed to be relevant or important: at worst they told what the governor's wanted Whitehall to believe although he knew better. As James Stephens wrote to Earl Grey in March 1850 'Commentators on colonial or any other history who confine themselves to official documents are as sure to go wrong as if they entirely overlooked them' (Quoted in Historical Studies, ANA Vol 13, No. 52, April 1969)

received less than an eighth of the Treasury Bills drawn by Governor King, and not all of these bills were for grain or meat put into the store'.[33]

According to the SRO which retains most of the King records, the King papers show that most store receipts for grain and pork were received by 'dealers' of one kind or another and that only a small proportion of the receipts went to officers. In contrast; during the 1790s it is reasonable to suppose that a majority of the receipts went to officers directly or indirectly.[34]

Entrepreneurs

Hainsworth concludes that the settlers of NSW were not in economic subjection to two dozen officers and officials[35] because there was already a commercial community with numerous trades and a variety of backgrounds including convicts, and this group became fiercely competitive, especially in seeking sub-contract work from the Lumber Yard and other divisions of the commissariat. The enterprise group included Simeon Lord, Henry Kable, James Underwood, Mary Reiby, Andre Thompson, Isaac Nichols, and it was apparent that most of these traders started as an adjunct of officer enterprise[36.] At the same time, two observations should be made. Firstly, lawsuits became a local pastime as alliances, partnerships and factions formed and reformed, changing their purpose and membership at the dictate of circumstance[37], and secondly, the absence of any account of the rise of these men is one of the serious deficiencies of the pioneer histories of the period. Their appearance is a vital chapter in the history of Australian commerce and, while more recent historians have noted the development, they have not sought to explain it[38].

Governor Phillip was active in most facets of the initial colonial administration, especially the planning for the new settlement and the difficult challenge of feeding the people. He found the soil conditions around Sydney Cove were unsuitable for vegetables, grain and fruit. The vegetable patches located in the Governor's Domain failed to provide the produce desired, and

[33] Hainsworth, D.R. The Sydney Traders – Simeon Lord & His contemporaries 1788-1821 p. 35
[34] Commissariat Records for the King period 1800-1806 are also located in the SLNSW MSS A2018
[35] A situation perceived by Fitzpatrick, The Australian People 1788-1949
[36] The rise of these men suggests that officer domination was being eroded before Governor King 's administration was forced to deal with it
[37] Hainsworth, *ibid* p.36

Phillip was constantly looking for new, locations that are more fertile. Travelling up what was to become known as the Parramatta River; he located more fertile soil, and what appeared to be a suitable clay reserve, on the south bank of the River; he named the area Rose Hill. Phillip planned a new settlement at the head of the river, which he named Parramatta. Phillip recorded that, 'the soil is more suitable for cultivation than the hungry sand covering the hills near Sydney'[66.] It was imperative to grow food as quickly as possible and Parramatta offered the additional advantages of a constant supply of fresh water and a means of transporting food by boat rather than having to build building a road.

During the Palmer administration of the stores, new settlements had to be served in addition to Norfolk Island established in 1789. Settlements were developed and serviced by branch stores in areas such as Hobart (1802), Port Dalrymple (later Launceston, 1802), Liverpool (1803), Hawkesbury (Windsor, 1802) and Bathurst (1814). The role of the main store in Sydney was constantly changing as was its location. All the stores required personnel and organisation as well as a good supply of clerical assistance and many of these roles were set-aside for trusted convicts and ticket-of-leave men. The reason for the use of convicts in a sensitive and secure area of government was straightforward. As Butlin has established, the cost of convict labour was a charge against the English Treasury and not included in the appropriation to the colony, so the use of convicts as workers for the government kept government civil salaries understated and artificially low. It was Commissioner Bigge who reviewed the workforce and, observing the number of convicts employed within government and thus civil service ranks, became aware of the understatement of costs in the colony. Butlin adds, 'as public employees, a great deal of convict labour was engaged on farming and public infrastructure construction and thus avoided being charged as a direct cost to the colony. It was more convenient, however, to transfer them into the labour market.

The use of convicts as public Servants, in the sense of filling positions in the normal operations of government, has a special interest!'[67] Butlin claims that convicts employed in

[38] The same conclusion could be drawn about the commissariat. The commissariat is always noted in the main texts as being an adjunct to the economic growth and wellbeing of the settlement, but rarely is it explained in terms of how it operated, its governance or its importance.

[66] HRNSW Vol 1, Part 2 p469 (Despatch by Governor Phillip to Hon W. Grenville)

[67] Butlin, N.G., 'What a way to run an Empire, fiscally!' *Working Paper in Economic History*, No. 55 (Australian National University, 1985) p.32

the commissariat carried no establishment salary charges and were therefore preferable to salaried civil servants. This claim fails to recognise the costs of convict worker inefficiency and theft within the store. Butlin writes 'Colonial officials chose to use convicts in the public service because they were cheap and their charge loaded on Britain. Had the offer price for clerks been raised one might expect more free or freed persons to seek the positions. Virtually none of the convict appointees appear as a charge in the Colonial Fund, for they were supported by the commissariat.' Butlin could also have pointed out that a subsequent head of the public service and its main supporter (William Lithgow) found that their were virtually no trained or skilled clerical assistants in the colony and so Lithgow took the time and opportunity to train young men with potential for these roles but then had great difficulty in retaining their services.

The Macquarie-created Operations within the Commissariat

The Macquarie guided commissariat established at least seven main operating centres in order to accomplish this challenge of distribution to new areas and of expanding the role of the government store. In addition to the seven 'business' centres, there were three new operating divisions.

Table 3.1: Commissariat Business Centres and Operating Divisions 1814

Centre	Operation
	Business Centres
1	Lumber Yard and Timber Yard
2	Female Factory
3	Government Farms
4	Work Gangs – road construction and land clearing
5	Stone Quarries – building materials
6	Dockyard
7	Livestock Compound
	Operating Divisions
8	Financial Services Division
9	Transport Services Division
10	Accounting Services Division

These 10 operating centres produced the widest range of goods for local consumption. They were import-replacements, thus saving valuable foreign exchange and making trading items available for sale, when surplus to the requirements of settlers other than convicts.

Table 3.2: Commissariat Product and Output[13]

Food (Govt. Store)	Manufactured Items	Other
Mutton	**Clothing**	**Brickyard & Stone Quarries**
Beef	Slops	Quarry Stone
Pork	Straw Hats	Quarry Gravel
Vegetables	Bonnets	Bricks & Tiles
Potatoes	Shirts	**Dock Yard**
Cabbages	Trousers	Small Boats
Cauliflower	Shoes	Unloading Ships
Carrots	Boots	Loading Ships
Turnips	Caps	Provisioning
Beans	Cloth	Repair Work
Onions	**Building Products**	**Financial Services**
Grain	Iron Bolts	Issue Store Receipts
Wheat	Building Materials	Consolidate Store Receipts into Bills
Barley	Nails – hand forged	Issue Bills
Maize	Timbers – pit sawn	Payroll – Civil & Military
Oats	Timbers – sized & dressed	Petty Banking
Fruit	Furniture	**Other**
Oranges	Tools	Issue Rations
Lemons	**Other**	Buying from Visiting Ships
Ancillary	Tobacco	Issue Purchase Orders for Imports
Tea	Candles	Pay for Goods Purchased
Coffee	Soap	
Sugar	Hides	
Processed Flour	Horns	
	Livestock	

Table 3.2 is a partial list of items produced by the commissariat using convict labour, mostly from the 20 locations around the Sydney and Parramatta areas (the County of Cumberland).

However, some products such as tobacco were produced at the penal settlements at Port Macquarie and later Moreton Bay, whilst items such as tea and sugar were imported under licence from the East India Company.

When a review of the output of the goods and services provided by the commissariat is undertaken, it is obvious that it was an important driver of the colonial economy. Not only was it the manufacturing centre of the colony, but until 1817 it was the quasi-bank, making loans and advances, trading in store receipts as a 'currency' and trading through a barter system. The commissariat was also a planning machine; one of its highest priorities was to keep sufficient foodstuffs and grains on hand to feed the growing number of people 'on the store' This meant forward contracting for grains, and calling tenders for the supply of many items when production was being transferred from the public to the private sector. In addition it became an incubator for many cottage industries and a breeding ground for many future successful entrepreneurs.

Macquarie increased the staffing of the commissariat dramatically. At the time of his arrival, the commissariat staff consisted of John Palmer, the Commissary, and a few temporary clerks. Palmer retired to half pay after complaining he was doing the work of 12 pursers; he was replaced by 20 appointees in 1815, consisting of:

Table 3.3: Commissariat Personnel 1815

Commissary-General*	1
Deputy Commissary-General	1
Acting Deputy Commissary-General	1
Clerical Staff	2
Storekeepers	4
Extra Clerks	9
Cooper	1
Messenger	1

The chief Commissary for the colony was later renamed the Deputy-Commissary-General when the Commissary-General was based in London.

The salary for each one of these personnel (below the D.C.G rank) was £91.5.0 per annum.

Although Macquarie tried to cater for the availability of free market forces in the range of rations and provisions provided by and for the store, there were always distractions. Bligh

[13] These items of foodstuffs are compiled from issues of '*The Sydney Herald*' which listed vegetables grown by the Government Farms and their market prices

reported to Castlereagh in 1809 that private shops, in Sydney Town, were stocked with stores taken by officers from the commissariat. He wrote:

> '*I can inveigh bitterly against the rebel officers who took over the reins of my government by claiming they practiced a deception inasmuch as certain officers are drawing stores and selling or bartering them to private shops such as Driver, Reddington, Chisholm and Parker. These stores are now stocked with articles from the commissary belonging to the government.*' [9]

Bligh mentioned two other deceptive practices, which would normally be frowned upon by government. The first was overpaying for private servicing (in this case sea freight) when naval vessels were available for the same purpose, without charge. Obviously rebel military officers were lining their pockets in anticipation of Bligh's removal and return to London but t his practice cost the colony a great deal of money, paid from local revenues. The second practice was detailed by John Palmer (the Chief Commissary), a Bligh supporter who had advised Bligh of thefts from the store by military officers. This second charge involved the distribution of government cattle herds by rebel officers. Over 600 head of cattle were distributed by the self-proclaimed Governor (Captain Johnson had illegally assumed office from Bligh) to individuals or bartered for maize. Palmer placed a gross value on this 'theft' and diminution of the government herd of £17,024. However, Bligh himself had manipulated the government store for his own personal gain, having used store personnel and supplies (materials and tools) on his Cumberland County land grant without making any contribution to their cost.

Manning the Commissariat under Macquarie

Using extracts from a variety of records[11], a personnel structure of the commissariat in 1816 has been assembled.

Table 3.4: Commissariat Chain of Command in 1816

Deputy Commissary-General David Allen (1)
Assistant D.C.G- Sydney – Broughton (1)
Assistant D.C.G – Parramatta, Liverpool, Windsor - Weymuss (1)
Assistant D.C.G - Financial Services

The Assistant D.C.G (Business Enterprises) was responsible for operating the government farms including Livestock facilities, Lumber Yard, Dockyard, Timber Yard, Stone and Brick-

[9] Governor's Despatches to Secretary of State HRA 1:15: 351
[11] HRA and W. C. Wentworth – *Statistical, Historical & Political Description of NSW* (1817)

yards. The Assistant D.C.G. (Operations) was responsible for overseeing distribution, including transport, communications, and storage.

Table 3.5: Commissariat Personnel- 1816

Position		Name
Deputy Commissary-General		David Allen
Assistant Deputy Commissary General - Parramatta		John Palmer
Acting Assistant Deputy Commissary-Generals	Hobart Pt Dalrymple Sydney	William Broughton P. Dalry T. Archer
Clerks	Parramatta Sydney Sydney Windsor	E. Hobson A Allan G. Johnston R. Fitzgerald
Principal Clerk		T.W. Middleton
Storekeepers	Sydney Newcastle Pt Dalrymple Liverpool Hobart	W. Scott J. Tucker R. Dry J. Gowen R. Rayner
Assistant Clerks		16
Messenger		1
Store Assistant		1
Cooper		1

A Change of Approach for Commissariat Operations

In 1813, these and other circumstances led to a revamping and restructuring of the colony's commissariat operations. After 1813 Colonial Commissaries were appointed from Britain (such appointments being on recommendations contained in the Report of the Commissioners on Public Acts of 1792) All financial business of the army abroad was conducted by the Commissaries of Money and Stores, appointed on warrant of the King, and directed to obey all instructions given by the Treasury.

Before 1813, the governor was in direct command of the commissariat functions, and this local knowledge and direction led to planning and regulation that appears to have kept adequate supplies in the stores and allowed fast adjustment to ration issuing, essential in keeping the growing population fed on a regular and routine basis. A brief outline of

commissariat functions and operations between 1788 and 1813 will serve to show how the commissary established itself as a prime economic functionary within the government and the settlement.

Governor Phillip had declared in a memorandum to the Colonial Secretary - 'The country has no treasury' [18]. The first financial institution, by default, was the government store or commissariat, based in form and function on the military commissariat responsible for provisioning troops[19]. Commissariat stores were established in Parramatta by 1792 and Hawkesbury (Windsor) by 1794[20]. In 1794 Commissary Palmer asked Governor Hunter for additional staff and stationary as the storekeepers were overworked! When King arrived to take up duties in 1800, he noted that at no time had proper instructions been prepared and issued on how to manage the commissariat. He therefore drafted a series of detailed instructions and issued them to Commissary Laycock, who had succeeded Williamson; an outline of these regulations appears in the appendix of this study. Williamson had been appointed on a temporary basis whilst Palmer was on leave[21] in England. The British Treasury had also felt the need for a comprehensive set of Commissariat regulations, for Palmer returned to the colony with a set of instructions for his guidance[22]. The Treasury regulations were more general in nature and were therefore not at odds with Governor King's instructions. However one area of the Treasury instructions did differ from King's and created a new policy, the drawing of Treasury Bills; the Commissary was now authorised to draw Bills directly, without the approval of the governor. This new procedure came as a surprise to King who, upon receipt of the Treasury instructions from England, wrote to the British Colonial Secretary pointing out his (the Duke of Portland's) earlier official direction to 'draw Bills for all public purposes through the governor and by no other person'[23]. King concludes his despatch with what appears to be reluctant approval 'whilst awaiting your Grace's commands, I am giving the Commissary an order to draw Bills, using every precaution'. The commissary had also been directed to pay the salaries of its storekeepers from funds held by the Colonial Agent rather than the Treasury. King's precautions were probably because, in

[18] A paraphrase of Governor Phillip's pronouncement was used by N.G. Butlin in 'Foundation of the Australian Monetary System 1788-1851

[19] T.G. Parsons 'Colonial Commissaries' – (Chapter 1 of Australian *Financiers – Biographical Essays* - Appleyard & Schedvin (Eds)).

[20] SRO records of the Colonial Commissariat (Research Group NC-11)

[21] HRA 1:20:675 and 632-6 (the complete copy of the instructions)

[22] HRA 1:3:5

[23] HRA 1:318 King despatch #3 to the Duke of Portland

actual circumstances, the commissary was becoming of considerable importance in the colony as a market and exchange, as revealed in a Report on the '*State of His Majesty's settlements in NSW*' dated 31 July 1801:

> '*The Commissary officer is charged with the provisions, stores and every other article or concern wherein the public expense or expenditure is included. To assist him one deputy has charge of the stores in Sydney and one at Parramatta; another storekeeper has charge of the dry stores in Sydney, and a third is in charge of the store at Hawkesbury. As there are only two storekeepers provided for in the estimates, this third person is a superintendent. The deputies and storekeepers make weekly returns to the Governor. No article whatsoever is received into or issued from the stores without the Governor's written order, which duty is perplexing and occupies one entire day each week. Those orders and returns are checked on the Commissary's accounts, and inspected quarterly by the Governor, and transmitted to the Commissioners for Auditing Public Accounts, which from September 1800 are forwarded with the Governor's despatches. In addition to regular duties, the Commissary is also charged with exchanging such articles as are sent by Government with the settlers, for grain or animal food, and disposing of the whalers' investments in the same manner, which effectively destroys all monopolies. These duties require the constant attention of four clerks in addition to the two provided by Government.* [24]

Further duties were added to the Commissary by an Order of August 1802 whereby, under certain conditions, the Commissary was authorised to sell surplus perishable goods to free settlers at a profit, fixed at 50%. Palmer was allowed to retain a percentage (described only as 'small') as compensation for the extra bookkeeping - he was instructed to pay any additional clerks out of his private purse. When Bligh was overthrown, Lt Foveaux declared the commissariat department was riddled by corruption and he dismissed Palmer, who, in turn, indicated the stores were now being rapidly depleted by the military officers for their own gain. This resulted in a series of personnel changes in the commissariat Administration; Palmer was dismissed and replaced by Williamson, who, after less than six months, was arrested and replaced by Wiltshire. Wiltshire lasted less than three months to be replaced by D.C. Fitz. When a charge was levelled against Fitz, William Broughton was appointed Commissary. [25]

[24] HRA 1:3:419 This statement is Para 5 from the 'State of His Majesty's Settlements in NSW' being enclosure # 1 to despatch by Gov. King to Duke of Portland dated 1st March 1802. The note 615 to this statement refers to 'these annual statements reported the yearly transactions of the colony in detail'.

[25] HRA 1:7:179

Parsons offers a partial explanation of this high turnover of personnel[26] 'although commissaries had immense responsibilities for which most of them were untrained, their recruitment was a haphazard response to times of crisis. Military officers constantly complained about the calibre of the department. Wellington himself observed 'the prejudice of society against a commissary almost prevents him from receiving the common respect due to the character of a gentleman'.

Palmer and his successors may not have sought respect but they certainly created a great deal of personal wealth, far beyond what a salary of £150 per annum would have achieved. Palmer accumulated one of the finest homes in the settlement, as well as a huge estate at Woolloomooloo Bay (100 acres of land grant), investments in land, livestock, mills for grinding government grain, and eventually a fleet of whaling boats. He did well for himself by being the Commissary-General, and having the governor's ear on so many matters, with the added advantage that his brother-in-law (Robert Campbell) was the biggest independent trader with the commissariat[27]. Palmer offered an interesting insight into his schematics. The ex-purser had come a long way in a very short time when he boasted to the 1812 Select Committee 'I had more ground than anybody else, and I farmed more than any other person does' [28]. Parsons concludes, 'Palmer was a competent, if unexciting administrator who believed that public funds were for private use. His failure arose from an attempt to reserve the trade of NSW for Campbell and himself. His administration of the commissariat during the 1790s had assisted the privatisation of the colonial economy; these years were personally profitable and socially rewarding.'[29]

Before 1813, the main role of the commissariat was to feed and clothe the convicts, the military and the civil officers. It also victualled all the settlers, mainly emancipists, who were supported for at least the first two years of their freedom and provided them with tools and clothing. The commissariat was the principal market for colonial produce, buying grain and other products from settlers, who relied on the commissaries for a secure, stable income. The commissaries in turn relied on the settlers for a regular and adequate supply of product to meet the commissary needs. During the period between 1788 and Macquarie's recall in 1821, the

[26] T.G. Parsons 'Colonial Commissaries - Chapter 1 of 'Australian Financiers' - Appleyard & Schedvin (Eds)

[27] Margaret Steven 'Merchant Campbell' p.143

[29] Parsons *ibid*

commissariat played a key role in the socio-economic development of the colony. Commissary bills and store receipts were the currency of the colony and the commissariat dominated colonial finance. At least until 1817, it acted as a bank, controlled and administered the flow of foreign exchange in the shape of treasury bills issued to pay for the cost of the colony, provided loans and credit, and encouraged the establishment of enterprises that could meet its demands. The essential personnel of the department were intimately involved with the emergence and maturing of colonial Australia.

Fletcher offers an interesting observation on the philosophy of the 'middleman' or commissariat in the colony. 'The gaol could not feed itself; whilst the private sector, composed of civil and military officers and emancipated convicts, started to produce surpluses of agricultural products in the early 1790s. A mechanism had to be found to transfer the surplus from the private sector to the government and gaol economy, and it was the commissariat that came to occupy the key role in this exchange relationship.' [29]

How did the Commissariat Become the Interim Treasury?

The colony did not have a treasury before 1825, but Macquarie had always considered a government-owned bank was essential. He had attempted to charter a government bank in 1811, but his request was denied. In 1817 he formed a private Bank (the Bank of NSW) by illegal charter, and used it as a depository for government funds. Before the formation of the Bank, the colony had really required a treasury to provide means of exchange apart from the basic barter system for trade payments, foreign exchange purposes and credit provision, but the Lords of the Treasury in London considered they would lose control if a sub-treasury was established. One indication of the commissariat's financing role was the use of 'store receipts' as private receivables able to be exchanged for goods and services at the commissariat, traded within the colony, or to be consolidated into a bill through the commissary. The commissariat was assigned the role of interim treasury whilst awaiting the chartering and formation of the 1817 colonial bank.

The commissariat's financial services role and activities included:

[29] B.H. Fletcher 'Landed Enterprise & Penal Society' (SUP)

As Paymaster, to exchange paymaster bills for commissariat goods, consolidate them and exchange them for goods from England

Issuer of 'store receipts'

Consolidator of bills

The only authorised drawer of bills in the colony, directly against the British Treasury in London

Providing foreign exchange and setting rates of exchange for imports and exports

The authorised recipient in the colony of coinage from Britain

The largest producer of goods and services

The largest purchaser of goods and services in the colony

The largest issuer of goods and services in the colony

The largest holder of inventory in the colony

The largest issuer of bills in the colony

Even without being assigned this new role, the commissariat was equivalent to the government 'treasury'

Official purchaser of supplies and foodstuffs from visiting American ships, using bills drawn on the British Treasury in London

It was the commissariat's role as fiscal coordinator that angered many local businessmen as well as the Colonial Office and Commissioner Bigge, and ultimately led to Governor Macquarie's recall. It was this misunderstanding of his role as the best economic developer before self-government in 1856 that so damaged Macquarie's legacy and treatment by history. William Lithgow, the first Colonial Auditor-General recommended that the revenue of the Colony is now to be classed under the following general headings:

- Taxation
- Land Revenue
- Receipts for services rendered
- Miscellaneous receipts

Table 3.6: Revised Classifications of Colonial Revenues - 1825

Taxation	Land Revenue	Receipts for Services	Miscellaneous
Customs duties	Crown Land auctions	Rail and telegraph	Rents
Excise duties	Improved land sales	Money orders	Fines
Gold export duty	Pastoral leases	Mint charges	Govt. property sales
Trade licences	Quit rents	Gold escort fees	Bank interest
	Mining leases	Pilot & harbour fees	Other general
	Miners' rights	Cattle brand registration.	

Lithgow commented:

> 'The revenue and expenditure of the Colony is increasing year by year in proportion to the prosperity of the people and the increase of population. This is naturally to be expected for as new lands are taken up and outlying districts occupied, demands upon the government for all those services which tend to promote the well-being of a community are constantly being made; and although these services when granted create an additional expenditure, there generally follows an augmentation of the revenue both from the sale and occupation of the waste lands of the Colony, and the larger consumption of dutiable articles.'

Further general observations on the origin and nature of the Colonial Revenue were made by James Thomson[68].

> 'The Revenues collected within the Colony of New South Wales, from its establishment until the commencement of the administration of Governor Macquarie in 1810, were raised in support of the 'Gaol' and 'Orphan' Funds respectively. The Revenue thus levied for, and appropriated to the Gaol Fund consisted of a Duty of 1s. per gallon on Spirits, 6d per gallon on wine, 3d per gallon on beer, together with a wharfage duty of 6d on each cask or package landed. These duties appear to have been first established upon the authority of Governor John Hunter R.N. during his administration in 1795 - 1800 and were the earliest sources of local revenue in the Colony.
>
> The Revenue raised for the Orphan Fund was derived from fees on the entry and clearance of Vessels, and for permits to land and remove spirits - both first levied in 1800; from licenses to retail liquor and from a duty of 1.5% on goods sold by auction (first collected in 1801); from a duty of 5% ad valorem on all articles imported, the produce of countries to the eastward of the Cape of Good Hope (first imposed in 1802) ; from fines levied by the Courts and Magistrates; from fees from grants of lands and leases, and quit rents on crown lands (Quit rents ceased in 1805). Other than quit rents and crown land fees, all revenues were levied upon Colonial authority.'

The following is revenue raised in 1805. James Thomson reports that the records from 1805 to 1810 are 'imperfect'.

Table 3.7: 1805 Revenues in Gaol and Orphan Funds:

Duty on Spirits	1569.11.03
Fees on Vessels, Licences	595.13.07
Ad valorem Duty	531.10.03
Fines by Courts	86.05.08
Revenue raised in Colony	£2783.00.09

[68] James Thomson (Ed) The Financial Statements of the Colonial Treasurers of NSW together with an Appendix (NSW Government Printer – 1881)

In 1810, Governor Macquarie changed the designation of these two funds to 'Police Fund' and Orphan School Fund. The designated revenues were split 3:1 into each fund. The Act (3 Geo IV c.96) of 1822 gave further powers of taxation to the Governor, after the legislation of 1819 ratified retrospectively all taxation from 1802.

Administration of the Commissariat

The administration of the commissariat after 1813 was under the total control of the Deputy-Commissary-General, with the Commissary-General being located in London. However, the colonial posting was, in practical terms, influenced by the governor's policy. This D.C.G. position was both political and influential and his standing was high, almost in line with the Chief Justice and just below the Lt. Governor as head of the military. Every D.C.G became wealthy or his posting was terminated for reason of fraud. It would appear the end-choice was solely in the hands of the D.C.G and depended on how blatant were any intended but unlawful practices.

In October 1802, King advised Lord Hobart of his recent measures to improve the operations of the commissariat.

> *'After taking the measure of striking off rations, those who had no pretension or claim to be fed at the public expense, I saw no reason why those convicts with long sentences and who have been in the colony for a number of years, and who have behaved well and been industrious, might not be permitted to labour for their own support under proper restrictions which policy has resulted in a lessening of the consumption of public stores, provisions, clothing, and therefore greatly reduce the expenses of the colony, stimulate individual industry and promote the collective produce of private property.'*

King tried without great success to limit the theft from the store. He authorised the employment of only long term and well behaved convicts and they were not employed in positions of trust, but rather in posts such as clerks.[33]

[33] HRA 1:3:378 King to Portland

The Commissariat as Colonial Banker.

Macquarie was less concerned with the supervision of the commissariat in its mundane but important daily operations of ordering, storing and distributing stores and provisions, but, because of its unique position in the colony, constantly searched for new roles, and carefully developed the financial services expertise of the store. Between 1802 and 1821, the commissariat was already developing into a multi-faceted operation and its strength and influence in the colony grew continuously. In many ways its early role paralleled the workings of various government departments and this gave the commissariat great influence and power with the governors and over the settlers in the colony. After the change to military supervision with the governor having only an overseeing role in operations of the store, Macquarie stripped the commissariat of its engineering and convict supervisory functions but added 'business enterprises' and 'financial services' to its operations. These were new activities for which the commissariat was initially not well equipped, and many of the difficulties it was to face in the 1810-1820 period were due to the ill-fitting roles assigned to it and its personnel who were unsuitable, untrained and mentally ill-equipped. The lack of suitably trained staff and supervisors created numerous problems for the store, the governor and not least – the colonial economy. These problems included the easy manipulation of commissariat systems by senior officials of the commissariat. The frauds of Allen and Drennan were due to excess personal power and exuberance, for which they had no guidance; the debacle over 'store receipts' was really a battle between the commissary and the governor over fiscal influence in the colony; and the conflict over pricing of produce was a confrontation between bureaucrats in the new public service, who felt their role and influence was at risk if the commissariat continued with its new fiscal responsibility. Macquarie made no apology for assigning these difficult, unauthorised and unfamiliar tasks to the commissariat, and he rather enjoyed the battle between his senior public servants and the commissariat for his favours and patronage. The view that Macquarie felt strongly about being thwarted in his endeavours to establish a government 'bank' is supported by his assigning of fiscal functions to the commissariat. These ranged from setting 'discount' rates on bills to the more active use of 'store receipts' as a medium of exchange, and the receipt and distribution of large amounts of 'specie' received from the Treasury in London.

There is little doubt that the commissariat was the first 'bank' in the colony - 'it is the circumstances that necessitated a colonial bank in a settlement that had fundamentally been designated for penal purposes and as such, without the need for coinage or a means of exchange' that is of special interest. In this observation[8] S.J. Butlin was referring to the early transition from penal to free settlement when the commissariat was handed the role of issuer and comptroller of coinage. During the development of a monetary system suitable for its transition from penal to free colony, the commissariat provided the official base for barter and exchange, the issuing and 'accepting' salary and wage notes, and providing 'store receipts' as transferable entitlements. It had an important official role in the colony's monetary and fiscal policy and was able to add this quasi-banking role to the list of other official duties it accepted. The commissariat created a quasi-currency by sponsoring a number of payment methods in the coin-less colony. It is S.J. Butlin's thesis that 'by 1803 the commissariat may reasonably be called Australia's first bank[9]. This is a valid conclusion and the commissariat's fiscal role only increased from that time. It made loans, provided credit and kept accounts that recorded deposits and withdrawals'.[10]

A continuing conflict with DSC David Allen over currency and 'petty banking' convinced Macquarie he should establish a separate bank (the Bank of NSW in 1817)[11]. Butlin concluded that the new bank did not solve the currency problem because:

> 'Store receipts were still far more important, with the Bank of NSW itself holding store receipts to the value of more than twice the value of its own note issue in 1821. In 1819, DSC Drennan's note issue of £49,200[12] was seven times that of the bank's paid capital while the petty bankers had by no means disappeared'.[13]

There were a variety of mediums of exchange in a coin-less colony: bartering, petty banking, store receipts, bills of exchange and paymaster notes. Bartering was used for government produce, labour and general commodities. In 1807 Governor Bligh tried to put an end to this widespread practice. In his general order of February 1807, he prohibited bartering, explaining 'he feels it his duty to put a stop to this barter (mostly of rum and spirits) in the

[8] S.J. Butlin *Foundations*
[9] Butlin, S.J. *Foundations of the Australian Monetary System'*
[10] Butlin, *Foundations* p.67
[11] Holder, R.F. '*The History of the Bank of NSW'*
[12] Holder confirms *ibid* P38, that of the £49,200, £29,300 had been sent to VDL and a further £10,000 was in circulation in NSW, where it was in competition with notes issued by the Bank of NSW
[13] Butlin, S.J. *Foundations of the Australian Monetary System'*

future and prohibit the exchange of liquor for grain, animal food, labour, wearing apparel, and any other commodity.[14] Obviously Bligh succeeded only in part, and in the process upset the power brokers to the extent that he was overthrown as governor, to be replaced by Macquarie who, with the support of his own regiment, returned the colony to a more traditional means of exchange. However, within months of his arrival, he foreshadowed a government bank, which would have satisfied the merchants, the pastoralists and the traders.

The 'petty bankers' were the publicans, the storekeepers and merchants, military officers and government officials, who made note issue part of their regular trading activity. In spite of the risks, private notes were frequently passed as 'currency', even at a discount, for internal trade was increasing and means of payment had to be created somehow in the absence of an effective officially accepted standard.[15]

Both the Governor and Mrs. Macquarie were responsive to any waste and excess expenditure by the commissariat. Mrs. Elizabeth Macquarie observed that the system left much to be desired and was subject to great abuse. She wrote to her sister in England about the store receipts system, as it existed in 1795:

> *'Thousands of persons are dependent on the government stores, all of whom had been supplied with flour from England for bread. But because so many have recently cultivated land and raised grain, there is a great quantity of it. The commissary purchases it at 10s. per bushel; and it is also issued by him (the commissary) for what are termed rations, or the proportionate quantity due to (eligible) people instead of flour In payment for grain received from settlers the commissary issues an official receipt. These receipts currently pass here as coin, and are accepted .by Masters of ships and adventurers who come here with merchandise. When these receipts become accumulated in the hands of individuals, they are returned to the commissary, which then gives a bill on the Treasury in England for them. These bills amount to thirty or forty thousand pounds per annum…. Pigs are bought on the same system, as would cattle and sheep also if there were sufficient to enable them to be killed for beef. Any horse is worth £100, but a good one is valued at £150. A cow is worth £80. You will perceive that those persons who took precautions to raise livestock have, at present, singular advantages'[16]*

[14] *Sydney Gazette* 15 February 1807
[15] Holder, R.F. '*The History of the Bank of NSW'-* Vol 1 p.5
[16] Macarthur Onslow: *The early records of the Macarthurs of Camden*

The practice of issuing store receipts and of later trading in them became officially recognised and widely practiced, accepted by traders and merchants alike. However, when Deputy Commissary-General Drennan was promoted and appointed to the position of Commissary-General in the Colony on 17 April 1818, he brought Macquarie's policies of replacing the role of the Commissary as the 'banking' institution, with the Bank NSW the attention of Under-Secretary of State Harrison in London. Drennan told Harrison:

> '...this is now at the end of the Macquarie period and the principal cause of His Excellency (Macquarie) patronising the store receipts system has been to favour the Bank, created by His Excellency; the principal shareholders and Directors of which are Mr Wentworth (Darcy), Robert Campbell (trader) Captain Antill (military officer), Mr Redfern (Assistant Surgeon) and acting Asst Commissary-General Broughton.'

These are the people who had the presumption to make a fool of the commissary by the declaration on the back of the store receipts, which reads:

> 'While we discharge our small engagements in the silver and copper specie of the colony, we will with equal promptitude pay the greater either in dollars, store receipts, or bills upon the treasury. This is our pledge to the Public, and we will redeem it; our truth will be inviolate, and no man shall say with truth, the Bank does not deserve a good name.'[17]

Drennan later incurred Macquarie's wrath and earned a dishonourable discharge from government service following an indictment on charges of fraud and malfeasance. Both Allen and Drennan had overstepped the boundary of commissariat tolerance for petty theft and were sent back to England under military arrest. A small touch of irony can be seen in the fact that those convicted in England was transported to the penal colony of NSW, whilst those committing offences in NSW were shipped back to England.

Government bills, drawn on the British Treasury, continued to provide the main means of paying for imports. Bartering by the store reduced the amount that needed to be drawn by bills, but it was still large[18]. The drawing of bills was carried out by the store (commissariat) which acted as importing agent for the government. Before 1800, private bills, other than for salaries, were quite rare as they could only be drawn as a result of exports or the private import of capital.

[17] Barnard ' *A History of Australia*' p.533
[18] Governor King reported drawing £87,478 on the treasury during his administration

After 1809, the paymaster for the regiment issued 'pay notes' each month. These were small promissory notes which circulated in the same manner as store receipts and were consolidated periodically for cash or bills in London[19]. A refusal to permit the commissary to give bills on the Treasury directly in payment for salaries forced most of them to be made through payment to local importers for goods. Recipients then had to discount them with local merchants like Campbell who took salary bills for goods and money in the colony, undertaking the collection of the bills from London agents[20]. The commissariat's role was moving quickly towards being a purveyor of foreign currencies. Whether this took the form of commissariat bills, military paymaster or private salary bills, the ultimate source was British government expenditure on the colony.

In commercial transactions, which constituted the largest range of fiscal activity in the colony, it was the privilege of the seller to specify what payment type he would receive. Money, in the form of copper coins, dollars, store receipts, paymaster or government bills, or 'storable' wheat or meat set at commissariat prices, could be specified and was regularly quoted in this way in the *Sydney Gazette*

Supervising the Commissariat Operations

In 1826 Darling tried a new approach to organising the commissary after the Macquarie years when 'full' employment[34] of the convicts was achieved by utilising them in the extensive public building program. Darling was not willing to resume[35] the pace of the Macquarie years, and he asked Major Ovens[36], his friend and military comrade, to examine the organisation of convict work to see if the output could be maintained but at a less frenetic pace

[19] Regular advertisements (e.g. 26 June 1803) in the *Sydney Gazette* informed the public about a pending consolidation

[20] Steven, Margaret *Merchant Campbell*

[34] The writer has determined in other studies that the Macquarie years produced an almost optimum utilisation of the convict resources in and for the colony. Fewer convicts were made available to settlers, and instead of having convicts taken 'off the store' by being assigned to settlers, Macquarie ensured that their productivity and output more than compensated for their remaining on the stores at a lower than previously estimated cost per annum. This annual cost is referred to in the statistical section of the Appendix.

[35] Both Brisbane and Darling had been told by the Colonial Office in London not to repeat the mistakes of the Macquarie years, and were requested to implement the major recommendations of the Bigge Report. (Fletcher – A Governor Maligned)

in the economy. Major Ovens prepared his analysis and report, in conjunction with the Deputy-Commissary–General for Accounting and the new Colonial Auditor, both positions being held by William Lithgow[37], and Darling, basing his deliberations on this rather spectacular and detailed report, restructured the government departments and their responsibilities to support the Ovens' changes.

Previously public works, engineering and roads and bridges had been the ultimate responsibility of the Commissary but Darling now separated each of these functions:

> The Chief Engineer was made responsible for the superintendence of all public works, the construction and repair of all public buildings, and the making and repairing of streets, wharves, sewers, canals and drains.

> The Inspector of Roads and Bridges was charged with the construction and repair of roads and bridges and the general superintendence of convict road parties and clearing gangs. This branch of the service was considered totally distinct from the Department of the Civil Engineer, who was now responsible for structural design and compliance in public buildings.

> The Principal Superintendent of Convicts was charged with the general superintendence of convicts employed by the government which included their conduct, victualling, clothing, lodging and accommodation in barracks or otherwise. Convicts attached to other departments were the responsibility of the Civil Engineer, the Inspector of Roads and all other departments and establishments which were responsible for their good order and the proper direction of their labour, while they were so attached.

> The Master Attendant at the Dockyard was charged with the superintendence of the Lighthouse, and the Dockyard, including the maintenance of government vessels and boats and the loading and unloading of ships carrying cargo.

> The Major of Brigade was charged with the superintendence of the batteries, ordnance stores and magazines including the telegraph and signal establishments.

> The Deputy Commissary-General was charged with sales of timber, coal and oil and the sale of surplus produce from government farms and other establishments. He was also to have immediate custody of all public stores, tools, clothing and bedding, building materials and supplies sent from outstations; as well as all articles manufactured in the

[36] Ovens was close to Governor Brisbane, but transferred his loyalty to Brisbane's successor, Darling, upon Darling's arrival in the colony and before his early death. Darling arrived in 1824 and Ovens died in 1825. (Fletcher *ibid)*

[37] The biography of William Lithgow has been recorded by this writer and is available in a separate volume. Lithgow arrived in Sydney in 1824, shortly before Darling and retired in 1852 after 28 years of continuous and noteworthy public service to five governors and the NSW Legislative Council.

government establishment. All sales of government items were to be by auction and all purchases were to be made by public competition.

The other observer of commissariat enterprise was S.J. Butlin:

> '*A currency was needed to provide a means of payment. The commissariat store receipts became the internal currency of the colony, dominating its monetary system until the end of the Macquarie administration. These receipts could be consolidated into a Treasury note, payable in sterling, along with paymaster's bills (the salaries of civil and military officers), which provided the colony's supply of foreign exchange. Access to sterling enabled imports to be obtained; access to the commissariat provided store receipts that could be consolidated. The commissary was the key to the system; the opportunities and temptations were considerable.*'[30]

Costs (and Benefits) of the colony to Britain

Before looking at the costs, at least one of the benefits has been considered. A House of Commons parliamentary committee, led by Porter in 1846, assessed the annual exports of British manufacturers to the colony of NSW between 1828 and 1846.

Table 3.8: Values of British Exports to the Colony 1828-1846

Year	£	Year	£
1828	433,839	1836	835,637
1829	310,681	1837	921,568
1830	314,677	1838	1,336,662
1831	398,471	1839	1,679,390
1832	466,328	1840	2,004,385
1833	558,372	1841	1,269,351
1834	716,014	1842	916,164
1835	696,345	1843	1,211,815

The British perceived that:

> '*The value of the transportation program lay in the rehabilitation of offenders, provided they were preserved 'in a due proportion of numerical inferiority to the untainted population, and that when so regulated they constitute the greatest possible addition to the strength, progress and riches of a colony'.*

This perception was proffered in its Crime and Transport Report of 1850. Of the 17,000 convicts transported to NSW between 1800 and 1817, no less than 6,000 had obtained their freedom for good conduct by 1817 and had earned as a further reward, crown property worth £1,500,000.

[30] S.J. Butlin 'Foundations of the Australian Monetary System 1788-1851' (MUP)

The colony itself prospered immensely from the forced labour of convicts being added to the voluntary labour of freemen and this was reflected in the astonishing progress made by the colonies between 1800 and 1850. This Report[33] also set out the amazing comparison exports per head in 1836 including exports per head of population for selected colonies in 1836.

TABLE 3.9: International Comparative Exports per head in 1836

Country	Per Head -£
USA	17.6d
Canada	1.16.0d
British West Indies	3.12.0d
Australia	8.14.0d

These returns demonstrate that progress that the convict colonies during the first half of the 19th century was three times as rapid as those countries enjoying equal or greater advantage. It would appear that in the case of the colonies of Australia, that fortuitous circumstances encouraged exports. For instance, in the efforts of the colonies to become both self-supporting and self-sustaining, the development of export industries was encouraged.

Bigge strongly recommended the opening up of new pastoral lands in western, northern and southern NSW, to allow the colony would flourish economically and export more products to Britain. The colonists wanted free labourers to be available as well as assigned convicts to assist in the creation of free enterprise in the colony and remove the total reliance on convict labour. They also wanted the colony begin a transition from penal settlement to a free enterprise export economy. The lifting of British restrictions on trade was encouraged (such as navigation and trade restrictions by the East India Company), as well as tariffs on colonial exports to Britain. This further opened up trade between the two countries.

Population increases assisted in increasing outputs especially as population increases per annum grew from an annual 3.3% between 1821 and 1828 to 13.9% between 1836 and 1841. The following table is an extract of key statistics relating to the costs of the transportation program:

[33] Allison, Archibald *Crime & Transportation* 1850 Vol 2 p595-98 as quoted by Evans & Nichol *ibid* p.180

Table 3.10 Comparative Costs of the Transportation Program

	Cost (£) per head p.a.	Source
Cost of maintaining prisoners in Britain	26.15.10	Matra
Projected value of their labour in Britain	8.07.00	Matra
Cost of maintaining convicts in the colony	20.00.00	
Estimated value of convict labour	60.00.00 (4/- p/head p/day)	
Victualling costs	13.00.00	
Clothing costs	3.00.00	
Housing costs in the colony	7.00.00	
Transportation costs to the colony	15.00.00	Matra
Cost of supervising convicts	2.00.00	

Estimated value of convict work for the government in the colony	£450,000 Avg 50000 convicts @ 6/- p/day

What do these figures mean? They mean that the colony was established by Britain not solely on monetary grounds for, by 1786, before the First Fleet left Portsmouth, the British Treasury authorities were aware that their cost projections were astray and did not conform to their political and philosophical plans. Their premise had been that there were potential savings to be made for the Treasury by establishing a remote penal colony and manning it with 600-1000 convicts each year. They would be supervised by a military marine contingent with the commanding officer appointed as 'governor', and convicts would be utilised as labour to develop the colony. They expected that the settlement would be well on the way to self-sufficiency within two years, without the need for large financial allocations to support the occupants. They would grow their own vegetables, meat, fruit and grain and the marines would defend the territory and supervise the convicts in their work.

The theory worked fine, but it was impractical:
The seeds and plants sent out with the First Fleet did not grow as expected. The plots were located in poor soil, and the ravages of sun and either an excess or shortage of water destroyed the crops before maturity.
The convicts were of such bad or poor character that they would not work.

The convicts had none of the necessary skills – the colony needed people with experience in building construction, farming and animal husbandry.

The marines refused orders to supervise the convicts which then required convicts to supervise convicts.

Lack of knowledge about local timbers caused the first buildings to warp, twist and fall down – the timbers had not been dried.

Lack of knowledge of horticulture caused the plants and livestock to be misused and, with no yield, the colony was bound for starvation until the second round of supply ships arrived.

There projected savings over keeping prisoners on the hulks and employing them on harbour and waterside maintenance did not eventuate. According to Matra, The cost of keeping a British prisoner on the hulks was a gross £26.15.10 per annum, with the value of work received estimated at £8.7s per annum, for a net cost of £18.8s. On the other hand, establishing the penal settlements proved to be more expensive in monetary terms than expected:

Establishment Costs	£50,000 or £25.0.0 per head p.a.
Transport costs per head	£15.0.0
Maintenance costs of clothing, housing & victualling	£23.0.0 p.a.
Value of Convict labour per annum	£60.0.0[35]
Net cost per head per annum	£3.0.0[36]
Less the expected capital cost per head of building penitentiaries in Britain for the growing prison population	£5.0.0.

The capital costs of building housing, barracks and gaols in the penal settlement had already been covered. The costs of establishment of the £50,000 referred to above included tools and implements as well as a variety of nails, hinges, and metal pieces for reworking when put into use in the settlement. It was also considered that timber, bricks, tiles, lime for mortar etc would be readily available in the colony, and that all labour was being covered by the regular maintenance costs projected above.

[35] Coghlan in *Labour & Industry in Australia* Vol 1 estimates the value to be only £30, and since he discounts the value by a factor of 30% for inefficiency and productivity adjustment, the equivalent labour value of a free worker must be £42. The value of convict labour at £60 was presented to the H of C Select Committee based on an opportunity cost (of free labour – if any was to be found) of 6/- per man per day.

The direct cost of the penal settlement, when compared in full to the costs of keeping the prisoners in Britain, was in theory on the plus side by about £2.0.0 plus any growth adjustments for poor estimating. Thus the intangible benefits would solidify the government decision to move ahead with this political cleansing plan.

However, if there had been no direct savings, what were some of the intangible or non-monetary benefits?

Cleansing Britain of misfits and malcontents, and not allowing them to return to the home country

Transferring the poor and the wasters out of Britain to the colony as development fodder

In general, ethnic cleansing based on economic and political benefits – by ridding Britain of economic and criminal refugees.

Establishing a settlement with future trade benefits for British shipping, manufactures and raw material procurements

A refitting and provisioning stop for the Indian and China trade ships

A foreign policy coup for Britain to have a post beside Portuguese and Dutch interests in the region

A continuing receptacle for British outcasts, which in a short time should not be costing the Treasury any maintenance costs

The potential of recovering any establishment costs by selling crown land to speculators and 'investors'.

Thus it would seem that the non-monetary benefits far outweighed the marginal costs of transferring prisoners to the penal colony. It would also seem that the commissariat kept the maintenance costs for convicts to a minimum, well below the equivalent cost of maintaining prisoners in the United Kingdom.

As a final comment before the completion of this chapter on commissariat business enterprises, a statement concerning the rise of private manufacturing and its contribution to economic growth is deserved. There was an unstated move by Governor Macquarie to transfer much of the government sector manufacturing to the private sector. He considered this a relatively important aspect of the overall transition of the colony from a penal settlement to a free market economy.

[36] This net cost is computed by adding £25+£15+£23-£60 = £3

Summary of Chapter 3

The introduction to this chapter set the challenge of determining the enormous task of clerical assistants in operating the commissariat at its peak during the Macquarie Administration. The challenge included processing inventory requisitions, and determining which ones could be met out of stock, or which ones had to be ordered from the Lumber Yard, or which ones needed ordering from Britain.

The second key role was production planning for the Lumber Yard and the various business enterprises operated by the commissariat. This planning commenced with projecting the future needs of food production, the planned public building construction and public housing programs From this initial information, together with the projections of the number of arriving convicts, the outcomes from the Lumber Yard would be computed. Much of this data was merely guesstimates because no-one in the colony, not even the governor, knew the expected number of arriving convicts not their training, background or skills level, until those convicts arrived at Sydney Cove. Thus the task of planning for 2,000 relatively unwilling workers, crammed into a few fenced areas around Sydney town was the biggest one ever faced by the leaders of the commissariat. In addition to the lumber yard workers, there was substantial planning for the government farm production and the government livestock management. In all the amount of planning within the commissariat structure was enormous and included the coordination of the store receipts program, their recovery and consolidation into large Treasury bills drawn on London.

Although entrepreneurs is further considered in the Chapter on the growth of manufacturing, the commissariat gave silent consent and support to the military officers who made their role the manipulation of the commissariat purchasing from local settlers, who were willing to exchange grain for goods and services, and for store receipts- all because there was no banking system, no financial institutions and indeed, no treasury in the colony before 1817.

CHAPTER 4

THE COLONIAL ECONOMY IN ACTION

Introduction to Chapter 4

In Chapter 1, the commissariat was introduced as the engine driver and powerhouse of the colonial economy. However, in order to be persuasive and beneficial in this role, it had to be operationally structured. This chapter introduces the economic role of the commissariat and the benefits it provided for the colonial economy. The existence of over 12,000 productive workers in a small settlement produced many outcomes, most of which generated some form of economic activity. The commissariat's personnel had to grow to provide supervision for all these workers and it became a cycle continued – more convicts arriving in the colony led to more work to be carried out, resulting in more output and a larger GDP.

The main theme of this chapter is that the commissariat was a very important part of the colonial economy, a blend of catalyst for growth and the focal point for the survival of the settlement. As the manufacturing centre of the settlement, the commissariat was able to utilise as much of the workforce as necessary. Its biggest problem was one of maintaining a balance between meeting the demand for stores (food, materials and tools) with the need to fully, or at least optimally employ, the available convict labour.

The commissariat like any government instrumentality was closely aligned to the governor of the day, and indeed between governors, and policies would change from time to time. Policy directives would be received from the Lords of the Treasury, or the Military Commissioners of the Commissariat in London, and they would be implemented as directed or modified by the local needs. One of the advantages of being in a geographical backwater was that the closest person looking over your shoulder was 18 months away, the time taken for a report to reach London, be reviewed, responded to and then sent back to Sydney. This chapter will also track the policy changes by governors and consider the specialty areas within the commissariat such as the accounts branch and the operational management. The overall fiscal and business policies of the commissariat will be examined and reviewed and a performance evaluation determined.

Like most organisations, the commissary was run on rules and regulations – it was run 'by the book'. A significant part of Captain Arthur Phillip's planning for the First Fleet and the establishment of a new settlement was spent on arranging for supplies and provisions for the trip and the settlement. He was guided by Sir George Young's Plan regarding costs, implements, livestock, seeds, and provisions for two years.[38] Phillip's commission or instructions as to how he was to operate as the governor, included reference to purchasing stores and livestock at ports of call on the voyage to Botany Bay and the method of payment for such purchases by bills drawn on the English Treasury.

The British Treasury was always seeking ways to reduce the cost of running the colony and especially the commissary, and orders were issued that certain practices be stopped. For instance, they directed that fresh fish be used to replace imported salted meats (prior to 1818, successive governors held that the government-owned pool of livestock had not reached the level which would allow fresh meat to be sold in the colony). They also directed that there should only be limited purchases of essentials from visiting American ships and that left-over provisions arriving on convict ships should be handed over to the commissary rather than left with the shipping contractors.[69]

This chapter will explore the everyday life of the commissariat and it makes the salient point certain operating criteria and numerous parameters had been established. These included the following facts: the colony had no Treasury between 1788 and the mid-1820s and therefore relied on a variety of coinage, barter, 'spirits' and 'commissary store receipts' as a means of exchange within the settlement; the colony relied on bills of exchange drawn 'on sight' on the British Treasury to pay for imported goods; and the Colonial Financial Institutions grew in importance from crude beginnings in a way that created a solid basis to the future Treasury of the colony. Had a Treasury been imposed in 1788, it would have failed simply because it would not have been relevant to the circumstances of the early colony. This essay will present the growth of the treasury functions through the 'financial institutions'. These pre-treasury 'financial institutions' had important roles and, were 'transparent' in a limited and appropriate

[38] Sir George Young was an Admiral of the British Fleet and proposed a "Plan" setting out the many advantages from a settlement on the coast of NSW (HRNSW Vol 1 Part 2 p11)
[69] Bathurst to Macquarie HRA 1:10:147

way, and included:

1800	Gaol Fund
1801	Orphan Fund and Police Fund
1804	Commissary Store Receipts
1805	Military Chest and Official Coinage

Other financial means adopted through the commissariat, and before either the Bank of NSW or the NSW Treasury were established, included Bills of Exchange and Notes of Hand. The lack of a regularised colonial treasury created a variety of unusual, semi-privatised financial institutions in the Colony. It is these operations that this study will review and outline.

The colonial economy in NSW was purpose-built in order to support and sustain a penal colony. Like most semi-planned economies it grew like haphazardly in the directions most responsive to the needs of the settlements. Production of food was the first priority and Phillip, the first Governor, decided that the military and emancipists would use their best efforts to clear the land, plant grain and reap the harvest. Thus the system of 'cottage' industry land grants commenced. Grants of 30 acres of uncleared land were not of great significance to the colony as a whole, but they represented a good first step towards self-sufficiency as well as providing a practical solution to the severe shortage of food. Phillip arranged for his Commissary John Palmer to set the rations for the ensuing year, compute the total volume of food required and guide these small 'hobby' farmers on what crops to grow.

The commissariat grew increasingly powerful and influential as an economic planner, forward buying the stores required, mainly from British manufacturers through the Commissary-General's office in London, but also from ships visiting the Port of Sydney. Ships' captains and visiting merchants were paid by the commissary in bills drawn on the Treasury in London. Local producers were paid on a barter basis, exchanging tools, hand-made items and foodstuffs for grain, vegetables, wild game and household necessities. Most small farmers had subscribed to the early assignment system where convicts they employed were entitled to draw food rations, clothing and bedding, as well as spirits, from the commissariat whilst the farmer was left to provide some form of shelter or housing.

Thus the commissariat became the earliest financial institution. Commissariat store receipts were traded by and between farmers and townspeople until ultimately the wealthier settlers or military officers would accept store receipts at a discount to 'sell' back to the commissary or

exchange for stores and supplies. S.J. Butlin in *Foundations* writes. 'The commissariat store found itself not only selling but lending. The beginnings occurred before the practice of import for sale and expanded later undesignedly' (p45)

Other than loose coins in the pockets of the military or visiting seamen, store and payroll receipts were the Colony's first means of exchange with an assigned value. Payroll receipts came about by military personnel serving in the colony accepting a bill drawn on the Treasury for their payroll entitlements; because of the time delay in those bills reaching London and the disadvantageous discounting extracted by wealthier military officers who 'cashed' these bills for other officers, the bills were traded in the settlement as a means of exchange. The barter system also flourished as a negotiable means of exchange until spirits became the currency of the day and attained a specific value. Barter even entered into government transactions (other than through the commissary) when Macquarie bartered a permit to import 45,000 gallons of rum, free of import duties, in exchange for a three-story hospital and offices for the court officials in Macquarie Street. J.D. Lang in *'An Historical & Statistical Account of New South Wales'* (1834) describes Governor Bligh carefully inquiring into settlers' needs and, when he found that 'His Majesty's stores at that time contained almost every article that was required in a family', arranging for barter at 'a very moderate price' (P92-3).

Even before Macquarie's arrival the colony needed a bank but, in spite of Macquarie's pleading with the Secretary of the Colonies office, no permission was even indicated until 1816. Therefore, in 1817 Macquarie granted an 'illegal' charter to the subscribers to the Bank of New South Wales, from amongst who were elected officers and directors of the institution. Commissioner Bigge's attitude was that, even if it had been established illegally, there was a definite need for a local bank and he simply suggested that the British Government take steps toward legal ratification. The impact of closing the bank down would have been most disadvantageous to the commercial life and trading prospects of the colony and government funds being held in the bank would have been at risk.

King introduces the First Local Taxation

Another first in the colony was the privatisation of government accounting which began in 1802 when Governor King wished to rebuild the Sydney town gaol after a severe storm had

blown the original wooden structure away. Considering that a strong showing of local pride and stewardship was warranted, he commenced a private subscription drive among the free settlers and townsfolk. His target fell much short of the sum needed and he had to dip into the official funds, which he then reimbursed. As a secondary solution to the 'rum trade', King imposed an import duty on spirits (broadly covering wine, beer, rum, gin, port and liqueurs sourced from the British West Indies). This local source of government funding was illegal (governors had no commission to impose local taxation) but it was designed to be 'discretionary funding' for the governors, not declared to the British Treasury, which could then be used for local social improvements. Thus the 'Gaol Fund' came into being. After the completion of the gaol, King wished to retain the discretionary funding. His favourite project had become 'save the children'. Those orphans and abandoned bastard children who ran wild in the Town streets needed regular and reliable housing and feeding. On this matter he sought the advice of Samuel Marsden, the colonial chaplain cum colonial hypocrite. The solution they arrived at was the formation of a second fund, the 'Orphan Fund', accumulated from donations from the increasing import duties on spirits. They then purchased Lieutenant Kent's house on the corner of High and Bridge Streets and transferred to that establishment 80 female orphans. Marsden was appointed the 'treasurer' of the Orphan Fund, but the level of revenue provided him with too much spending power in relation to his strict needs. King had allotted a fixed percentage of the (growth) tax, without questioning the need for expenditure limits. What Marsden received, he spent!

King responded by adding additional outlets for expenditure of the import duty revenue, such as a public school system which shared the funds raised with the 'Gaol Fund', renamed the 'Police Fund'. Darcy Wentworth was then appointed treasurer of the Police Fund which was used to pay off-duty military officers for work on projects areas such as patching roads, recapturing escaped convicts, whitewashing fences and some light weekend work.

So the second stage in the growth of colonial financial institutions was covered by the privatised revenue funds, the gaol, police and orphan funds. King thought that, by handing responsibility for administering the funds to private officials, their existence would not be discovered. However, first Bligh and then Macquarie kept extending the range of impost duties being applied by adding Harbour dues, watering fees for visiting ships,

terminal/wharfage dues, the sale of farm supplies from the commissary and finally the sale of labour by the orphans and some convicts. Licenses were other revenue sources; they included licences on liquor, auctions and market stalls. Other revenue was derived from court fines and tolls. Revenue grew quickly, as did the discretionary spending by the governors, and soon the British Treasury began wondering where all this extra money was coming from. By 1810 when Macquarie arrived, the British Treasury had discovered the new local money stream and asked for an accounting. No one was too concerned about the raising of local revenue except for the legality of it. There was a threat of a governor being sued for these monies raised illegally which caused the passing of legislation through Westminster in 1819 to ratify all taxation revenues back to 1802.

The Economics of the Commissariat

As part of its structure, the commissariat provided more than 20 outlets and sub-operations, all under the guise of supporting the civil and convict establishments and providing workplaces for the growing number of convicts. This level of complexity demanded sound management practices and, the commissariat structure grew, underpinned by a growing bureaucracy and financial reporting staff. The many layers of responsibility began with the Commissary-General, supported by his Tier 2 managers (the Deputy Commissary-Generals) who were directly responsible for the purchasing, storage, distribution and issue as well as the monetary side of the operation including the financial services and banking, store receipts and accounting.

Macquarie used the commissariat to the optimum. He used commissariat purchasing to hide government expenditures which Bathurst may have classified as over-expenditure. He used the convict workplaces to underpin his building program, for these expenses were not subject to direct analysis by the Treasury officials.

This chapter also discusses the operational systems within the commissariat, commencing with its numerous activities and finishing with an analysis of the building program supported solely through its organisation.

The locally–raised money was spent mostly on practical needs which the British government would not have considered a high priority for Treasury expenditure. These local funds paid for social improvement items such as:

> Fencing burial grounds
> Survey work in the settlements
> Police services
> Firewood and oil for the gaol
> General hospital supplies

The orphan fund, some of which expenditure helped line the pockets of Rev. Samuel Marsden, had its own set of payables:

> Butcher
> Baker
> Clothing and shoes for children
> Firewood
> General supplies
> Surgeon
> Public school expenses (teachers and books)
> School supplies
> Church expenses
> Servants
> Farm expenses

Macquarie's grand plan was for an influx of free settlers and investment capital and, under his guidance, the colony positioned itself to receive them. Already whaling ships brought good business to the ports of Sydney and Hobart; the ships needed reprovisioning and often refitting, and this brought money to the small colony. The major building program which was underway in the colony made the City of London look more closely at it as an investment opportunity. After years of reading little about the colony but bad news in the English newspapers, the gentlemen of the City read of the new developments and were influenced by them. After some 30 years of existence, the colony was finally beginning to reap the benefits of overseas investment. Was it ready?

Sir George Young in his colonising 'Plan' for Botany Bay of 13 January 1785, had predicted

> *'From this (commercial) review (of the opportunities to be derived from the proposed colony) it will, I think, be acknowledged that a territory so happily situated must be superior to all others for establishing a very extensive commerce, and of consequence greatly increase our shipping and number of seamen..... With a little industry we may in the course of a few years establish a commercial mart comprehending all the articles of trade in itself and every necessity of shipping, not to mention the great probability of finding in such an immense country metals of every kind.'*

As the Macquarie years drew to an end, the colony was ready but there was still no central financial institution. It had taken until 1817 to establish the basis for the future of banking transactions which were urgently needed if trading prospects and internal growth were to be realised. Banks provided bills and discounting services for merchants and other trading companies. Settlers sought mortgage finance to buy their pastoral holdings and finance livestock purchases whilst overseas investors saw in the banks a means of ensuring the security of their transactions and investments.

One bank obviously did not satisfy the need for competition; it did not pay interest on small deposit accounts; nor did its directors understand the 'needs' of those wealthy City of London investors. The next institution to come into being was the Savings Bank of New South Wales, set up to take small deposits from individuals and pay them a rate of interest. The third step in the development of banking was to permit British banks to operate in the colony; this required a greater circulation of currency (coinage) than had hitherto before been sought by Governors King and Hunter. Here Sir Joseph Banks entered the debate, writing a pamphlet entitled '*A project for supplying New South Wales with a circulating medium*' (1805).

Governors King, Hunter and Macquarie had all requested coinage be transferred from England through the Commissary and be credited into the accounts as 'transfer of specie'. It would thus be charged to the account of the colony, even though much of the coinage would arrive back in England in the pockets of seamen and shipping agents. These three governors also tried, with little effect, to regulate monetary transactions between private individuals, their efforts resulting in the development of a commercial code relating to acceptable means of payment and legal tender, the full emergence of a 'petty banking' system (promoted by Governor Macquarie) and the growth of 'a dual monetary standard expressed in terms of currency and sterling', according to S.J. Butlin in '*Foundations*' (P51). In practice however, commercial custom built up its own code which often disregarded the governor's instructions. No notion of legal tender entered into current business practice before Macquarie arrived and it was the privilege of every seller to specify what he would receive by way of recompense for the sale. Small coinage was often specified but commonly the value was to be paid in store receipts (from the Commissariat), paymaster bills (received by the military from their paymaster and handled much the same as store receipts), or government bills which were circulating widely in the settlement, having been bought and discounted from ship's masters

trading in the Port of Sydney. The term 'sterling' covered all these methods of payment. Macquarie's arrival in the colony signalled a change in all monetary matters: as he noted that 'commerce, at the time of his arrival, was in its early dawn'[70].

The Bigge Enquiry

After being criticised by Commissioner Bigge, Macquarie, wrote to Lord Bathurst in his own defence stating:

> *'I found the colony barely emerging from infantile imbecility and suffering from various privations and disabilities; the country impenetrable 40 miles from Sydney; agriculture in a yet languishing state; commerce in its early dawn; revenue unknown; threatened by famine; distracted by faction; the public buildings in a state of dilapidation and mouldering to decay; the few roads and bridges formerly constructed rendered almost impassable; the population in general depressed by poverty; no public credit nor private confidence.... The credit of the colony was also very low on account of the base paper currency which was then the only circulating medium, the lowest and most profligate persons issuing their notes of hand in payment of goods purchased without having the means of redeeming them when due. This terrified traders and prevented them from having any regular intercourse with Port Jackson.'[71]*

Macquarie may have overstated conditions somewhat but he left his mark everywhere, particularly on the monetary system. He regarded the formation of the Bank of New South Wales as his major financial achievement and wrote that it had 'saved the colony from ruin'[72] His other contributions included regulating and restricting the issue of private promissory notes, defending the store receipt system from predatory Commissariat officers and transferring government finance from a mainly barter to a mainly cash basis. He adopted the 'holey' dollar and created the first savings bank. He could also have claimed credit for transforming government from an autocratic administration to a benevolent one. This latter achievement was perhaps the epitome of his success, and the one worthy of greatest recognition.

The final colonial financial institution to be set up was the 'fund' that serviced the military support function in the colony, and from which transfers were regularly made into the commissary and colonial funds'. In administrations after that of Macquarie, loans were made

[70] HRA 1: 10: 671

[71] Macquarie to Bathurst: HRA 1: 10: 674

[72] Macquarie to Bathurst HRA 1: 10: 676.

between the three funds and the governors often directed that funds be taken from the non-colonial fund when there was a dispute or question about whose funding responsibility the expense should be.

When he was sent to Australia to investigate and report on the Macquarie administration, Commissioner Bigge was directed to review the cost of operating the colony in terms of its original charter. It was of great concern to Lord Bathurst that the British Treasury in 1820 was still paying for so much of the colonial operations.

Bigge reviewed and commented[26] on the high number of persons still victualled from the government store as late as 1821. His third report 'The Nature of the Expenditure in the Colony' *dated* January 1823, sets out his observations, including:

> *'The clerks in the commissariat generally consist of persons who have been convicts and also of persons who are still in that condition (being ticket-of-leave individuals). They are paid variously from 18d to 60d per day, plus lodging money. They also receive the full ration, and a weekly allowance of spirits.'*

Bigge recommended[27] that, to reduce fraud on the commissariat along with the high cost to the public purse, all bread used by government facilities in the colony should be baked by a variety of contractors in lieu of convicts, and tenders should be let for contracts for the supply of bread, meat and vegetables to hospitals.

He also recommended that all meat be furnished to the King's stores from the settlers by contract at a flat rate of 5d per lb. He reported that the number of provisioned convicts was constantly changing: for instance, the total number of people provisioned from the Sydney store on 30 December 1820 was 9,326, of which 5,135 were unassigned convicts. The number of persons victualled from the public store between 1795 and 1820 were:

[26] Commissioner Bigge writes that in 1821 'the Civil list salaries amounted to £8,474.17.6 but those paid from local revenues, being the '*Police Fund*' amounted to £9,824.05.0. So it is confirmed that within 22 years of the Colony being established, it was substantially on course to paying its own way. In fact Bigge further records, 'some of the salaries included in the parliamentary estimate (the Civil List) have not been drawn in this, or in some of the preceding years but have been defrayed by the police fund of NSW, including two government school masters, six superintendents and the clerk to the judge advocate, all amounting to £500'.

[27] The Bigge Report No. 3 printed by the House of Commons in 1823.

Table 4.1: Number of people on Rations

Year	# 'On the Store'
1795	1,775
1793	1,682
1799	1,832
1800	3,545
1804	2,647
1810	5,772
1820	9,326

(Compiled from individual statistics in Vols 1-7 HRNSW) [28]

Even emancipists or free settlers who carried out special duties (e.g. police constables) became entitled to support from the stores. As Bigge's report concluded:

> *'Some rations were issued in higher allowance than decreed because of extra work or hard labour. The Government owned livestock are held at the Cow Pastures, Parramatta and Emu Plains. These facilities are operated by a Superintendent and 3 overseers, all paid by the police fund. In addition 75 convicts are employed as stockmen and general labourers. All these people in total draw 122 daily rations from the public stores. The cost of daily rations were estimated by Bigge at 4s 8d or £56 per annum, or nearly 4 (four) times the targeted cost.'*

The Commissariat as an Economic Driver

The colonial economy began on the assumption that the settlement would be operated as a penal community. The colony required no currency and therefore no treasury. Bills of Exchange would be drawn on the London Treasury for any essential. Where would any regular purchases be made, other than from passing ships? It was to be a closed economy, except for the supplies transferred directly from Britain. The centre of the penal settlement had to be the commissariat, the government store that was obliged to issue food rations for every soul in the colony. It also had on hand the tools required for land clearing, and planting vegetables, fruit trees and small areas of grain as well as stocking tools and supplies for erecting tents and make-shift buildings from local wood, building wharves and bridges, and clearing cart tracks and farmland.

Exploitation of the Colonial Farmers (suppliers to the Store) by the Commissariat

O'Brien's *Foundation of Australia* records a widespread but very unsatisfactory practice reminiscent of the early fraud and corruption displayed by the commissariat seeking quick

wealth through opportunistic measures.[14] Twenty-seven settlers in the district of Kissing Point stated, 'The difficulties and impositions the farmers in general meet with in this colony are owing to the trading party meeting with great countenance and protection'.[15]

As a result of this favouritism: 'the farmer in reality is no better off than an abject slave of the mercenary trader, whose only merit lies in extortion and chicanery'.[16] Bigge was told

> *'A farmer is obliged by the forestallers from necessity to pay 400 percent (above the original purchase price) for every article of consumption or let his land go uncultivated. The settlers of Kissing Point cited instances where the Government Store countenanced this practice. Settlers in the Parramatta district gave numerous examples of trading in essential commodities at 400 to 500 percent above the imported price'.[17]*

Mrs Macarthur wrote to a friend in England:

> *'The colony is infested with dealers, peddlers and extortioners'. Not one man among them had brought with him a penny when he came to the country, but they are now in positions of eminence and wealth and are owners of storerooms. The settlers ask if their property is their own, or is it the property of the richer men for whom the other men act as secondary agents.'[18]*

Even if the middleman is an essential part of every distribution system, super profits, extortion and monopolistic practices should not and need not be part of it. Settlers from the Prospect and Toongabbie districts told Commissioner Bigge that:

> *'...exploitation by the dealers have tended to the destruction of many settlers and their families. Under the present circumstances we can't long exist. Necessity will force us to sell our farms for the payment of our debts'.*

Why did this problem arise? As with imported provisions and supplies, resale was in the hands of monopolists whose only intention was to profiteer by the supply being tightly controlled. Settlers from Concord and Liberty Plains told Bigge of their abject poverty. The commissariat was selective in whose grain he bought and forced them to sell to these 'forestallers' or middlemen who commanded the ear of the commissary. When the settlers' need for supplies reached desperation, they would agree to sell their grain for any amount,

[14] Eris O'Brien *The Foundations of Australia –1786-1800* (1837-A & R)
[15] HRA 1: 2:135-146
[16] Elizabeth Macarthur in *Early records of the Macarthur's of Camden*-Macarthur-Onslow
[17] Evidence to Commissioner Bigge as reported in Report # 3 to House of Commons on Agriculture & Trade - 1823

even as low as 3/- per bushel. The commissariat then bought the grain for the official price of 8/- per bushel, producing handsome profits to the middlemen. The farmers' cash shortage did not end there, for they had to pay for labour, since convict workers under the 'assignment' system were not eligible for public rations. Many articles for sustenance were purchased by the rich and sold onto agents at a 200 percent profit; the agent then added a further 200-300 percent for himself before retailing the item for a combined 500 percent mark-up above the original cost. Bigge accepted that these submissions were true. What did this mean for the commissariat? It was condoning profiteering and a fraud on the settlers. It had within its powers ways and means of stopping these monopolistic predatory practices but it became an accomplice to this human misery and unnecessary suffering without good cause by refusing to purchase grain on a rational and subjective basis. Rather, by declining to buy from small settlers and forcing them to sell to 'forestallers' at prices below production costs, it pushed small settlers out of business.

Governors Hunter and King were faced with this dilemma, but thought they had no choice in the matter. However, they did have an alternative, that of following Phillip's practice of accepting that the future of the colony's food supply was in the hands of small farmers. In the early years of the colony, the 30 acre land grants enabled small farmers to produce a living income as well as filling the commissariat grain bins. In these circumstances, at least in theory, the practice of these 'consolidators' need not have taken root and flourished at great cost of the settlement. Excluding small producers by the public store was both illegal and illogical, as became evident only two years later when the store remained empty when the price disincentive affected grain production and the official price had to be raised from 8/- to 10/- per bushel. Pricing by the commissariat really needed to equate to a market price. Often small farmers could sell their produce in the open market on stalls at prices higher than offered by the commissariat. This lack of impartial treatment to small farmers is suggested in a despatch made by Lt. Grose to the Colonial Office. He wrote[19]: 'Many of the settlers consider

[18] Elizabeth Macarthur. This cynical comment does not reflect the fact that husband John, also arrived in the colony penniless and then manipulated and defrauded his way to wealth and success and employed 'front-men' like Simeon Lord, an ex-convict, to sell his wares at great and excess monopoly profit.

[19] Grose was acting administrator, between governors, and represented the worst of the military opportunism in the colony.

these small landholders to be idle worthless characters and that their own imprudencies are the cause of this misfortune.'[20]

Was this situation the fault of the commissariat? In truth the fault lay in the original policies of Governor Phillip. Governor Hunter reported to the Duke of Portland[21] that these 30 acre farms of undeveloped land were given to military officers, privates, marines, chaplains, prisoners whose time had expired, emancipists and even prisoners whose sentences had not yet expired. The need was obvious but the plan was not so valid, because the grantees did not have the capital or experience to support and sustain their ambition.

It was a further two years before the governor changed the profiteering operations of the few by directing the commissariat to allow tenders for grain supplies and accepted produce based on quality and price. Is there a contradiction between the Phillip policy and the failure of later governors to continue the small acreage farmers? Phillip governed a very small settlement – small in both size and population, with plenty of convict labour to till the soil and carry out farming practices. As the colony grew and was hemmed in by the Blue Mountains to the west, the Hawkesbury to the north, and rugged land to the south, good agricultural policy suggested that broad acre farming was more productive, even more so if concentrated in the hands of the few men with practical farming experience. The soil was more productive beyond the 'limits of location' imposed until 1813 when the first formal exploration was undertaken by the Macquarie administration. As the population numbers in the colony grew and the demand for foodstuffs expanded, the whole concept of farming practices changed. The commissariat went through a transition period during which their buying practices obviously hurt a few farmers and settlers, but they evolved into a practical and manageable system and settled down into a free market-oriented arrangement that served the commissariat and the farming community well.

The Changing Economic Role of the Commissariat
Over time Phillip increased and improved the operations of the Commissariat and planned to offset the effect of having no currency in the Colony by creating a barter economy. To aid in this plan, Phillip arranged that all goods received into the Commissariat would be recognised

[20] HRA 1:1:438

and accepted by 'store receipts'. Payment for goods arriving by ship was completed via official 'bills' drawn for payment upon presentation on the British Treasury.

By 1790 store receipts and the related official government bills formed the basis of the currency in the colony. Settlers would lodge their grain, wool or meat with the store and receive an official receipt in exchange. This became known as the 'Store Receipt system'. The receipt stated the seller's name, type and quantity of goods and the price paid. Because they were Government- backed, the receipts became increasingly popular instruments of exchange. They could be transferred between parties in payment for a debt, exchanged amongst settlers in the course of trade and for products from the Government stores, redeemed for the equivalent in coin and banknotes and, through the commissariat, exchanged for government bills drawn on the British Treasury. 'Eventually when colonial banks became established, store receipts and government bills were accepted as deposits. In these early days, a store receipt was as good as cash and for many people, a lot more convenient.' (Encyclopaedia of Australia)

The final volume of Historical Records of Victoria[23] sets out some background of what was happening in the Port Phillip colony of New South Wales:

> *'New South Wales was one of only three of the Empire's colonies established at the expense of British taxpayers. Most British colonies were begun by trading companies or settlement associations, and were expected to be self-sufficient. The British Government was usually prepared to provide a civil administration and military protection, but wherever possible, these were to be funded from local sources. The commissariat was responsible for many of the early financial arrangements in New South Wales. From the beginning, practices had been highly unsatisfactory and allowed much corruption. The first fleet brought with it in 1788 only the most meagre of supplies of coin. This shortage of a circulating currency became increasingly acute. In the short term, the government used promissory notes, government store receipts, treasury bills, spirits and shipments of coins of various denominations and currencies to which varying values were assigned. All were part of a volatile and unstable money market.'*

Prior to the departure of the First Fleet, Britain had invoked its right to tax dependent colonies. The loss of its valuable American colonies in the 1770s, previously the dumping ground for convicts, was the direct cause of this policy. The Napoleonic Wars (1793-1815) almost beggared Britain, and ruthless experiments with new taxes and duties were tried in a desperate

[21] HRA 1:1:667
[23] Volume 7 of Historic Records of Victoria – 'Public Finance of Port Phillip 1836-1840 (published 1998 by MUP)

effort to meet a growing national debt. Income tax was introduced in 1798, modified in 1805 and 1807 and discontinued in 1816. The unpopularity of direct taxation resulted in wider nets of indirect taxation, such as customs duties. The New South Wales experiment echoed some of these developments but, in Governor Gipps' opinion, 'nowhere else was so large a revenue raised from so small a population'. This opinion is borne out by the official Treasury reports of the time (refer Statistical Synopsis).

Marjorie Barnard in her major work of Australian history[24] reflects on the early workings of the commissariat and the financial dealings it facilitated:

> *'The commissariat had charge, under the Governor, of all stores and provisions. It acquired locally produced supplies, but the importation of food, clothing and other necessities from overseas was the responsibility of the home office, or in emergency, of the governor. The commissariat was the colony's store and it also became the financial centre of the colony, where all transactions were by barter or note of hand. The only note in which there could be universal faith was that issued by the commissary as a receipt for goods received into the store. This department was the proto-treasury, so that when finally a colonial treasury was set up, the commissary remained for provisioning of the convicts and only withered away at the end of transportation. Large sums could only be paid by the commissary's notes, for these alone had credit behind them, and they had to be eventually redeemed by bills on the treasury.'*

R. M. Younger writes 'The only market for produce was the government store in the various farming districts, run by the commissariat under the ultimate control of the superintendent of public works. The governor fixed the price of grain, and it was left to the storekeepers to decide whose grain should be bought and who's refused'.[73]

David Collins, former secretary to Governor Phillip wrote of this operation:

> *'The delivery of grain into the public storehouses when open for that purpose was so completely monopolised that the settlers had but few opportunities of getting full value for their crops. The ordinary settler found himself thrust out from the granary by the man whose greater opulence created greater influence. He was then driven by necessity to dispose of his grain at less than half its value. He was forced to sell it to the very man who had first driven him away and now whose influence was the only available way to get the grain into the public store.'*[74]

[24] 'Marjorie Barnard ' A History of Australia P327
[73] R.M. Younger *Australia and the Australians* (Rigby Press – 1970)
[74] David Collins *An Account of the English Colony in NSW* 2 volumes (RAHS – 1975)

Such a practice showed a fundamental weakness in the economy. Farming had to be expanded so that the community could become self-supporting but, since the demand was in fact small and inelastic and there was no exporting, a glut or a shortage could easily occur. Because of strictly limited demand the wheat acreage could not be expanded too greatly, yet when two bad years occurred consecutively, there were dangerous shortages and the colony had to revert to imports.

The commissariat provisioned a vast proportion of the population. These included those on the military and civil list and their families, convicts unassigned or working for the government and, for a period of two years only, grantees of land (both free settlers and expirees). Military officers who were assigned convicts to assist with their farming were required to clothe, feed and house them but this was not strictly enforced and in 1800 Hunter's record showed 'that 75% of the population was victualled by the government'.

The anomaly was that by 1813 a few Sydney merchants were exporting, even though the NSW Corps still dominated local business. Exporting had begun in 1801 with Simeon Lord selling coal, whale oil and sealskins to American boats visiting Sydney for the purpose of two-way trade; they brought moderately priced cargo for general sale as well as provisions and supplies for the commissariat. Robert Campbell the largest trader circumvented British support of the East India Company trade monopoly with China by using French or American ships. In 1800 Campbell built a warehouse adjacent to the wharf in Sydney from which he supplied wine, spirits, sugar, tea, coffee and tobacco and a wide range of household articles. However he was soon selling livestock, grain and merchandise to the commissariat and private buyers, with the government spending several thousand pounds with his firm each year. He then entered the whaling and sealing trade and sent a trial shipment of each to England. This caused a dispute between the East India Company on one side (pushing for exclusion), Sir Joseph Banks on the other (encouraging freedom of trade) and Simeon Lord, whose cargo had been seized in Britain as contraband.

There were also 451 head of wild cattle, which had over the previous year escaped from the holding areas. They were recovered in 1820 and used for public meat supply. In total, with slaughtered sheep and cattle from government herds, over 237,000 lb of fresh meat was

supplied at a saving of £5,000 to the government. This still left 6,000 animals in the government herd, but the settlers were increasing their pressure on the Governor to use only meat bought from them, and not use government herds for slaughtering.

The total colony expenditure in 1820 was £189,008, of which the cost of rations for troops, civil list and convicts amounted to £143,370 or 75%. Bigge did state that the general expense of erecting buildings in the Macquarie years in the colony of NSW was lessened by the use of convict labour and locally found timbers and bricks, tiles and stone made locally. He suggested that the local funds which had been used for buildings would be better spent on clothing and feeding the convicts and taking them off the public stores.

Store Receipts in Practice

Store receipts became an important medium of exchange in the early colony. Their use as a monetary alternative, by necessity rather of choice, became a common practice in the colonial economy of the Macquarie era. The commissariat would receive supplies of grain or produce from local suppliers (settlers) and offer in return the equivalent of a promissory note to pay to that settler on a certain day, in a certain amount, the face value of the note. Store receipts were a binding agreement between the settler and the commissariat, and were assignable by law at equivalent value to the face value of the note. Upon presentment to the Commissary it could be exchange for goods, a bill of exchange or a limited amount of the sterling that was circulating in the colony.

A strong supporter (superficially at least) of store receipts was the Assistant Commissary in VDL, Frank Drennan, except he was manipulating and defrauding the system rather than working to enhance it. Drennan appeared to be concerned merely with the perception that the commissariat had lost the treasury function of the colony. He had no valid criticism of store the receipts system, the widespread use of which assisted the commissary in completing local purchases. Few settlers wanted to be burdened with a bill drawn on London and which was heavily discounted in the colony (up to 12% discount rate). This practice would have encouraged private trading of grain and produce and less store provisions to meet the commissariat's ration obligations.

The cashier of the Bank of NSW provided the Colonial Secretary (J. T. Campbell[35]) with the information that the Bank (and therefore the colony) had less than £6,500 in coinage and specie. Anticipating some official criticism against the Bank, which was due to have its charter renewed (if not validated) in the following year, the cashier announced that the bank would trim discount rates on store receipts to less than 2%. Naturally the bank wished to make public that Drennan had personally endorsed to it notes of approximately £14,000. Macquarie entered the dispute directly and announced on 8 February 1819 that store receipts were no longer to be issued and would lose their status as legal tender in the colony. Any outstanding store receipts would be cashed (without discount) by the commissary in Sydney.[36] Rather cynically, the order was signed on behalf of the governor by H.C. Antill (Major of the NSW Brigade), who was also a director of the bank.

Written instructions always overwhelmed the commissary. There could well have been one clerical assistant directed to read, understand, file and then index the maze of communications received from all quarters. Operating instructions were received on every topic imaginable: for example, a summary of proposed operations, instructions for record keeping, instructions on transmission of accounts and vouchers, general instructions to the commissary, Commissary regulations and Acts of Parliament, instructions to Palmer from London, administration to be carried out by the Commissary, the new system of requisitioning supplies, economies to be made in Commissary, new arrangements for operating the commissariat, reports on the condition of the commissariat, the condition of the Colony (including assessment of the commissariat by Macquarie), instructions for receiving grain into store, and instructions on staffing of the commissariat.[37]

The volume of written directives was obviously enormous and included instructions on coinage and currency, issuing store receipts, numerous accounting policies and procedures (such as classification of expenditure), preparation of returns and the record books to be kept by the commissary; other clerical procedures provided included inventory control; and accounts at the various banks (the commissariat was encouraged to share its business between

[35] Campbell had been Macquarie's principal private secretary until given leave of absence to form and administer the new Bank of NSW in 1817. Upon his return he was appointed as Colonial Secretary but still had close connections with the Bank and its principals.

[37] Barnard makes this same point in *A History of Australia p.*368

each of the banks in operation). Inventory control included keeping records of what goods were in the store and on hand each year. This return was related to the return of settlers in the colony and those victualled by the commissary. A ration for each group was computed against the stocks on hand so that at any time the commissary-general could advise the governor that so many days or weeks of rations were on hand. With ships so irregular in their arrival, the instructions were that on average a six months supply of rations would be on hand. Even when the imported foodstuffs were less relied upon, droughts, floods, and other natural disasters were frequent and damaging. Weights and measures were also important, as were the regulations for requisitioning medical supplies. As the commissariat grew and merchants and traders became 'tenderers for supplies and provisions', the commissary organised ways of securing the best terms and conditions by entering into multi-year contracts.[38]

The Economic Impact of the Commissariat on the Colony

An unauthorised but important role of the commissariat came about by default. Governors King and Macquarie refined and expanded the role of the commissariat into economic and fiscal policy, and allowed it to exercise a growing economic function in the new colony. In this respect the commissariat became an influence and a driver of the colonial economy, before changing its role to become treasury and ultimately colonial banker.

Butlin, N.G. explains in his WPEH # 32 ('what a way to run an Empire, Fiscally!') that:

> *'...forms for commissariat accounts for NSW survive from 1791 but relate only to those transactions that could be described as net cash transactions (including bills), originating in the settlement. They failed to disclose the gross cash or barter transactions and, in addition, they were highly condensed and unrevealing summaries, covering various periods of account. They were often made a long time after the period to which they referred and were audited after much longer delays.'*

Butlin is indicating that the figures are unreliable and often misleading. There were quite dramatic fluctuations in commissariat revenue and expenditures and they led to economic fluctuations. Butlin tells us:

> *'...as the authority responsible for penal affairs, the commissary was an important consumer of supplies until 1840. There were quite wild fluctuations in supplies purchases. This influence was destabilising rather than encouraging of economic*

[38] John Palmer in the Instructions he carried back to the Colony in 1812, was authorised to enter into on-going contracts for local purchases of grain and provisions of vegetables

activity, although after 1840 the commissary's lack of purchasing added a further deflationary role in an already depressed economy.'

By 1850, the commissariat was irrelevant as a purchaser in NSW and, as Butlin points out:

> *'...the fiscal function of the commissary from 1822, was to account for the British Military establishment, but by the mid-1820s, the military expenditure was often more substantial than the supplies. Military costs rose strongly between 1822 and reached a peal in 1836, a rise not consistent with either convict population or inflows. The growth in military expenditures kept pace approximately with the rise in GDP, although there was no direct association'.*

The economic importance of the commissariat is as a contributor to economic development.

The Commissariat as an Economic Driver of the Colonial Economy

The traditional thinking is that the pastoral industry was the primary and most important economic driver between 1788 and 1856. However, there were two non-traditional drivers of the colonial economy that have not been fully recognised, the commissary and the banking and financial institutions.

Why was the commissariat such an important vehicle for economic growth in the colony? Until 1830 it was central to the privatisation of the settlements, the concentration of wealth and income and the development of large private enterprises which led to the success of colonial economic development. The potential for the commissariat's operations to benefit private rather than public interest was substantial[1; Phillip] identified theft while King identified beneficial pricing and kickbacks and fraudulent recording[2]. Bligh did not observe malpractice, mainly because he was involved in it himself[3;] he was accused of massive use of the commissariat for his personal benefit by his use of convicts, supplies and tools from the store on his personal farms. It took eight years for Administrator Foveaux was found in possession of public monies. Commissary officers were always suspect and John Palmer, for a long time a pillar of the commissariat administration, ran a substantial biscuit-making enterprise by drawing wheat, flour and sugar from the store. Palmer was a purser when he arrived in NSW, but he quickly became wealthy enough to be given a substantial land grant at Woolloomooloo

[1] HRA 1:1:144
[2] HRA 1:3:474
[3] HRA 1:6:338

Bay where he built a prestigious house and a mill for grinding grain on behalf of the commissariat.

Such matters, were trivial and of minor interest to the administration but they do explain the relative importance of the store as a key component of colonial economic operations. The commissariat contributed to the economy, not only through it preference for buying local production and agricultural products, but also by deciding where and how local supplies were to be made. For instance, the commissary decided whether an item should be made by convicts in the Lumber Yard purchased from a small operator running a 'cottage industry'.

As well as being involved in the purchasing and storage of supplies both from local and overseas sources, the commissariat also became the means for paying supplementary allowances to officials, compensating persons for performing public services for which no British appropriation existed, or totally funding other public services. In addition, through rations distribution, the commissariat effectively paid workers engaged in convict gangs on public infrastructure. It also distributed all building supplies. Butlin claims, 'This last role was, at times, so far extended that they acted to subvert regulations and provide devices for arranging, through barter deals, access to land occupation by persons while still under sentence'[4].

All these activities would imply that the commissariat in the colony of NSW was a complex public institution, but it was more than that. It was a comprehensive economic performer which inserted goods and services into the colony, purchased goods and services from the colony and acted as the first banking institution in the colony. Its role was complex and comprehensive and its importance cannot be overstated. The commissariat had great influence over and upon the colonial economy from the first day of settlement until the day the last convict was handed over to public authorities after 1856. It processed million of pounds, and served numerous masters – the British Treasury, the Military Stores, the Colonial Governors and even the Orphan and Police Funds through the military funds advances made to keep the colonial treasury afloat.

[4] Butlin, N.G. *Forming a Colonial Economy* p.65

In summary, the commissariat operated over 20 locations and 'businesses', directly employing 7180 convicts and generating over £500,000 in pro *forma* income into the economy. Between 1800 and 1820, it expended over £80,000 each year on victualling and stores. The unvalued output of convict labour has been estimated at over £200,000 per annum [6]; using a multiplier effect of 4, the total gross product of the commissariat would have been over £3 million annually. It participated in many aspects of colonial life and actively supported economic development. This level of activity outperformed all other economic drivers before the advent of the colonial railway systems and the discovery off gold in the 1850s. The commissariat's efforts as an economic driver included participating in the public works program, the Land Board Program, the Banking and Financial Institutions program and the transportation labour utilisation program and it impacted on every facet of the colonial economy.

A variety of entrepreneurs was able to benefit from aspects of the colonial economy. The colony had settled into a pattern which supported and even encouraged entrepreneurs and scoundrels – in 1799 Ensign Bond reported that officers performed practices which allowed them to accumulate large fortunes. They purchased articles from visiting ships and sold them to a very great advantage. Rum and brandy, which cost 10/- per gallon, are sold to other soldiers and convicts from 20 to 25s per quart bottle. They have the labour of the convicts *gratis*, and for every bushel of wheat they place in the stores, they receive ten shillings and for every pound of fresh pork, 1s. Every officer is allowed a hundred acres of land, which with the sale of merchandise produces a very considerable yearly income.' [7]

Concealed within the commissary expenditures is an important issue – public capital formation. Construction activity is delineated in the colonial fund where 'construction', including works and surveys, grew rapidly from 1822 to 1840. According to the outlays which peaked in 1838, construction rose about 12-fold, far more rapidly than GDP. As the 1840s slump developed, these construction outlays were slashed to a quarter of their boom level and only partially recovered thereafter. Penal construction however must to be separated from other public works. The colonial fund expenditures did not include the other 'convict' expense of public land clearing where crown land was cleared for resale, but the resale price included an allowance for the land having been cleared. Therefore, it cannot be assumed that

[7] This letter from Ensign G. Bond is recorded in Crowley *Colonial Australia* 1788-1840

all commissary expenditure can be allocated to convict labour on penal construction, works or the maintenance of convicts, nor can it be assumed, suggests Butlin, that all supplies from Britain were invoiced to either the colonial fund or to the commissariat. The available figures would suggest that many items of outlay slipped through the cracks and were charged to the British Treasury without being on-charged against colonial NSW expenditures. Governor Bligh's administration was charged by '*An Epitome of Official History of NSW*' (1876) with 'seeking to establish a very limited coalition with commissariat and limit the access of the military-civil complex to the benefits of the commissary, although he, himself, misused and manipulated the commissariat to his own advantage'. Bligh's immediate concern here was that there appeared to be more ex-convicts than there were current convicts. He thought this increase eroded the security of the supply of labour and of the military-civil complex and he wanted the change to be a source of support from ex-convict farmers. He considered that these emancipist farmers rarely became successful, mainly because Britain had failed to deliver to the colony any convicts with farming experience.

Monetary Reform

The arrival of Macquarie at the end of 1809 marked the beginning of a new stage of development in the colony's monetary affairs. At the end of his administration in 1822, he wrote:

> '*I found the colony barely emerging from infantile imbecility and suffering from various privations and disabilities; commerce in its early dawn, revenue unknown, threatened by famine, the public buildings in a state of dilapidation and mouldering to decay, the few roads and bridges almost impassable, no public credit or private confidence, the population depressed by poverty*'.[21]

Fixing this situation then became the focus of the Macquarie agenda which included monetary reform and the development of a reliable colonial currency. His first plan for radical was a scheme for a government bank and, when it was disapproved in England, he turned to the use of regulation to replace the various and disreputable private note issues by importing dollars which he tried to keep in the colony by stamping them as 'holey' dollars. He also limited private note issues and ensured their issue in terms of 'sterling'. When all these efforts failed, he returned to his original scheme and manipulated the formation of the Bank of NSW.

[21] HRA 1:8:220 Macquarie to Bathurst

Macquarie's monetary reforms were usually entrusted to a group of wealthy local entrepreneurs, as he did with this illegally chartered bank and his land grants, which were restricted to moneyed persons with at least £500 in capital. This placing of key aspects of economic development in the hands of a relatively few capitalists was immediately attacked by Commissioner Bigge who, after listening to the argument of John Macarthur, a 'capitalist' not in the close group of Macquarie patriots, decided that this hand-over of favours to a small group was not in the best interests of the British Government and promptly declared the Bank of NSW to be outside government responsibility which meant that all liability rested on the hands of the directors and stockholders. This was contrary to the initial undertaking given by Macquarie, and he had to argue persuasively that this undermining of the Bank's position would lead to ruin for the colony. Bigge amended his stance and declared that the liability on the directors and stockholders would terminate when (and if) the British government ratified the charter of the Bank; Macquarie accepted this compromise.

These makeshift expedients to provide for payments between government and individuals and between individuals merged into a pattern of fiscal policies suitable for a gaol and later a free society. The gaol depended for its food supply on private enterprise and required a valid payment method between the buyer (the commissariat) and the seller (the farmer). Macquarie had initially thought a 'government' bank would fill the need, but during the next six years between 1810 and 1816), he was influenced by the growing involvement of free enterprise and influential entrepreneurs – the Macarthurs, Samuel Marsden, Simeon Lord, William Redfern, Darcy Wentworth and Robert Campbell. Macquarie was supported by a small body of government officials led by J.T. Campbell who were permitted to engage in large-scale private agricultural and manufacturing ventures and had access to a large number of convict labourers. At the core of these emerging commercial gentry was the commissariat store, with its Treasury bills for public and private external payments, its store receipts, and its loans in kind. The store receipts were supplemented by barter and private note issues, which were also used for other local commercial transactions.

This widening use of store receipts and their absorption into the banking transactions of the Bank of NSW was the main component of economic growth between 1810 and 1820. Another element of economic development came about as a result of Macquarie's policy of official

transition from public to free enterprise, penal to free society. He intended to implement this transition by moving manufacturing from the commissariat to the private sector, effectively privatising banking and financial transactions throughout the colony, as well as encouraging

the immigration of free settlers with capital and opening up large tracts of agricultural land to these new investors. He was hindered by the continuation and stepped up activity under the transportation program, which placed even more onerous duties and responsibilities on the commissariat. More convicts meant more food, stores and produce; more convicts meant more planning for using them effectively with minimal financial outlay, and that is where the Macquarie policies excelled. It was only the British Government (mainly the Treasury) which did not recognise the thought and sacrifice extended by its official representative in the colony. Macquarie planned for many activities, services and coordinated by the commissariat, all the while expanding its role. The Macquarie vision sought full utilisation of the 'free' labour in the colony, the optimised usage of the natural resources and an identifiable output on which the British Treasury was not prepared to place a value. These activities included land clearing, road making, timber harvesting, light manufacturing for import replacement and creating the building materials for public infrastructure; all these tasks were carried out by 'convict' labour. It was a circular plan of using the 'free' labour for every purpose consistent with a settlement in transition, and thus creating the ability to enlarge the settlement. The public building program was as meaningful to lift the spirits and improve the attitudes of existing residents, as it was to attract new residents. Macquarie was an asset builder but this was not recognised by the British Treasury which sought to control costs and gave no value to use of official funds. He was often able to use his powers of persuasion but, when this let him down, he was quite ready to resort to authoritarian methods and they worked too. In the first months of his administration, he achieved most of what he set out to change and he proudly reported: [22]

> *'The population in 1810 was 11590 but by 1821 it had grown to 38,778. Horned cattle had increased from 12,442 to 103,000 and sheep from 25,900 to 290,000, and land under tillage from 7,600 to 32,270 acres' He found a settlement in 1810 but in 1821 had left a widespread and diversified colony. By every measure economic growth had improved, the people were of a happier disposition; there were two towns when he arrived but many more when he left and 300 miles of roads, many bridges, culverts and flood mitigation works had been completed. The area penetrated grew from 2,500 square miles to 100,000 square miles. Macquarie declared that his greatest satisfaction lay in the knowledge his policies had been based on humanity.*[23]

[22] HRA 1:8:223 Macquarie to Bathurst
[23] HRA 1:8:223 Macquarie to Bathurst

Creating a Banking Scenario

The specific intention of forming a colonial bank was firmly in Macquarie's mind by the time he arrived in the colony. During his passage to Botany Bay in 1809, he had personally witnessed the impressive results of the 'Cape Bank', when he met with the governor of the Cape Colony.

Governor Macquarie had been briefed well prior to his departure from Britain and he arrived in the colony in 1810 with a plan. Macquarie was always seeking to make his mark in the history of the colony and he planned to form a real bank in Sydney before the completion of his first year – he would name it 'The New South Wales Loan Bank[24].' In introducing this proposal, he reported on the 'problems of the colonial currency' and referred to:

> *'...one circumstance that requires serious attention – due to the lack of legal currency or specie of any denomination, the people have been forced to find a substitute for real money, and petty banking has thrown itself open to fraud and impositions of a most grievous nature to the country at large. The persons principally involved are of the lowest order, and not infrequently the convicts themselves. Notes of Hand of these wretches pass into circulation as if they are guaranteed securities. When sufficient numbers have been passed into circulation, then the issuers become insolvent as a means of defrauding their creditors. The growth of the territory and its commercial pursuits are very much impeded by the lack of some adequately secured circulating medium'.*

At this point Macquarie proposed the establishment of a Government Colonial Bank.[25]

When Marion Phillips described Macquarie as 'a man of very ordinary ability'[26], she was overlooking the role he played in economic development within the colony. Possibly, from a blinkered historical viewpoint, there was nothing special about Macquarie but, from the viewpoint of an economic historian, his 10 years of government service in the colony, was replete with major accomplishments of an economic nature and he became the catalyst missing from other administrations both before and after[27].

[24] HRA 1:7:265 Macquarie to Castlereagh
[25] HRA 1:7:264
[26] Phillips, Marion *A Colonial Aristocracy*
[27] Macquarie's major accomplishments were (a) the exploration successes he sponsored & encouraged and which opened up the vast pastoral lands west south and north of the main ranges east of Sydney, (b) the construction program and the public capital formation, (c) the transfer of manufacturing from the public to the private sector and the encouragement of free enterprise and local entrepreneurs

When the idea for a local bank was firmly disapproved in England, he turned to 'vain efforts to regulate suppress or replace the multifarious and disreputable private note issues'[28.] By 1817, two divergent attempts were underway to introduce different mediums of exchange. Private Banks played a leading role in the development of the NSW economy in the 1820s and 1830s but their establishment did not completely fill the colony's financing needs, and the niche agricultural finance market was supported by the rise of specialty finance and loan companies.

Table 4.2: The First Colonial Banks and Finance Companies

Year	Banks	Finance Companies
1817	Bank of NSW	
1819	NSW Savings Bank	Waterloo Coy
1823	Bank of VDL	The Loan Coy
1826	Tasmanian Bank	The Trust Coy
1826	Bank of Australia	Aberdeen Loan Co
1827	Derwent Bank	Brit. Colonial Loan Co
1828	Cornwall Bank	Australian Trust Co
1834	Comml Bankg Co.	Scottish-Aust Inv Co
1834	Sydney Bank	Scottish Loan Co
1835	Bank of Australasia	
1835	Bathurst Bank	
1836	Bank of SA	
1837	Union Bank	

The formation of the first bank, the Bank of NSW, in 1817 had no great immediate impact on the colonial economy. Its note issue was small, never rivalling those the commissariat made at this period. It made little impression on the private note issues, which suffered more from commissariat competition and note issues and later the dollars which replaced the commissariat notes after 1822. Its loans were modest and, once a second bank appeared in Sydney (the Bank of Australia), it fell to a junior position and was not to regain any prominence until after 1856.[29]

On 17 July 1819, the New South Wales Savings Bank opened for business in Sydney, Parramatta, Liverpool and Windsor. It originated at a meeting at the General Hospital on Macquarie Street chaired by Governor Macquarie.

2 [8] Butlin *Foundations* p.7
2 [9] Butlin *Foundations* p.7

British capital was the financial basis of the boom in the early 1830s and it led to the formation of new banks. New capital formation was reliant on wool business rather than interest-bearing deposits. 'Only as the boom reached its turbulent crest was there a flurry of colonial bank formations which were only just able to survive the inevitable crash that followed in 1841-43'.[30]

The advent of a series of English banks on the Sydney market brought about the rapid growth of a modernised foreign exchange market, primarily operated by these English banks but, more importantly, outside and independent of the Commissariat. Foreign exchange had originally been the specialty and sole province of the commissariat since it had handled nearly all the bills drawn on English trading houses. However, apart from the Bank of NSW, most banks were British-owned or managed and their growth rested largely on British deposits, and depositors using their London branches to transfer currency and funds from London to the colony. Thus foreign currency transfers, and profits from foreign exchange transactions, became important to the private banking institutions. They were independent of the commissariat and to its detriment.

Table 4.3: Colonial Government Financial Institutions 1800-1825

>The 1800 Gaol Fund
>The 1801 the Female Orphan Fund
>The 1801 Police Fund (a successor, by name change, to the Gaol Fund)
>The 1804 Store Receipts (issued and collected by the Commissariat)
>The 1805 Military Chest (controlled by the Commissariat)
>The Official Coinage of 1805 (held by the Commissariat)
>Commissariat Bills of Exchange
>Notes of Hand (often 'accepted' and converted before 1817)
>The Bank of NSW in 1817
>The Auditor-General's Office (created by William Lithgow in 1825)
>The Treasury of NSW (in 1825, under the Colonial Treasurer)

The lack of a regularised Colonial Treasury before 1825 created a variety of unusual and semi-privatised financial arrangements in the colony, underpinned by the arrival of a growing number of convicts in need of commissariat assistance. Being purpose built, the colonial economy was sustained as a penal operation without the need for banking facilities until Macquarie's arrival. He encouraged private enterprise and a free society to run parallel,

[30] Butlin *Foundations* p.10

incorporating the penal side of the industrial and commercial governance of the colony. It was Macquarie who decided that the growing complexity of commercial transactions deserved an orderly financial mechanism and, without proper British authority, he created a private bank to assume the financial role formerly adopted by the commissariat – discounting of bills, acceptance of personal notes, cashing of payroll bills and exchanging of store receipts. This was merely the start of a major push for a financial industry in the colony; it was to oversee a series of booms and busts before settling into a market economy, strategically outside any direct government intervention. Even Governor Gipps appeared powerless to persuade the banks to change their practices to avoid the great depression of 1841-1843 although, of course, he did not help his own cause when he personally locked horns with the Legislative Council. However, due to external influences, there was probably little Gipps or the banks could have done to delay the inevitable depression of 1841 which followed the boom times of the mid-to –late 1830s.

Shortly after Palmer's reappointment, a second set of instructions was issued by Governor King to Palmer, indicating the manner in which the commissariat was to be operated. The third governor who tried to revise the commissariat operations (after Phillip and King) was Macquarie who set down detailed notes on how he proposed to make the it more efficient, in order to 'meet the needs of a growing population', and be more responsible to the governor.[50] Macquarie was in a particularly good position to review the commissariat; he was a visionary who saw the potential for the colony – a large population, self-sufficient and an attractive town with central government. In particular, he wished to ensure that his building program could be launched early in his term and carried out successfully. To this end, he established a new form of selective service for convicts, organised into work gangs with specific targets, and reorganised the Lumber Yard which was to be the engine of the colonial economy between 1813 and 1823. Secretary of State Liverpool set the pace for the Macquarie reforms in this direction by advising his governor:

> '...in consequence of a new arrangement of the new Commissariat department of the Colony, formed under the directions of the Lords Commissioners of the Treasury, the whole of the Establishment has been omitted from the Estimate (appropriation) for the current year. You will receive in due time either from me

[50] Macquarie to Bathurst HRA 1:9:73

or from their Lordships a communication upon this subject with further instructions thereupon'.[75]

Macquarie could read the writing between the lines: the Earl of Liverpool was on a cost cutting exercise and wanted to trim commissariat expenditure. Macquarie jumped into the fray by trimming rations for every person victualled by the commissariat, extending the working day, expanding the government farms and planning for more imported livestock. Liverpool's letter to Macquarie also referred to the dramatic increase in the amount of bills drawn on the Treasury from New South Wales.

Summary of Chapter 4

The colonial economy, of which the commissariat is just one aspect, was the backbone of the settlement. Its development was driven by growth in population, government services, manufacturing industry and communications and the maturing of the pastoral industry. Life was never meant to be simple but during the Macquarie Administrations many factors improved the quality of life for settlers, and the commissariat was always on hand to assist in new enterprises.

Economic and planning directives were received by governors from a variety of sources. The commissariat was overseen by the Military officials of the Commissariat division; the governors were overseen by the Secretary of State's office for Colonies; the appropriations for the colony were overseen by the Lords of the Treasury, and after the *Blue Books* were commenced, the whole British parliament oversaw the activities in the colony. The commissariat was one of 7 economic drivers of the colony, each of which had its own role and importance but integrated and coordinated by the governors offered a rich and rewarding period of economic growth and development. A most successful series of outcomes were achieved in terms of growth of GDP as is evidenced from the statistics and explanations contained in Appendix A to this study.

[75] Liverpool to Macquarie HRA 1:10:148

CHAPTER 5

COMMISSARIAT OUTPUT, PRODUCTION
AND BUSINESS ENTERPRISES

Introduction to Chapter 5

Not surprisingly, and probably by default rather than intentional policy, the commissariat became the prime producer of materials and supplies used within the colony. Out of necessity, the demand for timber products, bricks, tiles, stones, rude furnishings and carts needed to be and could be supplied locally. There was a need for local building materials, based on the length of time it would take to order and receive supplies from Britain, as well as the urgency of building accommodation for military and civil personnel, a secure storehouse and essential infrastructure, such as wharves, bridges, and housing for both settlers and convicts. Suitable local materials had been identified including good clay deposits for brick and tile manufacturing and grain was being produced which was suitable for liquor production. All that was needed was labour and basic equipment. Thus the government business enterprises were assigned as a responsibility of the commissariat and, in conjunction with the Superintendent of Convicts, commissariat personnel planned for equipment, materials, transport and the provisioning of remote convict camps.

These commissariat business enterprises covered a great deal of activity ranging from the making of bricks and tiles, basic forged tools, slops (clothing), shoes, furniture and timber frames for buildings to timber felling camps, vegetable and meat production, abattoirs, boat building, provisioning visiting ships and stevedoring. In addition, convicts were organised into gangs to clear land and build cart tracks. A ferry service was established to cross the harbour from north to south and by river between the Sydney and Parramatta settlements.

The commissariat was not only about producing goods; it also became responsible for business services and a means of exchange was created by way of barter of store receipts, negotiated payroll bills and consolidated bills for remittance overseas. Thus a foreign exchange facility was also created, and it became a catalyst for a local free market for agricultural products for settlers and emancipists.

Location, Location.

Early maps show the location of the various commissariat stores, warehouses and operating facilities. The Commissary even went to the Castle Hill area, to find the best trees to harvest and drag to the Lane Cove River for transport to the Lumber Yard by water. The largest of the government's initial garden plots (adjacent to the First Settlement) was immediately to the south-east of the 'Governor's 'mansion', facing South Harbour; whilst a further four smaller plots were located on either side of the Sydney Cove, obviously to use fresh water from the 'spring' (or Tank Stream) which into the Harbour there. The Commissariat was responsible for the planting and encouragement of these gardens which were originally intended to supply grain and fresh vegetables for the settlement. Phillip planted fruit trees were planted on 'Garden Island', the most fertile location within the original settlement. The Government Farms, which replaced these small gardens, were eventually located in the most fertile areas of the outer settlement.

The first store was a canvas tent located on the east side of the Cove adjacent to the governor's temporary dwelling, a prefabricated house, brought in pieces with the First Fleet. A second store for baled goods was erected, also under canvas, was located on the west side of the Cove adjacent to the military camp. Collins records [1] that by May 1788 a 'large store-house had been completed, and a road made to it from the wharf on the west side [of the Cove], and the provisions were directed to be landed from the victuallers, and proper gangs of convicts were placed to roll them into the store'

Amongst the convicts, some trades-people had been located – a bricklayer [2] led a convict team and a number of huts grew up in different parts of the area cleared for this purpose. 'Carpenters were now employed in covering in that necessary building [the Hospital], the shingles [3] for the purpose being all prepared; these were fastened to the roof [which was very strong] by pegs made by the female convicts.'

[1] David Collins: *Account of the English Colony in New South Wales – Vol 1*
[2] The first experienced brick-maker was put to work by Phillip in charge of the new brickworks (the second such facility) at Rose Hill, and recorded manufacturing 30,000 bricks in a week.
[3] Shingles were still preferred over tiles. The tiles being made at Rose Hill had not been perfected and failed in any strong winds or a hail storm

By July 1788, further land had been set aside for a larger storehouse[4] the first step in Phillip's contribution to town planning. A series of grids was laid on a scale map designating roads and sections for the military section, housing for civil officers, courthouse, hospital and government offices as well as the governor's residence. This new store location was on the west side of the Cove, between the proposed hospital and church. By this time the Parramatta settlement had been commenced and it also included provision for a storehouse. By 1792, the maps show streets with appropriate names such as 'Back Row, Chapel Row. Pitts Row and Barrack Row. High Street was prominently located and in 1812 it was renamed as George Street. These early Phillip-designated names remained in existence until Macquarie rewrote the street names in 1812 naming, them after former governors (Phillip, Hunter, King and Bligh Streets), prominent Secretaries of State for the Colonies (such as Castlereagh and Pitt Streets) and Kings and Queens (George and Elizabeth Streets). The 1822 Greenway map showed that the Government storehouses were built where Phillip had originally planned, but the church was replaced by the county gaol. A second Government store was also shown as a 'log cabin' type building on the east side of the Cove. This may well have housed dried provisions of a longer-term nature and some of the stores designated for the Governor. This facility became known as the 'dry-store', so named to differentiate the facility from the grain stores and the perishables store (fruit and vegetables).

By 1802, the map shows the majority of development had taken place on the western side of the Cove with and a large area set aside for the commissariat Dockyard, adjacent to the wharf, which in turn was adjacent to another new brick store. These buildings and establishments fronted High Street north, which ran parallel to the Tank Stream. Robert Campbell, whose home and large warehouses were located at the top end of High Street, had encouraged the governor to make High Street a prominent retail and factory thoroughfare. It took a further eight years, until the arrival of Macquarie, for further developments to take place. Macquarie changed the name of High Street to George Street, and located the 'Convict Factory' on the corner of George and Bridge Streets. This 'convict factory' was renamed and became the 'Lumber Yard'. The *Sydney Gazette* had made much of the poorly named Female Factory in Parramatta, and the resulting disrespect

[4] This second storehouse was to be constructed of brick and be adjacent to Sydney Cove in order to hasten the unloading of ships and protect the imported stores from theft. This was to be the first two-storey building in the colony, and made from a stone foundation with a brick elevation and timber flooring

shown to its occupants. The 1807 'Plan of the Town of Sydney' by James Meehan, confirmed this status quo, as did the 1808 plan prepared for Governor Bligh.

By 1811 Campbell had built a substantial store and wharf further around Sydney Cove, from the 'Hospital' Wharf, and John Cadman's cottage. The main wharves were The 'Government Wharf' on the south side of the Cove and the Governor's Wharf on the east side of the Cove, giving access to the Domain and Government House. The 'Hospital Wharf' was initially used to unload supplies for the hospital but it became the main wharf for the new three-storey commissariat-built brick and stone store adjacent to Sydney Cove. By 1821, the Dockyard had expanded to the south and was given direct access to the Kings Wharf (the renamed Hospital Wharf, originally called the Public Wharf).

The Lumber Yard was shown as occupying the 3 acres on the corner of George and Bridge Streets, running down to the Tank Stream, which was marked on the 1821 map as being, 'dry at ½ ebb'. Macquarie had also completed the straightening of the town roads and the removal of encroaching houses from the road reserves. By this time too most of the windmills had been removed as Macquarie considered them an eyesore on the landscape. In addition to the Dockyard and Lumber Yard, the commissariat controlled a third area for stonecutters, located in the main and largest quarry on the west side of George Street North directly opposite the commissariat store. This quarry, worked by a convict gang, supplied most of the sandstone blocks used in early colonial buildings, especially those commissioned by the team of Macquarie and Greenway. This first quarry was not large enough to supply the entire requirement for sandstone and two more quarries were opened on Bennelong Point and off Farm Cove, east of the (Governor's) Domain [5]

Organisation of Government Business Enterprises.

Under the guise of controlling the activities and rehabilitation of convicts Macquarie decided that, rather than placing all convicts on assignment and thereby removing any financial

[5] Many original names changed by being abbreviated over the years. The Governor's Domain changed to Government Domain and was then shortened to The Domain, whilst Semi-Circular Quay was shortened to Circular Quay. The Botanic Gardens was part of the Domain and became the public vegetable patch for Macquarie Street residents before being converted into a horticultural museum

obligation for their maintenance, a percentage could be put to work on behalf of the government. This would be accomplished in two ways.

Firstly, direct convict labour, rather than the preferred contractor program, would be used for infrastructure development and other public works programs, specifically government building. So there became a great concentration of convicts in Sydney, employed in two big workshops, the Lumber-Yard and the Timber-Yard. Both were located on George Street, together with the stone-yard (across from the Lumber-Yard) and the three-storey commissariat store, wharf and Dockyard, fronting the western side of Sydney Cove. The convicts worked on a task or piece system. In the Lumber Yard, surrounded by an 8 foot high brick wall, for security purposes, forges were used for making nails, hinges, wheel irons and other metal products.

Secondly, other 'sections' were set aside around the outside walls of the factory for boot-making, cabinet and furniture-making, barrel making, and the making of coarse wool and cotton for slops and hats. In the centre of the large factory the two saw pits were manned by up to 25 men, who cut the timber taken from the kiln after the drying process. In the timber yards, beams and floor-boards were sawn and prepared from the timber drawn from the Lumber-yard. The brick and tile yard was built around a huge kiln (22 ft long by 18 ft high) producing 24,000 bricks at one raking. The stone-yard not only produced large building blocks from stone but also flagstones, hearth-stones and mantelpieces. Within the Lumber-Yard, were stored all the tools required for the various business enterprises and for each work site. Each item was recorded going out and coming in while all materials – both raw material and finished product – were recorded equally carefully at the clerk's office located at the main gate. The Superintendent of Convicts, Major Ovens had set a piece work productivity rate; for instance, the shoemaker's gang of about eight men was supposed to produce a pair of shoes per man per day from leather tanned at the government factory at Cawdor and the brass-foundry and the tailors' gang each had their own production goals. The carpenter's gang was usually of 50 men, made up of cabinet-makers, turners and shinglers; the bricklayers' gang generally of between five and ten men who were expected to lay 4,500 bricks each week; the sawyers gang was usually 25 men. Other gangs based in the lumber yard were also sent out to garden, cut grass, dig foundations, and carry grain. The lumber yard was responsible for over

2,000 men in all. The government business enterprises were comprehensive and massive undertakings, and Macquarie took pride in their output and accomplishments.

Manufacturing is only part of the story in any study of economic development of the period. Economic development drove public finance in the same way that the growth in population, farming, decentralisation and land utilisation impacted on the source and use of public funds.

Other factors to be considered are that the commissariat established multiple stores and supplied foodstuffs and materials (at government expense) for convicts as well as civilian and military personnel and the commissariat also established work centres for convicts:

The Lumber Yard	Timber-Cutting camps
The Timber Yard	Land Clearing camps
The Dockyard	The Government farms
The Stone Quarry	The Government stores
The Boat Yard	

Until 1820, these centres employed over 50% of the convict population. Their output was directed at agricultural products, livestock supply, import replacement manufactures, materials required for the construction and building industries, materials required in the public works and infrastructure construction program, and the transport and storage requirements of the government.

Colin White[76] has concluded that the colonial government controlled the local economic mechanism. There were three main elements to the mechanism: (1) The government provided the social infrastructure to mitigate risk to individuals, and further, (2) guaranteed a market, at fixed prices, for output of the private sector. This government action also provided (3) grants of free land, inexpensive credit and cheap labour with the return of any redundant labour to government service when needed.

Public Works

Investment in public works infrastructure was a major challenge. Britain essentially saw the settlement as little more than a tent town. The inhabitants were prisoners, under guard, transported 'out of sight and out of mind' and had no need of money or coins, public buildings

fancy housing or amenities. Under the early governors from Phillip to Bligh, only the minimum amount of work was done and therefore expense was limited so, by the time Macquarie arrived, there was a deferred maintenance and construction schedule which dumped all of the expense and workload on his Administration. Commissioner Bigge recorded for his Enquiry that 76 buildings had been completed under Macquarie. Some of these were extravagant including the Governor's Stables, the Rum Hospital and the toll booths on the Parramatta Road. Bigge directed they be revamped and put to alternate, less extravagant use. He made no comment on the provision of water or the sewer and drainage measures made for a town with a growing population; Macquarie had drained the marshes in the present Centennial Park as the town water supply and outlawed the use of the Tank Stream for animal grazing, washing, and as a waste sewer.

In 1826 Governor Darling, as part of his structuring of a colonial public service, established the first Office of Inspector of Roads and Bridges with charge over the Engineer's office. From April 1827, his title was changed to Surveyor of Roads and Bridges and the office remained active until 1830 when, in an economy drive, Sir George Murray, Secretary of State for the Colony and War Departments passed these responsibilities to the Surveyor-General. In 1832 the Colonial Architect's Department was established to take responsibility for the planning, repair and construction of public buildings. In 1833, in another economy drive, this department was also transferred to the Surveyor-General. Later the duties of colonial engineer for superintendence over roads, bridges, wharves and quays were added to those of the Colonial Architect and all planning came under the Surveyor-General. It was this concentration of workload in such a few hands that led to an increasing public investment in public works.

Another effort by Governor Darling to centralise planning and control in a new public service bureaucracy was the establishment of the Clergy and School Lands Department in 1826. This corporation was to receive a seventh in value and extent of all the lands in each county in the colony out of which it was to be responsible for paying the salaries of clergy and schoolmasters and for the building and maintenance of churches, school and minister's residences.

[76] *Mastering Risk – Environment, Markets and Politics in Australian Economic History* Page 52

Governor Darling had centralised the planning for all public works into one department, the Land's Department, which in turn employed the Surveyor-General and provided for the Lands Board. This balance assisted in prioritising and funding all public works and brought order to the chaos of Macquarie's policy of building as he saw fit. A by-product of this new policy was that all convicts were now on assignment and 'off the stores', and a competitive contracting arrangement was used for tendering for all public works.

Having reviewed the commissariat business enterprises, it remains to further examine the convict work arrangements and outcomes. This chapter details the role, organisation and output of the six main operating centres of the commissariat. The most important reform or change to commissariat operations under Macquarie was his addition of the role of Supervisor of Convict Work. Although there was already a Superintendent of Convicts, that role was that of discipline, in all its forms. Macquarie asked of the commissary that this establishment prepare a work schedule, supply the tools and equipment required, and victual cloth and house the convict allocated to government work. This imposed on the commissariat a huge responsibility and burden. It was now their role to plan ahead for materials required on both government building works and what could be expected from private sales. The commissary had to estimate the timber, the brick and tile, stone and furnishings usage within the government programs and ensure the manufacture and preparation of all these articles. It was a mammoth role and based on the speedy completion of the vast number of government projects, a role that was accomplished with credibility.

Convicts at Work

The work gangs had an important role within the transportation program and the commissariat's work organisation. According to James Broadbent[1], 'Macquarie's public work can be grouped into four categories. Firstly, the purely utilitarian structures and engineering works: the storehouses, the markets, roads, bridges and wharves. Secondly, there were the buildings that had official government functions. Thirdly came the Greenway type civic buildings (with adornments) and then fourthly, there were the buildings of the urban type of

[1] Broadbent '*The Age of Macquarie*

architecture by Greenway'. [2] The Macquarie/Greenway team made a huge contribution to life in the early settlement and created much organisational work and planning for the commissariat.

Were the convicts to be viewed as Manning Clark classified them, an 'alienated working class...with no spiritual or material interest in the products of its work...driven or terrorised into labour', [3] or as 'a distinctive workforce, organised, directed and controlled in the performance of their labour',[4] or even as 'coerced labour emanating from a professional criminal class'[5] and members of the urban criminal class.[6] Meredith goes on to quote a vague, rather meaningless and un-attributed statement from the unidentified *British Monthly* 'Australia's colonial workers became the most murderous, monstrous, debased, burglarious, brutified, larcenous, felonious and pickpocketous set of scoundrels that ever trod the earth'.[7] It would make more sense if these attributes were applied to convict workers rather than colonial workers, as other than convicts, colonial workers were directly recruited mainly in Britain and imported under sponsorship or as free immigrants. It is doubtful that free labour should be or can be labelled in such an invidious way. The organisation of convict labour directly contributed to most of the problems associated with forced labour. Even penal labour today, in China or the USA, is renowned for its lack of productivity and these prisoners are supervised by salaried administrators or contractors and protected from abuse by strong laws defining prisoner rights. The colonial convicts enjoyed no such rights, and could not be simply coerced into working as hard as a free worker.

The incentive for work using 'on-time' release was also meaningless as few records existed or arrived with the convict ships, detailing the release date of each individual. There are two distinct phases of convict alienation in the workplace. The first came under King when convicts were supported by the commissariat for food, clothing and general provisions, and remunerated lightly by the 'master'. The second phase came when Macquarie assembled the

[2] . Francis Greenway was a convict transported to the colony for seven years for breaching bankruptcy laws in England. He was an architect working in his father's firm and after his arrival in the colony Governor Macquarie appointed Greenway the first colonial architect.
[3] Clark, Manning, *A History of Australia*, Vol 1 p.244 (MUP-1988)
[4] Nicholas. Stephen *Beyond Convict Workers*
[5] Meredith, David *Beyond Convict Workers* p.21
[6] Nicholas *ibid* p.3
[7] Meredith, David *Beyond Convict Workers* p.21

forced workers into an 'assignment' system, whereby the government disqualified itself from any financial support of the convicts and passed all responsibility, supposedly other than punishment, for the convict workers to the 'master'. With Macquarie picking the most skilled convict workers for government service, and assessing the desired level of subservience and productivity in each newly arriving convict for assignment to the government work gangs, it is little wonder that the remainder are considered 'dregs' and fail to meet productivity levels attributed to free workers. It is not hard to understand the lack of incentive in these 'assigned' workers – they were generally ill treated throughout the settlement, herded for counting at least once each year and often on a more frequent basis. Their provision allowance was generally less than optimum for a workingman. They had the lowliest of tasks to complete, ones in which productivity levels were generally difficult to set and more difficult to measure. For example, Convict Superintendent Ovens allocated 8 convicts to clear one acre of ground of trees and re-growth each week. We know from our own experiences even today that every acre is different – some land is super dense, with tall, ancient hardwoods, whilst an adjoining acre may be lightly treed with already thinned out softwood. Keeping in mind the aboriginals would run a fire through much open land to regenerate the bush and grass-lands; the country-side was always at different stages of re-growth and condition depending on drought and rains. Coghlan claims that convict works were only 50% as productive as a free worker, but one wonders if he has considered all aspects of the problem of such assessment. Convicts were mostly used on piecework, where goals were difficult to set. Building workers and work-gangs for clearing land and road formation were the majority, work which free workers were rarely sought for or encouraged to carry out.

Even today, it is not difficult to find a council or shire work gang of 5 or more men with two or three men digging and the remainder resting on their shovels, at any one time. Coghlan's generalisation is not hard to understand but closer inspection makes it an unreasoned conclusion. The answer as to productivity and commitment is probably found in the attitude and of superintendence of the work. Any man is resentful of being chained like as dog and treated as inhuman, underfed, abused both physically and mentally and having nothing to look to the future for. Superintendence by a peer, due to a shortage of free worker availability with people skills, was the normal arrangement, and most overseers would have been willing only to stand aside and verbally abuse the convict group or team, rather than be a working-

supervisor. Why should we expect a different set of standards for the convicts in 1788-1832, than we accept today? Human nature has not changed that much. Obviously there were exceptions, such as Greenway, Simeon Lord, Edward Eager and others, who stood as self preservationists and wanting to stand out from the crowd, embarrassed to be in such circumstances and intending to revert to former social and economic standing. However such people were rare amongst the 160,000-odd convicts transferred to the colonies.

It is doubtful that the assignment system 'would create a dynamic economy'.[8] Dyster asks 'what would be the incentive to use convict labour efficiently, or for the convicts to cooperate efficiently?' [9] He concludes 'there were four ambitious and rather contradictory standards of efficiency: punishment, reformation, cheapness, and a reasonable return to the Empire'. It was Commissioner Bigge's enquiry into how post-1820 New South Wales could be run more efficiently that recommended the solution of 'dispersal of convicts away from the delights of town and of each other into the service of men of capital and authority, who would grow wool for export to Britain'.[10]

Dyster records 'a genteel plan of getting money out of the British Treasury. It was in their interests [that is, the interests of the of the 'Officer's Ring' trying to monopolise importing in the first twenty years[11] that all convicts employed by government should be treated as generously as possible. Indeed as farmers and traders, it was in their interests that *private* employers should pay just as generously for their assigned convicts. The convicts would misbehave or seek to be returned to government [service] if their rations did not match those of the commissariat.

The earliest convict gangs were employed on timber harvesting, timber dressing, brick and tile making and construction. Construction crews were engaged in building barracks (military as well as convict barracks) storage facilities, hospitals, paths, roads, bridges and wharves, military fortifications and observation points. A full list of Macquarie's construction work is included in the Appendix to this study. Macquarie's initial dilemma was creating sufficient

[8] Dyster, Barrie *Beyond Convict Workers* p.84
[9] Dyster, Barrie *Beyond Convict Workers* p.84
[10] Dyster, Barrie *Beyond Convict Workers* p.85
[11] This theme is further developed in the sub-section relating to the commissariat and the *Rum Rebellion*

work to keep all these newly arriving convicts employed. But this situation was quickly reversed and the demand for skilled workers grew and could only be met from newly arriving convicts and/or specially recruited immigrants. At the same time as newly skilled workers became available, the new manufacturing operations took shape. The construction crews, wherever located, were to be victualled and fitted out with clothing and tools by the commissariat. This need, together with the spread of settlement, led to a diversification of commissary locations – Parramatta, Liverpool, Windsor, and Government Farms at Castle Hill, Pennant Hills, Toongabbie, Rose Hill, Emu Plains and Rooty Hill.

Bill Robbins, claiming to be a specialist in the 'Management of Convict Workers' in NSW between the years 1788-1830, takes the position that there was not a coercive relationship between government and convict workers, nor were the convicts powerless. He claims that there was interaction between managers and workers concerning control of the labour process. Robbins, a former union official, suggests there is evidence that during the 1788 to 1820 period there was a vibrant and at times fierce struggle between convict workers and colonial managers of convict labour. Robbins does not identify this evidence nor does he identify the source for his statement 'task work was the official designation of a minimum quantity of work, or quota for individual convicts or for a gang of convict workers.' Bigge obliquely referred to this policy in his first report (page 29) when he states '[the policy] was adopted more for the purpose of securing and ascertaining that a certain quantity of labour [was] performed, than of stimulating the quicker performance of it'.[12]

Under pressure from settlers wanting to contract for convict labour, Governor King set work and task work rates:

[12] Robbins, Bill *Contested Terrain: The Convict Task work system 1788-1830,* in Labour & Community: Historical Essays (ed) Raymond Markey p.37

Table 5.1 Setting Task Work Rates per Unit/Per Week

Task	£	Unit
Felling of forest timber	0.10.0	1 acre
Burning off fallen forest timber	1.05.0	65 rods
Breaking up new ground	1.04.0	65 rods
Chipping in wheat	0.06.8	1 acre
Reaping wheat	0.08.0	1 acre 60 rods
Threshing wheat (per bushel)	0.00.7	18 bushels
Planting corn	0.06.8	1 acre
Pale splitting (5 ft per hundred)	0.02.0	1000 (using 2 men)

(Source: HRA 1:3:37 March 1801)

John Ritchie in his study of the Commissioner Bigge Reports quotes Major Druitt, the 1817 Convict Superintendent, confessing: 'I have had more trouble with the Sawyers than any other description of convicts, and I attribute it to my obliging them to do a greater portion of work than they ever did before'. Druitt had increased their weekly target from '450 feet per week per pair of convict workers, to 700 feet but also demanded they cut more demanding types of timber such as Iron Bark, Stringy Bark, Blue Gum and cedar'.

When in another article, Robbins reviews the management of the Lumber Yard, his observations are purely quotations from Ritchie and other historians, and he makes no effort to understand the operation of the Lumber Yard.[13] It would be of interest to ask Robbins, how he can expect to understand the labour management of the Lumber Yard (a division of the commissariat) without identifying the interior layout and operating departments within the Yard, or the range of outputs from the Yard, or the labour manning schedule within each division.[14] Because of his invalid approach, Robbins concludes that convict labour in the Lumber Yard involved 'a basic conflict of interest between capital and labour'.[15]

Robbins obviously fails to understand the function of the Lumber Yard, and its attributes and great significance in the colonial setting. The Yard was the specialty manufacturing centre of

[13] Robbins, W. M. *The Lumber Yard: A case study in management of convict labour.*

[14] Chapter 6 of this study sets out the operations of the Lumber Yard.

[15] Robbins, *ibid* p.142

the settlement as well as the major employer of government convict labour. The Yard was enhanced in importance and relevance by becoming a major import replacement facility, and offered the advantages of fast supply of many components, on time delivery, quality control over imported goods and usually a price advantage. The lead-time for ordering from Britain was well over a year, whilst production from the Yard was locally and centrally controlled and allowed for minimum inventory and better utilisation of government controlled convict labour.

There was no conflict between capital and labour. Labour efficiency was under constant review as was the manning numbers within the Yard. Equipment was well used and technological advances were transferred from Britain to the Yard as need arose. Dr. Meredith writes; 'As time passed the authorities in Britain decided that assignment [system] itself was inefficient',[16] so by the end of 1837 it had been decided to scrap assignment and, in fact, bring an effective end to the transportation program[17]

Convict Work Organisation in the Colony

The first Bigge Report states that 'the centre of colonial industry is the Lumber Yard, a large space of ground now walled in, and extending from George Street to the edge of the small stream that discharges itself into Sydney Cove. The able bodied men who are lodged in the Hyde Park barracks and the Carter Barracks are divided into gangs, and are employed in the Lumber Yard'.

Bigge saw the use of convict labour for local manufacturing was quite appropriate but it employed too many persons at the expense of the government. He preferred the 'assignment' of convicts to the private sector where they would be kept at the expense of the employer. Bigge overlooked the huge saving included in making many building items locally rather than paying to import them, but then he really did not see the need for a local government building program in a penal colony. Bigge's reports did not opine on the quality or productivity of the Lumber Yard, nor on the timeliness of demand being satisfied within the settlement. As directed by Bathurst, his primary concern was with total immediate cost rather than the larger

[16] Meredith, David *Full Circle? Contemporary views on Transportation,* in Nicholas
[17] Dyster, Barrie *Why NSW did not become Devil's Island (or Siberia)* Beyond Convict Workers UNSW 1996

picture of benefit to the colony or to the future projected lower costs of its operation by improved public infrastructure, and the provision of an industrial base.

Other observations based on the Bigge assessment of the convict work in the colony can be made as follows:

In the seven years between January 1, 1814 and December 20, 1820, Bigge reports 11,767 convicts arrived in the colony.

Of the 11,767 convicts, 4587 were placed into government service, whilst the remainder of 7,180 were assigned to the military officers and other land grant beneficiaries, and taken 'off the store' and as such off the government expense.

The government assignees (4587) were placed into various enterprises as mechanics and labourers – they all (except for 594) were required to live in government barracks in Sydney (Hyde Park or Carters' Barracks) Parramatta, Windsor, and Bathurst.

In a report to Governor Brisbane in June 1825 on the state of the Lumber Yard Major Ovens[18], who had arrived in the colony as part of the Governor's staff, recommended a 'government contract' system. Ovens introduced his report by stating that:

> '...this colony was formed with a view prospectively of becoming in the course of years a useful appendage to Great Britain, and with the prospect of serving as a place for exercising that degree of discipline over the larger portion of its population who, forfeiting all claims to the more lenient laws of their own country, had rendered themselves fit subjects for a more coercive system of restraint. In the first case, therefore, it was only reasonable that the Colony should be indebted to the Mother country for a large outlay of capital in support of its principal institutions; and in the second, that the labours of the convicts should be rendered available for that purpose. Hence the numerous works and Establishments, that became necessary in the march of the colony's progress, were furnished from the industry and labour of that class of its inhabitants.'

Having tried to justify both the development of the colony and the use of convicts for that purpose, Ovens went on to state: 'the assignment system should be temporary and used only when a benefit on the colony of encenuating it natural productions or enhancing the value of its material by the skill and industry of the convict labour'. In other words, place the convicts into service, where they could do the most good, and where the colony could reap the largest reward. He pointed out that to that time priority had been given to town development, but the priorities should now change and concentrated effort be given to developing agricultural and

[18] HRA 1:11:653 Ovens' reports on the state of the Lumber Yard

pastoral industries. According to Ovens, the previous priority was not the most consonant to the principles of political economy but it was the most natural at the then existing state of society; when the extent of the agricultural resources of the country became better known, clearer and more enlightened views on the subject were entertained, and the labour of the prisoners could be applied to such pursuits as were eventually most likely to add to the wealth, comfort and independence of the community. A practical example of the happy result of such measures may be instanced in the system adopted in clearing the country by means of convict labour, and bringing into cultivation large tracts of land which otherwise would be dormant and useless to the colonist; this work has also improved the moral condition of the convicts as well as their habits assimilated to those of farming men.

Ovens then noted a new system (with incentives) for the land clearing gangs in the country areas. He recommended:

> 'Convict labour should be used not only for land clearing, road making, and public works in the towns (government buildings etc) but for repair work as well (rather than have contractors imposing costs on the colony). Ovens noted four commonly held objections to the privatisation of contract work. As a means of coordinating the government contract system, he recommended establishing an engineer's department, in order 'to give a systematic effect to the labour and exertions, as well as to the skill and mechanical arts of the prisoners.'

Not all of Ovens' ideas were adopted. Brisbane was influenced by others on his staff, who reminded the governor of the need to keep total costs down. One Ovens idea that was adopted and then failed was the convict land clearing program. This policy was based on the land being cleared by convicts before sale, with a premium being added to the sale price. The theory was great but in practice, buyers felt they were paying twice for the same work. Upon purchase of the land, the buyers were entitled to request a number of 'assigned' convicts, and if they were not used to clear the land what would they be doing?

The Operations of the Lumber Yard

The operations of the Lumber Yard are generally unrecorded, and yet as the manufacturing centre of not only the commissariat, but also of the colony generally, the Lumber Yard was responsible for a number of significant activities It gainfully occupied the over 2,000 convicts

at work, trained younger offenders so as to provide them with a skill for use at the end of their sentence, and built or manufactured a wide range of locally require supplies and stores.

The Lumber Yard also facilitated a transition arrangement for many manufactured items from government enterprise to free private enterprise. It was located on the corner of George Street and Bridge Street, which had earned its name from having the first wooden bridge constructed over the Tank Stream. According to De Vries [19] the lumber or timber storage yards were a standard feature of British colonial penal settlements. They were in fact convict work camps and the Bridge Street Lumber Yard contained workshops for blacksmiths, carpenters, wheelwrights, tailors and shoemakers. There was also a tannery where the convicts made their own leather hats and shoes. Nails, bolts, bellows, barrels and simple items of furniture for the officer's quarters and the barracks were also made in the Lumber Yard. Convicts wore identification on their uniforms –**P.B.** for Prisoner's of Hyde Park Barracks or **C.B.** for Carter's Barracks. They worked from sunrise to sunset. If they failed to fulfil their allotted tasks they were flogged at the pillory, conveniently situated nearby, also on Bridge Street.

The Lumber Yard continued in use as a convict workshop until 1834, at which time it was cut up and sold for up to £25 per front foot (for the best lots). Contracting for government work was a common path to independence for building craftsmen. Convicts or emancipists employed as supervisors of the government building gangs seldom wished to remain in service longer than they had to and there was always a shortage of reliable men to take their place[20]. Macquarie, in his efforts to retain his supervisors in government employment, permitted them to combine their official duties with the business of private contracting. The supervisor would undertake the management of a building project to which the government contributed labour and materials from the Lumber Yard. Major Druitt, the Superintendent of the Yard at that time, was unable to suppress the open practice of government men and tools being 'borrowed' and government materials from the Yard being diverted elsewhere.

> *'Already by 1791 the government (Lumber) Yard had been established on the western side of the Stream to collect and prepare timber for building and was the recognised meeting place where the gangs picked up their tools and materials and were assigned to work. Here building materials were collected, prepared for use and distributed to the various work sites, tools were issued and gangs allocated and checked. It became the core of the government labour system after the devastating Hawkesbury floods in the winter of 1809. Lt-Gov Patterson had the*

[19] De Vries *Historic Sydney*
[20] Scott, Geoffrey *Sydney's Highways of History*

Sydney working parties gather there for victualling before going to the relief of the settlers. [77]

Under Macquarie's expanding work program the Lumber Yard became the centre of the largest single industrial enterprise in the colony. Captain Gill, as Inspector of Public Works, exercised the general direction of the working gangs and controlled the issue of tools and materials while William Hutchinson, Superintendent of Convicts, distributed convicts to the work gangs.

'With so much activity the Yard was an easy target for thieves and by September 1811, the loss of tools, timber, bricks, lime, coal, shingles and nails from the government stocks had become so great that a General Order was issued directing that offenders, including conniving supervisors, would be punished as felons. The same order directed that all tools had to be handed in and counted at the end of each day and prohibited men from borrowing tools or doing private jobs in the yard after normal working hours. [21]

Gill's successor, Major Druitt, expanded the Yard to cope with Macquarie's work program. He took over the adjoining land in Bridge Street (by then abandoned by the debt-ridden merchant Garnham Blaxcell who had fled the colony) and built new covered saw pits, furnaces for an iron and brass foundry and workshops for blacksmiths, nailers, painters and glaziers, and harness makers. He raised the walls surrounding the Yard and built a solid gate to discourage truancy and pilfering; he built moveable rain-sheds for jobs around the town and provided two drags drawn by draft animals to replace the 90 to

100 men previously employed on the laborious task of rolling logs from the dock to the Yard. [21]

Men were selected off the convict transports, on the basis on their skills and experience and told to find lodgings in the Rocks area. Each morning a bell:

'...would call them to the Lumber Yard where they were set to work according to their trades or capabilities. Some went to the workshops, others to building sites or the Brickfields where they dug and puddled clay and pressed it into moulds for firing in the kilns. Unskilled labourers were allocated according to their physical condition; the fittest went to the gangs felling trees and cutting logs to length, others to barrowing heavy stones or dragging the brick carts to the building sites, with assignments often used as punishment for the recalcitrant. The unfit were not spared; weak and ailing men went to gangs tidying up the streets or weeding

[77] *Sydney Gazette* Sept 1811
[21] *Sydney Gazette* Sept 1811
[21] HRA 1:9: 832; ADB I-324-5

government land, a man without an arm could tend to the stock and a legless man could be useful as a watchman'.[22].

The day's work started at 5 am, there was a one-hour break for breakfast at 9 am and at 1 pm for lunch; at 3 pm the men were free to go and earn the cost of their lodgings. In 1819, Macquarie tightened the convict system, housing all convicts in the new Hyde Park Barracks, and the working day was extended to sunset. Only married or trusted convicts were allowed to live in the town. The men from the Barracks were marched down to the Yards but 'control was lax and as they went through the streets, some would slip away to follow their own devices'. [23]

'As a result of Macquarie's building activities, and partly as a means of employing more and more convicts, the range of activities expanded in the Lumber Yard'. [24] Every kind of tradesman was gathered: carpenters, joiners, cabinet makers, wood turners, sawyers, wheelwrights, cart-makers, barrow-makers, blacksmiths, whitesmiths, shoeing smiths, agricultural implement makers, tool makers, nailers, bell founders, iron and brass founders, brass finishers, turners and platers, brass wire drawers, tool sharpeners, steelers, tinmen, painters, glaziers, farriers, horse-shoers, saddle and harness makers, bellow makers, pump borers, tailors, coopers and many more.

The organisation was simple: the big work-sheds faced the central log yard where logs and sawn timbers from Pennant Hills and Newcastle were stacked. The Lumber Yard was the source of many of the colonial-made goods and the centre of the Government's engineering and building activities. It was the first step in the creation of the Public Works Department in 1813. Although the Lumber Yard serviced most of Macquarie's building needs, he badly required the services of a skilled architect and he found those skills in a convict – Francis Greenway. Greenway had a solid background of practical experience as well as theoretical training and he became influential in translating Macquarie's aims and ideas into reality.

Major Ovens in his report to Governor Brisbane described work in the Lumber Yard.

'In the Lumber Yard are assembled all the indoor tradesmen who work in the shops such as Blacksmiths, carpenters, sawyers, shoemakers, tailors etc. The

[22] Bridges, Peter *Foundations of Identity*
[23] Bridges, Peter *Foundations of Identity*
[24] Bridges, Peter *Foundations of Identity*

workmen, carrying on their occupations under the immediate eye of the Chief Engineer are probably kept in a better state of discipline than those, who working more remote, are dependent on the good behaviour of an overseer for any work they may perform.

Whatever is produced from the labour of these persons, which is not applied to any public work or for the supply of authorised requisitions, is placed in a large store and kept to furnish the exigencies of future occasions; the nature of these employments, also renders it much easier to assign a task to each, for the due performance of which they are held responsible.'

In the Timber Yard adjoining the Lumber Yard was kept an assorted range of the timber, scaffoldings etc required for the erection of public buildings: and whatever materials were carried away from the Timber Yard for building purposes and the different works, the same had to be returned, or the deficiency accounted for. The storekeeper of this Yard had charge of such timber as was brought from the out stations, or sawn and cut up in the Yard, such as flooring boards, scantlings, beams etc; and when these supplies exceed the demand for government purposes, the excess was sold by public auction, and the amount of the proceeds credited to government commissariat. The Crown 'owned' all standing timber in the colony and the revenues derived from also belonged to the Crown and were therefore used to offset crown expenditures in the colony.

The Ovens' Report to Governor Brisbane lists the workforce by category as well as their expected output. [25] Table 5.2 shows the structure of the Lumber Yard workforce:

Table 5.2: Manning Schedule of the Lumber Yard in 1823

Carpenters' Gang	50 convicts + free apprentices
Blacksmiths' Gang	45 convicts
Bricklayers' Gang	10 convicts
Sawyers' Gang	25 convicts
Brick-makers' Gang	15 convicts + boy apprentices – Carters barracks
Plasters' Gang(lathing, plaistering, whitewashing)	8 convicts
Quarrymen	15 convicts
'Loading, carrying, clearing the Quarries - 3 bullock teams + 5 horse trucks –	19 convicts
Wheelwrights' Gang (wheel, body and spoke-makers	23 convicts
Coopers' Gang	6 convicts
Shoemakers' Gang	8 convicts
Tailors' Gang (cloth is made at the Female Factory in Parramatta}	8 convicts

[25] HRA 1:11:655-7

Dockyard Labourers on repair work	70 convicts
Stonecutters and setters	13 convicts
Brass Founders' Gang (casting iron for all wheels, etc.)	9 convicts

Other occupations in which convicts were employed included: foundation diggers, rubbish clearers, commissariat store gangs, grass cutters, boats' crews, boat conveyance crews, and gardeners.

The plan of the Lumber Yard (Appendix No. C) shows how the Yard was laid out. Convicts were marched from the Hyde Park Barracks along Macquarie, Bent and Bridge Streets to the entrance to the Yard, which faced High (George) Street. Inside the entrance, which was two large solid wood gates set into a high brick wall, there was a supervisor's office, with room for clerical staff. A tool shed was located near the front gate so that convicts could be issued with tools and have them collected at the end of the working day. It may be assumed that there was some form of 'inventory' control of tools; otherwise the Governor could not have been advised that tools were missing (assumed) stolen. In the centre of the half-acre site, there was a large open, but roofed building, under which the logs were stored, debarked and sawn.

Along one side of the site, probably the back fence, the five operating divisions were housed, probably also under an open sided roofed building. These five independent areas included workshops for blacksmiths, carpenters, wheelwrights, tailors and shoemakers.

Sawpits were located in the central area, (Ovens reported two in the Lumber Yard and one each in the Timber Yard and in the Dockyard.) The sawpits were recorded by Ovens to be each of about 70 feet in length Furnaces, would have been located, for safety reasons, on a third boundary wall. The fourth boundary wall contained materials storage, since bricks, tiles, and sawn lumber were stored in the Yard ready for issue to local construction sites.

The four town Quarries were located at Cockle Bay, the Domain, the Gaol-site quarry off Pitt's Row, and the High Street quarry. Items maintained in the various commissariat stores included:

Table 5.3: Lumber Yard Stores and Products

Stores Maintained	Products Manufactured
Bricks	Sawn timber for framing and flooring
Lime	Window and door frames
Coal	Nails

Shingles	Bolts
Nails	Bellows
Tools	Barrels
Timber in process of drying	Wheels
Logs awaiting cutting	Furniture

Employment was considerable, and was categorised into at least these groupings for control purposes:

Table 5.4: Employment Categories within the Lumber Yard

Construction & Work-site gangs
Construction gangs for building, houses, public buildings, wharves, bridges
Gangs for land 'clearing'
Gangs for felling trees in the selected timber harvesting areas (Pennant Hills and Castle Hill)
Gangs for Road making
Work facility gangs
Gangs working in the Stone-yard on the west side of High Street
Haulage Gangs
Gangs for moving logs from the wharf behind the commissariat, further up High Street, to the Lumber Yard
Gangs for dragging 'materials' carts from the Yard to building and construction sites
Gangs for dragging the portable 'rain-sheds' to the various construction sites
Cart dragging gangs for bricks, tiles and stones

In all, over 20,000 convicts were organised from the centre of manufacturing (the Lumber Yard), with about 2,000 employed within the yard itself, at the time of the Ovens' Report. Many government assigned convicts were employed on government farms at Emu Plains, Castle Hill, Rooty Hill and in Sydney town. Their work ranged from ground clearing, cultivation, weeding, picking and storing, whilst the range of produce included vegetables, fresh meat and grain growing.

Table 5.5: Commissariat Work gangs and Convict employment -1809

Vegetables	150
Cattle	11
Hay/charcoal	110
Wheat/maize	269
Timber cutting	73
Lime preparation	27
Road making	362
Land clearing	386
Stone quarries	69
Cart operators	268
Brick/tile makers	124

Boat navigators	12
Official boat crews	120
Dockyard operations	47
Lumber Yard	1,000
Construction work	1,450
Convict Supervisors*	1,500

*(*There were over 1,500 convicts employed as supervisors, foremen, leading hands and clerical assistants in the Commissariat and its work gangs as well as in the Governor's office and other official government offices.*

Convict Work Supervision

The hierarchy carrying out the convict work supervision was equally as simple in structure to the convict work organisation itself. The Governor was ultimately responsible for supervising and assigning the convicts to the various tasks whilst the Chief Engineer, Major Druitt had overall responsibility for the works program –planning and completion. The commissariat was closely involved and recommended the production schedule, made available the raw materials and the tools and equipment. In 1814, Macquarie made three new appointments to assist Major Druitt. The principal superintendent of convicts was to be William Hutchinson, an ex-convict, whilst the chief architect for public buildings and quality control as well as convict productivity was another convict Francis Greenway, and the design chief for military and civil barracks and police posts, Lieutenant Watts of Macquarie's 46th regiment.

Operating the Stone Quarries

With knowledge of local building materials so limited, the more traditional British building materials were sought and encouraged in use. Sydney town was a fertile source for soft sandstone building blocks also suitable for sculpturing. The commissariat used four locations for sourcing Sydney sandstone for its public building program. A number of stonemasons were located within the ranks of the convicts assigned to government service.

Ellis writes in '*Francis Greenway*'[26] of a visit Greenway made to Liverpool, at the request of Macquarie, at which time he saw a few stones delivered and showed Gordon, the mason, how they should be worked. Greenway remarked on the excellent quality of the stone and commented further 'if a proper quarry were opened on the site from which the specimen came', then there would be unearthed the finest stone yet found in the colony. Greenway was

[26] Ellis, M.H. *Francis Greenway* p.95

very disappointed to find that in fact there was no quarry but what he had seen were only some loose surface stones. By letter dated 10th April 1818, Greenway recommended to Mr. Lucas (a contractor, and the Liverpool property owner) that he should open 'a proper quarry, and good white stone should be obtained'. This was not to be, as the *Sydney Gazette*[27] recorded a few weeks later that Mr Nathaniel Lucas, a respectable builder, was found dead near Moore Bridge, Liverpool.

Greenway wrote to Sir John Jamison on 8 November 1822 that a preliminary estimate for renovation work on the Jamison house included '16 enriched blocks' at 16/-. Without a private contractor able to extract and supply building stone, Greenway recommended to Macquarie that the commissariat establish and supervise various sandstone quarries to supply government and private building sites around Sydney.

A submission was made by John Oxley to the Bigge Commission in Sydney in 1821 and included a return of the number of buildings in Sydney in 1821.

Table 5.6: Stone Building Constructions in Sydney 1821

Location	Public Buildings	Private Buildings
Macquarie Street	2	1
Bent Street	1	0
George Street	3	21
Macquarie Place	2	3
Charlotte Place	1	1
Elsewhere	0	33
Total	**9**	**59**

The Macquarie Tower and Lighthouse on South Head used stone specified by Greenway, to be 'not less than 4 feet long by 2 feet 6 inches in the bed, joggled and cramped in the same way as the stones in the basement. The problem confronting Greenway at this time was no masons were obtainable' since there were only two or three government men who even pretended to call themselves such'. Greenway therefore selected twelve young men and lads and gave orders that they should be taught to 'face a stone' to handle their levels, plumb rules, trowels, hammers and chisels'. The foundation stone was laid, for the Lighthouse, on 11 July 1816, and completed on 16 December 1817.

[27] *Sydney Gazette- report dated 9th May*

Macquarie was being advised on one hand that the colony 'was a devil's island, with no need for public buildings, whilst on the other hand there were hundreds of convicts coming into the colony, who had to be put to work, and an expanding colonial revenue, supported by taxes, which was providing local resources not very closely watched over by the British Treasury'. Some of these funds were used for churches in Sydney, Windsor and Liverpool – the expense of which was paid from Colonial funds. Macquarie was not acting secretly, for he wrote to Lord Bathurst in April 1817 'In regard to public buildings still required in Sydney, and in other parts of the colony, I shall avail myself of the discretionary power provided by your Lordship to build as required and pay for them from colonial revenues'. Early reports identified a few stone masons in the colony – such as Thomas Boulton, a free settler arriving in 1801 and who by 1810 was well established and in that year won a government contract to build a 950 feet stone wall in the Domain and for which he received £481.12.0. It was Macquarie who had established the structure for civil engineering in the colony, especially for public buildings and works projects. Lt-Colonel Foveaux designed the commissariat stores and military barracks, but successive governors soon delegated responsibility to a single superintendent for each bridge, road, building and public works project.

The map appended to this study (Appendix C) shows the location of three stone quarries in Sydney Town. The first and oldest, in use, was on George Street (High Street) opposite the Commissariat Store and adjacent to the Military watch-house; the second was on the point now known as Bennelong Point (where the Opera House is now located) and the third was on the east side of Sussex Street North. Appendix C includes a reference to the Pyrmont Quarries as being the quarries that built Sydney, and claims 'the Pyrmont Quarries supplied virtually all the sandstone for every major construction in Sydney'.

The Timber Yard

Directly associated with the Lumber Yard was the Timber Yard. Although there were sawpits within the Lumber Yard, they were used for sizing sawn timber. The main function of the Timber Yard, and within it the sawpits, was to extract sawn timber of varying sizes and lengths from the large number of logs brought into the Yard. These logs were floated down the Lane Cove River and across the harbour to the commissariat landing, where they were hauled from the water and stacked to enable a drying process before being moved over the

sawpits. The logs, having partly dried in the sun, were then rough sawn into a variety of sizes and lengths before being placed for further drying on racks under weights, designed to minimise the twisting and splitting that naturally occurs when native colonial timbers were dried. The natural moisture of native timbers content is high and it is best reduced through kiln drying, but this method was untested until the 1830s. Governor Phillip had used timber directly cut from standing logs and found to his great cost that the timbers twisted, warped and split after a short time in the sun. All his early work had to be rebuilt after allowing the sawn timber to naturally dry before nailing into place. It took many years for the colonial building supervisors to understand the characteristics and nature of the native timbers and how different they were to the English timbers.

The third main function of the Timber Yard was to cut the rough sawn timber to preferred sizes and, after the drying process, to rack them until required for construction purposes. From early records, it appears that there were never sufficient sawn timbers and demand always outstripped supply, so much so that many British ships were still bringing in timber from Britain and the continent as ballast. Also local supplies were used in growing quantities for transfer back to and sale in Britain. Although an import tax had been imposed on timber originating from colonial NSW, timber was still in great demand for specific uses, especially for naval purposes and as hardwood.

The Timber Yard was the main timber operation in the colony, but as the source of most timbers was in the Castle Hill and Pennant Hills area, a second but smaller timber yard was built adjoining the Pennant Hills forests. Ralph Hawkins, in a study of the convict timber getters of Pennants Hills for the Hornsby Historical Society, has detailed the names and occupations of both convict and non-convict workers employed at the timber-getting establishment in the Hills area from the 1828 census (the first complete census following the last of the musters. In all there were 166 active convict workers who were employed as timber-fellers, wood and post splitters, sawyers, shingle makers, carpenters, charcoal burners, sawpit clearers and basket makers. A number of the convicts (10 in total) were working with animals as bullock drivers, stock keepers and grass cutters, whilst another sub-operation consisted of metal workers – i.e. blacksmiths and wheelwrights. As the finished products or cut timbers were moved by water, there were boatmen and wharf workers. As it was a self-

contained camp, there were also hut-keepers, barbers, shoemakers and tailors. Convicts were used on the administrative side, including approx 40 men acting in a military capacity as superintendents, overseers, watchmen, constables, clerks and a school teacher. The commissariat victualled and provided supplies for a grand total of 166 convicts and provisions would be taken by boatmen returning from the Timber Yard after delivering a supply of product from the Pennant Hills establishment.

The Timber Yard was an important aspect of the commissariat operations and underpinned the substantial quantity of timber supplies necessary to the colonial building program commencing under Macquarie.

The Female Factory of Parramatta

Both male and female convicts arrived in the settlement and, as far as balance between the sexes was concerned, the numbers seemed to be of little interest to the authorities in Britain. Upon arrival in the colony, male prisoners were housed in barracks in Sydney, Parramatta, Liverpool or Windsor. Female prisoners were expected to be retained under government supervision for a short period before assignment into the private sector as housekeepers or manual workers, and whilst awaiting assignment, they were temporarily housed in the female barracks in Parramatta. Governor King changed the name of the facility from the 'House of Industry' to 'The Female Factory' in 1800.

In his report on the Parramatta Gaol for Governor Macquarie, Greenway recommended that the existing female factory be removed and rebuilt on a new site as early as possible, since the 'factory had a very bad moral tendency'.[28] Governor Macquarie had included a new factory and barracks for female convicts in his 'List of essentially necessary Public Buildings' of January 1817[29] and in March 1817 he identified to Greenway[30] the 'intended site for the new Factory and Barrack'. However, it was not until 1818 that he instructed Greenway to 'make a plan and elevation of a factory and barrack, sufficient to accommodate 300 female convicts, on an area of ground of 4 acres enclosed by a stone wall, 9 feet high'[31]. The site chosen lay between the old Government millrace and the river, opposite the Governor's Domain. Greenway based his plan on a design submitted by Samuel Marsden and the contract was let in

[28] Broadbent & Hughes – Francis Greenway – Architect
[29] HRA 1:17:255 *Governor's despatches*
[30] Greenway had been appointed Colonial Architect and had responsibility for building what he had designed

April 1818 for completion within 18 months. Macquarie laid the foundation stone in July 1818 but, due to numerous delays, the building was not completed until 30 January 1821.

Commissioner Bigge described the building, in the following way: [32]

> 'The design for the building consists of a basement story containing two large rooms (for the females to take their meals), two upper stories with large sleeping rooms. Each sleeping area will contain 20 double beds (containing accommodation for 172 females). The rooms are separated by a staircase and landing places, and in the centre of the roof is a cupola for ornamental purposes and ventilation.
>
> In the outer yard is the principal entrance and the porter's lodge, and rooms for the superintendent and his family. In the inner yard is the hospital, a room for weaving cloth and four very small lodges for constables or overseers. Other buildings include the bake-house and kitchen, provisions and stores, storing wool, a spinning room, a carding room and a large storeroom for wool and cloth. No washrooms or privies had been included in the original design and these were added later with drainage to the river.'

Samuel Marsden, who Governor Macquarie had appointed a Trustee of the Female Factory, [33] had advised Macquarie of some background to the commencement of the original Female Factory:

> 'Nine looms had been operating since 1804 at the Government factory at Parramatta, where 50 women and 18 men were employed. At that time only a small proportion of the colony's sheep grew wool that was worth shearing, let alone exporting, so the course crossbred-wools, which predominated until the early 1820s, had from the King period been manufactured into slop clothing for the convicts, under the arrangement that the grower received 1/4th of the cloth as payment for the wool supplied.'

In 1814, Marsden told the Secretary of State in England that the absence of barrack accommodation for the female prisoners had forced many into prostitution, in order to find shelter). In the absence of a favourable response, he wrote to Wilberforce in 1815 complaining of Government inaction and seeking his support in building a new Female factory.[34] Later, in 1815, he reminded Macquarie of the appalling conditions at the Parramatta Factory.

[31] HRA 1:17:255 *Governor's despatches*
[32] Bigge, J. T *Third Report on the Colony of NSW* (1823)
[33] Yarwood, A.T. *Samuel Marsden*
[34] Yarwood, *ibid*

Early in 1816 Marsden pointed out that the lack of proper accommodation for the convicts employed by the Government at Parramatta not only subverted morality and law in that district, but also destroyed the most distant hope of reformation. The female convicts who were not assigned to private service were employed by day in the Government clothing factory at Parramatta. However, only 30 of the 150 women and 70 children slept there amongst the litter of wool, grime and machinery, while the remainder were forced to 'cohabit with wretched men or earn lodging money by prostitution' (Yarwood).

Yarwood writes that:

> 'Marsden's water mill was on his land adjoining the female factory grounds. The female factory was a controversial establishment and was reconstructed to Greenway's design with carding, weaving and looming rooms, three storeys high, including single-storey wings to accommodate 300 female convicts. The four-acre site was enclosed by a high stonewall and moat to conserve the morality of townsmen and impose a long-deferred constraint on the inmates.'

Macquarie's explanation for the delay in building the new factory was demonstrably untrue. He claimed he was waiting for Westminster approval, but many of the Macquarie buildings had been commenced and completed without any official approval. Bigge wrote that 'Marsden's lack of criticism of Macquarie's inaction was due to his effort to achieve reform, and not the embarrassment of the Governor.'

The Female Factory and Commissary Operations

The Executive Council Minutes of 15 August 1826 confirmed that it was Darling who proposed a change in the Female Factory operations. The Female Factory Board established by Darling to examine the overall Convict operations, especially those of the Female Factory at Parramatta, included Major Ovens and William Lithgow. The Board's recommendations included a change to rations for female prisoners. Convicts had been assigned rations based on their classifications. First and second class prison rations included tea and sugar and slightly higher quantities of meats and greens. Instead of being issued rations as if female factory workers were in the third or penitentiary class, they were to now have even less. On a weekly basis, they were to receive:

> ¾ lb of bread (half wheaten and ½ Indian corn); ½ lb fresh meat; 1 lb green vegetables or ½ lb potatoes; 1 oz corn meal to thicken soup; 8 oz corn meal for breakfast and supper; 1½ oz. sugar; 1 oz. salt.
> No milk was authorised and corn meal was the substitute for flour.

Personnel arrangements were revised so that salaries were paid to supervisors instead of a 'percentage' as was previously the case. Average percentage payments had been added to a salary base in order to set overall salaries at no less than the previous six-monthly average payments. In fact after over three years of no increases, salaries were adjusted by about 20%[36] in 1825.

The Board acknowledged how difficult it had been to replace the Factory Storekeeper (the previous occupant of the dual role of Storekeeper and Factory Secretary having resigned). Allowances for this position had previously been £180 per annum, but the replacement was only to receive a fixed salary of £100. Since there had been no applicants at that salary, the Board decided to revise the overall salary scale so that the Matron would in future receive £200; the Storekeeper/Secretary £150; and Master Manufacturer £150.

The Board had made this latter appointment in the previous year when the original Operations Report was completed, in order to co-ordinate manufacturing standards and output with the commissariat. The Female Factory had also reported a lot of waste in washing the wool, spinning and carding and then weaving. The Master Manufacturer was now responsible for machine maintenance, productivity, materials management and transporting finished product to the Commissariats responsible for convict blankets and clothing.

A Government Notice dated 27 June 1826 encouraged matrimony for Female Factory inhabitants, in order to get them out of the Factory and create room for newcomers, as well as getting more persons 'off the store'. The Notice encouraged assignment for good behaviour:

> *'To husbands who were newly arrived in the colony (for women who had married in England)*
> *To free men who married prisoners, since their arrival*
> *If both husband and wife were prisoners, they would be assigned to the same master*
> *No female prisoner being married to a free man or ticket-of-leave male was to be kept in the Factory*
> *All prisoners who sleep out of barracks would be allowed to work for themselves on Fridays and Saturdays.*
> *All prisoners who sleep out of barracks are to be regularly mustered before proceeding to the gangs to which they belong*
> *To assist in the public accounts it is planned to issue rations, to those who sleep out of barracks in arrears instead of in advance and such rations will be issued at the controlling barracks and not directly from the Commissariat.'*

[36] Salary table with comparisons HRA 1:14:526 Minute by Darling

Obviously bookkeeping simplification was required to keep records of rations issued and to stop these types of prisoners receiving double rations from different issuing points.

William Lithgow and Alexander McLeay responded to Governor Darling's request for financial information on 23 November 1826. Whitehall had enquired as to the actual cost of maintaining convicts in the colony, and Lithgow as Colonial Auditor-General responded with typical detailed accounting. For his response, he included the costs of running:

The office of 'Principal Superintendent of Convicts'
The prisoner's barracks at Sydney, Parramatta, Liverpool and Newcastle (including Carter's Barracks for Boys)
The Female Factory at Parramatta
The penal settlements at Port Macquarie, Moreton Bay, Norfolk Island and King George's Sound
The Agricultural Establishments at Grose farm, Long Bottom, Rooty Hill, Emu Plains, Bathurst and Wellington Valley
The Medical Departments at all stations, where colonial hospitals had been established
The Police & Gaol Establishments and the Judicial Department

According to the Lithgow Report, the actual cost of these seven operational areas for convicts came to £15,500. These expenses were defrayed from the 'proceeds of bills drawn on H. M. Treasury'. The cost of the Female Factory at Parramatta was £850.00 per annum, for an average of nearly 500 female prisoners. Food and rations cost was borne by the commissariat so the 'establishment' cost referred to was simply salaries and minor maintenance work. The result was a rather meaningless figure that could not be benchmarked to any other costing or, in fact, a guide as to efficiency by any British Treasury directive.

The Origins of the Dockyard

King advised the 'Victualling' Board, in London on 16 May 1803;

> '...the Commanders of Ships are requested to sent Boat Bills (i.e. Bills of Lading) of the articles sent in each boat, since a person belonging to the Commissary Department is constantly on the landing wharf, and he gives receipts for the specific quantities landed. Bills are delivered to the Deputy Commissary, who accounts finally to the Commissary-General, and the masters of the ships' expenses in charge of the provisions produce the receipts, when the whole are landed. On producing those receipts, the numbers of casks stated by the commissary were found to be deficient or rather no receipt was produced by the Purser.'

Land- clearing Gangs

Major Ovens arrived in the Colony with Governor Brisbane and, as the new Superintendent of Convicts was assigned the task of organising convict work gangs to produce better outcomes and productivity. He reported to Brisbane in 1824 and recommended that 'clearing' gangs (for clearing land before sale) be split into two divisions, each under a Superintendent, who in turn would be responsible to the Chief Inspector and Chief Engineer. The Southward gang would be headquartered in Liverpool, whilst the Northward gang would headquarter in Rooty Hill.

Ovens reported that the food, clothing, sugar, tea and tobacco rations made available to the 1,150 convicts working on the gangs amounted to approx £23,000 whilst the value of the wheat which could be grown on the 9,000 acres cleared would also be £23,000 (at six bushels per acre and 8/6d per bushel). Ovens noted that a certain amount of the timber being cleared was suitable for milling and would arrange for its transportation to the Lumber Yard. He was justifying to the end buyers the value of the clearing work was not an addition to the selling price of the land per acre, but an increase in the yield of grain produced. He recommended that 23 men be included in each gang under one supervisor, with 50 gangs in total (making 1,150 convicts in all). The amount of clearing by each gang was to be 15 acres monthly or 180 acres per annum, or 9,000 acres per annum in total. The incentive payments to each supervisor was 3/6 per acre, and to each convict was ½ lb tea, 6 lb of sugar, 10 2/3 oz of tobacco.

The significance of the Ovens plan is that he reorganised convict work practices on a cost-benefit basis, but in doing so used invalid assumptions. With the assignment system being current government policy whereby any settler was entitled to as many convicts as he could maintain and employ, there was little demand for 'cleared' land at a higher price when in the master's eyes, he could clear his own land and at the same time employ his own labour. However, Ovens' overall analysis and reorganisation of convict labour should have been seen by the British government as a reason for valuing the output of convict labour on government assignment and instead of trying to cut maintenance costs, to offset benefits of public infrastructure programs with the monetary costs of utilising this source of low-cost labour

Establishing and Operating the Government Farms

Governor Hunter had set the pattern for later government farming when in June 1797 he wrote to his Lt.-Gov and stated, 'I trust I shall soon have as much ground in cultivation on government account as will prevent the necessity of purchasing to such an extent from individuals, grain of any kind'. So Hunter accepted the role and necessity of government farms and passed this same philosophy onto his successor, Governor King:

> 'Your shortage of public labourers to cultivate the extensive quantity of public land set aside for such purposes (Hunter had previously advised the public land to be cultivated is one-third more that that land in possession of all civil and military officers) will mean that the many buildings you are in need of will not be constructed if you use labour for cultivating rather than building. Your approach calls for such radical reform as may affect a system of real and substantial economy, and confine the issues from the stores such as to eliminate individual production'.[37]

King took a particular interest in agriculture – not as an academic exercise but as a necessity of life in the colony – the regular production of foodstuffs, grain and meat in sufficient quantities to meet projected demand in a growing settlement together with strategic reserves for emergencies when floods and droughts impacted on the settlements. King also took a forward-looking approach to the use of Crown timber. He could envisage the productive use of the enormous quantities of standing timber that was being carelessly axed to open up land for grazing when a better system of timber preservation and a grazing use of naturally open pastures could be adopted.

Timber of useable quality was not to be found around Sydney Cove, so Phillip brought pine from Norfolk Island until he found good stands of eucalypts, blue gum, black-butt, flooded gum and box around the upper reaches of Lane Cove River and Middle Harbour. These logs were so heavy (and unable to float) that they had to be cut to length on site for moving by boat.

There was plenty of good stone and clay for building purposes, but again the shortage of skilled labour made these materials unusable in the early days of the colony. Bricks came

[37] Hunter had corresponded frequently with his Secretary of State for the Colonies – The Duke of Portland and in August 1797, the Duke responded to Hunter: -

more into use in 1789 when the early timber constructions were decaying and in need of replacement. Roofing tiles became necessary to replace grass or reed thatching previously used for storehouses as less flammable materials were needed to protect the valuable foodstuffs and other stores. Collins records that the living huts were constructed from pine frames with sides filled with lengths of cabbage palm plastered over with clay to form 'a very good hovel'.

In the colony, close confinement was neither necessary nor practical and, except for hospitalisation, most convicts before 1800 had to find their own shelter. Building huts for convicts had not been part of official building policy, although some huts were built especially for convicts. In Rose Hill for instance, Phillip designed and built huts as part of his town layout. Since the sawn timbers were used for officer accommodation or public buildings; convicts building their own huts would use saplings covered with a mesh of twigs and walls plastered with clay (mud and daub). Convicts were not given any special access to the limited quantity of building supplies, such as ironmongery and glass, which had been brought from England so that windows were covered by lattices of twigs. The best buildings in the town were those for Government use, such as the stores, the barracks and the hospital and housing for officials. Only when convicts became free or went on ticket-of-leave status was there any call or need for private building and a building industry began to emerge.

Early Convict Organisation under Successive Governors

When Phillip returned home in 1792 his successor as interim Administrator (Major Grose), pending arrival of a new governor, reallocated convicts to officers and small farmers and succeeded in depleting the government work gangs which could only complete public works by paying soldiers one shilling a day. 'With the depleted government gangs and with no firm direction', Bridges writes that roads and buildings were neglected and fell into disrepair. For lack of barracks, soldiers built their own homes along the road to the brickfield. David Collins reflected on the difficulties of the time:

> 'To provide bricks for the barracks, three gangs, each of 30 convicts with an overseer was constantly at work. To convey materials from the brickfields to the barracks site, a distance of about ¾ths of a mile, three brick-carts were employed, each drawn by 12 men and an overseer. Each cart held 700 tiles or 350 bricks and each day, the cart made 5 loads with bricks or 4 loads with tiles. To bring the

timber to the site, 4 timber carriages were used, each drawn by 24 men. So 228 men were constantly used in heavy labour in the building of a barracks or storehouse, in addition to the sawyers, carpenters, smiths, painters, glaziers and stonemasons'.

Bricks were used mainly for government buildings or official houses because of the cost, while private housing continued to use timber framing. Private buildings activities increased and slowly improved and in the year following Phillip's departure 160 houses were built in Sydney, with an allowance of 1,400 bricks per dwelling including the chimney and floor. When Hunter finally arrived, public works had slumped and his first action was to plaster soft brick buildings as some protection against wind and rain. He ordered the collection of foreshore shells for lime making and plaster. In a map prepared by the Frenchman Leseur in 1802 some 260 houses are identified, but in 1804 an official count listed 673 houses in Sydney, indicating a rapid building program between 1802 and 1804.

King again wrote to the Duke of Portland in July 1801, trying to re-state his position on government farms: -

'Although I have been obliged to rent a large farm to employ the government convicts on, and the rent is to be paid from the produce, I have no doubt of its turning out very advantageous. I have previously described how very circumscribed government cultivated lands are, and the cause of it. I am now beginning another farm for the Crown and shall take care the grants of land are not made so as to exclude government from the ground cleared by the convicts at public labour, which had been the case at Toongabbie and Parramatta, to the great accumulation of expense to the public'.

Later in August 1801, King reminded the Duke:

'As the land at Toongabbie and Parramatta (being only 380 acres) had been improperly leased and granted to individuals, perverting Gov. Phillip's plan of concentrating the labour of government servants to one place, which would have greatly facilitated the public work and interest, instead of employing the convicts at public labour in detached situations, and not having people to direct their labour and secure the produce of it without incurring much additional expense.'

King advised that Toongabbie and Parramatta were to be closed because the soil was 'of the most unproductive kind', and he was moving the farm to a location selected by Phillip (Castle Hill), where 'the soil was of the best and most productive kind. 50 men have been clearing the land and much public benefit will be realised in raiding grain and feeding government cattle'.

After King's energetic administration, Bligh's government was not very interested in agriculture. An earlier report had outlined the minimal cost of guaranteeing food supply by government in the face of regular floods and droughts. Government storage was an important part of the government farms plan and, in economic terms, it was cheaper for the government to maintain its own team of convict labourers and produce its own grain, vegetables and meat for commissariat use, and even resale when appropriate, than rely on the private sector and pay above market prices in a competitive market. But the Colonial Office did not see it that way. King had set down the facts about government farms some four years before Macquarie's arrival. He had prepared a comprehensive report on the state of the colony on 12 August 1806, [39]in which he described the status of the government agricultural farms.

> *'Cultivation on the public account is confined to the agricultural settlement at Castle Hill, where only 177 convicts are employed, the remaining 1,774 full rations victualled being composed of the civil, military, stockmen, artisans, and others employed at necessary public works, with the women, children, invalids and aged (who) do not productive labour in agriculture on the public account; nevertheless that object has continued on the part of the Crown, which goes to prove the disadvantage of any cultivation on the part of the public. By the annual muster, taken August 1806, the land in cultivation for the Crown was 330 acres, and 854 acres being worn out by repeated and constant cultivation, and the want of labourers to till it. The government herds will in time remedy the first evil, but the others will continue to diminish or increase in proportion as the convicts now in the colony sand those sent in future may be appropriated to public labour or assigned to individuals. It seems advisable to encourage the latter, which eases the public of a very considerable expense; but relinquishing public cultivation entirely, and depending on that of individuals, will be far from beneficial to the interests or safety of the colony.'*

King reported that land grants and leased land amounted to 84,465 acres of which less than 11,227 were under private cultivation. There was a further 19,768 acres cleared of timber, leaving 15,000 acres fallow and in pastureland and reserves. On the question of livestock, King reported that cattle were from the Cape and small buffalo from Calcutta, with the most valuable cross being the Cape and Bengal cows mated with an English breed sent from St. Helena. He further noted that as of August 1806 there were 552 horses, 5286 cattle, 21457 sheep, 2358 goats and 6988 swine, in the colony. The swine numbers had dropped from 23,000 a year earlier, apparently due the great flood in March 1806. By this time, convicts had ceased being the draught men, and instead, over 100 oxen, belonging to the government,

[39] HRNSW Vol 6, page 135

were yoked and did much work in ploughing and hauling timber carriages, wagons etc, which saved much manual labour. King referred to the levels of grain in storage in the colony:

> *'For the number necessarily victualled from the public stores, there remains in the government stores, sufficient wheat (and maize being harvested) to last until July 1807 (i.e. less than 12 months supply). Vegetables are also scarce, with turnip-seed and cabbage being in reasonable supply and seeds being provided to individual gardens for additional support to offer food supplies.'*

Table 5.71: Summary of expenditures in the colony between 1800 and 1806.

'Stores, clothing, provisions for the commissary'	£ 87,477.14.09
'Bills drawn by commissary on treasury'	£186,431.02.11
'Cattle on hand, belonging to the Crown'	£ 36,317.00.00
'Value of inventory in government stores'	£180,246.13.06[40]

This submission by King was following the precedent of other governors in trying to estimate for the British Treasury the 'wealth' of the colony. In their mind the estimate of wealth needed to match or exceed the 'investment' made by the British Treasury in the colony. However, as Coghlan found some 85 years later[41], the estimation of wealth was a flawed exercise and in essence quite meaningless, since the admonition by Treasury to the governors was to make the colony self-supporting and the British government would only be delivering, at their expense, the convicts into Botany Bay. The Treasury wanted to reach the exalted plateau, where every 'local' expense, other than this 'delivery' cost, would be met by the colonial administration funds. King decided that the only way to meet these goals was to raise 'local' revenues, although he hoped that there would be an element of discretionary expenditure available to the governor.

King advised his Secretary of State for the Colonies, Lord Hobart, of progress in other government-operated sidelines – the Crown had sent hops and brewing equipment for a government-owned brewery at Parramatta; barley and hops were bartered from local settlers for the same purpose, while encouragement was given to the local growing of hops and grapes. King visited the Cow Pastures – 18 miles beyond the Nepean River – and recorded seeing 'streams sufficient for water-mills, and an abundance of feed and water for livestock'. In the Cow Pastures he also saw the wild cattle which had escaped some 10 years previously and now numbered about 630 head[42]

[40] This figure includes the value of cattle loaned to private farmers, the value of private buildings, the value of clothing, grain (in store and growing), and debts due to the commissary for barter and sale items less store receipts issued.

[41] T. A. Coghlan *Labour & Industry in Australia*

[42] It took a number of years before Governor Macquarie decided to capture this government owned livestock and two years to round up and pen these 'wild' cattle and the majority were slaughtered for sale as fresh meat. Macquarie estimated their value to the colony as over 17,000 pound. Macarthur had demanded part of the Cow Pastures as his special grant of land and caused long delays in the recapturing of the wild cattle by claiming 'ownership'. His claims were dismissed sand title remained with the government.

The mills operated in the Sydney and Parramatta settlements were both wind and water mills, and could grind sufficient grain to meet the weekly ration requirements of 8 lb of meal to those victualled by the Crown. King observed that 8 lb of flour made 10 lb of bread, which 'had we public ovens built[43], would be a saving of one pound of flour on each full ration, using Hobart's suggestion that an allowance of 9 ½ lb of bread be made each week. King also advised that potatoes and yams had been grown on public land at every opportunity (since 1788). Such plantations were maintained on public lands at Castle Hill. 'The yams being eleven months before they come to perfection, the cultivation of potatoes is preferable, as two crops a year of that root is not uncommon.'

Lord Hobart had suggested that public farms should be minimised in favour of private farming. King responded that 'the greater part of improved land should be kept for pasturage and the stock of government cattle should be regarded as the foundation of the stock of individual settlers'. King also added that:

> '...before I left England, I was directed to promote the public cultivation, and encourage that of individuals. To this end, I hired the Hawkesbury Farm in 1801, and began clearing the public agricultural settlement at Castle Hill in August 1802, where there are now 700 acres of ground cleared and durable stone buildings erected upon it. 350-400 convicts are employed at public cultivation. The result is that at present (1st March 1804) the government has a store of 11,000 bushels of wheat and maize of 7,000 bushels. After deducting 1200 bushels of wheat for seed, this leaves only 4 months reserve of grain'.

The Convicts at Work in 1806

We learn from Governor King's Report to Earl Camden (which due to a change of office holder, should have been addressed to Viscount Castlereagh as Colonial Secretary) dated 15 March 1806 that the convicts engaged in widely diverse work. Large-scale employment of convicts by government was not the preserve of Macquarie. Governor King had set a major part of the convict population of 1806 to work on government activities. A Report on employment of convicts was sent to the Colonial Office, as Enclosure #2 and is entitled

[43] This same argument was later used by Commissioner Bigge when he recommended (Report to the House of Commons # 3- 1823) that it would be more efficient use of grain if contracted bakers were substituted for government bakers in making bread for official uses such as the hospitals. King had supported public employment whilst Bigge supported privatisation

'Public Labour of Convicts maintained by the Crown at Sydney, Parramatta, Hawkesbury, Toongabbie and Castle Hill, 1805':[44]

Table 5.8: **'Public Labour of Convicts maintained by the Crown at Sydney, Parramatta, Hawkesbury, Toongabbie and Castle Hill, 1805'**

Cultivation - Gathering, husking and shelling maize from 200 acres sowed last year - Breaking up ground and planting 1230 acres of wheat, 100 acre of Barley, 250 acres of Maize, 14 acres of Flax, and 3 acres of potatoes - Hoeing the above maize and threshing wheat.
Stock - Taking care of Government stock as herdsmen, watchmen etc

Buildings -
At Sydney: Building and constructing of stone, a citadel, a stone house, a brick dwelling for the Judge Advocate, a commodious brick house for the main guard, a brick printing office
At Parramatta: Alterations at the Brewery, a brick house as clergyman's residence
At Hawkesbury: completing a public school
A Gaol House with offices, at the expense of the Colony
Boat and Ship Builders: refitting vessels and building rowboats
Wheel and Millwrights: making and repairing carts

Manufacturing: sawing, preparing and manufacturing hemp, flax and wool, bricks and tiles

Road Gangs: repairing roads, and building new roads
Other Gangs: loading and unloading boats"[45]

Thus the total benefits from these six (6) items of direct gain to the British comes to well over £174 million, and this is compared to Professor N. G. Butlin's proposal that the British 'invested' £5.6 million.

However, in 1810 Macquarie offered his advice on government agriculture to Viscount Castlereagh.

> *'Your Lordship entertains doubts as to maintaining government farms or government cattle in the colony, but from what I have seen for myself I conceive it will be highly desirable to continue a stock of government cattle for several years to come, and also a government farm on a limited economical plan'.*

In response the Secretary of State urged Macquarie to see 'that every department of the government farm was managed with the strictest economy'. The scheme was not popular at

[44] HRNSW - Vol 1 Part 2 Page 7 Enclosure 2 King to Camden 'Public Labour of Convicts maintained by the Crown at Sydney, Parramatta, Hawkesbury, Toongabbie and Castle Hill, for the year 1805'
[45] HRNSW -Vol 6 P43

the Colonial office, and soon, on 18th October 1811, Macquarie advised London that 'he had totally abolished the government agricultural establishments'[38]

Thus Macquarie's decision brought to an end an experience with public agriculture which was appropriate enough for its time but which had obviously run its course in the then climate of vicious cost-cutting for any and all colonial operations. This new policy was short sighted and would come back within a few years to add to the political woes of not only Macquarie but also the Colonial office. Due to food shortages, Macquarie was forced to reinstate government farms and government food production in 1815. The ill-considered policy of relying totally for strategic support in food production on the private sector was not aligned with other government policies. The farmlet approach to grain production and other foodstuffs, initiated by Phillip, was suitable only for a population of 1-2,000 in the colony. Macquarie's population was ten-fold that administered by Phillip, but even the broad acre approach by Macquarie was presently unsuitable. Macquarie needed a comprehensive plan of market-oriented prices offered by the commissariat, and since farm to market roads were far from reliable or passable at most times, the commissariat would need to find storage in the grain growing areas rather than require the farmers to deliver to Sydney.

The commissariat could do well by providing seed grain for farmers, instead of them withholding portion of their crop from the market. The commissariat could dispose of dirty grain or unmillable grain for planting purposes and purchase the best quality from all farmers at reasonable market prices.

Summary of Chapter 5

The Commissariat was the manufacturing centre for the colony and the Lumber Yard was its hub. In terms of physical output through both convicts and supervisors employed, the Lumber Yard was the key to the success or failure of the commissariat in the colony. The overall operations of the commissariat were earlier discussed in Chapter 2, but in this chapter the detailed operations, output and staffing of this key work centre have been discussed, especially in the context of the commissariat being an 'economic driver' in the colony. In addition to the

[38] HRA 1: 7: 339 Bligh to Castlereagh

highly influential financial services role played by the commissariat, the government store maintained responsibility for food production planning and supplies, a wide range of manufacturing operations from equipment to tools, to clothing, building materials, and commodities.

The commissariat was the powerhouse of economic activity in the colony as well as the catalyst and facilitator for large amounts of public investment. Without the commissariat acting so responsibly, the colony could not have grown and matured as it did. Neither the private nor rural sectors could have developed as they did, mainly, without assistance by loans to farmers and pastoralists of breeding stock leading to the upgrade of livestock suitable for the export market.

Nowhere was the commissariat more important than its personal encouragement of a manufacturing industry, which became an important source of import replacement and encouraged British industry to invest in or transfer to the colony. The commissariat assisted private industry, in conjunction with the training program instituted by the adult education program of the government, and the transfer from the public to the private sector of many items of manufacture. The transition of the store through many phases of colonial economic growth was an important vehicle for the dramatic development of the colony. The commissariat was on hand to assist in the barter system, the store receipts system, the farming of a new range of vegetables, grain and livestock, and the creation of financial systems that allowed future governments access to the London capital markets.

The importance of the government store can be seen from the effect any contraction or expansion of commissariat expenditures had on the colonial economy. The commissariat payments by Treasury Bills regularly eased the coin shortage in the colony, but the most telling aspect of the commissariat importance comes from the 1812 *Select Committee on Transportation Report.'* Settlers had no market but that of the government; government purchased from them what corn they wanted for the feeding of convicts on the hands of the Crown.[29] Robert Campbell estimated government demand for grain as 60% of the total and increasing in relative importance.[46]

[29] *Evidence by Governor Hunter to the Select Committee on Transportation* 1812

None of the historians describing the commissariat in their literature disagree that the commissariat was the first colonial bank. What has been missing in the various texts is the impact of the commissariat as an early financial institution. There were a number of 'pre-Treasury' financial institutions, and each had a specific role to play and contribution to make.

[46] Steven, Margaret *Merchant Campbell*

CHAPTER 6

ACCOUNTING AND REPORTING
(FROM THE FUNDS TO THE BLUE BOOKS)

Introduction to Chapter 6

In 1788, one goal of the Governor was to achieve self-sufficiency even though it was a penal colony. By 1823, the British Government had decided to limit its direct expenditure on relocating prisoners from Britain to the colony to the costs of transportation of the convicts, their victualling during the voyage and supplies. The colonial administrators would be responsible for the security and accommodation of the convicts upon arrival, whilst the commissariat would be responsible for food and clothing in the colony[22]. The proceeds from the sale of Crown land were to be the exclusive reserve of the British authorities, and not that of the colonists. In fact, Governor Brisbane was instructed that the newly formed NSW Legislative Council, a body appointed to advise the governor, was not to have any authority over or become involved with any aspect of Crown lands. Each of the governors (from Phillip though to Macquarie) had employed the convicts for growing food, extracting minerals (e.g. coal production), clearing land, developing roads, and building housing and public buildings. They paid their own way but no British government saw it in those terms. By 1796, government convicts were being assigned to landowners on a fully-maintained basis, thus saving the British Treasury a great deal of money. The whole purpose of such transfers was to move as many convicts as practical off the government work rolls into the private sector, where they were fully maintained by their masters.

This policy of Government maintenance of convicts created the need for the colony to set up accounting procedures to keep the British Parliament informed. This would require the appointment of a Treasurer acting as a Financial Controller, who could prepare monthly and annual reports to the British Colonial Secretary. Following responsible government in 1856, these procedures changed as the colony became fully responsible for their own economic planning and fiscal management.

[22] Although this was a charge on the British Treasury, it was spread between a number of budget items and responsibility areas

Colonial Accounting in NSW

The colony went through two stages before adopting the standards recommended for the 1822 *'Blue Book'*, which replaced the privatised colonial accounting through the 'Gaol/Police' and' Orphan' funds. These two phases were the Gaol and Orphan Funds before 1810, and the Macquarie-promoted Police and Orphan Funds of 1811-1821. The financial statements of the latter were published quarterly in the *Sydney Gazette*, after a cursory glance, officially an 'audit', by the Lt-Governor. The Gaol fund was a record of funds raised by a surcharge on the citizens of Sydney town, as a means of completing the construction of the Sydney gaol, which had burnt down in 1798. The voluntary collections fell far short of the funds needed, and the partly completed gaol required official support, by Governor King misappropriating funds from the General Account for a short period until they were replenished by locally raised revenues. From 1802 customs duties were imposed on imports (especially spirits) and, since the gaol had been completed with government monies, these local revenues were reported in the 'Goal fund', but the fund was later renamed the Police fund. In 1802 the Orphan Fund started; it had as its source of funds a share of the customs duties on spirits and tobacco. In 1810 it was re-named the Orphan School Fund with the intention of creating a fund to erect the first school building in Sydney town. The advisory Legislative Council was appointed in 1823, and the first Appropriation Act was passed in 1832 under the guidance of Governor Bourke. In the interim, the governors passed annual 'messages' of the financial condition of the colony to the members of the Council.

The colony adopted the standards recommended in the 1823 *'Blue Book'*, which replaced the 'gaol' and 'orphan' funds. The 'gaol' fund was a record of funds raised by a surcharge on the citizens of Sydney town, as a means of completing the construction of the Sydney 'gaol'. Once customs duties had been imposed on imports and the gaol had been completed with government monies, the fund was renamed the 'police' fund. The orphan fund recorded the customs duties on spirits and tobacco and was later named the Orphan School Fund with the intention of creating a fund to erect the first school building in Sydney town for the education of the large number of orphans roaming the streets.

Upon self-government in 1851, government accounting procedures were again revised, since the colony was now fully responsible for all its fiscal policy. At this time, gold was

discovered and license fees, duties on exports of gold and duties on the domestic conversion of gold were applied, helping to fill the Treasury coffers. The first Appropriation Bills and 'Ways and Means' were introduced by Governor Bourke in 1832 and passed through the NSW Legislative Assembly. This was a major step forward in Government economic planning, as was the limited deficit budgeting that commenced at this time. Deficits were short term and recovered usually within five years, although the colonial debt, mainly to overseas bondholders was kept very much in check after the surge of investment in railways and telegraph services.

The first written instructions [6] required appropriate record-keeping in conformance with information being received from other colonies:

'It is highly necessary that a yearly return should be made and signed by the governor of the settlement, or the person administering the government thereof, of all births and deaths within the settlement. A like return should be transmitted of all provisions, clothing and stores annually received for the use of the settlement; and you will, therefore, not fail to regularly transmit such return to the secretary of state for this department, and to the Lords of H.M Treasury, with the commissary's returns of their distribution, under separate heads of clothing, stores and provisions. The distribution of the provisions should appear in a victualling book, which should be kept by the commissary, in like manner as is usual with pursers in the navy, bearing the persons on separate lists, where their rations differ, the title of each list expressing the ration; and the ready-made clothing should be distributed in the manner above mentioned; and a regular account, both as to the time and the numbers, mentioning their names to whom it is distributed, should appear in a yearly return of clothing' [7]

By the 1820s, this simple system had been entirely overturned and Governor Darling was able to advise Earl Bathurst that the commissariat was now so complex that it had responsibility for many departments within the public service of the colony.

Table 6.1: Commissariat Responsibilities Transferred to the Military in 1813[8]

Public Works and Engineering	Ordnance
Dockyards	Surveyor-General
Clothing, bedding and utensils for the convicts	Mineralogical
Observatory and Trigonometrical survey	Clothing for Mounted Police and Orderlies
Civil and Medical	Horticulture

[6] Commissary-Generals Instructions to Colonial Officer 1808

[7] Further discussion of the Governor King instructions, the Treasury instructions and Colonial Office instructions are to be found in the next Chapter of this study.

[8] A discussion of the military role and the rise of the public service in the colony, which included the establishment of numerous Government Departments, are to be found elsewhere in this study.

Darling also suggested that theft could account for a proportion of the growing cost of commissariat operations:

> *'The loss by theft has been very great, particularly in nails and other articles of iron. When articles are purchased on the spot, the expense is enormous; every argument is therefore in articles of stores being sent out from England, rather than depend on our means of making them or on the supplies of merchants who require large profits.'*

Darling was turning the clock back before the Macquarie era. Governor Macquarie had observed the growth in import replacement products and free enterprise in the colonial economy, as well as the growth of the merchant class.

The Cost of Keeping the Convicts
The commissariat provided of all material items required in the colony, from food supplies to tools, and the British Treasury was continually seeking ways of controlling and cutting colonial operating costs. The largest portion of colonial expenditures was the cost of maintaining convicts. The challenge of computing the cost to Treasury of keeping the convicts in the settlement is a complex one.

A first step would be to estimate the number of persons on rations, estimate the cost of rations and compute a total cost per head. However there was not one single ration but a number of different categoriess.[30] Hard-working men in the service of the government received the full ration without tea or sugar, men of age or infirmity who were incapable of work received less, and the ration for men returned from settlers because they would not work was to:

> *'Be limited both in quantity and quality to the smallest ration consistent with the support of such individuals. In fixing the ration, it is important that it operates as a punishment to the men without permanently endangering their health*'[31]

On the other hand, convicts designated as working in a harsh occupation were given 1½ or even double rations. There were also civilian rations for government employees, military rations for officers, military rations for other ranks, rations for Female Factory workers and rations for the children of the convicts. Substitutions and changes were authorised. The Under Secretary of the Treasury advised the State Department 'the substitution of corn, for

[30] HRA 1:11:135 Bathurst to Brisbane
[31] HRA 1:11:140

Indian Maize, or wheat, would give stimulus to the cultivation of land, and create a demand for the labour of convicts'. This had originally been recommended in Commissioner Bigge's report. The next suggestion was the elimination of tea and sugar from the rations but this decision created a black market in these two precious commodities.

In fact, if what would be considered an average ration for each category of person victualled could be determined, as well as an estimate of the average number of persons victualled, the remaining obstacle would be to discover the prevailing price of provisions. Grain purchased in the colony was a very different price from imported grain, whilst provisions might be fresh or imported (salted meats etc), and some self-provisioning occurred when the convicts were encouraged to grow their own vegetables. Certain convicts were encouraged to find board and lodging in private houses, rather than the convict barracks, while were given monetary allowances instead of actual rations and could buy what they liked.

According to a Return of Convicts employed in government establishments, on 2 April 1830 there were 358 mechanics and 1169 labourers, making a total of 1527 convict men working for the government. They were employed in various remote convict settlements including Port Macquarie, Moreton Bay, Norfolk Island, Port Raffles as well as road and bridge gangs. They were working in irons and on the Tread Mill at Carter's barracks in Sydney. A number were described as invalids, cripples and idiots and there were boys at Carter's Barracks who worked and were housed in separate accommodation. On 1 January 1830, a total of 4879 convicts were provisioned by the Government.

Location made it difficult to provide equal rations. The road gangs were often provided with one set of rations in the field and, because of poor record keeping and inadequate supervision, they would receive a further ration when they returned to their huts or barracks. Numbers were continually changing: the return of convicts for 1828 showed 1,918 convicts working, even though there were only 4,877 convicts in the full count.[32] In addition to food rations, convicts in each location received issues of clothing and bedding once each year.

[32] HRA 1:11:145

In determining the cost of keeping the convicts it is necessary to track total costs through the '*Blue Books*'. However, what should be treated as a cost for keeping convicts? It must be remembered that there was an 'opportunity' cost of keeping them in British prisons and it was actually found that the cost of maintaining prisoners in the colony was significantly cheaper per head than in England.

In the *Blue Books,* expenditure was listed under headings such as Public Works (including costs of tools and convict work clothing), Police Establishment (including the apprehension of 148 escaped convicts; fuel for the gaol cells and food for prisoners), Commissariat (including rent for store houses), the Parramatta establishment (including superintendents), the Windsor establishment (including cost of carrying convict baggage)and Crown livestock (including three bulls, and the costs of the castrator and stockyard). In other words, the early goal of maintaining the convicts for less than 4 pence per day was affected by and complicated through many innovations, such as food production within the colony, import replacing supplies and provisions made in the colony and regular changes of rations. In addition there was the question of fluctuating commodity prices and changing numbers being victualled.

Further complications arise from the distribution of costs between the accounting of H.M. Treasury and the Colonial Fund. Naturally, the benefits of the work carried out by the convicts must have offset the cost of maintaining them. These benefits included the public building and infrastructure program and the land improvements (the clearing gangs) from which higher land sale prices were achieved. The benefit of exports to Britain from the colony was a further gain but it cannot easily be measured, since the value of colonial trade lay partly in the security of supply it afforded Britain, especially in war time. Britain also imposed duties on imports from the colony, increasing the cost of doing business in the colony, as well as revenues for the British Treasury.

Valuing Convict Labour

As has been noted earlier in this chapter, colonial record-keeping and financial statements allocated no value to convict labour. Initially this may have been an oversight on the part of the British Treasury, but it is more likely that the exercise of 'valuing' convict labour was just

too difficult to compute and it was not regarded as a cost benefit exercise of any worth. For instance, how was the commissariat to value coal, extracted from the coalfields of Newcastle? 'Mining' convicts had been assigned to the AAC (Australian Agricultural Company) and their only cost was maintenance paid by AAC. Coal production was significant; the AAC colliery in Newcastle increased output from 5,000 tons in 1831 to 12,000 tons in 1835 and 30,500 tons in 1840. It was only in 1840 that convict labour was found not to be as productive or as suitable for mining work as private contractors. Coal was shipped to Sydney and sold through the commissariat. Initially, zero 'cost' was recognised, although revenues were identified and recorded.

A similar situation occurred with bricks, tiles and timber. Convict work gangs dug clay for the three brickfields around Sydney and Rosehill, making over 30,000 bricks each week. However, apart from the commercial sale of bricks, tiles and timber framing, no 'value' or cost was attributed to those materials used in public buildings.

Even the products of the commissariat's own manufacturing centres, such as government farms, livestock areas, stone quarries or the Lumber Yard never had a value assigned to them. Products from the Lumber Yard, the farms and the female factory are identified above, but had no value other than in the market place when excess or surplus product was available for retail. In line with no convict output having any value, convict labour itself also had no value. Convicts were sometimes hired out to settlers for specific work; a daily rate was charged for this labour and the money collected was allocated to general revenue.

The Accounts Branch of the Colonial Commissariat

It has been established that the colonial commissariat was a huge operation, employing directly and indirectly nearly 500 people (refer table 8.2) and creating work for nearly 5,000 convicts. Operationally, this huge task was managed well, but what about the accounting for the establishment. Accounting fell into three areas of requirement: accounting for government revenues to keep the commissariat operating efficiently; accounting for all expenditures and revealing where all the government funds had gone; and accounting for the output and assets of the commissariat. These accounting activities revolved largely around the future planning for work and the future planning for purchases to keep all foodstuffs, tools and

equipment in stock sufficient to keep every part of the colony operating. Not every aspect of the commissariat's accounting services was carried out efficiently.

As a way of introducing the commissary accounts for the period 1788 to 1835, an outline of the working of the commissariat's Accounts Branch is to be identified in this chapter. It can be seen from the various instructions on commissariat procedures that the British government (as well as the British Treasury) imposed huge burden on the colonial governors and their officials by insisting that they sign each requisition and authorise the weekly distributions of stores.

It was not until after the arrival of Governor Brisbane in 1821 that 'public' attention was drawn to the fact that the signing of treasury bills and other commissariat accounts was taking up a high proportion of the Governor's time. In a despatch to the Secretary of State[1], Brisbane requested that a 'Public Accountant' be appointed to assist with the fiscal control of the commissariat. In response, Secretary Harrison wrote to William Lithgow, the Commissary of Accounts at Mauritius, directing him to proceed as soon as possible to NSW, where he was to be appointed as the head of the Accounts Branch of the New South Wales Commissariat[2]. It was mentioned that the accounts branch would be established 'or the examination of the military expenditure within that command and for all other expenditures defrayed by the commissariat'. Lithgow was advised he would have three deputy assistants in the establishment of the new branch. Duplicate accounts would be sent to his office from Van Diemen's Land and NSW departmental locations and he was instructed to examine these thoroughly before he sent them to London.

The *Sydney Gazette* reported Lithgow's arrival in Sydney in early May 1824 and then on 27 May it reported that Lithgow had taken up his new office[3]. However, a government notice dated 25 June 1824 stated that the new office had just been established,[4] a month after Lithgow had taken up his position. The notice also set out instructions that quarterly accounts

[1] HRA 1:11:58 Brisbane to Secretary Lushington 20th March 1823: Brisbane submitted a contradictory argument to support his contention of wasting his time. He referred to the charge of theft and fraud against D.C. Drennan and his subsequent dismissal; he referred to a decreased quarterly expenditure by the Commissary; but then pointed out he wished to be relieved of 'the unpleasant responsibility' of countersigning bills, as well as the protracted suspense attendant on these measures'

[2] SRO - copy in Colonial Secretary letter file 1824 (from PRO records and AJCP)

[3] *Sydney Gazette* 27 May 1824

[4] The *Australian* 14th October includes the government notice dated 25th June 1824

and estimates were to be drawn up after the 24th day of March, June, September and December each year. In October, Brisbane wrote expressing gratification that the new Branch had been established[5]. He wrote:

> *'I am happy to bear testimony to the value I attach to Mr Lithgow's services, since his arrival in the colony; as I am sure his appointment will be productive of incalculable benefit to me in regard to the reduction in the amount of the expenditure, as in the systematically arrangements and simplification of the disbursements connected with the whole commissariat department'*[6].

Lithgow was officially appointed as the colony's first Auditor General on 8 November 1824[7]. When Bathurst would not approve Brisbane's request for an additional £50 per annum for Lithgow to attend upon the general accounts of the VDL commissary branch, Brisbane separated the two commissariats and the Hobart store was no longer responsible to Sydney[8]. DAC Boyes was transferred from Sydney to Hobart to head the new independent VDL accounts branch and commenced his new duties in November 1826. The office of Auditor of Colonial Accounts was also instituted in Van Diemen's Land so that the administrative separation of the two colonies was complete. Darling also brought to the colony instructions on the keeping of the colonial accounts which had been issued to all colonies. This approach was intended to make colonial expenditures comparable and, in an overly simplistic plan, attempted to classify expenditures into two categories, ordinary and extraordinary. Two subcategories were required, contingency charges and fixed expenses (rent, stationery etc) and variable (construction and repair of public buildings etc – although such expenditure was uncertain in occurrence and amount). No expenditure over £200 could be incurred under the latter category unless specifically authorised by Treasury. Darling protested strongly on this latter point and argued that, by the time approval was received, any cost estimate might have doubled. Having disagreed with the notion of approval for every small expenditure, Darling put this loophole to very good use in future years.

[5] HRA 1:11:379 Brisbane to Bathurst - Governor's despatch #8. In the same despatch, Brisbane begged Bathurst to allow Lithgow to be made responsible for all colonial revenue, in order 'that he may have the entire financial state of the colony under his eye'. Brisbane wanted to pay Lithgow an additional £100 per annum from local revenue

[6] HRA 1:11:380 Brisbane to Bathurst

[7] Blue Book for 1826

[8] HRA 1:12:124 These changes were incorporated into Brisbane's successor - Governor Darling - and the commission dated 16th July 1825

A similar lack of understanding of local conditions was demonstrated following the Bigge Commission of Inquiry. Treasury recommended that all public works should be carried out by private contractors instead of by convict labour - this would enable more convicts to be assigned to settlers and 'taken off the stores'[9]. The fallacy of this argument was that contractors charged much more than the cost of convict support by the store; there was also a shortage of free labourers and mechanics. In fact, where contractors were used, it was necessary for the governor to provide a number of convicts as labourers.

The instructions to the new Governor (The Darling Commission) ran to 20 pages[10] and mostly refer to the establishment of a Lands Board, the sale of public lands and the use of revenues therefrom as well as changes to be made to accounting and recording of transactions in the colony. Lithgow raised a concern about the inefficiency of commissariat record keeping and recommended additional records be maintained.[11]

In 1826, Lithgow's successor as Commissary of Accounts, George Maddox (like Lithgow, transferred from Mauritius Commissariat), was charged with keeping a set of 'nominal ledgers' for the several convict, gaol, hospital establishments and the female factory, in which the name of every person ascertained by muster (on the 25th of each month) as actually entitled to receive rations was to be recorded. These records were maintained from 1828 to 1831 when Governor Bourke found them to be 'totally useless'.[12] Bourke found that the keeping of such records required a great many efficient clerks, although McMartin in *Public Servants & Patronage* appears to justify the increasing numbers of support staff (total establishment) involved[13]. McMartin relates clerical assistance in the commissariat to total population numbers and finds that in ratio terms the clerical numbers had to increase annually and this is exactly what happened in practice. After 1840, the accounts branch in NSW became of little importance after 1840 and it was reduced from 11 to only four persons. It was expected the Department would be abolished and this eventually took place in 1846. Commissary accounts

[9] Bigge Report # 3 p69

[10] HRA 1:12:107-126

[11] Lithgow letter to Darling June 1826

[12] HRA 1:16:399 since none of the ledgers have survived; the SRO considers that their apparent uselessness resulted in their destruction.

[13] McMartin: *'Public Servants and Patronage'* incorporates a table (P129) reflecting that each commissary employee served more and more population and therefore were increasingly efficient in their operation.

summaries are found in a variety of sources. The SRO maintains the detailed transactions directed by Governor King, and the AJCP details the records available from the PRO; but most records are intertwined in the Military Chest records in the '*Blue Books*' from 1822. Prior to this, the Commissary sent summaries to England and the Treasury assembled parliamentary reports and requested appropriations.

As a percentage to total white population, the number of convicts in the colony reduced from 100% in 1788, to 54% in 1793, and to a low of 38% in 1804, before rising again to 61% and stabilising at about 35-40%. These statistics are important because they reflect the numbers 'on the store' and, as long as there were many convicts victualled by the store, commissariat expenses were going to be heavy. Treasury issued constant instructions Treasury to minimise the numbers 'on the store' so, even though many convicts were arriving in the colony, the governors found ways of assigning them into private hands and taking them off public 'support', which in effect represented a cost transfer from government to private employers.

It is of interest to compare various statistics relating to NSW colonial revenue and NSW commissariat revenue. Such an analysis has been undertaken in the statistical synopsis of this study (Chapter 8) and some initial observations are set out below:

Both revenue and expenditure rise at a similar rate and move through the same fluctuations, which are reflective of economic conditions in the colony and in Britain. Further analysis using the commissariat expenditure and comparing it against the convict population, which for the first 40 years of the colony averaged 77% of the population 'on the store', shows and average cost of 1/3d per head per day to maintain a convict in the colony[14] the cost of food, clothing, bedding and a rooming allowance, paid by the commissariat. This cost of 1/3d per head per day should be compared against the average pay rate of a labourer of 5/- per head per day. If we accept Coghlan's[15] assertion that a convict was only 60% as productive as a free worker, the cost of convict labour compared with free labour was approximately 2:1 or 5/- versus 2/6d. This raises the question of why the British Treasury wished to use contractors for

[14] W. C. Wentworth in *Statistical, Historical & Political Account of the Colony* uses this figure and supports its computation by referring to then current costs referred to the House of Commons Committee on Transportation.

[15] T.A. Coghlan 'Labour & Industry in Australia' - Vol 1 Coghlan makes this reference in a comparison of building costs using contract labour in lieu of convict or government labour.

public building construction instead of convict labour, as they would have known that the cost would double. By following this policy, convicts were restricted to work gangs on road making and repair and land clearing as by this time the British Government had also abolished government farms. This annual maintenance charge of £4.15.0 per head per annum for convicts in the colony compares favourably with the cost to the British Treasury of prisoner maintenance in England at the same period , approximately £24 per annum[16]

The colonial population was subjected to a taxation impost averaging £5.15.4 per head per annum, within a range of £6.2.6 in 1822 to £2.15.0 in 1848[17]. This was a significant charge against the colony's settlers and added an average 10% to their cost of living. Such an impost was higher in the colony than it was for the people of Britain who suffered taxation of an average of 4%[18] for the same period. The point being made here is that the colonial free settlers were more heavily taxed than taxpayers in Britain. Although this is a social economics and quality of life issue, it is relevant that taxation rates between the colony and the mother country be comparable. The colony had been set on the path to becoming self-sustaining and self-supporting, but it had to endure tax on exports into Britain with no preferential advantages. Settlers also had to pay taxation by way of government duties on every item imported. Indirectly the government was promoting 'home' manufacturing.

The final statistical observation that should be made relates to the cost of operating the colony and the benefits that flowed to Britain therefrom. The total cost between 1788 and 1827 was in excess of £4.7 million[19], but the minimum direct savings to Britain can be assessed at over £50 million[20]. In addition to the direct savings to Britain, English industry gained a new source of raw materials for its wool, oil and timber manufacturers, and the efficiency of the

[16] E.A. Wrigley & R.S. Schofield 'The Population History of England 1541-1871'. An excellent work about trends in British population movements and discourses on the prison populations and the cost of their maintenance between 1775 and 1855.

[17] These calculations have been made by the writer from an analysis of colonial revenues raised from import duties and reflect an added cost to the consumer of government charges. Obviously the charges declined per head of population as the colony grew and the internal demographics changed

[18] Biggs & Jordan 'An Economic History of England'

[19] N.G. Butlin *'What a way to run an Empire, fiscally'*

[20] Beckett 'British Colonial Investment in the Colony 1788-1851' SLNSW & NLA

shipping industry increased by full loads being carried to the colony and ships returning with full loads from India, China or Batavia.[21]

The commissariat fed and clothed the convicts, the military and the civil officers. It also victualled all those settlers, mainly emancipists, who were supported by the government for at least the first two years of their freedom and provided them with tools and clothing. It was the principal market for colonial produce, buying grain and other products from the settlers, who relied on it for a secure, stable income. Commissariat bills and store receipts were the first currency of NSW. The commissariat dominated colonial finance, acting as a bank, controlling and administering the flow of foreign exchange in the shape of treasury bills issued to pay for the cost of the colony, providing loans and credit and encouraging the establishment of enterprises that could meet its demands. These activities were the basis for the story of the economic role of the commissariat and an analysis of its operations in the colony of NSW.

Crown Land Transactions

From the *'Blue Books'* commencing in 1822, a number interesting observations can be extracted:

References to Crown land sales are found in the 1825 *'Blue Book'* and show that there was to be a Land-holders fee of 15/- per 100 acres of crown land reserved for each three years for free settlers, followed by a 2/- fee per 100 hundred acres redeemable after 20 years from purchase:

On 18 May 1825, the 'rent' was changed, by order of Governor Macquarie, to a flat rate of 5% of the estimated value of the grant, without purchase, as opposed to purchased land. This was to commence 7 years from the date of grant. 'Rents' on any second and subsequent grants were payable immediately, without the benefit of the 7 years grace period.

Reference to the Statement of Land Grants 1789-1850 (see chapter 8) shows the number of acres granted to settlers and the conclusion can be drawn that this revenue source of 'rents' on Corn Land grants could build into a considerable sum for the Crown.

By Proclamation, also dated 18 May 1825, George III authorised the sale of crown land at the rate of 10/- per acre, to a maximum of 4,000 acres per individual or 5,000 acres per family. Payment was by way of a 10% deposit and four equal quarterly instalments.

The 1822 *'Blue Book'* is entitled 'Abstract of the Net Revenue and Expenditure of the Colony of New South Wales for the Year 1822', which indicates (confirmed by detailed records) that all colonial revenue and expenses were being accounted for in the *'Blue Book'*. An interesting

[21] The statistics have been assembled from the following sources: Butlin, Forster and Schedvin, and are to be found as an attachment to this paper.

question to be answered, and a topic for further research, is 'how does the British Colonial Office accounting records a link with the '*Blue Book*' figures. This area is to be further examined. It is immediately obvious that the Table is incomplete and misleading in that the outgoing expenditures do not reflect any offset revenues which would provide an 'offset' net expenditure. The official Table overstates the expenditure by the British Treasury on the colony.

The official 'Observations upon revenue for the Colony in 1828' (written by the Colonial Treasurer of NSW) makes an interesting point. It observes that the 'net colonial income' of the year 1828, as actually collected, is exclusive of sums in aid of revenue, which cannot be viewed in the character of income. This item is further defined as 'the proceeds of the labour of convicts, and establishments connected with them, being applied to the reduction of the amount of parliamentary grants for their maintenance'.

The Governor imposed a fee of one halfpenny per foot for all cedar cut on crown lands. The '*Blue Book*' makes the further observation that 'this charge 'has checked bushrangers and other lawless depredators by depriving them of ready means of subsistence by the absence of all restraint from cutting Cedar upon unallocated lands'.

If the colony was to be self-supporting, which was the public direction to successive governors, the government store would have to operate along the lines of a successful business enterprise. Planning for a market-driven economy was central, and its ability to purchase supplies without individual governor approval from any source was paramount. The diverse sources to be encouraged and dealt with included visiting ships and private treaties with seamen and military officers, as well as the setting of realistic prices for grain as an incentive for local farmers to produce sufficient quantities to survive 'off the store'. The organisation structure of the commissariat and its relationship to the governor as its local sponsor and protector would have to be developed along commercial lines. It was to be a government instrumentality in commercial service to its core constituents – settlers, emancipists, entrepreneurs and traders, military personnel and convicts. Each sector of this constituency had its own goals and needs. How would the commissariat achieve and maintain this important position?

Fiscal Policy Before 1820

The governors' need for a 'discretionary' fund from which they could draw funds for 'special' purposes prompted revision of the fiscal management in the pre-Macquarie era and set the standard for 'local revenue raising'. The governors wanted to do something other than perform the minimalist functions allowed by the British Treasury. Every official pound sterling had to be begged, and the governors needed just a little extra for the people of the settlement, especially to carry out public works of a slightly better quality than that officially authorised for this minimalist public bureaucracy

From the earliest records (as recorded in HRNSW), certain conclusions can be drawn on colonial public finance and these can summarised. These revenue-raising measures impacted on the commissariat because all locally raised revenues affected the cost of goods in the colony and the cost of doing business. Although the commissariat was not a public department store, its role included the purchase of provisions from visiting ships and import duties on the major portion of those cargoes affected the pricing of all goods in the colony.

There was a wide range of duties and taxes imposed on the early settlers, ranging from duties on imported alcoholic beverages, such as spirits, beer and wine, to license fees, tolls and a general duty on all imports. The general rate of duty was 10/4 per gallon on spirits and 9d. per gallon on wine. On tobacco the rate was 6d. per pound, while timber attracted a rate of 1/- per lineal foot. General Cargo attracted an ad valorem duty at a flat 5% rate. There were also a variety of licenses and tolls. Hawker's licenses sold for £20, and it cost a settler 2d. (tuppence) to go from Sydney town to the settlement of Parramatta. A country settler in the Hawkesbury district paid 1d. to cross the Nepean River at Windsor. The rationale behind the tolls on public roads built by convict labour was that tolls collected would and should offset not only the cost of construction but also the cost of maintenance. Between 1789 and 1850, a substantial amount of land was granted to settlers and the British Treasury reached the conclusion that the revenue sourced from 'rents' on Crown land grants could accumulate into a considerable future windfall for the Crown.

The total of Civil List salaries in 1792 was only £4,726.0.0 (of which the governor's salary was £1,000 per annum), but by 1812 the total had increased to £9,828.15.0, due to both individual salary increases as well as more names being placed on the Civil List. By 1815, the governors' establishment budget was now over £15,000 per annum.

Fiscal Policy post-1820

Crown land sales were first recorded in the 1825 '*Blue Book*'. A proclamation of 25 March 1825 by George III imposed a new charge on crown lands at the rate of 1/- for every 50 acres, to commence five years after the date of the original grant. To that date all crown lands had been disposed of by grants, and this 'quit' rent was a form of back-door compensation to the crown. In the official grant documents, the receiver of the land grant was given notice that

further costs may attach at some future time to the land, and this gave the Crown the opportunity raise this 'rent' charge on the land. There was to be a landholder's fee of 15/- per 100 acres of crown land reserved for each three years for free settlers, followed by a 2/- fee per 100 hundred acres redeemable after 20 years from purchase. On 18 May 1825, the Governor Sir Thomas Brisbane ordered that the 'rent' be changed to a flat rate of 5% of the estimated value of the grants, without purchase (as opposed to purchased land), to commence 7 years from the date of grant. 'Rents' on any second and subsequent grants were payable immediately, without the benefit of the 7 year grace period. By Proclamation, also dated 18 May 1825, George III authorised the sale of crown lands at the rate of 10/- per acre, to a maximum of 4,000 acres per individual or a maximum of 5,000 acres per family. Payment was by way of a 10% deposit and four equal quarterly instalments.

The 1822 '*Blue Book*' are titled 'Abstract of the Net Revenue and Expenditure of the Colony of New South Wales for the Year 1822', which indicates that all colonial revenue and expenses were consolidated in the '*Blue Book*'. The detailed records confirm this.

'*Observations upon revenue for the Colony in 1828*' by James Thomson, a consultant to the Colonial Treasurer of NSW [23] observes that the 'net colonial income' for the year 1828, as actually collected, was exclusive of sums *in aid of revenue* which could not be viewed in the character of income. This item is further defined as 'the proceeds of the labour of convicts, and establishments connected with them, being applied to the reduction of the amount of parliamentary grants for their maintenance'. In subsequent reports, the item 'receipts in aid of revenue' appeared in the '*Blue Books*', and included revenues such as - 'sale of Crown livestock; sale of government farms produce; sale of clothing and cloth made at the Female Factory at Parramatta; sale of wheat, sugar, molasses and tobacco produced by the convicts at new settlements such as Port Macquarie'. Such revenues were reluctantly included in official financial statements on the grounds that livestock had originally been included as an 'expense', whilst convict production was produced by 'prisoners' whose cost of maintenance was not recorded if self-produced. This is a significant point and has been made previously. There was no recorded value attached to the output of convicts and, even though their production was sold through the commissariat store and the revenue was recorded, there was

no 'cost of sale' attached to this revenue. This practice defied logic, common sense and all accounting conventions.

James Thomson's note show the total quantity of alcohol imported into, and thus consumed in, the colony, in 1828 when the population was only 37,000, of which adults would have numbered less than 25,000. 162,167 gallons of spirits and 15,000 gallons of wine were imported, a total of 177,167 gallons or the equivalent of 3/4ths of a pint per week of Colonial alcohol beverage for each person –men, women and children. Local distillation from sugar was prohibited in 1828 and the high price of grain and the higher taxing of locally-manufactured spirits also became a natural deterrent to local production. A final observation was made in the '*Blue Book*' compilation of 1829 that the only duties imposed on spirits that year was upon those imported directly from H.M. Plantations in the West Indies. So the British authorities received the double financial benefit from the trading in spirits and charging duties on them at their destination. Local duties were collected in the colony but used to offset British Treasury expenditures, so in effect the British government reaped the benefit.

In 1828 the quantity of dutiable tobacco was 136,748 pounds weight, compared with 91,893 pounds in 1825. The government experimented with locally-grown tobacco at establishments in Emu Plains and Port Macquarie with 51,306 pounds being produced. In 1828, total consumption of tobacco was 5 lb. per head of adult population per annum or 3 oz per head per day.

Shipping companies paid lighthouse charges, along with wharfage. The growth of shipping into the Port of Sydney was so great that, by 1828 revenue from lighthouse dues, harbour dues and wharfage was over £4,000.

In 1828, the postage of letters attracted fees for the first time and the official Postmaster collected £598 for general revenue. This grew rapidly so that by 1832 the amount of postage collected was £2,000. Each colony imposed its own postage and printed its own stamps until Federation.

[23] The piece by Thomson is an Appendix in *Financial Statements of the Colonial Treasurers of NSW 1855-1881 -*

The commencement of sales of both crown lands and crown timbers increased general revenues to the extent that in 1828, the amounts realised were as follows:

already cited

Table 6.2: Crown Revenue Earnings for the Treasury in 1828

Sales of Crown Land	£5,004.19.02
Sales of Cedar on Crown Land	744.15.11
Sales of Other Timber	9,365.11.04

The British Treasury had reserved for itself all revenues from crown lands, and from standing timber on crown lands. The Governor had also imposed a fee of one halfpenny per foot for all cedar cut on crown lands. The '*Blue Book*' makes the further observation that this charge 'has checked bushrangers and other lawless depredators by depriving them of ready means of subsistence by the absence of all restraint from cutting Cedar upon unallocated lands'.[24]

Historical financial data is relevant to understanding the social conditions in the colony. The application of duties, tariffs, tolls and fees made up the essential revenue of a colony that was designed to be self-sufficient. It was being given minimal economic support by the British Government, even though the opportunity cost of housing 'prisoners' in the colony was a fraction of the cost of housing them in England.

Stores to the Colony

In June 1801, the Duke of Portland advised the Treasury Commissioners of new arrangements for regular transportation of stores to Sydney:

> '*I transmit to your Lordships a list of articles necessary to be sent out yearly to New South Wales, consigned to the Governor and to be used by settlers, and convict labour, or exchanged for grain or animal food supplied His Majesty's stores (exclusive of stores, implements, sent for the use of convicts at public labour), 30% to be charged on all such items to indemnify government for freight, losses and issuing in small quantities. These items are to be sent out annually in the South Sea Whalers, or other vessels destined to the colony. The advantages which government, as well as settlers, will derive from this proceeding are very considerable. At present the charges made by individuals on such items of necessity are calculated on a profit of from 100% to 500%'.[25] It was the intention of the British Government, in a belated response to Governor Hunter's suggestion of a government retail monopoly store to combat the price hiking by local traders, to purchase consumption items in Britain and ship them to the colony and make a limited profit from such trade.*'

[24] 1824 *Blue Book* p.6
[25] HRA 1:3:167 Portland to King

The pre-1800 years brought the desire to expand commissariat operations into retailing goods at reasonable prices, which in turn would inhibit military officers from charging exorbitant prices for similar goods through the military monopoly. The expansion of the commissariat into retailing, together with the arrival of 'resident merchants from Madras and London, marked the end of their monopoly'.[26] In February 1805 some of the officers successfully applied for an advance of special 'commissary notes' equivalent to sterling with which to buy stock and other articles from the captain of the *Lady Barlow*. Others found kangaroo products a lucrative source of business, bringing more profitable returns from the commissariat than agriculture.[27]

The Blue Books

Whatever happened in the colony was reflected in the *'Blue Books'* one way or another. They commenced in 1822 and provide a fascinating glimpse into the early colony. Although they will be seen as financial statements, because they reflect the financial condition of the settlement, they are, in fact, much more. They included details of births, deaths and marriages, they showed the substantial number of shipping movements into and out of Port Jackson, they listed all imports and exports, and they recorded the values of all production in the colony. As statements of accounts, they are reproduced in great detail and are valuable sources for the economic historian. Prior to 1822 and the introduction of the *'Blue Books'*, the financial records of the colony were privatised in their preparation. Two non-salaried, non-government individuals were appointed to keep the records for an annual fee. Both were well-known and probably well-intentioned, but they both became very wealthy as a result of being in charge of the colonial 'treasury'. Their remunerations as treasurers was supplementary to the already generous civil salary they earned in other capacities

In 1800, Governor King began to raise local private revenue; he was acting illegally because it was not authorised by the British Parliament. When the wooden gaol in Sydney was sabotaged and burnt down, it had to be replaced and Governor King promised the Secretary of State the building would be replaced by public subscription, because the British Treasury balked at paying for another gaol. King's attempts to find public labour and contributed

[26] Oxford History of Australia Vol 2 'Possessions 1770-1860'

materials failed, and he was left with a shortage of funds if the building was to be completed. However, the work was finished using government funds, which he agreed to 'make good'.[28] and, to achieve this, he instituted a basic form of duty on spirits entering the colony. Like any form of 'taxation' it was easily manipulated, both as to the rate and the application. The revenue grew and King looked for to apply the revenue locally, rather than allow it to be appropriated by the H.M. Treasury. King and his successors were well aware of the British Government's wish to place a limit on growing colonial expenditure and they wanted to see local revenue used to 'top' up limited funds coming from London, not to replace them. The biggest appeal of this local revenue was its use on a 'discretionary' basis, rather than having to conform to prior appropriations by the Parliament. The Gaol Fund was established to rebuild the Town gaol and was administered by Darcy Wentworth, an official assistant Surgeon. Its successor by name change was the Police Fund, also administered by Wentworth. The second fund was the Orphan Fund, officially known as the Female Orphan Fund, which was administered by the Reverend Samuel Marsden. The starting point of the Orphan Fund was when Governor King purchased, on behalf of the colony, the residence of Lieutenant Kent who was returning to London and had no further need of one of the finest houses in the colony. The house was located on the northeast corner of 'High' street (now George) and Bridge Streets, so named because of the wooden bridge erected for the public to cross the Tank Stream. It also led to the second Governor's Residence, the so-called 'Governor's Mansion', located further down Bridge Street.

Initially the revenues raised from duties on spirits, and later all imports, grew rapidly along with the economy as immigrants, convicts, emancipists and free settlers swelled the population. Almost everything had to be imported from Britain and so, with import duties, harbour and wharfage charges, and even charges for fresh water taken on by visiting ships, the colonial coffers overflowed. A primary collection agent, the Naval Officer for the Port of Sydney, was installed in 1803, sharing his net collections between the two funds[29]. Essentially, the problem of formalising collections and recording and reporting local revenues

[27] Oxford History *ibid* p98

[28] HRA 1:3:167 King to Portland

[29] The Naval Officer was John Piper, who was remunerated on a percentage of his collections. His annual emoluments grew to over £5,000 until William Lithgow, the Colonial Auditor, uncovered a 'deficiency' of £6,000 in his monies, and Piper was dismissed from office. At that time the position was converted to a salaried remuneration.

was not brought under any form of control until the arrival of Macquarie. The colony had no treasury, other than the commissariat, but Macquarie manipulated a novel means of exchange in common practice. Store receipts issued by the commissary sufficed in lieu of coinage until Britain finally agreed to transfer basic coinage to the colonial commissary[30]. This marked the beginning of the increasingly important role for the commissariat, the provision of financial services, including banking activities, to and within the colony.

The *'Blue Books'* replaced this antiquated mode of record-keeping. Governor Brisbane was selected to implement the Commissioner Bigge's proposal that the financial recording in the colony be broadened, and the *'Blue Books'*[31] were thus born. The Books were assembled annually from subsidiary hand-kept records, so they were not original documents as such but were rewritten once each year from other assembled documents. This system, and indeed duplication of many records, made additional work for the commissary clerical staff, the colonial treasurer, the centralised government accounting staff and especially the newly-appointed Colonial Auditor, William Lithgow. For all years between 1822 and 1844, the fiscal year for the *Blue Books* ended on 30 December, the calendar year. In 1843, the Lord Treasurers in London directed that the new fiscal year would end on 30 September. Lord John Russell instructed Sir George Gipps to have a Governor's Report on the State of the Colony accompany the *'Blue Books'* to London each year which he would lay on the table of both houses of parliament. In general, the *'Blue Books'* gave no hint of the policies being pursued in the colony; they were the bookkeeping records of today, a tedious list of past historical past facts, rather than forward-looking road map of economic and fiscal planning.

In 1832, Sir Richard Bourke introduced Estimates and Appropriation Bills for local expenditures before the NSW Legislative Council. The Legislative Council's realisation that the Governor had acquired additional fiscal responsibilities on behalf of the colony compromised planning opportunities when estimates were presented, along with the actual statements of revenue and expense. This caused some members to become quite vocal in opposition to the governor's plans; for instance, in 1843 Blaxland and Wentworth were adamant and vociferous when they learnt from the estimates that the British Government did

[30] Beckett, Gordon 'The Public Finance of the Colony' and 'The Development of the Public Accounts', -a full description of the early record-keeping and revenue raising in the colony.
[31] The name came from the blue coloured covers in which these extensive reports are contained

not intend to subsidise colonial expenditure on police and gaols. This practice began in 1834, and the cost to the colony over the eight years after it commenced was in excess of £700,000. Members of the Legislative Council thought this sum could have been better used by the colony for education, public works, and the reduction of unemployment or even to replace the British investor funds, the withdrawal of which had largely caused the 1841-1843 recession in the colony. This 'political storm' was the result of a misunderstanding, for the British Treasury had written to Bourke's predecessor stating quite clearly that the cost of policing was to be a charge against local revenues. The governor had not advised to the NSW LC of the amended policy and, in any case, the 'principle' was quite out of step with the protection of local revenues, which the members considered should be used for developing the local economy, not controlled by the British Treasury.

The estimates were of great advantage to the members of the Council and provided an opportunity for Treasury to quickly compare what had been planned with what had actually been achieved. By this time, local revenues were a significant portion of total colonial revenues and they had largely replaced transfers of funds from Britain. The 1843 Gipps Report to the Colonial Office shows that, whilst in 1838 local revenues had reached £211,988; by 1842 they had doubled to £414,156. These figures excluded crown land sales revenue, which Britain had reserved for its exclusive accounting and appropriation. Annual revenues and expenses may be related to the growth in population which was growing in excess of 5,000 people per annum and this rate kept the 'per head' figure of revenue expenses, imports and exports, very much in line. By 1843 exports were running at £1,579,000 per annum of which wool was 50%, and growing. In line with economic thinking of the day, and government planning generally, the colonial colony was running at a small surplus each year between 1838 and 1842.[32]

The next year's report by Gipps highlighted the dramatic effect of natural elements on the agricultural sector. Even though production of wheat and maize grew from 1,335,000 bushels in 1842 to 1,719,000 bushels in 1844, the importation of these grains grew from 178,000 in 1842 to 265,000 bushels in 1844. Most imports were from Tasmania by private traders and speculators.

A solid indicator of the growth in the colonial economy may be found in the 1844 '*Blue Book*' reference to banking statistics, which included commissary advances and deposits. Discounted paper held by the banks fell from £2,562,000 in 1842 to £1,583,000 in 1844, this being the central period of a very bad recession. These figures are in contrast to those of deposits held in the same banks which rose from £988,000 in 1842 to £1,028,000 in 1844.

Military Rations Cost Offset by Deduction

In November 1802, King informed Palmer, his Commissary-in-chief that,

> '...in accordance with His Majesty's warrant of February 1799, each non-commissioned officer, and private, shall have deducted from their full pay the amount of three pence halfpenny (3 1/2d per quarter) – this was applied to each corporal, sergeant, trumpeter, drummer and fifer when stationed in Jamaica, New South Wales or Gibraltar.'

The commissariat, at this stage was also the paymaster within the colony and handled both civilian and military pay vouchers or bills and assisted in crediting these bills to the official's account at the commissariat for purchasing purposes or exchanging for goods, since no cash was available in the colony. The purpose of the deduction was to contribute to the military costs of rations from the commissariat.

Valuing the Commissariat Inventory

In August 1804, King advised Hobart that the value of inventory and stores held by the commissariat amounted to £243,519.10.00. These stores consisted of: [38]

Table 6.3: The Value of Store Stocks and Inventory in Sydney - 1804

Livestock	£75,628
Grain and flour	£14,833
Salt meat	£41,134
Clothing	£20,562
Spirits	£2,047
Debts to the crown	£10,396
Public buildings	£54,100
Vessels and boats	£2,250
Land in cultivation	£6,375

[32] Elsewhere in this study is a statistical analysis of local revenues per head of population, which indicates the

At the same time King advised Hobart that livestock and stores items belonging to private individuals in the colony amounted to £245,543. A large part of the private stores would have been held by the trader, Robert Campbell, who was in the process of transferring large quantities of stores and other inventory from his head office in India, by way of back-loading after delivering quantities of sandalwood to Indian merchants. It is difficult to imagine why King bothered to value the livestock and stores in private hands, other than that he was trying to impress the Colonial Office with the colony's progress. It was a part of each muster that the numbers of livestock were collected, but their value was artificial at best and of little interest to any party.

Store Receipts as an alternative to Specie

In March 1815, Macquarie issued a general order stating:

> '*In order to obviate the inconveniences that are likely to result to the public from the want of a sufficient quantity of Specie belonging to the government, the Governor deems it advisable to return to issuing 'store receipts' for all purchases made on account of the crown, at all commissary locations. The store receipts are to be declared every two months and 'be redeemed' or be forfeited. In order to avoid fraud each receipt is to be matched against the original 'cheque book' before being despatched to London.*'[39]

Setting Prices for Grain to be sold to the Commissariat Store

David Allen, who succeeded John Palmer as Commissary-General, wrote to his superior (the Commissary-in-Chief) about problems with setting fixed prices to purchase grain and provisions from settlers:

> '*The mode of supplying His Majesty's stores in the colony has to-date been by the governor fixing by general orders, the price at which grain and fresh provisions were to be paid for by the crown. Notice would be given that the stores were open to receive goods at set prices and when the desired quantity was attained, the notice was withdrawn. The order of 10th December 1812, directs 8 shillings. per bushel to be paid for all wheat, and 7p. per pound for all meat supplied. In years of plenty this system works fine, but when supplies are in short supply, then the price is generally well below that available on the open market and the stores remain empty.*

colony was highly taxed compared with other British subjects
[39] Governor's despatches 1814-1816

It would be most beneficial to the Crown if all purchases were to be made by public tender or contract, as no individual could be expected to supply wheat at 8s, when the market is paying 9s, 10s, or even 15s. for each bushel' [40]

Circulating Currency and the Recession of 1827

Governor Darling released the colony's first coinage August 1826. Prior to the administration of Sir Thomas Brisbane, drafts, drawn on the English Treasury for government services and sold in the colony, had formed a convenient and practical medium of paying for imports in London and had eliminated the necessity of developing an export trade. By utilising a local currency and setting exchange rates, an export industry became necessary. During the Macquarie era, the annual total of these drafts increased disproportionately to the population; however, in reality there was a great deal of deferred maintenance work which needed completing. However, in any case Macquarie did increase government spending– but the real question was not what was expended, but whether it had real value to the colony and the British Treasury. In 1806-1809, the annual average was £29,415; by 1821 it was £166,315. During this time the population had trebled, but the value of bills drawn had risen even faster. Under Macquarie, the colony's prosperity was largely based on the 'money' circulating in the colonial economy. Successive governors discovered that this was contrary to London's expectations, but also Macquarie's successors did not have the stamina to continue in this frenetic pace of activity. Darling complained directly to Bathurst that he had 'never worked so hard in his life'.

In proposing the release of a 'circulating currency', Darling commented to Bathurst: 'as a result of the speculation of individuals and the excessive discounts on the part of the Bank of New South Wales, the present distresses in the colony have taken place' when referring to the 1827 Recession. During the period 1827-1834 (the duration of the recession and its aftermath) the amount of circulating and usable currency in the colony was not less than £200,000 sterling. For the most part, this large sum consisted of drafts on the British Treasury.

The following information, in pounds sterling is extracted from the 1826 '*Blue Book*':

Table 6.4: The Amount of Circulating Currency in the Colonial Economy 1827-1834

Drafts estimated at	140,000

[40] HRA 1:4:387 David Allan to Lords of the Treasury (including the Commissary-in –Chief)

Store receipts for grain and beef	20,000
Notes of the commissary due on demand	15,000
Notes of the Bank of NSW	15,000
Notes of respectable individuals	10,000
Total (in Sterling)	£210,000

Macquarie had left a legacy of over £150,000 in Treasury drafts and Darling accused building speculators of using this circulating currency as the basis for their activities. Brisbane had been directed by the British Treasury to reduce the amount of Treasury bills, as they were considered inflationary, and it was not until his arrival in 1821 that their value was reduced to about £80,000.

Darling wrote to Bathurst:

'The introduction of a sum of £400,000 at this period, and the commencement of the Dollar System, while it made a very serious alteration in the property and profits of the bulk of the people, still afforded a sufficient circulating medium for all the purposes of an increasing trade; and, including the value of our exportable produce, there was still a floating capital of nearly 200,000. The alleged over speculation of individuals and the apparent excess of discounts on the back of the bank, therefore, had the amount of our circulating available and usable capital remained unaltered; but, such speculations and discounts, supposing the customary average circulation to be afloat, must have reached considerably higher, and the present difficulties of our money market may fairly be attributable, as much as the cessation of the ordinary and expected expenditure of government, as to the mentioned causes'

Darling correctly anticipated the coming financial crisis and, with the help of the NSW Chamber of Commerce, persuaded the Legislative Council to enact such measures as controlling discount rates and interest rates so as to minimise the impact of the recession. This measure of public relations was pursued by William Lithgow on Darling's behalf, since Darling was not the most favoured official in the colony. However, Lithgow's measure enhanced Darling's reputation amongst the settlers, traders and investors.

Darling reported to Bathurst:

'Anxious to promote the commercial prosperity of the colony, at all times by every lawful means, the Committee of the NSW Chamber of Commerce feel themselves more especially called upon at the present moment to endeavour to prevent by timely measures the otherwise approaching crisis and, satisfied that His Excellency desires nothing so much as the permanent association of his name with

the wealth and happiness of the community, they are more confident in laying before him their suggestions for effecting the purposed relief.[42]

How far the internal consumption and the consequent energies of the industrious settler may be curtailed, and all other channels of our colonial wealth obstructed, it is painful for the committee (of the Chamber of Commerce) to contemplate: this hitherto prosperous colony with its large tracts of the finest soil, and a climate with natural resources, inferior to no country on the Globe, to see its active and intelligent population plunged into difficulties of a pecuniary nature, unless some immediate aid be given to the commercial body. Already large failures have been announced among one class of traders, and a closure of that important branch of commerce, the Whale fishery.'

The day before his appeal to Bathurst, Darling prepared a·Memorandum [43] on measures that could be taken to relieve the money market. He proposed that:

'Treasury bills were to be issued in the amount equivalent to the Commissariat debt to the Colonial Fund and the money thus paid out will enable merchants to obtain bills on demand, which bills would assist the banks promoting circulation of their own notes, and therefore add to the circulating medium'.

Darling felt the 'depression' was a commercial one, caused by British investors withdrawing their funds from the colony, banks speculating on highly discounted bills resulting in borrowers becoming insolvent and commercial lenders 'loaning on mortgages' but using short term depositor funds[44]. All these components made for a severe and desperate shortage of ready cash in the colony and Darling's answer was to inject new monetary capacity into the economy and use the multiplier effect to generate more circulation of funds. The commissariat was a most useful tool in all of this. Darling wanted to use the funds borrowed by the commissariat from the colonial treasury to put circulating currency in the hands of the banks.

Darling's solution would not occur in today's economic thinking. The result would be a commercial recession which would spread very quickly through the consumer ranks. Inventories would decline, imports would slow, exports would decline and a full-scale recession would be at hand, together with spiralling inflation. In the colonial economy, the

[42] HRA I: 12:512 (July 1827) Darling to Bathurst on the subject of the anticipated financial crisis

[43] HRA 1:12:398 Memorandums from Darling to Bathurst in Governor's Despatches dated 30th August 1826.

[44] From the 'Memorandum' from Darling to Bathurst – August 1826

commissariat played such a large and controlling role; its action or lack thereof would determine the length and extent of any recession.

In 1826 the commissariat was preparing for large intakes of convicts and anticipating a great deal of activity in the Lumber Yard and the Female Factory. Exports were growing but were in line with the growth of imports. However, British investors had reacted to the decline in the British economy, and the resultant build-up of manufacturing raw materials in the hands of British industry and the decline of prices, and they chose the cautious alternative of withholding investment and speculation abroad whilst they waited for the British economy to recover.

In these circumstances, Darling's response was reasoned and valid, even if it did pass the major responsibility to the banks and their shareholders. The banks in fact had to bear some responsibility as they had been discounting the commissariat notes at high rates, before they were finally shut out of that market by a restoration of the store receipts program. Their response was to withdraw funds from the money market and, move into mortgages and fixed term securities, which decreased the amount of currency circulating in the economy. This, in turn, slowed the whole economy and created a 'commercial recession'.[45]

Accounting for the Commissariat

As recorded by both N.G. and S.J. Butlin, details of commissariat financial statements before 1832 have been lost. Analysis of total expenditures has been prepared from other PRO records, such as summaries of bills paid between 1788 and 1830. Parliamentary appropriations for the Colonial Office have also been prepared and the results of both these sources are incorporated into the tables below.

The other analysis prepared and also set down below relates to the accounting classifications. We know from other records of the same period[57] that accountants and auditors used ledger systems not unlike those manual systems still used today including a chart of accounts. Government ledgers between 1810 and 1822, like private company ledgers, were all prepared

[45] This concept is referred to by S.J. Butlin *Foundations*

on a strictly cash basis; there were no accruals, depreciation or provisions. All appropriations were accounted for by a funds statement for annual presentation to parliament.[58] Thus the internal (revised) accounting system introduced by William Lithgow, the first Deputy-Commissary General (Accounts), in 1824 would have been moulded on Lithgow's experience of the commissariat accounting systems he had installed in Heligoland in 1807, and Mauritius in 1812. Lithgow was an experienced commissariat accountant and would have established a set of accounting records showing the accumulation of revenue and expenditures, not unlike the classifications set down in the table below:

Table 6.5: Probable Financial Reporting Structure within the Colonial Commissariat

Consolidated Commissariat Statement of Revenues and Expenditures

Revenues
Appropriations from British Treasury, for:
Convict maintenance – clothing, bedding, general supplies
Purchase of commissariat inventory
Purchase of convict, civil and military foodstuffs
Purchase of building materials for public works – lot prepared by convict labour from commissariat resources
Proceeds of sale of minerals, government livestock, produce and grain to the general population
Proceeds of 'renting' out part-time convict labour

Expenditures
Purchases from U.K. paid by bills drawn on the British Treasury
Purchases of local colonial supplies, initially paid by store receipts and then consolidated into bills drawn on the Treasury
Purchases of merchandise from visiting ships arriving in Sydney Harbour and paid by bills drawn on the Treasury
Raw materials purchased for reworking by convict labour in commissariat manufacturing centres
Payment to independent contractors for providing services to the commissariat e.g. grinding and milling of grain, contract transportation and shipping services
Purchases of meat, livestock, grain and vegetables and commodities for use as rations for persons 'on the store'

Categories/classifications of expenditures
Convict Maintenance
Military and Civil personnel maintenance
Government public works – construction & maintenance

[57] Beckett, G. W. ' An Economic History of the Van Diemen's Land Company 1824-1900'
[58] Appropriation statements and 'Appropriation Bills' were introduced to the NSW Legislative Council in 1832 by Governor Richard Bourke

Inventory Classifications
Purchased supplies, produce and provisions
Stocks of building parts and products, including timber
Stocks of manufactured items by convict labour
Stocks of minerals and other extracted products by convict labour
Stocks of livestock and other farm supplies

What the commissariat accounting system could not, and did not report, was a new classification designed specifically to account for output by convict labour. Convict production of coal, timber, lime, tiles and bricks was important; these commodities were used extensively for government public works and they were also sold onto the public. Revenue from these sales was usually credited to the commissariat, apart from in 1823, when it was recognised in the *Blue Books* (refer Table 8.1). In all other years the substantial value of convict output used in the commissariat escaped unrecorded and unreported. In just one year the estimated value of manufacturing output from the various government instrumentalities which relied on convict labour has been computed at nearly £500,000 [59] per annum. In addition, the value of public works during the Macquarie administration has been estimated at £2,000,000[60]. What has not been estimated as yet is a breakdown of convict output identifying the value of the natural resources used, which is timber, clay, seashell, and coal were significant raw materials used for local manufacturing and export.

What Does This Mean?

From this brief analysis, the conclusion can be drawn that any accounting system would identify purchases made for convict maintenance, civil and military support costs and the costs of supporting other settlers placed 'on the store' as part of their inducement to relocate in the colony. The commissariat accounting system should also have identified, but did not, was the value of local resources and convict labour used on the public works program, acting like a simple job cost system, and then the value of natural resources produced for use both within and outside the colony and developed by convict labour. An example of the first analysis would give an understanding of the true costs attributed to the major public buildings and

[59] This writer's estimated of production from the Lumber Yard, Timber Yard, Brick & Tile Yard, Female Factory and mineral extraction
[60] This writer's estimate of construction costs including valuing labour for the 76 buildings listed as being completed by Macquarie – refer Table 4.5 herein

other significant public works (such as the four main roads within the colony), whilst the second analysis would identify the value of local timber used and the value of coal extracted.

It is of interest to note that William Lithgow, as Colonial Auditor-General, joined in Governor Darling's strategy to cover up the true costs of public works. He urged Darling to react to the request from the Secretary of State that London pre-approve any public works costing over £200 by declaring that no public works cost that much because the convict labour and native resources had 'no value'. Thus the British Treasury had no opportunity of reviewing let alone controlling, expenditures on public works. Of course, despatches from the Secretary's office made it plain to the governors that public works was a low expenditure priority but, as responsible government developed and members of the NSW Legislative Council pursued natural justice and better living conditions, no governor could resist the minor beautification projects or slightly wasteful government services over and above the officially authorised basic amenities. Even if all development work, standing timber and minerals belonged to the Crown under the *Terra Nullius* concept as ratified by British laws, their usage had value and a fairer and more rational accounting system would have given credit to the development of these and other Crown resources

In summary, convict maintenance as required under the transportation program cost the British Government nearly £150,000 each year, but use of convict labour and Crown natural resources benefited the colony to the extent of nearly £500,000 per annum. Most of this benefit came via commissariat operations, achieved by effectively using convict labour in the various manufacturing operations, on government farms and other commissariat-sponsored work centres. In addition to these non-recorded entitlements, the Crown received the benefits of the revenues from the sale or lease of all land in the colony. This summary does not fit with the N.G. Butlin conclusion that the British government spent over £5 million in the colony without seeing any return. What Butlin and others[61] with a similar pro-Mother country disposition should have concluded was that 'The British involvement in the colony of NSW necessitated funding from the British Treasury for a variety of expenditures associated with the transportation program and the use of the colony as a penal settlement'. The development of colonial natural resources, together with its public investment program, increased the pace

of growth and the promotion of two-way trade. In return the British economy received raw materials for its manufacturing industries, benefits which relieved it of dependence on European suppliers and allowed greater utilisation of its shipping interests and the emigration of a substantial number of its prison population, together with a good sampling of its poor and social outcasts. The British Treasury saved the cost of housing nearly 16,000 medium term convicted criminals and benefited also from the accompanying reduction in crime. British manufacturers exported nearly £400,000 of goods to the colony each year between 1810 and 1820.

Table 6.6: NSW Commissariat Financial Operations 1788-1820

Year	Expenses £'000	Year	Expenses £'000
1787	211	1801	10,786
1788	4,346	1802	16,468
1789	831	1803	16,975
1790	1,309	1804	10,192
1791	1,075	1805	17,442
1792	5,127	1806	9,083
1793	15,807	1807	10,483
1794	3,572	1808	13,800
1795	32,103	1809	25,199
1796	41,736	1810-1815	259,972
1797	19,465	1816	12,0673
1798	27,035	1817	112,691
1799	41,588	1818-19	188,700
1800	50,910	1820-21	428,986

Table 6.7: NSW Commissariat Revenues and Expenditures 1822-1836

Year	Revenues £'000			Expenditures £'000	
	Treasury Bills	Sale of Goods	Total Revenues	Supplies	Total Expenditures
1822	230.1	4.4	253.5	175.9	212.2
1823	119.0	4.7	134 1	110.7	149.7
1824	n.a.	n.a.	n.a.	n.a.	n.a.
1825	193.9	4.4	198.3	13.8	155.0
1826	59.3	3.9	63.2	68.8	103.3
1827	164.6	1.6	166.2	81.6	130.7
1828	98.5	n.a.	98.5	69.0	238.0

[61] Brian Fitzpatrick in The *British Empire in Australia* took a similar position regarding Britain's one-sided generosity.

1829	154.4	n.a.	158.9	71.4	243.2
1830	138.7	n.a.	139.6	46.0	196.8
1831	117.8	5.8	182.6	46.9	203.6
1832	114.8	9.3	165.7	n.a.	194.3
1833	81.0	15.0	146.5	42.2	165.5
1834	141.9	20.8	174.2	64.6	187.0
1835	176.9	40.0	250.2	79.1	230.2
1836	223.4	60.0	354.4	100.8	344.4
1837	173.9	n.a.	254.8	92.6	234.8
1838	292.5	n.a.	383.7	97.9	363.7
1839	248.0	n.a.	474.7	132.6	474.7
1840	205.6	n.a.	389.5	126.5	389.5

It has been recorded previously that commissariat records do not exist for the post-Governor King periods but summaries are produced in Table 6.10 of commissariat fiscal operations found in Chapter 5. It should be understood that such summaries as recorded here are essentially unreliable because they are based on bills drawn on the British Treasury by officers of the commissariat and the NSW governor. Many expenditures are based on the consolidating of store receipts into bills, and a number of store receipts which were held firstly by individuals and then by banks and were probably not returned to the commissariat within a reasonable time. Likewise bills drawn in the colony and handed to captains of visiting ships may have taken years to be returned to merchant banks representing the bill's 'payee', before being sent to the Treasury. Thus it is unlikely that the periods of the expenditures, as reported above, are any more than 60-70% accurate but there is no way of adjusting the summaries because the underlying records no longer exist. These figures are extracted from an unpublished manuscript by Julius Ginswick who did not record his sources for these figures. We do know he took them from PRO records in London, and he himself made the observation that they are of questionable accuracy, especially since the allocation of expenditures was taken from a notation on the bottom of each bill and the accuracy of allocations was notoriously biased toward understating expenses in certain areas so as to avoid further examination. Ginswick reported that the figures which are not available are zero in most cases, although one must ask why this could or would be the case.

Another observation which cannot be explained, other than by reporting delays in the return of bills to the Treasury, is why the annual totals of revenues and expenditures do not matching, even though the balance of funds on hand was recorded by the Treasury accounting system. As Colonial Auditor-General, William Lithgow, found in the early 1830s, the old fashioned accounting system of open-ended transactions meant huge delays in reporting, cumbersome ledger-keeping and a mountain of paperwork. The commissariat would have found the same problem with bills issued in one fiscal period but not 'presented' until a later period.

The main components of expenditure were 'convict services', followed by maintenance of various sections of the civil administration such as 'police, clergy charities, the military and pensioners'. The commissariat was a 'banking' institution long before the commercial banks were operating and this is reflected in the loans made to the colonial treasury and loans made

by the colonial treasury to the commissariat. This meant that often one or both funds ran short of money and they had to pool their cash resources and help each other over a difficult period. Another interesting method of accounting was the recording of transfers to the colony of 'specie', or notes and coinage from the British Treasury, as 'revenue' to the commissariat. This had the effect of the revenues of the colonial commissariat being overstated quite significantly. For instance, specie transfers in the 1830s were as follows:

Table 6.8: Specie Transfers 1831-1836

	£'000
1831	20.5
1832	5.0
1833	15.0
1834	20.8
1835	40.0
1836	60.0

Thus in a period of five years, commissariat revenues were inflated by over £160,000. The figures above also reflect the cyclical nature of the colonial economy. They were affected by population inflows, the demand for public infrastructure in a developing colony, economic cycles in Britain, the growth of the pastoral industries and the large increase in exports and imports. The advent of the Legislative Council in 1823 and the development of the public service, government departments and a bureaucracy from 1826 also had an impact.

What should be apparent from these tables is the inadequacy of the accounting records provided by the colony which were used by various Parliamentary committees and policy makers to impose governance. The main thrust of Bathurst's administration of the Colonial Office was that Macquarie was overspending and this led to the invaluable Bigge Enquiry. In fact, in economic terms, the Macquarie administration spent less per head of population in commissariat areas of responsibility than any of his predecessors starting from Governor Phillip and certainly less than Governors King and Bligh with whom Macquarie was most often compared. In absolute terms Bathurst was correct but, in a fast growing economy with an exploding convict population who required government maintenance, higher absolute expenditures were to be expected. The underlying problem is that the value of convict output was not measured and therefore it did not offset or benefit commissariat revenues in any way.

Reconstructing the Funds

There is still much to learn about the Military Fund, and neither S.J. nor N.G. Butlin has examined its operation in any detail. In 1830 the Commissariat Department dispersed expenses of £162,717 for the colony out of a total Treasury appropriation of £243,891. By what right, audit or direction, were these transactions made?

At the end of 1830, the balance in the Military Chest stood at £34,123 and the Colonial Treasury had £21,799. Such balances were high in relation to the value of transactions going through the accounts and raised the question as to who in London controlled such bank balances, especially as by this time the City of London had commenced a short term money market, earning interest on short term deposits by matching them with short term credit loans.

In 1825 the Military Chest reported that the 'receipts in aid of revenue' and included a statement that a 'deposit' was made into the Military Chest for 'the amount of the Parliamentary Grant issued for the charge of defraying the Civil Establishment'. This was the first time payment on account of the civil salaries made through channels other than the Colonial Fund or the British Treasury on account of the Colony.

In 1826 'Receipts in Aid of Revenue' included a consignment of specie for the first time as well as the parliamentary grant for regular payments.

The revenue figures appearing in the Colonial Fund reflects loans sometimes drawn against the Military Chest, obviously for funding. What right or direction authorised these transactions? Was any security offered, or should any interest have been paid? In the 1828 revenue statements for the Military Chest, there was an item marked 'receipts in aid of revenue' which included transactions relating to sales of:

 Crown livestock
 Coals ex Newcastle
 Wheat at Bathurst
 Sugar & molasses grown at Port Macquarie
 Cloth manufactured at Parramatta
 Surplus and condemned stores
 Articles of colonial produce delivered to the commissariat from the several
 Convict agricultural farm establishments and coal mines

A special note is included that 'the stores received from England for the service of the colony since 1825, not having been accompanied by Priced Invoices, no appropriation of the value of the issues thereof can be made.'[78]

It is interesting to note that nowhere in the accounts of transactions in the commissariat, Colonial Fund or Military Chest is the value of the convict contribution noted.

In 1829, the Receipts In Aid of Revenue contain a note that 'the total is exclusive of the value of articles of colonial produce delivered to the commissariat from the convict agricultural establishment'. This is the very first reference to the fact that convicts contributed goods and services which obviously had 'value' to the colony and that they should have been recognised and accounted for in the Books of Account (the Blue Books).

In 1830, the 'receipts in aid of revenue' are shown as having been 'paid into the Military Chest'. This is another first since traditionally, and by instruction from the Lords of the Treasury, receipts in aid of revenue were included in the Colonial Fund. That year, the disbursements on account of miscellaneous civil services are recorded as 'total disbursements, out of the military chest, in aid of the civil establishment of the colony'.

Each year the revenues recorded an amount, usually less than 500 pounds, for supplying water to visiting ships. This had originally been a 'Police Fund' transaction but obviously the British Government considered it had the rights in water as a condition of Terra Nullius and wanted their ownership of fresh water recognised in the accounts.

Each year pensions were paid, not only to retirees who remained in the colony, but also former government officials who had returned to England. Retirees in the colony received their pensions through the Colonial Fund. From 1835, school expenses were paid to The Church of England (Episcopalian) school and to Presbyterian and Roman Catholic schools all of which were recognised in the Colonial Fund under the Religious Establishment costs. clerical costs and salaries were also recorded by denomination of church in the Religious Establishment.

[78] Found in the 1828 Blue Book Statement relating to the Military Chest.

In 1837, 'Revenue of the Crown' became a separate heading within the *Blue Books* Revenue and included:

Movement of specie into the colony, first shown in 1826 under the heading 'Receipts in aid of Revenue (in Sterling) - 'consignment of specie' appeared regularly in the Military Chest accounts.

Arrears in payments on account	Proceeds of imported goods
Land sales	Land sales at Port Phillip (1838)
Quit rents	Licenses to depasture cattle
Fees on the delivery of title deeds	Proceeds of the sale of charts of Port Phillip
Leasehold sales	Rent on land

The total amount of fixed revenue was recorded in the accounts in sterling, according to the current rate of exchange (1826). Rates of exchange between sterling and the local currency were originally set by Macquarie and this was retained by his successors. One notation recorded [79] 'of the above total (£216,562.16.2 in Sterling) there is cash expenditure of £196,562.16.2 of which the amount for stores expended is £21,662.16.2.' As can be seen there is still much to learn about the accounting practices and fiscal symbolism shown in the *'Blue Books'*.

The development of the colonial financial institutions reflected the needs of the day, but it took Macquarie's anticipation of a growing economy. and the refinement and reform of the monetary system as the catalyst for foreign investment and economic development, to encourage facilities such as export bills, export financing, auctioning in the colony before export and securing loans over livestock and chattels instead of only fixed assets.

It is now appropriate to develop in more detail the study of the commissariat by identifying its importance within the colonial economy. For instance, what was the impact of commissariat expenditures on the local economy? What areas of the colonial economy were dependent on commissariat expenditures? What direct and indirect benefits did commissariat operations and expenditures bring to the local economy? Did the commissariat grow with the demand for its services, or was it always lagging behind demand and dragging the economy back with it? The commissariat did grow with demand and reflect colonial needs by being true economic driver and acting as a catalyst for foreign investment, immigration and new economic activities.

[79] On Page 7 of the 1826 Blue Books

Summary of Chapter 6

All items produced at the work centres were recorded and reported but not valued. The underlying concept of accounting for official (government) output was that anything produced by convicts had no official value although coal from Newcastle, clothing and materials from the Female Factory and produce and grain from the government farms were all sold publicly. The Commissariat accounted for that revenue, but there was no 'cost' of goods sold, as it would be termed today. No value was ever recorded in the books of the Orphan Fund, Police/Gaol Fund, Commissariat Accounts or '*Blue Books*' for convict output, only the revenue from the sale the items produced. So materials produced in the Lumber Yard, the Timber Yard, the Brick Yard or the Stone Yard had no value even when they comprised 80% or more of the component of public building construction in the colony and the Earl of Bathurst complained regularly of the cost and wastage of such construction. The cost of maintaining convicts was calculated as being officially about £13.10.0, even though their clothing was made locally, their food was grown locally and they were housed in public buildings built by convicts using publicly supplied materials.

Accounting for the commissariat must have been a nightmare and' in 1815, 20 clerical assistants were employed on this work. However because they were convicts, they were not 'expensed' to the commissariat and this high clerical cost was never revealed in the accounting records. Darling's contribution to the post-Macquarie commissariat was significant as the rise of the public service was aligned with a personnel restructure of convict management and maintenance and the role of the commissariat was further integrated into the public service. Darling's management style left many wondering whether progress was being made, as he had surrounded himself with a Board of General Purposes, composed of the colony's intelligencia, and ordered an impressive array of committees and boards which reported on 29 occasions on such important matters as the Crown land management, school and church land management, immigration and a wide range of financial policies in addition to a rational development of the colonial public service.

Before 1820, three governors[46] attempted to improve the operations of the commissariat but it had been in operation for 12 years before the British Treasury released the first set of written instructions on how it should be run.

One aspect of commissariat operations which grew was the importation and control of 'specie' mainly because it did not fit into any other section of the government. Coinage was a monopoly controlled closely by the commissariat. A total of £60,000 of British coinage imported by the commissariat, of which no less than £50,000 was said to be in the commissariat at one time in September 1827 in payment for bills.[47] This meant that the commercial banks had to cease making advances before ships sailed to limit the outflow, but in fact the outflow continued - £30,000 left for London on the *Elizabeth* in November 1827, £20,000 to Mauritius in March 1828 and £30,000 to London on the *Boddington* in September 1828.[48] This 'run' on the banks seriously reduced coinage and liquidity in the colony and for a third time in four years the Bank of NSW applied for a government loan (this time for £15,000). One reason that this application was for a lower amount than previously was that the Treasury bill rate had been reduced from 3% to 1.5 %, and this circumstance somewhat discouraged the amount of coinage exported from the colony.

In its control of the importation of coinage, the commissariat played the role of fiscal and monetary comptroller, principally because the colony still had no 'official' treasury and had subrogated this important role to the commissariat and the banks. On three occasions the Bank of NSW had been granted a short-term loan by the government on condition it increased its capital base but, on each occasion, the nominal capital increased, the subscribed capital increased, but the 'paid-up' capital increased only very marginally, not enough to improve the liquidity or debt-equity ratio of the bank.[49] The dramatically 'illiquid' position of the bank was partly due to advances made by buying up commissariat 'loans', and the high discount rates imposed on Treasury bills for overseas purchases, a policy encouraged by the Executive Council and Governor Darling. The bank had taken no action against a large accumulation of overdue loans but part of the governor's support for it was on condition that overdue bills and

[46] Phillip, King & Macquarie
[47] *Australian newspaper* 21 September 1827
[48] *Australian* 7th March 1828 *Sydney Gazette* 3 September 1828
[49] HRA 1:14:549-60 *Darling to Murray*

loans, 'should be retired immediately', with the threat that action (foreclosure and seizure, under the new Insolvent Debtors Act-*NSW LC V &P-1830)* would be taken against all parties 'whether they be drawers, payers, acceptors or endorsers'[50]. This threat could not legally be carried out, but it accomplished its goal. The bank collected over £12,000 in cash or valid security and restored its balance sheet to 'good standing' before the Executive Council's review of the Bank of NSW licence and the threat of closure by Darling. There was a basic conflict of interest situation in the fact that large shareholders of the Bank of Australia included Colonial Auditor-General and Comptroller of Banking (William Lithgow) as well as various members of the Governor Darling's family.

Apart from the Comptroller of the Currency, the commissariat became the major source of capital imported into the colony through British expenditure on maintenance of the penal establishments. Bills drawn by the commissariat were averaging nearly £150,000 per annum. N.G. Butlin estimates that the commissariat contributed up to 75% of private capital in the colony between 1800 and 1820.

Table 6.9: Bills drawn by NSW Commissariat[51]

1819	129,499
1820	181,376
1821	166,315
1822	229,826
1823	95,828
1824	199,112
1825	170,899

The third type of financial transaction controlled by the Commissariat was that of inter-departmental, government-sponsored loans. The Colonial Treasurer arranged loans to and from the commissariat as a means of strengthening the reserves of the local banks (the Bank of NSW and the Bank of Australia). Both banks were holding large government deposits and Darling, through William Lithgow, his Comptroller of Banking, was concerned about their financial stability. The banks lodged monthly returns with Lithgow's office, which in turn reported on the 'state' of the banks to Darling and the Executive Council.

[50] *Sydney Gazette* 29 January 1829
[51] HRA 1:14:130 Darling *to Huskisson*

In August 1826, Lithgow drafted a memorandum for Darling to send to the Earl of Bathurst[52] proposing that the commissariat issue notes of £100 denomination to a total of £60,000 [53], to be held by the two banks as a reserve. In an endeavour not to interfere with the amount of coinage circulating within the colony, the commissariat was encouraged to make all future payments in British coin. This plan became operative on 1 September 1826[54]. The store was also encouraged to issue £5 and £10 notes.

The use of the commissariat as a 'financier' and comptroller of currency was logical when the flow of imports by the commissary is taken into account. With food short supply from June 1828, and the commissariat stores empty, the governor waived duty collections on wheat imports and the commissariat imported record quantities of wheat in 1828 (85,716 bushels) and 1829 (107,929 bushels) This food relief brought with it an aggravation of the balance of payments problem,[55] and affected cash reserves generally. The *Sydney Gazette* of 27 January 1829 commented:

> *'Such things as ready-money transactions are nowadays never heard of; credit is the only hinge on which business turns; credit in town, credit in country, credit with the wholesale merchant, credit with the retail dealer. Credit with the farmer, the grazier, the butcher, the cabinetmaker, the blacksmith, the mason – everywhere, credit, credit, credit.'*

The *Gazette* brought home to its readers where this credit balloon was leading" 'One in every 4.25 persons was served with a writ of one kind or another…one in every 10.3 persons either had an execution that was held to bail… and one in every 14.3 persons had an execution against his person or his property'.[56]

The commissariat had assumed its most influential role under Macquarie, Brisbane and Darling, and it was becoming the major regulator of the colony's fiscal matters. Although this role was immediately outside the commissariat's terms of instructions, there was historical precedent for it to use this opportunity since, in reality, there was no alternative administrator for this fiscal control elsewhere in the government structure.

[52] HRA 1:12:511-12 Darling *to Bathurst*
[53] The amount of a loan from the colonial treasury to the commissariat and intended to be repaid by the selling of commissariat notes. This method would obviate the need to export dollars and retain the coins for cash purposes
[54] *Sydney Gazette* 2 September 1826
[55] S.J. Butlin *Foundations* p.209
[5] [6] *Sydney Gazette* 12 July 1831

CHAPTER 7

THE GROWTH OF MANUFACTURING IN THE COLONY
AS A RESULT OF COMMISSARIAT OPERATIONS

In the prologue to *The Sydney Traders* Hainsworth writes 'To study the 'entrepreneur' is to study the central figure in modern economic history - the central figure in economics'. The years 1788 to 1821 are the seed-time of Australian government'.[80]

Although it is difficult to connect the growth of economic development for any one sector in terms of percentage of contribution, we know that the more important sectors must be;

Growth of population

Government immigration policy

Foreign capital

The need for import replacement

The need for foreign exchange through exports.

In each of these sectors, the commissariat had a role and there was an important government need. The government had to grow the economy at the lowest practical cost, while also offering official services which would attract growth, trade and population. It achieved this, at least through 1821, by using the commissariat as the quasi-treasury, the manager of government business enterprises, and the employer of government-sponsored convict labour. The point here is that the economic model had to incorporate and reflect each of these 'input' factors. Here in brief is the methodology used.

The influence of the commissariat over foreign exchange, imports and exports, government-sponsored manufacturing and even attracting foreign investment capital is without comparison, but it is measurable. The economic model for the period does not nor cannot parallel Butlin's measurement of post-1861 GDP, but it does use basic ingredients like:

Computing the free working population

Computing the working convict population

Assuming a productivity adjustment for lower than expected convict output

[80] Hainsworth *Sydney Traders* prologue page 14

Valuing productive labour at Coghlan suggested rates

Interpolating labour product to total output.

Comparing annual total production per head of population and per head of 'worker'

Estimating total output by industry and comparing this to underlying assumptions about labour output.

Extending the estimated GDP from 1800 to 1860 to ensure the recessions of 1810-1816, 1828-29 and 1842-45 as shown in the GDP figures were responsive to these downturns.

Comparing the growth of local revenues from 1801 and of trade, for the same period reflected changes to estimated GDP.

Announcing the adopted GDP figures for the period 1800 -1860 and seeing how they blended in with the Butlin figures.

The results are assembled on a spreadsheet for each year, but a summary has been produced as an extract in order to evidence gains for each ten-year interval, and to show that the Beckett compilations and the Butlin compilations fit in with each other.

Table 7.1: Estimates of GDP between 1800 and 1900

Year	GDP per head of population	GDP per head of workforce
1801	13.61	35.10
1811	28.06	49.95
1821		59.70
1831	35.68	63.51
1841	39.66	70.60
1851	40.13	76.43
1861	46.00	85.00
1871	47.00	118.00
1877	57.00	139.00
1881	63.00	151.00
1889	67.00	158.00
1891	66.00	155.00
1900	57.00	132.00

Source: Beckett *Handbook of Colonial Statistics for period 1800-1860*
Butlin, N.G. *Investment in Australian Economic Development 1861-1900*

Certain conclusions can be reached about this table. GDP in the colony grew in each ten year period because the components of that GDP grew eg population, manufacturing enterprises, convict numbers, exports and immigration. As the colony went through its transition from

penal to free, especially a free market-based economy, so government investment in services and infrastructure grew. Personal investment in housing increased and the wealth of individuals grew, as well as the collective wealth of the colony. The downturn in 1900 was due to the recession in the mid-1890s when many banks failed, unemployment increased and the previous land boom of the 1870-80s crashed, leaving many families and businesses in financial difficulty.

However certain questions remain: This model relates to restricted sectors of the colonial economy, but it only touches indirectly on important sectors such as the pastoral, whaling and seal industries. These sectors were indirectly reflective of a growing export market and a more detailed model with declared sub-elements would express the importance of the natural resource and primary production industries including timber, shipping, coal, minerals, wool and wool by-products.

There were some distractions from within the colony to Macquarie's aggressive enterprise policies. In a wave of perversion, William Charles Wentworth led an anti-Macquarie movement against local manufacturing in favour of importations. In January 1819, Macquarie gave permission for a group of clergy, merchants, settlers, and other gentlemen to convene a meeting in the court-room of the new General Hospital, to prepare a petition. The petition was for a redress of grievances and essentially sought expand rather than restrict imports into the colony. Macquarie, by trying to match exports with imports in value terms, was restricting the type of imports authorised. In a despatch to Bathurst of 22 March 1819, Macquarie notates[81] the resolution:

> '*1. That a regular demand exists in the colony for British manufactures of nearly all descriptions, greater than the established mercantile houses here have supplied or are likely to supply regularly.*
> *2. Restrictions prevent merchants from employing ships of less three hundred and fifty tons burthen (under the Navigation Acts)*
> *3. That this meeting requests Gov Macquarie to try and expand shipping between Britain and Australia for transporting Manufactures and colonial produce.*'

The sentiments were laudable but the request baseless. The commissariat, with its huge buying opportunities, could have achieved the desired result as could merchants collaborating

[81] HRA 1:10:52 Macquarie to Bathurst 22nd March, 1819

into a buying group. The obvious solution was to encourage the local production of all imported items at a lower cost. Macquarie made no recommendations to Bathurst, which meant that he had strictly fulfilled his role to the petitioners and left Bathurst with the opinion that the colonial manufacturers and merchants were ill-prepared to fight British exports.

In over 300 pages of text, John Ritchie[82] reviews the submissions made in the colony to Commissioner Bigge, but does not recite any submission made by merchants or manufacturers. However in the Bigge reports, we find details of evidence submitted by Simeon Lord about his manufacturing activities. At his factory at Botany Bay, he employed between 15 and 20 convicts in the making of:

Blankets	Possum skin hats	Glass tumblers
Wool hats	Boot leather	Kettles
Kangaroo hats	Stockings	Thread
Seal hats	Trousers	Shirts

Between 1810 and 1820 the number of sheep trebled, and many producers were finding it more profitable to sell carcasses rather than fleeces.

Local manufactured items did not entirely replace imports and items were still imported from India and China.

From India	From China	Local exports included
Sugar	Sugar Candy	Sandalwood
Spirits	Silks	Pearl Shells
Soap	Wearing Apparel	Bêche-de-Mer
Cotton goods	Whale Oil and Meat	Seal Oil

Trade exchange was made on a barter basis, of 'coarse cotton' and ironware for coconut and salt pork was carried on with a number of the Pacific Islands

Among other evidence to the Bigge Enquiry, there were numerous complaints by manufacturers about the limited supply of materials and the high cost of buying from government business enterprises – for instance the cloth produced by workers at the government

[82] Ritchie, John *Punishment and Profit - The Bigge Commission into NSW'*

female factory was 2/9d per yard, whereas at Mr Kenyon's private establishment it was only 11d. The manager of the Robert Campbell merchant business complained to Commissioner Bigge about the duties levied in England on whale and seal oil from the colony. He also criticised the port regulations which required captains to give 10 day's notice of intention to sail – he claimed this resulted in high wharfage charges. Ritchie *'Punishment & Profit'* concludes that, although Bigge wanted to encourage trade and certain manufacturing, he was reconciled to the fact that their promotion would not provide an adequate or proper solution to the question of convict employment, punishment and reform.[83]

Observations on Industry and Commerce in NSW
By 1820, Simeon Lord had turned the profits of fishing in the south seas and trade in the Pacific Islands into a manufactory at Botany Bay where he employed convicts and 15 to 20 colonial youths making blankets, stockings and hats of wool, kangaroo, seal and possum skin. All were shoddy but cheaper than similar items imported from England. [84]

The heavy influx of immigrants during the Darling Administration brought its own difficulties, especially when drought and depression descended on the colony at the end of the 1830s. This period led on to the severe economic depression of 1842 which had been fuelled by a reduction of foreign investment, a cessation of British speculation and a further withdrawal of absentee landlords. There were also numerous local factors, partly encouraged by Sir George Gipps, Governor Darling's successor. Between 1831 and 1841, imports had increased by 1257 percent to a total of over £2.5 million.[85] The severe drought of 1825-8 was unfairly blamed on Darling, as were the epidemics of 'hooping cough' and smallpox which afflicted the colony. Darling's own son died in the whooping cough epidemic.

Between December 1831 and December 1832, 325,549 gallons of spirits and 109,406 gallons of wine were imported and at least another 11,000 gallons of gin were distilled locally – all for a population of only 15,000. As for the prices of consumer items, milk was 8 pence per quart, potatoes 15/- a hundredweight, beef had declined to 1 ½ pence[86], mutton 2 ½ pence, veal 5

[83] Evidence by sundry manufacturers to Commissioner Bigge Enquiry

[84] An quote extracted from Clark, A History of Australia sourced by Clark from 'An account of Mr Lord's manufactures, submitted to Commissioner Bigge, 1st February 1821

[85] Barnard, Marjorie *Story of a City* p.18

[86] Beef during the Macquarie Administration was bought by the Commissariat at 5 pence per pound

pence, pork 4 ½ pence. Fowls cost from 1/9d to 2/3d per pair, whilst butter varied from season to season between 1/- and 3/- per pound and cheese sold at 4 pence per pound. Cape wine was 8d to 8½ per pint and port was 1/5 to 2/- per quart. Respectable lodgings were a £1 per week and a horse could be hired for 10/- a day and a gig for 15/- per day. Housing costs had risen to £530 for a six-roomed cottage.

The depression had lasted from the late 1830s to 1842 but it created a slow down in the colony which lasted until gold was discovered in 1852, causing an estimated 1638 bankruptcies. There was a glut of livestock and sheep were selling for 6 pence per head. Land sales ceased and there was an oversupply of labour for the first time in 50 years. Another blow to the struggling economy came with the discovery of gold in California, with estimates of 5757 houses being empty out of the 7100 houses in Sydney town.[87]

In the period up to 1800, the economy was based upon the limited trade monopolised by military men like John Macarthur, as well as a steady expansion of government-financed agriculture to feed the growing number of convicts. This expansion could only continue until the colony became self-sufficient in food; then an alternative product of sufficient value to be exported, would be required to generate the hard currency to pay for the increasing number of imports demanded by the growing economy. Only by developing such a staple export could the colony become economically viable and thereby partially relieve the Treasury of the burden of supporting it. With such a staple export attracting additional population, the colonists would also have some hope of eventually claiming the continent's wide interior.

By 1802, Governor King could report to London that seal skins were the way ahead in terms of exports. More than 100,000 skins were landed in and shipped from Sydney between 1800 and 1806. In 1804, 11 Sydney-based ships were engaged in the Bass Strait sealing trade, in addition to the large number of ships engaged in whaling.

By the early 1800s there were four main types of economic activity in the colony. Agriculture and grazing were making the colony almost self-sufficient in these products, and large landowners were undermining the governor's attempts to encourage yeomen farmers. Many

[87] Barnard Marjorie *ibid*

of these large landowners also engaged in mercantile activities but a growing number of emancipated convicts became traders on their own account, with speculation in trade marked by gluts and scarcities. Many merchants also operated their own vessels, engaging in sealing and whaling. The number of whalers operating out of Sydney rose from 5 in 1827 to 76 in 1835. Between 1826 and 1835 the value of fishery products passing through Sydney reached £950,000 and in 1849, there were 37 boats based in Hobart employing 1000 seamen. [88]

Sealing and whaling exports were followed by wool. Although only 29 sheep had arrived with the First Fleet, successive convict fleets added to the flocks and numbers quickly expanded by natural increase. By 1805, there were 20,000 sheep in the colony, in addition to the 4,000 cattle, 5,000 goats, 23,000 pigs and 500 horses. The efforts of these large landowners, including John Macarthur, resulted in a dramatic change in the export statistics with the weight of wool exports rising from just 167 pounds in 1811 to 175,433 pounds in 1821. [89]

By 1835, the supremacy of pastoralism was beyond dispute, with exports of fine wool dominating the trade figures. The success of the pastoral industry defeated the British government's efforts to slow the invasion of the interior. The success was the result of a combination of factors - cheap land taken from the Aborigines, cheap labour in the form of convict workers and even Aboriginal labour from those able to supervise large flocks over extensive unfenced grasslands in the interior. [90]

Not surprisingly the Europeans found the places they wished to settle were those the aborigines had found most desirable – land with water sources and native grasslands. By 1850 over 4,000 pastoralists with their 20 million sheep occupied 400 million hectares (1,000 million acres) of inland Australia.

Population growth contributed greatly to the rise of manufacturing and the general economic growth in the economy. NSW grew from 76,845 Europeans in 1836 to 187,243 in 1851, and growth in Port Phillip and South Australia was even more dramatic. By 1841, more than half the male population of NSW had been born in the colony or was an immigrant rather than

[88] Day, David *Claiming a Continent – A new History of Australia.* Pages 49,50,51
[89] Day, David *Ibid pages 52,53*
[90] Day, David *ibid* page 74

convict, while convicts and emancipists comprised just over one-third of the total population. However males still outnumbered females by roughly two to one.

When it comes to identifying special and important exports, one aspect of trade is generally overlooked. Wool exports began to drop in the early 1820s, but most historians claim wool dominated agricultural exports and that opinion clouds the real truth. In fact in the 49 years from 1788 to 1828, if a reliable set of export statistics were compiled, it would be surprising if Australian-owned whaling and sealing vessels were found to be less productive than sheep. Figures do exist for the next six years from 1828 and for Australia as a whole. Whaling narrowly exceeded wool for that period whilst, as late as 1833, it was the main export industry of NSW. However, after that time, 'wool races away, yielding in the last three years of the 1830s almost double the export value of Australia's whale products' [91]

A secondary importance of the whaling industry is that each vessel is estimated to have spent an average of £300 whilst in port. This did not include the sovereigns spent by the crews in the inns and elsewhere.[92] There was also the work for the dockyards and shipbuilding was probably the largest and most dynamic colonial manufacture before 1850. Tasmania alone built 400 vessels, from small cutters to ships of 500 tons, which joined the England-Australia run. Blainey also observes that reluctance to put whaling into an accurate perspective in importance to the colonial economy stems from apathy towards maritime history. He claims that 'except for ship-lovers, the sea and ships are still virtually banished from written history'.[93]

In his third report in 1823[94,] Commissioner Bigge referred to the high level of efficiency amongst the convicts assigned to 'task work' for the government manufactures. He discovered that, at the close of the Macquarie period, the significance of the Government Store as a market for colonial produce and a source of foreign exchange were greater than ever. A heavy increase in the number of convicts transported after the end of the Napoleonic wars had correspondingly increased the government's demand for foodstuffs. Bigge reported that the

[91] Blainey, Geoffrey *The tyranny of Distance* Page 115

[92] Coughlin, T.A. *Labour & Industry in Australia* Volume 1, Page 367

[93] Blainey *ibid* Page 116-7

[94] Commissioner Bigge's Estimate of the value of convict labour in Sydney for 1822

concentration on producing foodstuffs had retarded the growth of export industries while encouraging the growth of agriculture – farming as opposed to grazing. He added: 'it is possible, given other circumstances the settlers might have turned their attention to the production of other objects than those that solely depended upon the demands of the Government'.[95] Bigge also referred to the high level of skills used in the Government Business Centre - the Lumber Yard - and to the benefit derived by the colony from the local public sector manufacturing.

Commissioner Bigge reported on the extent of the trades utilised in the Lumber Yard and it was an impressive list[96]. The trades carried on in this government business enterprise [in this case, the Lumber Yard] were also reported on by Major Ovens, the former Superintendent of Convicts[97:]

> *'In the Lumber Yard are assembled all the indoor tradesmen who work in the shops such as blacksmiths, carpenters, sawyers, shoemakers, tailors etc. The workmen, carrying on their occupations under the immediate eye of the Chief Engineer are probably kept in a better state of discipline than those, who working more remote, are dependent on the good behaviour of an overseer for any work they may perform. Whatever is produced from the labour of these persons[98], which is not applied to any public work or for any supply of authorised requisitions, is placed in a large store and kept to furnish the exigencies of future occasions.'*

In the colonial economy, growth came in numerous guises including as technological progress in industry and agriculture, transport and communication, population growth, the accumulation of capital; the discovery of raw materials and the spread of economic freedom.

The rise of a manufacturing sector relied on most of these areas, especially technological gains, supply of capital, immigration of skilled trades and Macquarie's sympathetic encouragement of entrepreneurs. Although not as vital as the agricultural sector, the manufacturing sector provided substantial employment, innovation, skills training, and a basis for potential decentralisation. Most importantly, during the Macquarie Administration, the manufacturing sector supported the colony's transition from a penal to free market economy. As it stabilised, it became attractive for a large number of British-based industries wishing to

[95] Bigge, J.T. *Report on the Agriculture and Trade of NSW* 1823 Page 22
[96] Bigge, J.T. *Report on the Agriculture and Trade of NSW* 1823 Page 22
[97] Report by Major Ovens to Governor Brisbane on reorganisation for the Lumber Yard HRA 1:11:655-7

open branch offices in the colonies and invest in small-scale activities, often transferring skilled labour from Britain to underpin their colonial operations.

Local industry also helped to develop local resources, both human and capital. Both coal and timber became important exports for the colony, whilst the list of other natural resources being developed for both local use and export continued to expand. New industry required new talents and skills, so a number of adjunct industries came into being - engineering design, equipment manufacturing and equipment maintenance. Not all new equipment was imported and, particularly for agricultural equipment suitable for local conditions, local manufacture and assembly was the norm rather than the exception.

Employment in the sector grew to an important level, with the number of factories in NSW increasing from 37 in 1829 to 174 in 1850[99]. Exports increased during the same period from £79,000 p.a. to over £8,000,000[100]. Boatbuilding peaked in 1843 at 46 vessels for the year, although the average size halved between 1841 and 1843. There were 102 vessels registered in the colony in 1841 displacing 12,153 tons; by 1843 this number had declined to 77 and it continued to decline until the 1900s.[101]

Even as late as 1827, the Colonial Office was still very suspicious about the expenses of the convict establishment. Lord Bathurst wrote of '...the difficulty I feel in reconciling the scarcity of assignable convicts...with the enormous and increasing expense with which this country is still charged'.[102]

Every effort to trim convict maintenance expenses or expand the assignment system impacted on commissariat business operations. The Superintendent of Convicts would agree to the training of apprentices only to find them sent off 'on assignment', whilst the best workers in the Lumber Yard were always in demand by private manufacturers and government building workers were constantly in demand by the private contractors.

[98] Sawn timber for framing, roof battens, flooring, window frames, doors, nails, bolts, bellows, barrels, furniture - from Beckett *The Operations of the Commissariat of NSW 1788-1856*
[99] Butlin, Ginswick & Statham *The Economy before 1850* (Australians: Historical statistics – p.108)
[100] Butlin et al *ibid* - P. 109
[101] Sourced by Beckett from original data in *Australians: Historical Statistics,* Coghlan and Butlin
[102] HRA 1:8:221

There are few signs that the colonial governors attached great importance to colonial manufacturing. Bligh dismissed it as trifling and, while Lord's textile and hat ventures were launched whilst he was Governor and there is no evidence Macquarie appreciated the long-term significance of such enterprise; he only saw that Lord employed an average of about 20 convicts. However, the rise of manufacturing did not depend entirely on private enterprise, for there was plenty of government enterprise for instance the Female Factory at Parramatta, which enjoyed the dual role of maintaining about 300 single 'at risk' women and providing the spun yarn for slops. There was also the contribution made by privately-owned industries which became so important to the colony's development. The search for staple basic industries began early; shipping, sealing and whaling were the first industries followed by wool.

Since European settlement, there had always been two frontiers – the interior and the ocean. As noted by Hainsworth, 'between 1800 and 1821, the more enterprising settlers, found the oceanic frontier a more hopeful source of gain than the harsh and alien terrain at their backs'.[103]

Therefore, it was not illogical that the first activity undertaken by convicts and free settlers with the necessary skills was the building of boats. Boat building led on to the second phase of staple activity, the use of those boats for exploiting the ocean's possibilities. Not only was construction a challenge but the task of keeping them seaworthy year after year was even more formidable. As Hainsworth points out[104], to harvest export staples from the Pacific and Australian coastal waters, and to establish a colonial carrying trade with outlying settlements, the traders needed a large number of smaller craft. This rationale even sat comfortably with instructions to successive governors from Phillip to Macquarie, *viz* 'It is our royal will and pleasure that you do not on any account allow craft to be built for the use of private individuals.'[105] Activity was brisk and during the first 25 years of the colony's development, hundreds of vessels of up to 200 tons were built.

[103] Hainsworth, D.R *The Sydney Traders* page 115
[104] Hainsworth, D.R *The Sydney Traders* page 117
[105] From HRNSW I (part 2) – Phillip's instructions which became a model for Hunter, King, Bligh and Macquarie)

Sealing, the first staple export industry, followed because '...the agriculturalists, knowing that exports in grain were altogether impracticable, resorted to the external, though near resources of the colony, viz: in procuring seal-skins about Bass's Straits'[106]. The story of sealing is that of a cruel industry set in a harsh environment. Total numbers were not recorded, but from Macquarie Island alone over 101,000 skins were taken[107] each season. In addition to the skins, which usually brought about 5/- each in the English market, hundreds of tons of oil were exported to Britain. It usually took about 3,000 seals to produce 100 tons of oil; and from the gross earnings the British Treasury extracted a duty of £24 a ton for oil. Many sealers working for small firms would be paid, not on a piece rate, but as a percentage of the gross value of the catch at Sydney prices.

The Need for Manufacturing

G.P. Walsh, a historian, has already made two significant contributions to the literature on the *'Dawn of Industry'*. This writer's purpose is not to retrace the same ground but to examine closely how the traders supplemented or replaced government activity, and how they launched types of manufacturing which had no government involvement. At first, it was only natural that the government should play a dominant role, for it had the responsibility of clothing, housing, feeding and finding employment for its convict charges, both male and female. Thus it became the chief employer of labour, provider of capital and the chief consumer. The local government was also prepared to foster industrial enterprise, though their support was haphazard and random. In fact after they had launched brewing, salt-making, milling and crude textiles, and operated a number of crude industrial processes, needed for their convict charges, the government allowed some of these ventures to pass into private hands.

In Chapter 12 'Dawn of Industry' of *'The Sydney Traders'*[108,] Hainsworth guides us in a review of the growth of manufactures before 1825. He pointed out that 'Thanks to the initiative of

[106] Collins, David; *An Account of the English Colony in NSW '- 1806. Collin's reference notes also records (page 581) a report from Grose to Dundas of September 1793 (also found HRA 1:1:447) that 'Dusky Bay possessed all the advantages of Norfolk Island, but had a safe harbour and could become the centre of a sealing industry.*

[107] The *Sydney Gazette* in 1815 made this comment, but also noted that the numbers declined rapidly as the trade became more competitive. The muster of July 1804 showed 123 'free men' (emancipists) 'off the store' and in the southern ocean 'sealing'. By 1805, one private firm (Lord, Kable and Underwood) alone reported 206 men sealing –HRA 1:5:371

[108] Hainsworth, D.R. The Sydney Traders

Sydney traders, manufacturing and processing industries emerged very early and helped to transform NSW from penal settlement to colony'.

By 1800, sealing[109] was dominating the trading calendar. The official return for that year showed over 118,000 skins had passed through Sydney with Simeon Lord and his fellow ex-convicts, Kable and Underwood, handling over 72,000 from just one source – Antipodes Island. By 1815, the *Sydney Gazette* was reporting the sealing industry was in decline as this intense harvesting had lowered their natural numbers. However, the British Government was influenced by the 'whale lobby' to raise discriminatory duties against colonial oil, seal and whale. Spermaceti oil was to bear a duty of 15s 9d per ton for British ships but £24 18s 9d if obtained by colonial ships and £8 8s a ton were imposed on Black Whale oil from the Derwent estuary. Thus, through these discriminatory tariffs, colonial oil was virtually barred from London.

Cottage industries were not only the preserve of the small home-based manufacturers. Coghlan[110] points out 'those who had the enterprise and industry to devote land to gardening were amply repaid'. The broad acre crops raised were chiefly wheat and maize, with a little oats and barley, and some potatoes and other vegetables. Excellent opportunities for growing fresh fruit and vegetables were provided by the weather, the climate and the generally good soil around Sydney, but gardening was not generally undertaken except by the few who were conscious of home grown vegetables. They were able, says Coghlan:

> *'to grow almost all ordinary English vegetables, all the English fruits and some fruits, such as grapes, grew in abundance. Macquarie described his garden at Parramatta as 'full of vines and fruit trees and abounding in the most excellent vegetables.'*

In 1805, stock-raising was given impetus when the two Blaxland brothers arrived in the colony, bringing a considerable amount of capital and more than a little acquaintance with cattle husbandry. In 1810, horned cattle numbers stood at 12,442. When Macquarie left 10 years later the herds numbered 102,939, an annual increase of 20.5%. Herd numbers were carefully guarded with no undue slaughtering and in 1814 salt beef was still being imported. Even so, the records show that beef was cheap with a herd selling at £8 per head. Horses, says

[109] Based on Hainsworth 'The Sydney Traders Ch12 'The Dawn of Industry'
[110] Coghlan, T.A. 'Labour & Industry in Australia' (Page 117 –Vol I)

Coghlan, 'throve[111] in the settlement from the beginning although their numbers increased very slowly'. In 1800 there were only 203 horses, but by 1810 numbers had grown to 1134 and they totalled 4564 by 1821.

Coghlan recognises the importance of the timber industry and writes

> '...the export of timber became fairly considerable and in 1803, Governor King spoke of it as 'the only staple of the colony' – the inland forests could not be exploited because of the lack of any means of transport, and as a result 'numerous saw-pits were established on the inlets of Port Jackson, along the banks of the Hawkesbury, and later at Newcastle on the Hunter, where convicts were engaged cutting timber as well as in mining coal.'

Occasionally cargoes were shipped to India; in 1809 timber to the value of £1500 was sent there in part payment for a return shipment of rice.

> 'The presence of so much valuable timber would in ordinary circumstances have led to the establishment of shipbuilding yards. Vessels were built for sealing purposes as early as 1791, but the presence of craft capable of going to sea was considered a menace to the safe-keeping of the convicts and the governor directed no boats were to be built of greater length than 14 feet.'

In 1798, Hunter removed this restriction, and encouraged the shipbuilding industry by permitting a vessel of 'thirty tons to be built to procure seal skins and oil in Bass Straits'[112]. Campbell then built a vessel of 130 tons which was launched in 1805[113]. There was considerable activity mostly through the Dockyard, attached to the commissariat, in boat-repairs, refurbishing and provisioning, but the stoppage of the fishery in 1810 was a serious blow to the industry.

Between 1821 and 1826, immigration to the colony was mostly by way of assigned servants, but it was difficult to collect the payments due, and this made the whole notion impractical. Coghlan writes:

> 'in the matter of indentured service many employers, principally those in the country districts were willing to advance £8 –10 towards the cost of each immigrant labourer obtained by them and in February 1832 Governor Bourke despatched a list of 803 labourers who might be sent out on these terms. It was on immigration at the cost of land revenue that the colonial authorities placed their confidence. They offered to set aside £10,000 from the land fund for emigration purposes; of this sum they desired that about two-thirds be devoted to promoting the emigration of unmarried women, as the proportion of men in the colony was

[111] This is an editor's change – the Coghlan text states 'shrove'
[112] Coghlan, Labour & Industry Vol 1 Page 121-2
[113] Steven, Margaret 'Merchant Campbell 1769-1846'

excessive and that one-third should be used in loans for the emigration of mechanics.'

After 1836, it was decided that the rapidly increasing land revenue of NSW should be entirely devoted to immigration[114] and in 1837 over 3090 immigrants were brought to the colony of whom 2688 were sponsored through the Emigration Commissioners in London and 405 were under the bounty scheme by colonial employers.

The need for manufacturing in the colony was created by local demand for tools, materials and supplies, largely for meeting general construction and housing needs. Manufacturing in the colony was carried out by both the private and government sectors. The private sector was sponsored by a handful of entrepreneurs or skilled settlers who sought to create a 'cottage industry' to satisfy local demand for their products, sales of which were affected by limited demand and a constantly changing market.

Through the commissariat, the public/government sector became involved. The aims were to put convicts to productive work, reverse the long lead time for purchasing urgent materials from Britain and more fully utilise the 'free' local resources such as timber and convict labour. Barnard observes[115]:

> *'The colony was never wholly penal, nor was it intended to be. It was, in due course, to be balanced by freed men, their children, and such other settlers, soldiers, seamen and the like who cared to take the reward for their services in land, of which the Crown had a superfluity. Actually, NSW suffered very little from being a penal settlement and was fortunate in that her first unpromising colonizing material was early swamped by infusions of new blood, that wool, land grants and then gold attracted free colonists. There were no foreign elements to arouse Imperial suspicion, no subject race to put what might have been considered a necessary brake on progress.'*

This statement by Barnard is a rewriting of history but it would be an ideal policy, if it were true. It was designed to be a penal settlement and every move made centred on the convicts - their work, protecting them from themselves, feeding, clothing and maintaining them and providing them with tools, equipment and supplies. Laissez-faire might have been the vogue in London but during the Phillip Administration the settlement struggled whilst awaiting food and other supplies, and convicts were held tightly accountable for all their activities. Until

[114] Coghlan 'Labour & Industry in Australia –Vol I Page 178
[115] Barnard, Marjorie *A History of Australia* 1962 (Page 304)

1823, the entire responsibility for the settlement rested on the Governor; upon him was bestowed a power to control lawlessness, and he effectively exercised it.

By 1821 at the end of the Macquarie Administration, the diversity of manufacturing in the colony was far more impressive than could reasonably be expected from a former penal colony transforming itself into a free market economy. Macquarie's enthusiasm for free enterprise and 'cost saving' led to a great deal of production sponsored by the commissariat. Convict labour was considered to be without 'cost' and therefore without 'value' as were local raw materials, so much of the output of the commissariat business enterprises left without recognition of their value, which well-suited Macquarie's purposes. As early as 1812, he had been sternly warned by Colonial Secretary Liverpool [116] that:

> '...the burden of the colony of NSW upon the Mother Country has been so much increased since the period of your assumption of the government of it, that it becomes necessary that you should transmit a more satisfactory explanation of the grounds upon which the unusual expenditure has been sanctioned by you.'

Liverpool admitted he had misgivings about this attack when he continued his letter to Macquarie in terms of: 'I can't point out what expenses have been unnecessarily incurred, and the only ground I have for forming a judgement is by comparison of the total amount of bills by your predecessors and yourself'.'

Naturally enough, the absolute totals became progressively higher but, in terms of bills drawn on the store per convict head on the store, the comparisons declined. Macquarie was actively creating an investment for the future so that at some point the colony could be self-supporting and outside the need for Treasury appropriations. However, in philosophical terms, why should local revenues be used to support any form of penal colony for Britain? Surely the population of free settlers could grow in conjunction with the transfer of convicts to the colony; whilst Britain supported the convicts and the colony supported its own operations. One of Macquarie's goals in encouraging active government business enterprises was the early achievement of self-sufficiency so that the colony would be out of the clutches of Whitehall. His thinking was only half right. He was so preoccupied with the colony's economic and fiscal arrangements that he lost sight of the overall plan. Local revenues were first raised in 1802, designed for 'discretionary' expenditure by the governor of the day. The reason for this

[116] HRA 1:7:476 Liverpool to Macquarie 4th May, 1812

loose arrangement was that the Treasury appropriated funds for specific purposes such as convict maintenance and civil establishment salaries, but did not see the need for maintenance works, repairs, infrastructure development and the like. Thus the money for these essentials had to be sourced locally and reserved for deployment by the government. Whitehall soon discovered this stream of revenue and, although the Treasury officials knew it was illegally-raised, they restricted its use by withholding British funds to the amount of revenue raised within the colony. Thus in Macquarie's administration, private enterprise figured as a means of both import replacement and cost saving and manufacturing filled the joint roles of availability of key/essential merchandise and of putting convicts to productive work.

Barnard records[117] that even:

> *'...boys - some as young as eleven- were kept in Sydney at Carter's Barracks near Brickfield Hill and were working as a carpenter, shoemaker, stone-cutter, blacksmith, and other trades to which the boys were apprenticed. The product of their labour went into the public store, and a pool of much needed mechanics was created.'*

This observation is rather unique; it is unsourced but it does not have the ring of accuracy about it. Barnard is implying that these trades were carried out at the Barracks, which means that materials and tools were brought there daily. With carts and manpower for hauling purposes being in very short supply, it seems unlikely that large lumps of stone or tree trunks would be hauled from Upper George Street (the Lumber Yard was at the corner of George and Bridge Streets) all the way to Brickfield Hill for young boys to play with. Carter's Barracks were used for confinement and punishment, and there was little space for practicing woodcraft or stone masonry. It is much more likely that the boys were released under supervision on a weekly basis and taken to the source of the raw materials, for instance the stone-yard and the Timber Yard, which were both on George Street North. This is a rare unsourced and apparent contradiction by Barnard. She is probably incorrect when she states the output of the apprentices went to the public store – it is likely that it went to the Lumber Yard store, - where all building materials, supplies and tools were inventoried. The public store kept only for dry goods, fresh foods or grain.

[117] Barnard, M *A History of Australia* Page 237

The extent of private sector manufacturing ranged from clothing, castings and carts to soap, silver-smithing, tanneries and tin-smithing. Government manufacturing covered an equally broad range – from nails to timber framing, bricks, tiles and stone blocks, forged items and boot making. Because the small local population would not have supported such a sector by itself, the broad intent was two-fold – to replace imports and negate the timeframe of at least a year between the ordering and receipt of goods, and to create an export market of sorts.

According to Jackson[118], the population in the colony during 1820 was only 34,000, too small to create sufficient demand for private sector output and encourage economic development. The early entrepreneurs and their activities raise numerous questions which have not been studied in the literature to date. Hainsworth records[119]

> '*Simeon Lord cannot be described as a typical emancipist trader for his operations were too large and diverse, but he was a member of numerous local groups. Another was Henry Kable, whose commercial beginnings are still more shadowy - an illiterate man transported in the first fleet, Kable was for several years a constable of Sydney and probably profitably plied with liquor by the drunks he locked up.'*

By implication, Hainsworth is questioning how these two (of many) eventually became such successful traders? What was their source of start up monies? How did these emancipist traders get started? Hainsworth concludes 'the capital they mobilised for shipbuilding and sealing in 1800 must have come from trading'.[120] Other examples of early unexplained success include John Palmer and his close colleagues. Palmer was the third Commissary who began on 5/- per day and became the wealthiest man in the colony during the King Administration. Later his sister Sophia married the largest merchant in the colony, Robert Campbell. Palmer and his trading colleagues prospered in a colony where the commercial life was supposedly monopolised by an officer clique.[121]

Historians usually describe the officer class as having cast a large shadow in the early 1790s under Hunter but the officers could not stop an undertow of small dealers and emerging traders growing up around them. Rather the officers themselves brought this about by

[118] R.V. Jackson *Australian Economic Development in the 19th Century*

[119] H.R. Hainsworth *Sydney Traders* P.41

[120] Hainsworth refers his readers, on this point, to his inserts in the ADB for Lord, Kable and Underwood Volumes 1 & 2

[121] ADB Volume 2 – John Palmer (Hainsworth)

allowing the retail trade to fall into the hands of 'ambitious and able (if uneducated) men with no gentility to lose'[122] In many cases, because the wholesale market was officer-controlled and these emancipist retailers wanted to continue to expand and grow, they moved into 'cottage' manufacturing – often working with the commissariat to supply finished goods or raw materials for further processing by the Lumber Yard or Female Factory (such as tanned leather, scoured wool, and crushed grain). For many emerging entrepreneurs, this was the way they commenced their manufacturing activities – trader, marketer and then manufacturer.

According to Hainsworth[123], Simeon Lord was typical of the early merchant traders. When a shortage of circulating notes occurred, Lord (amongst others) requested his creditor customers to liquidate their debts to him by any means possible. The result was that Lord accepted grain, most of which he had bartered from his retail customers and then sold into the store on his own account. He also accepted payroll bills from military officers with whom he was dealing on a wholesale basis and individual 'notes or bills' payable which were freely circulating and classed as petty banking. Lord would consolidate these bills and exchange them for one large bill drawn by the commissariat on the Treasury in London. He would then release this bill to his suppliers, usually visiting ships' captains, or transfer them to his Indian or Macao (Hong Kong) suppliers. Obviously the greatest limitation to entrepreneurial activity in the colony was 'the medium of exchange': the lack of a mint, a Treasury or even a private bank of issue. However with all its faults the system worked; it was the only system they had and the traders made the best use of it'[124.] Thus private sector output was limited by government demand for food and materials.

The Jackson theory is that the sale of goods to the government store (commissariat) provided a major source of foreign exchange to the private sector because sale proceeds were made available in the form of Treasury Bills drawn on London.

Summary of Chapter 7
Of the nine economic drivers within the colonial economy, manufacturing had the most far-reaching and desirable results.

[122] Hainsworth *The Sydney Traders* Page 42
[123] Hainsworth *Sydney Traders* Page 83
[124] Abbott & Nairn (*Growth)* Chapters 8 & 9

The Macquarie Administration decided to centralise and highly regulate the labour and output of the more than 50% of the convicts who were assigned to private or government work after their arrival in the colony. For those assigned to government labour, the broad range of activities required a smarter government store than had hitherto been the case. The store had to have on hand sufficient tools and materials to keep these people fully utilised. Those convicts assigned to land and road clearing needed grubbing tools and axes as well as hauling equipment and food supplies. Those allocated to public building and infrastructure projects required tools, bricks, blocks, tiles and a large array of sawn timbers.

The Governor ordered the commissariat to create a central facility for assembling and distributing these materials. Most items could have been ordered in from Britain or elsewhere in Europe but the lengthy purchasing and requisition procedures required a lead-time of between 15 months and 2 years. Thus Macquarie's charge to the commissariat, to employ convict labour to manufacture locally as many imported items as possible created an import replacement program which resulted in employment and the rise of private sector entrepreneurs as well as generating the transition of local manufacturing from the public to the private sector.

The story of the rise of manufacturing in the colony of NSW is that of the business enterprises promoted and operated by the commissariat. The 900-page volume of the story of manufacturing in Australia, *'Industrial Awakening'* by G.J.R. Linge, does not officially recognise the link between the growth of manufacturing and the commissariat business enterprises. After a few definitions of business enterprise, manufacturing and secondary industry, Linge claims on page 24 claims:

> '...the importance of government activities during the whole of this first period can hardly be overstressed. To a considerable extent the administration controlled the factors of production: it regulated, restricted, and occasionally encouraged the private sector: it ran its own farms, herds and workshops and above all it was the main consumer of goods produced'.

In fact, there was no manufacturing prior to the introduction of the Lumber Yard. Although Linge and others refer to this merely as a workshop to keep convicts busy, the Lumber Yard was strategically located, well supervised and enjoyed a sophisticated production-planning

regime that would still be admired in industry today. Just to place the Lumber Yard in perspective, it was not only as a means of 'working' convicts but a source of making locally many items needed within the settlement. You cannot have 2,000 convicts in a facility without producing some items of value and necessity. So the Lumber Yard commenced with the goal of using local resources and local labour to produce a wide range of products for local consumption and use.

Linge makes the comment on page 30-1 that 'at first most of the convicts worked for the government, but from late 1792 some were assigned to officers as agricultural labourers'. He refers extensively to the shortage of skilled labour as well as a general shortage of labour. What he does not recognise is that the forced labour of the Lumber Yard and its associated enterprises enabled this important, if not essential, business enterprise to get off the ground and created an opportunity for 'cluster' industries to be established, the starting point of the real secondary industries.

As was stated in the introduction to this chapter, 'out of necessity the demand for timber products, bricks, tiles, stones, rude furnishings and hand carts needed to be and could be supplied locally'. Wheelwrights forged simple iron rims, while coopers steamed woods for barrel making. Local timbers were cleared from suitable timbered hills on the north shore, clay was extracted from location at Brickfield Hill and on the south side of the Parramatta River, government buildings were being erected in Sydney and the new outlying towns, land was being cleared to the north, south, east and west of the settlement roads were under construction, and the commissariat was responsible for its coordination and planning. It was a massive planning exercise as well as a major exercise in saving government funds. Although no-one in the Colonial Office thought in terms of opportunity cost, there is sufficient evidence to suggest that import replacements were saving hundreds of thousands of pounds each year, and underpinning the desire for the colony to be self-sufficient.

The commissariat business enterprises drove the growth of the colony for over 30 years but most importantly, they created a manufacturing base for the colony and that, in turn, provided some balance to and support of the agricultural industry that was producing much needed foreign exchange and exports.

CHAPTER 8

SUMMARY AND CONCLUSIONS

A Satistical Synopsis of the Commissariat in Action

Because the financial statements are not directly available in the original format it does not mean the commissariat was without statistical information. In fact, a wide range of partial and general sources reveal a great deal about the commissariat in action. Although it would be ideal to have analytical data available which directly covers the commissariat, similar data can be assembled, interpolated and assumed to reflect the commissariat scenario. This approach has been taken in this summary where implied data is used to draw certain conclusions on the operations of the government store.

This statistical summary is intended to highlight much about the operations of the commissariat between 1788 and 1830. For example, if it is assumed that the materials for the Macquarie building/public works program were acquired through the commissariat, then the £922,857.13.11 of material costs, as reported to the Bigge Enquiry, was processed through the government store during the Macquarie Administration. These materials included timber of all shapes and sizes, both imported from Britain and cut locally by the Timber Yard, cured and processed by the Lumber Yard and stored by both 'yards' until required by the building program. It also included stone extracted from the local quarries and cut to size in the Lumber Yard. Bricks and tiles were manufactured in the Brick Yards, and 'mortar' was produced from lime extracted in the Newcastle pits by convict labour and shipped to Sydney town. These 'investment' expenditures were handled over the period of 8 years when Macquarie and Greenway were most active in the public works program. The paradox here is that, at all times before 1828, the output derived from convict labour and the value of convict-produced materials had no value. That is, the British Treasury did not reward the colonial administrators for optimizing convict output and self-sufficiency. This concept was too remote and complex for a 19th century mind and, instead of a performance incentive, only absolutes were recognised and they did not include convict production. This strange state of events, even for those times, skewed unreasonably the performance of, and within, the colonial economy. If 70-odd public buildings had an assigned 'value' based on opportunity

cost of components, consider the value-added during the British administration of the colony as a whole. Bridges, roads, gaols, barracks, boats, wharves, houses, churches, hospitals, courts were only the public infrastructure assets being financially assessed. Consumables could be added to this total, and even the 'value' to the colony of locally grown vegetables, grain and processed goods (such as bread) etc.. If convict output was counted, the GDP estimate for the period to 1824 would easily run into the £180-200 million range. The economic benefits to Britain in terms of strategic supplies of timber, coal, seal and whale oil and then wool would be a significant value, far beyond the cash payments made and the import taxes collected by the British Treasury.

Naturally a number of ancillary 'industries' were developed in association with the materials processing for public works. The Lumber Yard produced all the items for 'materials handling' such as handcarts and drays, to transfer the materials from depot to building site as well as portable 'rain-sheds' to protect on-site stores and supplies and only sometimes the workers. In addition, the commissariat and the Lumber Yard utilised an early form of apprenticeship and 'skills training' which provided the very first element of adult education in the colony. There is evidence of literacy programs being offered within the commissariat business enterprises, but naturally such advancement was self-serving as illiterate workers could not read instructions or count.

The missing financial statements for the commissariat were based on the fallacy that all this 'expenditure' (on local building materials and convict labour) was treated as an 'expense' and never referred to as a public infrastructure asset. Thus the valuable Macquarie public works program was 'expensed' by the commissariat in the same way as convict transportation and maintenance expenditures. Naturally Macquarie had to account for his high commissariat 'operating' expenditures and explain higher spending levels than those incurred by his predecessors. The British Treasury made no allowance for the growing numbers of convicts in the colony during the Macquarie Administration but compared 'absolutes' in an ingenuous manner, even though Macquarie's expenditure per head of population was less than that of his predecessors and his expenditure per maintained convict was no greater than theirs. It was also the high Macquarie expenditures rather than a rational cost-benefit analysis that caused the closure of the government farms program in 1818. Such a move was irrational and, in

reality, did not lead to the expected savings since the convicts previously housed and supported by the government were now 'assigned' and privately housed, but still maintained on the government store.

The statistical analysis in this study is broken down into two categories. The first part of the Statistical summary for the commissariat is in Tables 1-5 and includes British government outlays in seven categories of expenditure relating to the commissariat's role of supporting government. A summary of public expenditures within the colony is also reproduced. Although the main expenditures were approved and appropriated through the commissariat, because of the 'convenient' way of public financing and accounting for the colony there are numerous sub-categories of public expenditure. These include the Colonial Fund, the Gaol/Police Fund, the Orphan Fund, the Land Fund, the Military Fund, the Commissariat Fund, the Naval Fund and the transfer of 'specie' from the British Treasury to the commissariat. These statistics are summarised into a number of tables showing the growing level of Government financial support for the colony.

The second part includes Tables 6-8 which contain an analysis of convict labour and work allocation (by trades) and an estimate of the unreported 'value' of this labour per annum. A summary of the 1793 commissariat transactions is included, together with an account of the 'supplies taken into the store'. The importance of this statement is in the nature of the 'support' services provided by the store and its ever-changing responsiveness to local demands. In 1793 the accent by government was on food supplies and the concentration of the commissariat was thus on provisioning and victualling the convict and civil population. The purchase of 'stores' and spirits' accounted for 92% of total commissariat expenditure for the year. That expenditure did not include the vegetables, meat, poultry and dairy supplies provided by the government farms. In later years, as the public works program was under development and food supplies for the colony were stabilised, the composition of expenditures changed and more was spent on 'government supplies', including materials purchased for the public building program. Again, the expenditure did not include extracted natural materials for use in the commercial production of bricks, tiles, forged products or sundries such as stone, lime, leather goods, timber products and clay.

Table 8.1: Colonial Fund Revenue & Expenditure 1822-1834

Totals per annum '000

Year	Revenue	Expenditure
1822	66.7	58.0
1823	53.4	46.8
1824	n.a	na.
1825	97.3	142.2
1826	156.9	113.2
1827	95.6	118.4
1828	119.5	107.6
1829	182.7	98.3
1830	159.6	103.
1831	135.3	135.3
1832	135.9	147.7
1833	147.7	203.5
1834	203.5	270.0

This table documents a fluctuating but growing colonial economy. Note should be made that each year is in 'surplus' albeit small in many years. There was obviously no local mechanism or Treasury allowance for other than strict control over expenditures in the colony. Appropriations were earmarked specifically and not authorised to be varied. The source of this table is from the original *'Blue Books'* contained in the National Library of Australia. There are no copies of the *'Blue books'* for 1824. The PRO in London has no records of this year neither does the SRO in Sydney, the NLA nor the SLNSW. Certain figures are at variance with statistics prepared by Jules Ginswick and used by N.G. Butlin in his Working Papers in Economic History published by ANU. This writer has checked his own figures and stands by their accuracy.

Table 8.2: Commissariat Revenue and Expenditure 1822-1834

Totals per annum £'000

Year	Revenue	Expenditure
1822	255.5	212.2
1823	134.1	149.7
1824	na	na
1825	198.3	155.0
1826	63.2	103.3
1827	166.2	133.7
1828	98.5	238.0
1829	158.9	243.2
1830	139.6	196.8
1831	182.6	203.6
1832	165.7	194.3
1833	146.5	165.5

| 1834 | 174.2 | 187.0 |

The commissariat figures are unquestionably inaccurate and therefore misleading. However, they are the best available at this time and should be interpreted with their limitations kept in mind. These figures have been extracted from British Treasury summaries of payments made on account of the colony. In most cases the figures relate specifically to the colony of NSW, but obviously some errors may have been made in accounting for the transfer of goods to the Colony of VDL, at least until 1827 when a separate set of commissariat records were established in Hobart. Butlin, Ginswick and other observers claim most figures and statistics before 1856 are suspect as to accuracy and reliability and they are error-prone At least three points of error can be identified:

Firstly, the erroneous figures are mainly the result of misallocations within the British Treasury office itself. Bills were drawn in the colony, and only 'notations' were made on the drafts for allocation purposes, so guesswork was commonplace. The second problem was one of paperwork between the colony and the Treasury. Although it sounds simple for supporting documentation to be matched up with the 'bills and drafts in the Treasury office, there was usually a great delay in communications between the colony and London, and so this principle of 'matching' was difficult and not regarded as important. The third problem was one of paying the drafts. Bills could be held by visiting seamen for months or even years before they were presented for payment, and thus the 'timeliness' of the expenditures arose. Usually drafts were reported in the year they were paid, rather than the year incurred or when the goods were received.

Table 8.2 reflects the widening and more active role of the commissariat between 1822 and 1834. Economic growth was inevitable due to the growing convict and free population. Treasury bills made up 95% of the expenditures shown above, although the first transfer of 'specie' was reported in 1831, and each year thereafter until 1836. From 1833 there were also regular transfers of funds (e.g. loans) between the colonial treasury and the commissariat. They varied between £5,000 and £60,000 but averaged less than £20,000 per annum, and remained in place usually for a period of not less than eight months. An average of less than 2% of the revenue came from local commissariat sales. This problem was one of the options for reforming the commissariat recommended by Commissioner Bigge in his 1823 Report

(No. 3 – Agriculture and Trade). However, the growth of private stores and merchandising slowed any real opportunity for the commissariat to become a substantial retailer. Allocation of revenues was arranged into Convict Maintenance, Military and Civil, and public sector, which would have included government public works and maintenance.

Table 8.3: British Government Outlays 1788-1799

Totals per annum £'000

Year	Convict Maintenance	Stores and Food	Other	Total
1786	28,339	0	7	28,346
1787	23,779	2099	5463	31,.341
1788	7393	33,978	7753	41,731
1789	39,588	19,242	772	59,602
1790	8203	51,285	1414	60,902
1791	47,356	48,401	33,263	129,020
1792	34,234	19,762	50,592	104,588
1793	21,411	37,779	10,772	69,962
1794	15,363	40,189	23,830	79,382
1795	14,909	38,011	22,361	75,281
1796	16,156	11,122	56,577	83,855
1797	7703	17,202	95,468	120,373
1798	18,990	6656	85,868	111,514
1799	7672	25,631	46,971	80,274

The figures for Table 8.3 are sourced from PRO (London) located through the AJCP records in the NLA microfiche files. Once again they are questionable because of unexplainable surges in annual totals. Comparing the annual expenditures above to those set out in exchanges of correspondence between the Governor and the Secretary of State for the Colonies (in London) suggests business as usual and no explanation was provided, or even requested in most years, for the dramatic fluctuations. Either the figures have been incorrectly compiled by bookkeepers in the British Treasury or the ramifications of over-expenditures were overlooked. Reference should also be made to Table 7.5 wherein actual annual expenditures are compared to a 'per head' of convict and total population.

Table 8.4: Colonial NSW Major Government Expenditure Components 1822-1834
Totals per annum £'000

Year	Convict Commissariat.	Military Commissariat	Police Commissariat
1822	180.0	27.8	
1823	116.9	27.7	
1824			
1825	86.8	35.9	
1826	68.8	29.8	
1827	91.6	37.	
1828	118.4	60.3	11.2
1829	115.4	68.2	19.5
1830	89.7	59.5	20.3
1831	89.5	61.3	19.3
1832	77.7	67.4	16.9
1833	78.1	53.2	19.9
1834	98.2	65.0	15.8
1835	105.3	82.7	5.5

As set out in Table 8.4, the commissariat was divided into three 'expense' categories for 'accounting' purposes, namely Convict, Military and Police. The military, police and civil sections were supported by common staffing, provisions and stores, and a monthly adjustment was made in the commissariat accounts to reflect the amount of supplies allocated against each of these categories. The figures, in themselves, were quite meaningless and consumed many clerical hours for no real purpose. Each category received the same rations and support per head with the police and military men and assigned convicts being awarded additional rations and allowances.

Overall, an ideal working Chart of Accounts for the commissariat would have included a capability for assessing costs of operating each working division of the commissariat – e.g. Lumber Yard, Dock Yard etc. Within this framework, assignment of material and labour costs could be made thus allowing for a 'product' cost, which would provide a basis for capitalising the costs of public works. On the other side of the ledger, a breakdown of 'expenses' made to support the transportation program, military and the civil service establishments, and then government by department, would have allowed the British Treasury to compare the true costs of these programs and of maintaining the colony as a whole. This would have resulted in a simple yet meaningful accounting system that could have been used for strategic and policy

decision-making, rather than the cumbersome, meaningless system actually installed by William Lithgow, the first Commissary of Accounts in 1824.

Table 8.5: Comparative Commissariat Expenses 1788-1834 – per convict

Totals per annum £'000

Year	Total Commissariat Expenditure	Total Commissariat Revenue	Expenditures per Convict (in pence p.a.)	Expenditures. per Head of Population
1822	212.2	255.5	4.316	1.710
1823	149.7	134.1	3.234	1.198
1824				
1825	155.0	198.3	2.292	1.205
1826	103.3	63.2	1.511	.799
1827	133.7	166.2	1.869	.877
1828	238.0	98.5	3.646	1.603
1829	243.2	158.9	3.437	1.595
1830	196.8	139.6	2.695	1.139
1831	203.6	182.6	2.541	1.055
1832	194.3	165.7	2.337	.958
1833	165.5	146.5	1.618	.653
1834	187.	174.2	1.647	.678

Table 8.5 is intended to put the these expenditures into a comparative format in order to demonstrate just how important the commissariat was to the colony, the unreliability of the official figures, and the misuse of expenditure data by colonial administrators. For example, the official statements made to Commissioner Bigge set the 'cost' of maintaining a convict in food at 13 pence per annum and the total cost at 18 pence per annum. Although these figures were given in reference to the Macquarie Administration, there is no way such a decline would have occurred between 1820 and 1822. Into this latter figure is built the 'cost' of housing and clothing. The food and supplies portion of the official estimates is quite low which can be explained by their access to outside paid work, food production from their own vegetable patches or additional support from their employer or 'Master'. Once again, as has been seen in previous tables, the absolute figures or the total expenditures passing through the commissariat may have been large, but the alternative cost of maintaining the prisoners in England was larger still. These figures are sourced directly from the *Blue Books* and have been compared with the Ginswick statistics included in various N.G. Butlin studies. The 'capital' cost of housing prisoners in Britain would have alone been more than the total cost of transporting and maintaining convicts in the colony of NSW. In Britain, as in the colony, prisoners were put to work on government jobs (mainly public infrastructure projects), but the value of their

work was not assessed as being of any more value in Britain than it was in the colony. Maintenance costs in Britain were also estimated as being higher than in the colony.

Table 8.6: Commissariat and Military Expenditures in the Colony 1788-1840

Year	Comm Exp	Public Exp.	Victualling	Stores	Bills	Military	Commissariats	
							Convict	Military
1788)	261	n.a.	4,728	n.a.		
1789)	21,125	12,853	891	6,847		
1790)	1,840	18,402	1,341	6,576		
1791)	25,682	25,603	13,064	9,946		
1792)	17,261	31,140	2,842	10,110		
1793)	19,762	n.a.	11,411	10,724		
1794) 8.9	25,470	12,309	11,217	10,228		
1795)	26,697	4,392	3,814	10,228		
1796)	31,080	7,931	10,020	13,427		
1797)	7,092	4,030	78,898	16,906		
1798) 129.2	12,033	5,169	26,407	19,726		
1799)	6,568	88	43,448	16,481		
1800)	13,834	11797	50,707	18,953		
1801		57.4	12,126	7,187	17,267	20,576		
1802		n.a.	93,272	11,189	17,837	19,592		
1803		n.a.	16,609	16,204	21,465	16,223		
1804		n.a.	n.a.	306	19,298	15,386		
1805		n.a.	9,511	10,289	32,351	15,384		
1806		n.a.	38,782	6,921	13,973	19,983		
1807		106.7	21,772	17,067	3,264	30,663		
1808		n.a.	35,876	1,848	23222	25,101		
1809		n.a.	11,901	115	49,921	26,377		
1810		n.a.	18,136	2,134	78,805	25,357		
1811		n.a.	55,114	20,748	92,128	24,312		
1812		258.8	17,911	1,296	91,019	31,257		
1813		n.a.	31,760	829	57,948	33,792		
1814		116.8	23,009	34,651	74,174	20,893		
1815		95.3	18,833	557	86,021	24,350		
1816		120.2	24,613	16,513	109,118	17,121		
1817		110.2	31,821	21,927	101,163	10,765		
1818		186.5	50,382	5,290	14,520	33,478		
1819		n.a.	42,619	2,343	163,465	24,097		
1820		414.2	48,296	17,391	174,110	35,204		
1821		n.a.	39,892	52,647	207,050	35,111		
1822	212		35,689	47,760	162,677	40,996	180.0	27.8
1823	149						116.9	27.7
1824	Na						n.a.	n.a.
1825	155						86.8	35.9
1826	103						68.8	29.8
1827	133						91.6	37.
1828	238						118.4	60.3
1829	243						115.4	68.2
1830	196						89.7	59.5
1831	203						89.5	61.3
1832	194						77.7	67.4
1833	165						78.1	53.2
1834	187						98.2	65.0

Year	Comm	Public	Victualling	Stores	Bills	Military	Commissariats	
1835	250						105.3	82.7
1836	344						133.5	98.1
1837	254						125.8	83.2
1838	363						127.4	81.0
1839	474						159.2	86.1
1840	389						149.5	88.4

The opportunity for misallocating elements of expenditure within the commissariat to categories where there was little or no oversight e.g. military or civil, and thus hiding the actual outlays was tempting and manipulative. Thus the figures used are unreliable as to both component allocation and total annual costs. If the British Government's official policy was to make the transportation program self-supporting and keep the convict maintenance costs to the bare minimum, then Table 8.5 verifies that this policy worked.

These tables incorporate the only official figures available. What they do not allow is an examination of the inventory control records of the commissariat, other than during Governor King's administration, or the purchasing of supplies, their distribution or usage. All that is available is the annual allowance by the British Treasury to the commissariat in the colony and the approximate use of those funds.

The main conclusion that can be drawn from these tables is that the commissariat was an important and integral part of the colony, and was active in providing supplies and support to the transportation program, the military and civil establishments and the government generally. Expenditure and revenue levels reflect economic activity in the colony, as well as economic conditions in Britain and in particular the financial impact of the Napoleonic Wars. The figures are also influenced by the level of population growth in the colony, the public works program under Macquarie and his successors, the pork-barrelling that occurred after the introduction of appropriation bills into the NSW Legislative Council in 1832, and the changing role of governance in the colony. Moreover the advent of social policy – economic diversification, decentralisation, extended boundaries of settlement (public roads, bridges) and more government services in areas such as education, infrastructure maintenance, aboriginal welfare and policing, and the church - also impacted on government finance.

Tables 8.6- 9 are indicative of commissariat operations before the *Blue Books* came into being. Table 8.7 shows the early record-keeping of Commissary John Palmer about which he wrote

to Governor Phillip that he was doing the job of 12 pursers. Obviously the Palmer record-keeping (he was also the clerk of these records) accounts for both expenditures and inventory. As pointed out previously, the mix of the 1793 stores is of interest in setting down the very limited variety of supplies at that time and the very limited expenditures being processed through the commissariat under Phillip. The quantities of supplies received into the store indicate the concentration of rations in flour, sugar and pork. Only imported salted beef was used, as the local cattle herd was being set aside solely for breeding purposes to build up a greater herd so that demand for fresh beef could be satisfied from local supplies.

Table 8.7: Commissariat Transactions - September 1793

Receipts		Expenses	
Bills payable	13,502	Provisions and spirits	2,957
Cash received from Gov. Phillip	70	Wine	38
		Stores	9,603
		Purchase of live hogs for settlers	115
		Purchase of corn grain	362
		Rent of longboat	13
		Purchase of pigs	12
		Purchase of general supplies	27
		Salaries of convict supers	245
Total Receipts	13,572	Total Expenses	13,382
		Balance	200

Table 8.8 Supplies Received into Store - September 1793

Beef	(lb)	303.94
Pork	(lb)	17,368
Flour	(lb)	121,576
Sugar	(lb)	32,628
Molasses	(lb)	3,260
Pease	(bu	8,141
Clothing	(bundles)	100

Table 9.9: Convict Workers Accommodated by Government- 1821-22

Carters Barracks	375
Hyde Park Barracks	1,250
Out of Barracks (Private dwellings, using rent allowance and assigned)	5,656

Parramatta Barracks	2,335
Windsor Barracks	175
Liverpool Barracks	250
Bathurst Barracks	200
Total	10,241

Table 8.10 Government and Private Assignment 1821

Convict Arrivals	15,767
Public Work Assigned	
Government work in Lumber Yard, Dockyard & Timber Yard	4,585
Private	
Assigned – mechanics	1,587
Assigned – labourers	4,069
Clerks and supervisors	1,524
Total Assigned	**11,765**

Table 7.9 shows that convicts were housed in Sydney, Parramatta, Bathurst, Windsor and Liverpool. Within Sydney, the two main barracks were Carters barracks (mostly for boys and young unskilled men), and Hyde Park barracks (for hardened convicts and older offenders). The Women's barracks (The Female Factory) was located in Parramatta but completely separate from the men's barracks. Carter's barracks was located in the Brickfield Hill area, and was relatively small (only 375 men and boys), whilst Hyde Park barracks housed a maximum of 1400 convicts in 1825 (having risen from 600 at the time of its opening in 1819). Macquarie tried to reduce government costs by having the more reliable convicts housed in private quarters and, if necessary, they were supported by a 'rent allowance' from the commissariat funds.

This table (7.9) also shows a policy in transition. The Macquarie policy of optimising convict workers on government programs was being gradually replaced under Governor Brisbane with the reintroduction of the 'assignment' policy. So by 1822, less than 50% of convicts were put to work by the government (down from 68% under Macquarie). In 1822, more than 90% of government workers were directly employed through the commissariat operations – the Lumber Yard, Dockyard and Timber Yard. Under Governor Darling this situation would further change and the level of assigned convicts would climb to well over 70%

Table 8.11: Valuing Convict Labour 1817 (by day rate and task)

Category of Labour	No. of Convicts	Task	Annual Labour Value
Carpenters' Gang	50	Builders, cabinet makers	3,510
Blacksmiths' Gang	45	Working in iron, copper or tin	3159
Bricklayers' Gang	10	4,500 bricks per week	702
Sawyers' Gang	25	750 feet of plank per week	1,755
Brickmakers' Gang	15	Gang lays 24,000 bricks per week	1,053
Plasterers' Gang	8	Lathing, undering, flanking = 20 yds p/week	561
Quarrymen	15	14 Ashlar stones per man per day	1,053
Quarry labour	14	25 ft flagging per man per day	983
Wheelwrights' Gang	23	Construct carts, drays, trucks, wheelbarrows	1,614
Coopers' Gang	6	1 barrel per man per day	421
Shoemakers Gang	8	1 pair shoes perf man per day	562
Tailors' Gang	8	2 suits of slop clothing per man per day	562
Dockyard	70	Mechanics assisted by labourers	4,914
Dockyard Town Gang	22	Loading/unloading vessels or boats	1,544
Stone-cutters & Setters	13	Cut 15 ft of fine ashlar stone	913
Brass Founders' Gang	9	Cast iron for wheels and millwork	632
Lumber Yard	319		22,394
Construction	1,197		84,029
Roadmaking	362		25,412
Land Clearing	1,150	9,000 acres cleared per annum	80,730
Cart Operators	268		18,813
Brick/tile Makers	124		8,704
Boat Navigators	12		842
Grass Cutters	304		21,340
Boat Crews – Official	120		8,434
Gross Farm	160	Vegetables	11,234
Canterbury	11	Cattle	772
*Long Bottom	110	Timber, hay and charcoal	7,722
Emu Plains	269	Wheat and maize	18,884
Total	**4,747**		**333,239**

Table 8.11 shows that 4,747 convicts in government service performed 25 different tasks having an opportunity labour rate benefit of nearly £6,500. The more important aspect of the table shows the productivity of the convicts and the goals set for them for tasking. The table also shows the variety of work performed by convicts through the various commissariat operating centres. In 1817, the location of convicts included Sydney, Parramatta, Liverpool, Windsor, and Bathurst. The largest work unit was the Lumber Yard, which comprehensively dealt with timber, iron and steel, shoes and clothing. The total convict numbers utilised by government was high (at 4,747), whilst by 1822, when the total number of convicts in the colony had increased significantly, those in government service had declined, with the greater

number in private work under assignment to landowners and pastoralists. The estimated 'cost' of this labour is computed at a day rate of 4/6d and a working week of 6 days. Even using the Coghlan 'efficiency' factor of 40%, the daily value of convict labour in these various categories would still be in excess of £3,800. The effect of this policy change was a huge saving to government, including lower housing, food, clothing and maintenance costs. However, the Macquarie public works program had created a 'town' in which free settlers felt welcome and safe. Macquarie created an environment in Sydney town where this transitional policy could be adopted with minimal outlay and additional infrastructure to cater for the increased numbers of convicts arriving the colony.

Productivity targets within the commissariat operational area were modified on a regular basis, as they were very dependent on the skills of relevant convicts, the volume of planned work in the Lumber Yard and the availability of raw materials. Obviously convicts resisted work at every opportunity and would use any excuse to lay down tools, so that weather related conditions, poor work-site supervision, irregular supplies of raw materials or disruptive individual convicts could have a considerable impact on output. However in general terms, the coopers' shop would regularly turn out 25-30 barrels per week, which largely met the production target of 36 barrels. The shoemakers' gang targeted 48 pair of shoes each week, whilst the tailors aimed to produce 100 sets of slop clothing per week, but both trades invariably failed in this task.

Macquarie was adamant about keeping the town looking neat and tidy and having a suitable atmosphere for the gentry to parade in the governor's domain or watch the races at Hyde Park, so he had a band of over 300 grass-cutters working in the town area. The cattle herdsmen were relatively few in number (only 11) but they managed a herd of over 2,000 fairly wild and unfenced horned cattle. The only set of cattle yards was centralised at the Cow Pastures of Camden, which created a problem for transferring cattle to Sydney Town and Parramatta for slaughtering purposes.

By 1817, Macquarie had rebuilt the facilities on government farms, and they were producing vegetables, grain and hay for sale through and use by the commissariat. When these farms closed in the following year, by direction of Lord Bathurst, nearly 500 convicts had to be

reallocated, and the only real benefit of this policy change to the colony was that the farming equipment used by the government was auctioned off to private users. This action assisted those fortunate few who were able to buy and pay for the equipment purchased, to increase their productivity and reduce their reliance on convict labour.

The Dockyards were generally a favourite place for convicts to work, as the potential for theft was high. There were specialist dockworkers, loaders and provisioners, in addition to the dockyard mechanics involved in patching and repairing visiting ships. There was also a greater potential for absconding through the Dockyard, although most that tried were recovered quickly.

The economics of the convict assignment system are of interest. The commissariat supplied one set of 'slops' clothing, 2 pairs of shoes, and 1 mattress each year to each convict. The 'master' furnished housing, food, internal transport and usually an allowance of tobacco and tea. The cost to the master of each convict assigned was reportedly 2/- per week, whereas free labour would cost the employer between 5/- and 7/- per week. If a factor for inefficiency for using convict labour is applied, there was very littler saving for a landowner in using convict rather than free labour. It all came down to the availability of free labour.

An Age of Expansion

Two fundamental, and essential, components of colonial economic history are 'the Age of Expansion' and the economic drivers of the period. This concept of an age (or period) of expansion derives from a deliberate change of government policy towards the functioning and development of the colonial economy. This period between 1810 and 1822 was devoted to a redirection of the previous development patterns and, albeit unapproved by the British Government, became the most influential years (in economic, social and political terms) of the British colonial administration between 1788 and 1856. The economic moulding came from a carefully woven transition from penal to free economy, more government by regulation, and directed growth mostly in the guise of free enterprise. The role of the 'state', both in terms of British influence and colonial governor engagement, also changed. Public administration became too large for one man to manage the many aspects of government rule and, as part of the exercise of 'state' governance', Macquarie resorted largely to government by regulation.

This in turn influenced the role of the free press, and witnessed the growth of a public service and a decentralised exercise of government. Successful exploration also influenced and enhanced decentralisation of markets as well as governance. A growing local tax impost, as evidenced by increased colonial revenues, was the corollary of a social framework that recognised effort and rewarded risk-taking.

Colonial society was being encouraged to recognise the 'value' of a smart town, with well defined streets, building standards and grand public buildings. A tax burden on everything imported was the 'cost' of accepting this social reconstruction. Commissioner Bigge responded both favourably and critically to the worthiness and cost of these Macquarie pretensions. Bigge had been warned by Lord Bathurst of unregulated government expenditure and so expected an active town life, but he was not ready to accept the economic activity that confronted him when he stepped ashore with his 'secretary', Timothy Scott. Bigge was hard pushed to find substantive recommendations for improvement, and instead relied on narrow charges of waste, excess and fraud, most often based on complaints from locals which were common to all colonial administrations. The lowly commissariat was in the nether region of public administration. Changed from local gubernatorial control to centralised, military control in 1813, the commissariat was outside the purview of local budgetary control and the governor wholly relied on the goodwill of the commissary to work usefully in moving the colonial economy forward in a regularised manner. The commissariat encouraged expansion and economic development directly and made it possible for the economy to grow and diversify. This kept the basis of an institutional framework, influential in Empire affairs whilst maintaining European and British standards and values.

Colonial Economic Drivers 1788-1856

Colonial economic drivers were certainly influential but the age of expansion encouraged a variation on private versus public enterprise and produced local policies as a definitive modification to traditional British colonial guidelines.

Identifiable economic drivers of the period include:

> Population growth, including convicts and free settlers
> Foreign private investment
> British public funding transfers

Colonial government revenue and expenditure
The Land Board
The commissariat
Colonial financial institutions

What statistical information reflects growth in an economy? Logically the various economic drivers in an applied status would represent economic growth. A special element of economic growth was population growth and its associated elements, foreign investment, local taxation and expenditures, waste lands policy, growth of local financial institutions and government regulations. However, at this point the key components of the Age of Expansion should be recognised, for the commissariat was totally involved in progressing both the economic drivers and the other main components of the developing economy. The commissariat was responsible for encouraging the climate for population growth and foreign investment. The commissariat was the backbone of the largest element of population increase being the transportation program, and without the aid of the government store the feeding, clothing and useful employment of this growing convict population, the transportation program would have been headed for an early demise.

The commissariat was the largest individual component of British public expenditure within the colony and through its quasi-banking facilities and mechanisms (for instance, bartering, payroll bills, store receipts and acting treasury before 1825) it encouraged the growth of local financial institutions and a banking system. The commissariat assisted the development and credibility of local banks by depositing its cash and transferring its right to accept and issue bills. However, the commissariat accepted this important role as an economic driver by its visible local financial and material support which underpinned the whole economy and facilitated its expansionary phase.

The commissariat was in the process of closing its doors at the important time of the gold rush, the start of the railway system and the move toward self-government. However it did oversee and influence the freedom of shipping from state control, support many components of the agricultural revolution and initiate free trade versus protection debates and the dramatic growth of trade and foreign investment.

Table 8.12: Population Statistics 1810-1821 and 'Off-Store' figures[125]

Year	Total Population	No. on Store	Convicts Total nos
1810	10,452	6,225	4,766
1811	10,025	6,429	4,801
1812	10,521	6,445	4,938
1813	12,173	8,367	5,019
1814	12,116	8,318	5,234
1815	12,911	8,828	5,377
1816	15,175	11,136	5,490
1817	17,265	11,878	5,795
1818	na	na	6,082
1819	26026	na	12749
1820	29963	na	10873

As a percentage of both total population and convict population, the number 'on the store' is significant and accounted for much of the expense of the commissariat, both before and following this 'age of expansion'.

Table 8.13: Free Immigrants to NSW 1788-1850[126]

1788-89	0
1790-1800	47
1800-1809	304
1810-1819	237
1820-1829	1,202
1830-1839	31,626
1840-1849	85,399

[125] Sourced from various musters, recorded in the HRA. These original figures appear faulty but have been reported as set out in the original documents
[126] The Australians: Statistics *The Economy before 1850*

Table 8.14: Convict Arrivals 1788-1850[127]

Year	Convict Arrivals	Year	Convict Arrivals	Year	Convict Arrivals
1788	717	1819	12,749	1837	36,109
1789	16,65	1820	10,873	1838	38,562
1790	3,384	1821	13,814	1839	38,035
1791	3,439	1822	11,801	1840	38,415
1792	3,499	1823	11,110	1841	26,977
1793	3,367	1824	n.a.	1842	24,948
1794	3,358	1825	16,233	1843	21,426
1795	2,934	1826	16,413	1844	19,175
1796	2,492	1827	17,164	1845	16,843
1797	2,017	1828	15,668	1846	10,838
1798	2,837	1833	24,543	1847	6,664
1804	2,077	1834	27,251	1848	4,015
1816	5,490	1835	29,182	1849	3,517
1817	5,795	1836	27,831	1850	2,364
1818	6,082				

Table 8.15: British Outlays on Colonial NSW 1810-1822[128]

Year	Convict Transportn	Victuals	Stores	Bills	Civil Salaries	Military	Total
1810	40,767	18,136	2,134	78,805	12,269	25,357	178,700
1811	5,637	55,114	20,748	92,128	13,309	24,312	214697
1812	31,115	17,911	1,296	91,019	11,701	31,257	185,547
1813	79,348	31,760	829	57,947	13,295	33,792	218,735
1814	55,536	23,009	34,651	74,174	13,298	20,893	225,086
1815	39,041	18,833	557	86,021	12,788	24,350	181,590
1816	36,504	24,613	16,513	109,118	12,423	17,121	216,292
1817	54,094	31,821	21,927	101,163	12,815	10,765	232,585
1818	77,856	50,382	5,290	145,520	12,605	33,478	325,132
1819	78,496	42,619	2,343	163,465	16,825	24,097	327,845
1820	81,234	48,296	17,391	174,110	17,081	35,204	373,316
1821	73,569	39,892	52,647	207,050	17,081	35,111	425,350
1822	65,260	35,689	47,760	162,677	10,996	n.a.	365,729

[127] The Australians: Statistics *'The economy before 1850*
[128] Sourced from Ginswick MS as reported by N.G. Butlin

Table 8.16: Local Revenue Collections and Expenditures – 1811-1818

Orphan & Police Fund

Revenue		Expenditure	
Import duties	17,649	Bridge Repairs	9,404
Farm supplies sold	998	Contract Construction	15,778
Work by orphans	310	Gov't buildings, churches	9,920
Licences sold	21,422	New wharves	2,002
Road tolls collected	2,530	New roads	6,080
Court fines collected	583	Sundry charges	56,836
Market fees collected	2,568	Public schools	2,480
Auction licences and fees	301	Orphanage and other	12,589
Naval officer net collections	73,442	Cash on hand at end	5,515
TOTAL	£120,286	TOTAL	£120,286

This brief analysis of the commissariat contribution to the colonial economy must confirm that it was an influential and even powerful figure in the colonial economic administration. Successive governors saw the commissariat as a means to an end, rather than a tool for planning and improvement. Certainly it was not the ultimate in economic fiduciary responsibility: in fact the operating instructions commissary stressed accountability rather than responsibility. There were virtually no budgetary parameters for spending limits or expenditure guidelines other than overall appropriations. In other words, the commissariat was an accidental tool of economic development and growth but an important, if haphazard, economic driver.

General Conclusions

Many aspects of the colonial economy depended on the commissariat as a facilitator:

The agricultural sector relied heavily on the commissariat to purchase its grain and meat production. Although most farmers held back grain as seed for the following year's planting, the commissariat was always willing to act as supplier of seed grain to new farmers.

The fledgling manufacturing sector was reliant on the commissariat's entrepreneurial policies to transfer operations from the public sector to the private sector.

Before 1824, coal production for the settlement was carried out on the cliffs of the south-coast by convicts working under commissariat supervision. In 1824, the newly-formed AAC

received land grants, which included coal reserves in the Newcastle region, and coal production became privatised and was sold locally and exported eventually through the commissariat.

When grain shortages occurred in NSW due to droughts or Hawkesbury floods, the commissariat entered into contracts with its VDL counterpart to purchase grain from their farmers.

Civilian housing was initially constructed privately with timber and fittings purchased through the commissariat.

Early visiting ships were victualled and provisioned with supplies arranged by the commissariat. They generally bartered with the commissariat to sell items brought into Sydney Harbour.

The commissariat advanced credit to farmers and other civilians who were in need of short-term financial support.

The commissariat facilitated bartering arrangements by issuing and accepting back 'store receipts'.

Many aspects of the colonial economy depended on the Commissariat's spending and supply.

The agricultural, industrial, and retailing sectors each depended on the commissariat's spending and purchasing patterns. The boatbuilding industry was sponsored by the need to remit supplies to the Parramatta region via river boats. The commissariat was always mindful of making itself, or arranging to have a local cottage industry make, many items formerly only received by import.

All foreign currency transactions were carried out through the commissariat.

All military officers could receive their pay in the colonies by way of 'payroll bills'. The commissariat facilitated the conversion of these bills into cash or goods and would often advance credit against future bills receivable.

Britain also benefited in numerous ways from Commissariat expenditures, in addition to the direct benefits of creating and investing in the colony.

All purchases by the commissariat were from within the British economy

Shipping contracts between Britain and the colony and from the colony were all for British flagged, insured and manned vessels.

Most returning vessels considered 'back-loading' by way of Asia a source of low cost/high profit return loads especially via India and China.

Low cost charter of supply vessels by Governor's in lieu of having permanent ships located in Sydney. The British Treasury saved large expenditures by not investing in permanent vessels for the colony's use, but relied on visiting ships being leased for short-term local use.

Shifts in administrative structures.

Early on the growth within the commissariat caused a need for a colonial 'public service structure'.
With the commissariat acting as the treasury, Macquarie recognised the need for a new financial services structure, including establishing the Bank of NSW.

The need also grew a for governmental departmental structure with individual areas of responsibility and feedback to the governor.

Macquarie recognised and acted upon the need for transport and communication planning.

There was a need for a 'treasury', other than the commissariat – thus the appointment of a Colonial Treasurer and Colonial Auditor in 1824.

Although there are 8 recognised economic drivers before self-government in 1856, the Commissariat is recognised as the first and most important as both a catalyst for population growth, economic growth and foreign investment, and as the premier economic driver.

The Commissariat was:

The only purchaser of local production and without that function the colony could not have survived and the agricultural sector would not have succeeded.

The main facilitator of local manufacturing of import replacement goods.

A financial institution which created both credit and foreign currency trading facilities.

A token 'treasury' - trade bills, payroll bills, specialty imports.

A direct employer of hundreds, and the facilitator of thousands of workers.

The foremost government business enterprise in the colony with its various yards, cattle and agricultural farms, timber production, boat building, ferry services and stevedoring activities.

A catalyst and developer of decentralisation & distribution plans and policies.
A record-keeper which may have seemed of poor quality but considering the inventory and reporting needs, upwards of 26 clerks were utilised in the service.

An 'entrepreneur' an almost neglected area. This responsibility came about by the time-lag in importing many urgent items, and created the opportunity of making goods and equipment locally.

Summary of Chapter 8

Even with the limited records of the Commissariat in NSW,still available, the efficacy of the Government Store can still be evaluated in the style of an annual report to the stakeholders of any public company. In this case the stakeholders are the government of the day and the population of the colony whom the store was initially designed to serve. In summary, the Commissariat operated over 20 locations and 'businesses.' It directly employed 7180 convicts (employees), generating over £500,000 in *pro forma* income into the economy. The Commissariat expended over £80,000 each year on victualling and stores between 1800 and 1820. The unvalued output of convict labour is estimated at over £200,000 per annum.[6] Using a multiplier effect of 4, the total gross product of the commissariat would have been over £3 million annually. The commissariat participated in many aspects of colonial life and actively supported economic development. This level of activity outperformed all other economic drivers until the advent of the colonial railway systems and the discovery of gold in the 1850s.

It is clear that between 1793 and 1820, staffing in the store rose from three to 202. This number included employees in all branches Sydney town and the outlying districts and all categories of workers from the DCG (Deputy-Commissary General) to the humblest storeman/packer. Thus the commissary was a significant employer in his own right, even before even before it was made responsible for convict employment.

The value of output for each division in any year can be estimated by applying a labour rate and productivity to each of the operating divisions (for example, Lumber Yard, Timber Yard, Stone Yard and Brick Yard). Similarly, the 'cost' of labour can be computed for each division, but all these figures are hypothetical because the commissariat did not record either the input value of local raw materials, the 'value' of convict labour, or the value of any commissariat output. The value of output of the four Government farms operating before 1818 can be assessed by applying a 'market' price for grains, meats and vegetables to government farm production, but the commissariat, in practice, gave a nil value to each of these items, even to the point of valuing the government herds at zero.

Thus the efforts of the commissariat to be an economic driver included participating in the public works program, the Land Board program, the Banking and Financial Institutions program and the transportation labour utilisation program. The commissariat impacted on every facet of the colonial economy. The British Treasury took a simplistic approach to comparing the fiscal efficiency of one governor with another. Everything was compared in totals or absolutes. Macquarie spent more than Hunter, King or Bligh according to the Treasury, but they missed the point that the number of convicts rose by 16 times over the same period, and not even the Treasury could expect total costs to have remained the same. That the cost per head of convict maintenance declined each year under Macquarie was a tribute to his economic planning and good management.

So the question arises, if all of the important operating data for the commissariat can be artificially recreated, what is still missing from the picture? In the same way the *Blue Books* offer a fiscal picture of the colony as a whole, then a financial picture of the commissariat would be of interest and of some collective value. The missing papers would evidence the 'into' and 'out of' store transfers by year, as well as the consolidated financial statements of the commissariat by operating division. However, this would assume that the commissariat accounting system of the 1800-1830 periods was more sophisticated than any other colonial accounting or reporting system, and this is unlikely. So it is more realistic to conclude that the actual physical records are lost or destroyed, and the recreation of the more important details into a format suitable to support the perception of virility within the commissariat organisation will have to be sufficient for the purposes of this study.

[6] The author's estimates based on GDP and capital formation estimates during the Macquarie Administration 1810-1821

OPEN FOR BUSINESS

BIBLIOGRAPHY

Secondary Sources

Author	Text Name	Publisher	Year
	An Epitome of the Official History of NSW	NSW Gov Printer	1887
Parson, T. G.	The Colonial Commissaries	McMillan & Co	1988
Ashton, T. S.	An Economic History of England	Methuen	1955
Briggs & Jordan	Economic History of England	OUP	1954
Barnard, M	The History of Australia	A & R	1976
Beckett, G. W.	Biography of William Lithgow	Colonial Press	2003
Beckett, G. W	John Palmer – Commissary-General	Colonial Press	2002
Broadbent, Hughes	Francis Greenway	HHT	1997
Broeze, Frank	Mr. Brooks & the Australian Trade	MUP	1993
Butlin, N. G.	The Economy before 1850	MUP	1953
Butlin, N. G	Forming a Colonial Economy	CUP	1994
Butlin, N. G	Economics & the Dreamtime	CUP	1993
Butlin, N. G	Investment in Austn Economic Dev	ANU	1972
Butlin, N. G	What a way to run an Empire, fiscally!	ANU	1981
Butlin, S. J	Foundations of the Austn Monetary System	MUP	1953
Coghlan, T A.	Lbr & Industry in Australia Vols1-4	McMillan	1969
Ellis, M. H.	Francis Greenway	A & R	1949
Ellis, M. H.	John Macarthur	A & R	1955
Ellis, M. H.	Lachlan Macquarie	A & R	1947
Fitzpatrick, Brian	The Australian People 1788-1945	MUP	1946
Fitzpatrick, Brian	The British Empire in Australia	MUP	1941
Fitzpatrick, Brian	British Imperialism and Australia 1783-1833	SUP	1939
Fletcher, Brian	Ralph Darling – A governor maligned	OUP	1984
Forster, Colin	Australian Official Statistics 1788-1855 (WPEH # 33)	ANU	1985
Hainsworth, D. R.	The Sydney Traders	Cassell	1972
Holder, R. F.	Bank of NSW – A History 1817-1970	A & R -2 vols	1970
Larcombe, F. A.	History of Local Government 1831-1973	SUP – 3 vols	1973
Linge, G.	Industrial Awakening	ANU	1979
McMartin, Arthur	Public Servants & Patronage-	SUP	1983
Melbourne, A.C.V.	Early Constitutional Development	UQP	1962
Kociumbas, Jan	Oxford History of Australia Possessions 1770-1860-	OUP	1992

Ritchie, A	*Punishment & Profit*	Heinemann	1970
Shann, Edward	*An Economic History of Australia*	CUP	1930
Shaw, A. G. L.	*Convicts & Colonies*	Faber	1962
Younger, R. M.	*Australia & The Australians*	Rigby	1960
Yarwood, A.T.	*Samuel Marsden*	MUP	1977
Cobley, John	*Sydney Cove*	A & R 4 vols	1963
Various	*Beyond Convict Workers*	UNSW	1996
Meredith, D.	*Selected for Transportation*	UNSW	1996
Dyster, B	*Why NSW did not become Devil's Island*	UNSW	1996
Flannery, Tim	*The Birth of Sydney*	Text	1999

Primary Sources

Historic Records of Australia – Series 1,2,3,4 - Volumes 1-32

Historic Records of New South Wales -Volumes 1 – 9

Historic Records of Victoria – Volume 7

The Australian Dictionary of Biography (ADB) MUP 1996

State Records Office of NSW – Guide to the State Archives –Record Group NC11

Mitchell Library 'Manuscripts ML 803'

Collins, David 'An Account of the English Colony in NSW' (Reed Press – 1975)

Bigge, J. T. 'Report on the Colony of NSW '(House of Commons Reports 1-3, 1823)

AJCP

Contemporary Newspapers: *Sydney Gazette, The Monitor, The Australian*

Abbreviations used in Bibliography

UQP – University of Queensland Press
ANUP – Australian National University Press
SUP – Sydney University Press
MUP – Melbourne University Press
OUP – Oxford University Press
CUP – Cambridge University Press
CP – Colonial Press
HHT – Historic Houses Trust
McM A - McMillan of Australia
A & R – Angus & Robertson Publishers
Text Publishers
Faber Publishing
Methuen & Co. (London)
Heinemann Press
R. H. Reed & Son (London)
Cassell & Co Publishing

APPENDICES

An Economic Model of the Colonial Economy GDP

The pre-1861 period has long been considered[129] too risky for the assembly of data and creating an economic model. However certain elements of such a model can be identified and used for at least a good indicative assessment of the economic growth between 1788 and 1860. A practical example of an economic model which could be adapted for this period was found in McTaggart, Findlay and Parkin *Macroeconomics*. The basis for the model is that 'aggregate expenditure equals aggregate income i.e. $Y - C + I$, where aggregate income (Y) equals aggregate expenditure $(C + I)$'. A corollary will be that aggregate production or GDP = aggregate expenditure= aggregate income'. There is a circular flow which equates *inputs* and *outputs.* A detailed development of such a model is to be found in Appendix A to this study, together with a valuable outcome of GDP between 1800 and 1860. The rise of manufacturing was a significant part of the economic growth in the early colony. Of all the sectors, agriculture (including whaling, sealing and wool) gave the most significant results in terms of manpower used, capital invested, export returns, and GDP. In second place would have been the development of local natural resources, followed closely by manufacturing outcomes. These observations can be made from individual statistics of employment, exports, convict work organisation and data about immigrants and their assets. However, the more reliable statistics will come from the assembly of a model using either the production approach, or the aggregate income/expenditure approach. Both methods will be attempted and compared but, as can be seen, an understanding and assessment of manufacturing is essential to either methodology.

[129] N.G. Butlin and T.A. Coghlan write of the inaccurate statistics and other data for this period.

Table 7.1: Estimates of GDP between 1800 and 1900

Year	GDP per head of population	GDP per head of workforce
1801	13.61	35.10
1811	28.06	49.95
1821		59.70
1831	35.68	63.51
1841	39.66	70.60
1851	40.13	76.43
1861	46.00	85.00
1871	47.00	118.00
1877	57.00	139.00
1881	63.00	151.00
1889	67.00	158.00
1891	66.00	155.00
1900	57.00	132.00

Source: Beckett *Handbook of Colonial Statistics for period 1800-1860*
Butlin, N.G. *Investment in Australian Economic Development 1861-1900*

INDEX TO APPENDICES

130